Volume 20

DIRECTORY OF
WORLD CINEMA
SOUTH KOREA

Edited by Colette Balmain

intellect Bristol, UK / Chicago, USA

791.4309
Direct
2013

First Published in the UK in 2013 by Intellect, The Mill, Parnall Road, Fishponds,
Bristol, BS16 3JG, UK

First published in the USA in 2013 by Intellect, The University of Chicago Press,
1427 E. 60th Street, Chicago, IL 60637, USA

Publisher: May Yao
Publishing Manager: Jelena Stanovnik

Cover image credit/caption: Poetry (2010) Pine House Film/The Kobal Collection
Cover Design: Holly Rose
Copy Editor: Heather Owen
Typesetting: User design, UK

Directory of World Cinema ISSN 2040-7971
Directory of World Cinema eISSN 2040-7971

Directory of World Cinema: South Korea ISBN 978-1-84150-560-2
Directory of World Cinema: South Korea ePDF ISBN 978-1-78320-055-9
Directory of World Cinema: South Korea epub ISBN 978-1-78320-170-9

Printed and bound by Gomer, Wales.

DIRECTORY OF
WORLD CINEMA
SOUTH KOREA

ACKNOWLEDGEMENTS

A Note on the Language

All contributors have used the Revised Romanization system for translations of names of films, directors and actors. I have tried to ensure consistency, but there may be some errors as the Revised Romanization system is translated differently across various sources that were used. As a result, I apologize in advance for any translation errors that there may be.

Acknowledgements

I would like to thank all my contributors for their hard work and dedication, the Korean Cultural Centre in London for a wonderful year of Korean Screenings and Events which has inspired and solidified my love for South Korean cinema, John Berra for his constant support and guidance, and the staff at Intellect for commissioning me to edit this book. Finally, the book would not have been possible without the love and support, both financial and emotional, of my sister and her family.

Colette Balmain

INTRODUCTION

The purpose of this Directory is to introduce readers to the rich history of South Korean cinema from its troubled beginnings through to its current triumph on the global stage. This is the first volume in a series, and covers some of South Korea's key directors, cinematic movements and offers over one hundred reviews of films. While the body of scholarship on South Korean cinema is in its infancy compared to other East Asian cinemas such as Japanese and Hong Kong cinemas, there are a number of excellent books available including Jinhee Choi's *The South Korean Film Renaissance: Local Hitmakers, Global Provocateurs* (2010), and *New Korean Cinema* (2005), edited by Julian Stringer and Chi-Yun Shin. However the structure of the Directory allows a much broader range of genres and films to be covered than within a conventional academic text, as well as opening up the arena for discussion on areas of South Korean cinema which generally have been given limited critical attention. In this volume, along with the well-known films associated with New Korean Cinema, director essays, and reviews of films from the romantic comedy and horror genres which tend to travel well outside of the domestic context, writers discuss the recent emergence of Queer Cinema, analyse the work of politically-motivated New Wave directors and examine diverse genres including musicals and period dramas. This Directory, then, comprises the most comprehensive volume of work on South Korean Cinema published to date.

Unlike many other national cinemas, it is almost impossible to construct a coherent linear history of Korean cinema, from the silent era to the coming of sound and to the modern era. This is a result of Korea's troubled history during the development of the film industry, which is defined by a repeated pattern of colonization and oppression – first at the hands of Japan between 1910 and 1945 and subsequently by the US (South Korea) and Russia (North Korea) between 1945 and 1948, and after the Korean War (1950-1953) when this division was formalized with the separation of the nation into two: the Communist North and the Capitalist South. In Lee's words 'the Korean film industry is inseparable from the political situation of the country.'[1] Consequently, it becomes difficult to trace the growth of a national cinema that can be categorized as distinctively Korean or to determine the presence of a Korean aesthetic around which such a definition could cohere. In addition, South Korean cinema has not had the type of visibility on the global stage that other East Asian cinemas have had, including Japan and Hong Kong, only coming to prominence in the mid 2000s with the films of Kim Ki-duk and Park Chan-wook. While Kim Ki-duk had garnered a cult status with his violent, aesthetic contemplations on morality and masculinity with hits such as *Seom/The Isle* (2000) and *Nabbeun Namja/Bad Guy* (2001), it is arguably Park Chan-wook's second film in the Vengeance Trilogy, *Oldeuboi/OldBoy* that represents a pivotal moment in the emergence of South Korean cinema in the West, winning The Grand Prix at the 57th Cannes Film Festival in 2004 and a powerful advocate for South Korean Cinema in Quentin Tarantino who chaired the Festival panel. As some of the main chapters within the Directory provide a more-or-less chronological analysis of the main periods and movements in South Korean Cinema from the 1960s onwards, I have chosen here to concentrate mainly on early Korean cinema in order to foreground key debates around South Korean cinema as a national cinema, rather than repeating what has already been said, in more detail,

elsewhere in the Directory. In addition, as genre in South Korean cinema is often difficult to determine, an understanding of the formation of cinema in Korea helps to elucidate the reasons for this. I suggest that the reasons for the difficulty in defining South Korean cinema and the place of genre are a result of the fact that cinema was imported into Korea, bypassing the invention phase associated with 'exporting' countries.[2] As a result, Korean cinema did not develop as an indigenous art form, constructing a national identity through difference, but, rather, was a foreign import whose development was determined by the colonizer. Indeed, as we will see, debates over what was the first Korean film highlights the difficulty of determining a South Korean national cinema.

The arrival of cinema in Korea can be dated to the late 1880s, with the importation of factual shorts (actualitiés) from Pathé and Gaumont. In Korea, even before the Japanese Occupation, there was little discernible domestic cinema, with foreign imports dominating movie theatres, which were established on a permanent basis in 1906. According to Kim, 2,570 foreign films were screened in the period between 1910 and 1922, with a high point of 218 imported films in 1919.[3] American cinema was particularly popular with audiences, including Francis Ford's (the brother of the famous John Ford) western series, *The Broken Coin* (1915), which ran to 22 episodes. Yecies and Shim argue that one of the reasons why no Korean films were made before 1919 was to do with the fact that the Japanese occupiers wished to suppress any anti-Japanese sentiment: 'Koreans may have been prevented from gaining production training as a way for both Governors-General to limit the spread of potentially anti-Japanese and revolutionary ideas.'[4] If it was difficult to produce Korean films, it was even more difficult to exhibit them, as after 1910 all motion picture theatres were owned by the Japanese, with the sole exception of the Dansungsa.[5] From 1918, the Japanese Motion Picture Regulations (1917) were used to censor and regulate Korean cinema as well as dictating what type of 'foreign' film could be shown and was enforced by the central police bureau in Gyunggi province. In 1926, formal censorship laws, known as Government-General Law No. 59, laid down the regulations for the production, distribution and exhibition of cinema in Korea. Police boxes were set up in cinemas to closely monitor the types of films shown and to ensure that exhibitors were adhering to regulations. This was also necessary because of the presence of byunsa, silent film narrators – the equivalent of the benshi in Japan – who narrated the film's story, often embellishing the narrative and changing the meaning of the film in the process. In Korea, as in Japan, cinema was a performance rather than an event, with the film itself only one aspect of that performance. The recent live tour of the earliest surviving Korean film, *Cheongchunui shibjaro/Crossroads of Youth*, which was directed by Kim Tae-yong, complete with orchestra and byunsa, is a demonstrative example of the performative nature of early Korean cinema. Discussing the film with Director Kim, he commented that he changed the script every year to reflect contemporary issues[6], which gave an insight into how much the performance of the byunsa could have affected the meaning of films in the early days of Korean cinema. The presence of the byunsa was necessary because most of the films screened were foreign imports and byunsa became celebrities with their own dedicated fanbases. The byunsa resisted the coming of sound to cinema, fearing that they would lose their lucrative jobs as a result. Jo-Sung Kim is one of the few that managed the transition to sound by establishing himself as an actor and appearing in *Chunhyangjeon/The Story of Chun-hyang* (Lee Myeong-woo, 1935), the first sound film. In addition, the gisaeng (female entertainer) was central in the development of Korean film. Although, on stage, female roles continue to be played by men, gisaeng performed female roles in the cinema. While the most noted gisaeng of the early period is Lee Wol-hwa, the first gisaeng to appear on film was Han Myung-ok (Han Ryong) who appeared in *The Story of Chun-hyang* (Hashikawa Koju), in 1923. Despite the advent of sound, silent film continued to be made well into the 1940s, with the last

film being *Geomsa-wa yeoseonsaeng/Public Prosecutor and Teacher* (Yoon Dae-Ryong, 1948).

The first films in Korea were kino-dramas – stage plays with filmed inserts – the first of which is *Uilijeog guto/Fight for Justice* directed by Kim Do-san in 1919. 'Kino-dramas were multimedia performances, which mixed live theatre and filmed sequences on one stage. A series of still photos was also often displayed on the stage as well.'[7] Whether *Fight for Justice* can be considered the first Korean film is a matter of debate because as a kino-drama it is not considered an example of narrative cinema, but the date of its release – 27 October 1919 – is heralded as the beginning of Korean cinema, and 27 October is commemorated as Film Day in Korea. The first narrative film is also a matter of debate, with the Korean Film Archive naming *Weolha-ui mangseo/The Vow Made below the Moon* (Yun Baek-nam, 1923) as the first, while Kim cites *Gukgyeong/The Border* by Won san-man.[8] However, as *The Border* was released earlier, largely produced by Shochiku, a major Japanese production company, and by a largely Japanese crew and cast, it is therefore not considered by many to be the first Korean film. Indeed the first fully Korean film in terms of director, film crew and technicians and actors was *Janghwa Hongryeon jeon/The Story of Jang-hwa and Hong-ryeon* (Park Jung-hyun) in 1924. The difficulty, then, of identifying a national cinema during the Occupation is also demonstrated by the fact that that the first adaptation of a famous Korean folktale, 'Chun-hyuang', (The story of Chun-hyang), – which has been remade countless times since – was directed by a Japanese Director, Hashikawa Koju, in 1923. Such debates around the 'nationality' of cinema in Korea even at this early stage of its development emphasizes Lee's point about the history of Korean cinema being inseparable from the political situation of the country. These kino-dramas were the earliest form of melodrama – perhaps the archetypical Korean genre – to be filmed, and were performed by 'shinpa' troupes. According to Kim So-hee, '[t]he typical stories and formulaic characters of these melodramas have had a deep impact on Korean films and television dramas to this day.'[9] For a country which has been repeatedly invaded, colonized and forced to suppress its identity, the pain and sorrow of the typical melodrama provided and provides a particularly apt form for expressing these emotions. It is little surprise, therefore, that melodrama continues to be one of the most dominant genres in South Korean cinema.

The 1920s saw the development of a number of production companies, including Joseon Kinema, founded by a Japanese merchant, Yodo Orajo, which used Japanese directors and film crew/technicians and Korean actors.[10] The fact that Yun Baek-nam, who would go on to be one of the most important directors in Korean film history, was Chief of the Directing Department at Joseon Kinema emphasizes the interdependency between the development of Korean Cinema and the Japanese Occupiers, even though the company only released in total four films. In August 1934, approximately 62 per cent of all films screened in Korea were from the United States. However, few films remain from this period in Korean cinema, with the earliest surviving Korean film being the 1934 *Crossroads of Youth* directed by Ahn Jong-hwa, the print of which was uncovered by the Korean Film Archive in 2007.

The history of South Korean Cinema, as opposed to Korean cinema, only really begins in 1945 after Japan was forced to relinquish control over Korea and the US moved into the south and the Russians into the north of the country, formally dividing Korea into two along the 38th parallel or the Demilitarized Zone (DMZ). Only five films remain from this period and, in fact, most of the infrastructure set in place during the Japanese Occupation was destroyed.[11] Films of the post liberation era, which Cho dates as 1945-1950, were naturally celebrations of liberation and represent a reassertion of a national identity long denied by the Japanese oppressors. Perhaps *Jayumanse/Viva Freedom!* (Choi In-kyu, 1946) is the best example of the post-liberation cinema. Another significant trend,

one which continues to this day, were films dealing with the division of Korea which included films such as *Seongbyeog-eul tthulhgo/Breaking the Wall* (Han Hyung-mo) and *Muneojin Sampalseon/The Collapsed 38th Parallel* (Yoon Bong-choon), both from 1949. American dominance continued apace, with over one hundred US films screened annually and only 61 Korean films made during the post-liberation period.[12] During this period, documentary was one of the most popular genres, along with melodramas and period films, all of which attempted to construct a distinct Korean cultural identity through a reassertion of traditional culture and values.

In 1953, President Rhee Syngman made films exempt from tax and a strict quota system was imposed, which, between 1955 and 1969, ushered in the golden age of South Korean cinema. Melodrama continued to be the dominant genre and mode of expression, inflecting genres as diverse as horror, action and comedy. The 1960s also saw the debut of South Korea's most prolific and culturally-significant director, Im Kwon-taek, with *Dumanganga jal itgeola/Farewell to Duman River* in 1962, set during the Japanese occupation of Korea. Other key directors of this period include Shin Sang-ok and Kim Ki-young, both of whose work confronted the challenges that a rapidly-modernizing Korea entailed and the socio-economic consequences of this modernization. Kim Ki-young's *Hanyo/The Housemaid (1960)* lays bare the hypocrisy of the emergent bourgeois class, even though its political message had to be diluted through the use of a frame device in order to situate the film as a warning to the bourgeois about the threat posed by the working classes. His later films return time and time again to the theme of class divisions, more often than not by collapsing class and gender onto the body of a sexually-disruptive woman. The 1960s are best known for the centrality of the melodrama, whether in 'straight' melodrama films or for infusing genre cinema with a melodramatic sensibility, as in the domestic gothic films of Kim Ki-young and Shin Sang-ok's historical dramas/fantasies.

This hybridity has become perhaps the defining feature of contemporary South Korean Cinema, with films often starting off in one genre before suddenly shifting into another genre, as in *Beseuteu Serreo/Bestseller* (Lee Jeong-Ho, 2010), which starts off as a typical generic ghost film before abruptly shifting into the more realistic horrors of the psychological thriller genre. As is the case here, it is often difficult to categorize South Korean cinema using conventional definitions of genre, even taking into consideration that the concept of genre is inherently problematic. Genre hybridity in South Korean Cinema is closely aligned to the troubled development of cinema in Korea, as genres, like cinema, were something which were imported rather than developing naturally out of existing cultural artefacts and ideas. Indeed Chung[13] goes as far as to argue that '[t]here are no indigenous genres in the Korean cinema. Rather, they are all imitations of or variations on Western and other Asian film genres.' As we have already seen, the melodrama owed a debt to Japanese shinpa films: 'the Korean melodrama was an exact copy of Japanese shinpa films to the extent that they were called "namida (tears, なみだ)" films, adopting the Japanese term for a tearjerker … In other words, melodrama brought in and modified Japanese melodramas and led Koreans to discover Korean cultural sentiments' (ibid.).

In these terms, the way in which genres were imitated through variation and difference produced culturally specific genres through an imbrication of Korean sensibility with foreign narrative forms. Take, for example, Lee Yong-min's 1965 film, *Sal-inma/A Blood-thirsty Killer*, which copies almost exactly the death scene of Oiwa from *Yotsuya Kaidan/The Ghost Story of Yotsuya* directed by the Japanese Director Nakagawa Nobuo in 1959, and whose narrative owes as much to Edgar Allan Poe as it does to Japanese gothic cinema of the 1960s. The manner in which these foreign elements are fused with folklore, around ghostly cats as vessels of revenge as an explicit critique of Westernization and modernization, brings a Korean sensibility to the film. This is also true of the figure

of the monstrous maid or 'the Myeong-jas'[14] who wishes to take her employer's place in the household: a product of rapid changes to the socio-economic infrastructure of South Korea. Genre in South Korean Cinema, then, is not just tightly connected to context but needs to be thought of in terms of continually-shifting categories which combine the foreign with the domestic in order to portray a particular Korean sensibility, which in itself is not reducible to a set of codes and conventions associated with genre cinema. Furthermore, as Stringer insightfully comments, 'the meaning of a film genre is never fixed but rather contingent on circumstances of reception'.[15] In a discussion with Director Lee Joon-ik in June 2012, he told me that, in his films, the emphasis is on 'happy starts' rather than 'happy endings'. One could extrapolate that this tendency towards 'unhappy' endings in South Korean Cinema is a consequence of Korea's traumatic history and the continued division between North and South Korea and the longing for reunification, until which time a happy ending is not possible.

However, while South Korean cinema has come to be associated with commercial blockbuster cinema, with the exception of a few independent and provocative directors including Kim Ki-duk and Park Chan-wook, the 1980s saw the emergence of the Korean New Wave, a politically-orientated cinema, which marked a major transitional point in the development of contemporary South Korean cinema. Associated with directors such as Park Kwang-su and Chun Ji-Young, The Korean New Wave needs to be clearly distinguished from the New Wave Korean cinema of the late 1990s, which is associated with the rise of auteur and independent film directors and cinematic movements including human rights cinema. Contemporary South Korean Cinema, often called 'New Korean Cinema', or commercially-orientated cinema, is often dated as starting in 1993 with Im Kwon-taek's box-office smash *Sopyonje/Seophyeoje*. While Im's film is not the type of big-budget blockbuster more commonly associated with New Korean Cinema, it marks an important point in the history of South Korean Cinema as the first film to break the one million admissions in Seoul.[16] The success of *Sopyonje* inaugurated an era of the record-breaker film, marked by substantial investment by the Government in the film industry, the dominance of South Korean film at the domestic box-office and the growing power of the 'Big-Three' 'investor/distributor/exhibitor 'majors' – CJ-CGV, Showbox-Megabox and Lotte Entertainment-Cinema'.[17] Record-breaker films include some of the best-known South Korean films such as *Shiri, Nowhere to Hide, Joint Security Area* and *The Host*, all of which dominated the home box office and achieved success, albeit limited in some cases, in the West. These films were made possible not only by significant changes in the structure of the South Korean Film industry, including initiatives put in place by President Kim Dae Jung (1998-2003), but also as a response to the lifting of the foreign import quotas which meant that Korean films had to compete for audiences for this first time in over 40 years.

In opposition to blockbuster cinema and record-breaker films are the low-budget independent films, which tend to be more successful on the Festival circuit and in the West than at home, associated with directors such as Hong Sang-soo, Lee Chang-dong and, of course, Kim Ki-duk. While KOFIC (Korean Film Council) has played a substantial role in promoting independent South Korean cinema with initiatives such as the Art Plus Network, the stranglehold of the Big-Three on exhibition and the rise of the multiplex has meant that independent films struggle to succeed at the box-office, limited to be shown on just a few screens. In 2012, Kim Ki-duk pulled his award-winning *Pieta* from exhibition in order to allow other independent films to be screened, highlighting the struggle still faced by independent directors within Korea.

2012 has been an extraordinary year for both South Korean cinema and culture, not just domestically but also globally. At the Venice Film Festival, Kim Ki-duk's *Pieta* was awarded the Golden Lion, while Jeon Kyu-hwan's *Mooge/The Weight* won the Queer Lion Award, while in South Korea Choo Chang-min's *Gwanghae, Wangyidoen*

Namja/Masquerade, a historical drama set during the Joseon Dynasty, is likely to pass the 10 million mark, behind *Dodookdeul/The Thieves*, a caper drama, which has become the highest grossing film at the box office in history, displacing Bong Jong-ho's *The Host* in terms of both box-office admissions and receipts, which, at the time of writing, stands at 13 million and 93.6 Won respectively (September 2012). Related to this is the incredible success of South Korean rapper and singer Psy, whose 'Gangnam Style', has broken the record for number of views on YouTube (as well as receiving global success in the charts), which stands at over 1,500,000,000 views to date. The halcyon days of the dominance of Korean popular culture associated with the Hallyu movement – which had widely seen to be over – seem set to be surpassed, inaugurating a new era of South Korean cinema, both domestically and globally. As such, the contribution to scholarship contained in this volume by a wide range of writers, scholars and academics seems to me to be essential to demonstrate to those outside of Korea how vital and innovative the Korean film industry is today as well as to shed some light on the history of Korean and South Korean cinema.

Colette Balmain

Notes

1 Hyangjin Lee (2000) *Contemporary Korean Cinema: Culture, Identity and Politics*, Manchester: Manchester University Press, p. 17.
2 Kim Jong-won (2006) 'The Exhibition of Moving Pictures and the Advent of Korean Cinema 1897-1925', in Kim Mee Hyun (ed) *Korean Cinema : from Origins to Renaissance*, KOFIC Available at <http://www.koreanfilm.or.kr/jsp/publications/history.jsp> p.18.
3 Kim, pp. 17-18.
4 Brian M. Yecies & G. Shim (2003) 'Lost Memories of Korean Cinema: Film Policy During Japanese Colonial Rule, 1919-1937', *Asian Cinema*, Fall/Winter 2003, 14(2), p. 75.
5 Yecies & Shim, p. 77.
6 Interview with Director Kim, 2 August 2012.
7 Yecies & Shim, p. 87.
8 Kim, p. 19.
9 Jay Kim (2007) The Japanese Colonial Period, Heyday of Silent Films 1926~1934, in Kim Mee Hyun (ed), *Korean Cinema: from Origins to Renaissance*, KOFIC. Available at <http://www.koreanfilm.or.kr/jsp/publications/history.jsp> p. 49.
10 K. Shuk-Ting Yau (2007) 'Imagining Others: A Study of the "Asia" Presented in Japanese Cinema', in D. M. Nault (ed), *Development in Asia: interdisciplinary, post-neoliberal and transnational perspectives*, Boca Raton: BrownWalker Press, p. 144.
11 Darcy Paquet (2007), 'A Short History of Korean Film', *koreanfilm.org*. Available at <http://www.koreanfilm.org/history.html>. (Accessed 29 October 2012).
12 Cho Hye-jung (2007) 'Liberation and the Korean War 1945- 1953', in Kim Mee Hyun (ed), *Korean Cinema: from Origins to Renaissance*, KOFIC. Available at <http://www.koreanfilm.or.kr/jsp/publications/history.jsp> p.107.
13 Chung Sung-ill (2006) 'Four Variations on Korean Genre Film: Tears, Screams, Violence and Laughter, in Kim Mee Hyun (ed), *Korean Cinema: from Origins to Renaissance*, KOFIC. Available at <http://www.koreanfilm.or.kr/jsp/publications/history.jsp> p.1.
14 Chris Berry (2007) 'Scream and Scream Again: Korean Modernity as House of Horrors in the Films of Kim Ki-young, in Frances Gateward (ed), *Seoul Searching: Culture and Identity in Contemporary Korean Cinema*, New York: State University of New York Press, p.105.
15 Julian Stringer (2005) 'Putting Korean Cinema in its Place: Genre Classifications and the Contexts of Reception', in Chi-Yun Shin & Julian Stringer (eds), *New Korean Cinema*, Edinburgh: Edinburgh University Press, p. 102.
16 Darcy Paquet (2009) *New Korean Cinema: Breaking the Waves*, London & New York: Wallflower, p.33.

17 Chris Howard (2008) 'Contemporary South Korean Cinema: "National Conjunction" and 'Diversity'", in Leon Hunt & Leung Wing-Fai, *East Asian Cinemas: Exploring Transnational Connections on Film*, New York: I.B. Tauris, p. 94.

Arirang, 2011, Kim Ki-duk Film/Kobal Collection

FILM OF THE YEAR
ARIRANG

Arirang

Studio/Distributor:

Terracotta Distribution

Director:

Kim Ki-duk

Producers:

Kim Ki-duk

Screenwriter:

Kim Ki-duk

Cinematographer:

Kim Ki-duk

Composer:

Kim Ki-duk

Editor:

Kim Ki-duk

Duration:

100 minutes

Genre:

Documentary/Drama

Cast:

Kim Ki-duk

Year:

2011

Synopsis

Taking its title from a traditional Korean song, *Arirang* takes the form of a docudrama, offering an intimate and at times provocative portrait of Kim Ki-duk, who is simultaneously object and subject, interviewer and interviewee, director and actor, and who constructs a narrative by turning the camera lens inwards on himself. Through a series of confessional monologues, interspersed with menial scenes of everydayness during a period of self-isolation in a cabin located in the mountains, Kim Ki-duk gives us a portrait of an artist as a tortured man. His only company is a cat, while mementos of his career as a director and artist paper the walls of the cabin, serving as reminders of what he has abandoned for this solitary journey into self. . While the film sets out to document Director Kim's life during this period of self-imposed isolation, the final third of the film subverts any pretentions of documentary by veering into an externalized madness against the world, against the self, against Korea, and against the film community itself.

Critique

Arirang is a welcome return to film-making for Kim Ki-duk after a gap of three years, which was purportedly brought about by an accident on the set of *Bi-mong/Dream* (2008) in which the lead actress nearly died. Much of what Kim Ki-duk anguishes over during the 100-minute running time already exists in the public domain: the perceived betrayal by film-makers that he has nurtured; the poor reception of his films domestically both in terms of audience receipts at the box office and by critics; the inherent irony of the fact that Kim Ki-duk, probably more than any other South Korean Director, has played a pivotal role in enhancing the visibility of South Korean cinema on the global stage and, yet, is given little credit for this in his home country: a Korea for whose acceptance Kim is continually striving, here demonstrated by Kim's frequent plaintive singing of 'Arirang' – a folksong often seen as Korea's unofficial national anthem relating a tale of despair and loss – with which the film begins and ends. Yet how seriously we are meant to take Director Kim's heartfelt pleas for forgiveness and acceptance is debatable, as this is not a conventional documentary; the emphasis on acting and performance throughout undercuts the 'truthfulness' of Director Kim's 'staged' confessions, as do the frequent addresses to camera in which we are reminded of the porous boundaries between film and fiction, reality and representation, life and art. Even at the very beginning of *Arirang*, Director Kim undercuts the realistic aesthetic by 'staging' knocking on the cabin door during the night but, of course, there is no one actually there. Perhaps we are meant to take this on a metaphorical level, with the unconscious seeking to find a way to seep into reality – to be let in and let loose. Even when the Director or perhaps actor is confessing about how he felt over the incident on the set of *Dream*, the direct address of camera is undercut by the fact that the film cuts between Kim Ki-duk the confessor and Kim Ki-duk the interrogator, and even, at a number of points, cuts to

Kim Ki-duk the director editing the film's footage. By doing so, Kim Ki-duk reminds us that film is never a mirror on reality but a construction of a particular reality as mediated through the camera lens. Irrespective of the performative nature of *Arirang*, it is impossible not to be moved by Kim Ki-duk's predicament or to feel that we are offered glimpses of the 'real' Kim Ki-duk, which is what makes the film such riveting viewing.

Arirang marks the return of one of South Korea's greatest directors to centre stage with the film winning 'Un Certain Regard' at the Cannes Film Festival in 2011, to add to the Silver Bear that *Samaria/Samaritan Girl* won in 2004 at the Berlin International Film Festival. Director Kim's next film, *Pieta*, a return to feature film-making, would go on to win Golden Lion award for best picture at the 2012 Venice Film Festival, making Kim Ki-duk the only South Korean director to win all three major awards at European Film Festivals. *Arirang* itself is representative of South Korean cinema at its best – it challenges cinematic conventions around narrative and genre; it utilizes stillness and silence in order to allowing the unfolding of time in the image rather than focusing on movement as the image; and requires the spectator to actively construct meaning. I never realized that watching someone build a coffee-maker over the duration of a film could be so fascinating or that the intricacies of daily life could be so mesmerizing. At the same time, philosophical musings about what it means to be human, a definition that here is situated through its relation to death or 'a door closing' as Director Kim so succinctly puts it at one point, offer a profundity to the viewing experience beyond the surface detailing of the banality of everyday life.

While it may well be that foreknowledge of Kim Ki-duk's back catalogue – 15 films – and the debates circulating around both the director and his films, make *Arirang* a richer experience, it is one of Director's Kim most accessible works and well worth seeking out as an antidote to the frenetic big-budget blockbusters which tend to find both distribution deals and audiences outside of South Korea.

Colette Balmain

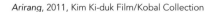

Arirang, 2011, Kim Ki-duk Film/Kobal Collection

Director Lee Jeong-beom at the Opening Gala of the LKFF 2010/KCCUK

FESTIVAL FOCUS
LONDON KOREAN
FILM FESTIVAL

While access to Korean cinema in the UK is largely dependent on the UK home DVD market where there are some 80 titles available, the London Korean Film Festival gives those who have an interest in Korean cinema an opportunity to not only watch films that have been released in Korea over the last 12 months but, more importantly, the Festival screens films that would not normally secure a distribution deal in the UK and thus moves away from the label 'Asian Extreme' which has so often been associated with Korean cinema. Although releases of Korean films in the UK have become a little more diverse over the last couple of years, the London Korean Film Festival demonstrates that Korean cinema cannot be tied to one particular genre or label.

In relation to tracing the roots of the London Korean Film Festival, it is difficult to determine a particular date or place when the London Korean Film Festival emerged. While the festival in its current form – organized and funded by the Korean Cultural Centre, UK – began in 2006, it was preceded by a small number of festivals which did not necessarily share the same form. The first of these was in 1994 when Tony Rayns curated a film festival titled 'Seoul Stirring' at the London ICA (Institute for Contemporary Arts) which screened films from some of the 'New Wave' Korean film directors, such as Park Kwang-su, Lee Myung-see and Jang Sun-woo. Whilst Korean cinema at this time was not as popular as it is today, this festival gave UK audiences an opportunity to view films that have become an integral part of Korean cinema history as they document changes within the film industry as well as in the wider social and political context. This festival may not have seen itself as the 'first' London Korean Film Festival as such, but few could deny that it was the first film festival in London to exclusively screen Korean films.

It was not until some seven years later that the next London Korean Film Festival took to the stage at the London Metro Cinema in Rupert Street, London. The Festival screened a number of films including EJ Yong's Jung sa/An Affair (1998) and Park Chan-wook's Gongdonggyeongbiguyeok JSA/Joint Security Area (2000). In 2003 and 2004 the Korean Anglican Centre screened Korean films on DVD to audiences in London at the London School of Economics. As the interest in Korean cinema grew in 2004, particularly with the successful theatrical releases of Park Chan-wook's Oldeuboi/Oldboy (2003) and Kim Ki-duk's Bom yeoreum gaeul gyeoul geurigo bom/Spring, Summer, Fall, Winter... and Spring (2003) combined with the string of other Korean theatrical releases in the same year (2004), including Bong Joon-ho's critically acclaimed Salinui Chueok/Memories of Murder (2004) and Kim Jee-woon's popular Janghwa, Hongryeon/A Tale of Two Sisters (2003), there was a market for sponsorship. Consequently, leading distributors, CJ Entertainment, came on board and utilized the sudden appetite for Korean cinema, which gave audiences in the UK an opportunity to see films that did not secure UK distribution. Some perhaps were quite cynical about the move to have a sole distributor fund the festival, but this cynicism was negated by the fact that the festival produced a line-up that screened films from the recent past in addition to screening a handful of classic films such as the Obaltan/Aimless Bullet (Hyun Mok Yoo, 1961) and Hanyeo/The Housemaid (Kim Ki-young, 1960), which gave a fairer representation of Korean cinema.

A total of 17 films were screened at the Prince Charles Cinema at the heart of the West End 9-13 May 2005 and admission was free, which provided a greater incentive for many of the seven thousand or so who attended the festival. Although, of course, the lack of any admission fee contributed to the success of the festival, much of its success is testament to the interest in Korean cinema that continued to grow from 2004. Interestingly, the festival also included a discussion chaired by Professor Chris Berry and Julian Stringer on Korean cinema and UK reception, which included contributions from some of the distributors who had distributed Korean films (Tartan and Soda Pictures), Korean distributors (CJ Entertainment, Tube Entertainment) as well as an academic and journalistic input from specialists in Korean cinema history.

Given the success of the 2005 festival, it was no surprise to see the festival return a year later in a similar form. Returning to the ideally-located Prince Charles Cinema, it screened a total of 9 films including *Yeonae-ui mokjeok/Rules of Dating* (Han Jae-Rim, 2005), *Dalkom, salbeorhan yeonin/My Scary Girl* (Son Jae-gon, 2005), and *Yeonae/Love is a Crazy Thing* (Oh Seok-geun, 2004). While the programme was less diverse in 2006, it screened films from the past year and, thus, gave audiences a rare opportunity to view the latest films to emerge from the Korean domestic market. Matching the success of the previous year, it attracted people from all over London and further afield with a well-balanced mix of nationalities. Later that year, in September, audiences were treated to another Korean Film Festival, this time a collaboration between the Korean Cultural Centre, UK (KCCUK) – part of the Korean Embassy, London – and the Korea Creative Content Agency (KOCCA). This festival has now become the annual London Korean Film festival, which takes place every November.

In its first year, it screened 11 films at the Odeon Cinema in Covent Garden, which included a Q&A with director Kwak Gyung-taek after the UK premiere of his big-budget *Taepung/Typhoon* (2005). Director Kwak was the first of many prolific guests to attend the London Korean Film festival. Importantly, this was the first Korean film festival to include a number of Korean animated films, among them *Mangchi/Hammer Boy* (Ahn Tae-geun, 2004) and *Pai seutori/Shark Bait* (Howard E Baker & John Fox, 2006). Animations have become an annual feature of the festival and, while Korean feature films continue to be popular, animations are often ignored, so it plays a significant role in promoting not only Korean cinema but also Korean animation. In addition to the animated features, the festival screened a combination of commercially successful films including *Welkeom tu dongmakgol/Welcome to Dongmakgol* (Kwang-Hyun Park, 2005); arthouse cinema, *Oechul/April Snow* (Hur Jin-Ho, 2005)) and the final installment of Park Chan-wook's popular Vengeance Trilogy, *Chinjeolhan geumjassi/Sympathy of Lady Vengeance* (2005).

The following year saw a move in venue, and prestige. On 7 November 2007, the Korean Film Festival opened at the Barbican Centre – the biggest Arts Centre in Europe, located in the City of London. It opened with the UK Premiere of Kim Ki-duk's *Soom/Breath* (2007) to a packed audience, which included a surprise appearance from the film's main actress Park Zi-a. The opening gala was followed by a lavish reception for invited guests at the Barbican Centre. The programme featured a total of 15 films, most of which were new features – a combination of commercial features – *Tajja/Tazza: The High Rollers* (Choi Dong-Hun, 2006); arthouse cinema – *Gajokeui Tansaeng/Family Ties* (2006); classic cinema; and a Park Chan-wook directorial retrospective. Most significant was the UK premiere of his (then) latest feature, *Ssaibogeujiman Gwaenchanha/I'm a Cyborg, but that's Okay* (2006). Park Chan-wook attended the festival as a special guest and attended a Q&A session following the screening, which gave his fans an opportunity to meet him. Perhaps most striking was the change in ticketing – tickets were no longer free and, consequently, there was perhaps a concern that audience numbers would drop, but there was sufficient interest in Korean cinema to entice people to purchase tickets, and these concerns proved short-lived.

In the following years (2008-2010) the festival seemed to get ever more ambitious as they raised the bar each year, yet it always seemed to exceed expectations. Following the success of 2007, the 2008 the festival returned to the Barbican Centre and opened with the UK premiere of Kim Jee-woon's western *Joheunnom Nabbeunnom Isanghan-nom/The Good, The Bad and the Weird* (2008) and, to match the previous year's notable guests, both Kim Jee-woon and A-list actor Lee Byung-hun attended the opening gala in addition to the Q&A screening, which happened later in the festival. The programme, likewise, adopted the same format as the previous year, and thus included a number of animations, – *Achi-wa ssipak/Aachi & Ssipak* (Jo Beom-jin, 2006); commercial films

– *Woori Saengae Chwegoui Soongan/Forever the Moment* (Yim Soonrye, 2007); classic cinema – *The Housemaid* (1960) as well as a directorial retrospective; this time, audiences were treated to the films of Lee Chang-dong.

Mother, 2009, C J Entertainment/Kobal Collection

2009 saw an additional venue, the BFI (British Film Institute), Southbank, which screened a comprehensive directorial retrospective of Bong Joon-ho. It included all his feature films as well as his shorts and, in accordance with London Korean Film festival fashion, Bong Joon-ho was flown over for a screen talk with Tony Rayns following the screening of his latest film *Madeo/Mother* (2009). The Barbican continued to host the festival with a variety of screenings from animations to classic cinema – this included a retrospective of Yu Hyun-mok – in addition to the screen talks. Park Chan-wook once again attended to open the festival with the director's cut of *Bakjwi/Thirst* (2009), and Yang Ik-june answered questions following the UK premiere of his critically acclaimed independent feature, *Ddongpari/Breathless* (2008).

In 2010, the London festival produced its most ambitious and compelling programme yet, amassing 17 features, 7 short films, 9 animations, 7 screen talks, a discussion on

the future of Korean cinema, and a symposium following the festival that accompanied a small publication titled *Discovering Korean Cinema* edited by Mark Morris and Daniel Martin. While there were no classic screenings, this was compensated for with a number of independent short films. The programme itself was divided into different categories, such as 'War', '*mise-en-scène*', 'women', 'action/thriller', perhaps reflecting the difficulty in categorizing Korean cinema. The 'War' programme coincided with the fiftieth anniversary of the Korean War and, therefore, screened films that explored the subject of war, including the controversial *Jageun Yeonmot/A Little Pond* (Lee Sang-Woo, 2010). The *mise-en-scène* category, meanwhile, screened shorts that had previously been shown in the Mise-en-Scène Short Film Festival (MSFF) held in June in Seoul, a Festival which was established by leading Korean film directors. To highlight the increasing role over the last year of women, who have traditionally taken a back-seat in Korean cinema, the 'Women' programme screened a number of films that sought to reflect this, including the critically-acclaimed *Paju* (2009), by female director Park Chan-wok. Since there are a large number of contemporary action/thrillers in Korean cinema, the programme screened a selection of these films to hit the cinemas in the previous year.

The festival would not be complete without a directorial retrospective and, in 2010, it explored the work of Director Jang-jin. Given the film festival's reputation for showcasing Korea's most iconic auteurs at Korea's most famous auteurs that had already established a profile abroad, this was perhaps a bold, but wise, move. Jang-jin might be a prolific director in Korea, but he has not quite met international acclaim in the same way as, say, Park Chan-wook or Bong Joon-ho have. By giving UK audiences an opportunity to see his film and meet Jang Jin himself, it gives the impression, for those who are unaware of his work, that Korean cinema is more diverse than the work of a number of internationally successful Korean auteurs.

In 2010, the festival was spread over three locations in London, including one of the Odeon cinemas in London's iconic Leicester Square and, as result, the opening night adopted the glamour often associated with London premieres, and, with the director Lee Jeong-beum present for the Q&A session following the screening of his film, *The Man from Nowhere/Ahjeosshi* (2010), and a guest appearance from Jonathan Ross, one of Britain's most popular TV hosts, few could disagree that the opening night success was impressive. The following night included a screen talk with Kim Je-woon and his controversial *I saw the Devil/Akmareul Boattda* (2010) and with Jang-jin present for all his films during the retrospective together with a Q&A session with director Im Sang-soo following the UK premiere of *Hanyeo/The Housemaid* (2010), 2010 will be a difficult year to surpass in terms of its size and success.

It is also important to note that the London Film Festival was not restricted to London. In 2007, a selection of films went to Oxford and Warwick; in 2008 a number of films were screened in Liverpool; in 2009, part of the festival went to Nottingham and Manchester; and in 2010, a number of films were screened in Cambridge, Cardiff and Belfast. Some of the directors invited to the London festival also attended these festivals, which demonstrates a strong intention on the London Korean Film Festival's part to not restrict the festival to the locality of London.

While the success of the London Korean Film Festival broadly correlates with the increasing growth in the popularity of Korean cinema in the UK, it is necessary to stress the importance and impact of the London Korean Film Festival in raising the profile of Korean cinema through its mandate to screen a diverse range of Korean cinema that supports the popular directors and their work, while at the same time encouraging newcomers to Korean cinema and those who are more well-versed to broaden their horizons rather than to fixate on directors who are already well-known outside Korea. It is also important to acknowledge the London Korean Film Festivals and those who organized

them prior to its current form, for they gave audiences an opportunity to engage in the growth of Korean Cinema before and during the early years of its popularity and have thus contributed towards the fan-base on which the current festival has built.

Jason Bechervaise

The Host, 2006, Chungeorahm Film/Kobal Collection

DIRECTORS
BONG JOON-HO

With the exception of Kim Jee-woon, who tackled black comedy in 1998's *Joyonghan Gajok/The Quiet Family* before going on to make a wrestling film (*Banchikwang*), a horror film (*Janghwa, Hongryeon/A Tale of Two Sisters*, 2003), a gangster drama (*Dalkomhan insaeng/A Bittersweet Life*, 2005), and a Manchurian western (*Joheun nom, nappeun nom, isanghan nom/The Good, the Bad, the Weird*, 2008), no commercial auteur has expanded the boundaries of genre film-making in South Korea as consistently as Bong Joon-ho.

Born in the politically conservative city of Daegu on September 14, 1969, Bong – a self-described cinephile – grew up watching movies broadcast on television, his favourite channel being AFKN (the United States Armed Forces Network). His interests were diverse, even at an early age, when he eagerly consumed televized French thrillers from the 1950s, such as Henri-Georges Clouzot's *Le Salaire de la peur/Wages of Fear* (1953), and American action films from the 1960s, such as *The Great Escape* (John Sturges, 1963) and *The Wild Bunch* (Sam Peckinpah, 1969). He supplemented these viewings with hours of *manga*-reading, an adolescent pastime that became a passion throughout his early adult years, and which eventually sparked his own desire to draw comic strips. After encountering the films of Shohei Imamura, Hou Hsiao-hsien, and Edward Yang as a member of a cine-club at Yonsei University, where he earned a degree in Sociology, he enrolled at a newly-opened film school (the Korean Academy of Film Arts), where he learned the art and craft of movie-making. Two of Bong's completed shorts, *Frame sok ui giogdeul/Memory in the Frame* (1994) and *Giri meolryeol/Incoherence* (1994), were so well received among his peers and teachers that he was encouraged to submit these graduation works to the Vancouver, San Diego, and Hong Kong film festivals, his first taste of critical acceptance on an international scale.

As a film student, Bong sought ways to combine the visceral excitement of thrillers, war films, and westerns with the thematic profundities and socially-relevant subject matter that he associated with post-war European classics like *Ladri di biciclette/Bicycle Thieves* (Vittorio De Sica, Italy: 1948). Upon entering the film business in the mid-1990s, he was given the resources to do that, first as an assistant director (on *Suk Maegjuga aeinboda joheun 7gaji iyu/Seven Reasons Why Beer is Better than a Lover*, Chung Ji-young, Park Chul-soo, Kang Woo, 1996), and then as a director. Since that time, Bong has remained an important, if initially overlooked, part of the post-millennial film renaissance, someone whose feature-length debut – *Peullandaseu ui gae/Barking Dogs Never Bite* (2000) – was met by a tepidly receptive critical community busy heaping accolades on Park Chan-wook, a graduate of Sogang University who had just burst onto the scene with his internationally-distributed third feature, *Gongdong gyeongbi bohoguyeok JSA/Joint Security Area* (2000). Nevertheless, the dial on the critical compass swung swiftly in Bong's direction with the release of his second feature, the 2003 police procedural *Salin ui chueok/Memories of Murder*. Based on a real-life serial murder case that gripped the nation in the late-1980s, a time when – after decades of military dictatorship (under Presidents Park Chung-hee and Chun Doo-hwan) – Korean society was marching closer to democratic reforms, the film generated attention for its deft handling of the police procedural genre and for its frequently-comical representation of authority figures. Police officers in particular are presented as bumbling, incompetent extensions of a government that, to paraphrase Darcy Paquet, was more 'focused on controlling and suppressing its populace' than in protecting them. Attracting nearly 6 million Korean viewers upon its theatrical release, *Memories of Murder* announced Bong's status to overseas audiences in the process.

With the release of his third feature, *Gwoemul/The Host* (2006), Bong ascended even higher up the echelons, earning raves from local reviewers as well as international critics and setting a box-office record in the process. More accurately translated as 'Monster,' the title of this film refers to a gigantic, lizard-like denizen of the Han River –

the mutational result of an environmental disaster involving hundreds of bottles of formaldehyde being dumped down the drain of a US army base sink. A critical and commercial success (selling over 13 million tickets in South Korea), this generically-hybrid film is not unlike other, more recent science fiction/horror/comedy combos such as the South African production *District 9* (Neill Blomkamp, 2009), which superimposes the kind of iconography specific to those genres atop spaces of political contestation, social disenfranchisement, and ecological disaster (in the case of the latter film, the slum areas of Johannesburg). With such genre diversity comes the kind of tonal variety – the sudden shifts from hilarity to sentimentality to sadness to shock – that make the watching of Bong's films an always-entertaining, if occasionally exhausting, activity. Although audiences should perhaps not put too much stock in the generic labels given to films on the Internet Movie Database (IMDB), the online site's description of *The Host* is appropriately expansive. Indeed, labelling it as an 'action/comedy/drama/fantasy/ horror/sci-fi/thriller' might be the best way to classify this most unclassifiable of motion pictures.

Bong himself has noted the frequency with which seemingly-antithetical concepts and existential states or conditions collide in his films, stating in an interview (included in the press kit notes for *The Host*) that his first feature-length film, *Barking Dogs Never Bite*, brings together 'mundane life and *manga*-like fantasy'. As one reviewer has remarked about the generic intermixing of that film, '*Barking Dogs Never Bite* runs the emotional gamut of romantic comedy, slasher horror, slapstick, and absurdist black humor, sometimes all in one scene.' The juxtapositional logic of such manoeuvres, which induce a kind of 'emotional whiplash' (according to that same reviewer), is borne out in his two overt genre pieces, *Memories of Murder* and *The Host*. The former, a police procedural ushering forth many of the visual tropes associated with American thrillers, is larded with the kind of realism (with respect to settings, characters, actions, and events specific to 1980s' South Korea, the provincial town of Hwaseong in particular) that Bong believes to be essential in tapping into the collective fears of audiences familiar with the notorious murder cases. Similarly, the latter film looks as if it follows the conventions of classic Japanese and American monster movies, from *Godzilla* (*Gojira*, Honda Ishiro, Japan: 1954) to *Them!* (Gordon Douglas, US: 1954), but features sequences that (to paraphrase the director's own words) audiences have 'never seen' before. Oscillating wildly between scenes of sudden terror, when the savage title creature threatens to destroy everything in its path (wreaking havoc throughout Seoul), and moments of mounting familial crisis, when the good-hearted yet dim-witted protagonist Gang-du (a struggling snack vendor played by celebrated actor Song Kang-ho) strives to bring his bickering siblings and aging father together in unified pursuit of his missing adolescent daughter (Hyeon-su, who has been snatched by the monster), the darkly-sardonic film is a visceral yet discombobulating mixture of postmillennial anxieties. An exemplary scene in this respect occurs early in the film, when Gang-du, his siblings, and his father mourn the apparent death of Hyeon-su in a gymnasium full of grieving families. In several interviews conducted after the release of *The Host*, Bong expressed a devilish delight in situating the excessively-emotional protagonists in close proximity to corpses, the grotesquely comic wailings of the former casting in relief the cold silence of the latter.

When asked why such a mixture of extremes occurs in *The Host*, Bong responded that he finds catastrophes to be both frightening and risible. Referencing the structural failure and collapse of the Sampoong Department Store in 1995, which resulted in over 500 deaths, the director has admitted to feeling shocked and deeply saddened upon hearing the news. Those feelings were soon mixed with bemusement when he learned that looters flocked to the disaster site, looking to lift golf clubs and other luxury items out of the store's import section. As Bong has stated, 'When an extreme catastrophe like that takes place, tragedy and comedy always come together. It's inevitable, because people are out of control.' In this respect, it is not difficult to discern the reasons for his play with

extreme emotional juxtapositions in *The Host*, a film in which a little girl's funeral (ostensibly the saddest moment in the movie) is comically inflected – her hysterical family members rolling on the floor with exaggerated displays of sorrow and pain.

Of the four feature-length films currently comprising Bong Joon-ho's oeuvre, the one that most dramatically foregrounds the affective registers of sorrow and pain is his recent production *Madeo/Mother* (2009), which stars veteran TV actress Kim Hye-ja as the title character, a widowed woman who goes to great lengths to protect her mentally-disabled son, Do-joon. After a high-school girl is found dead on a rooftop (visible to many residents of the provincial town that serves as the film's principle setting), circumstantial evidence leads the local police to suspect the perpetually-stupefied young man of the crime. When he is arrested and incarcerated (following a hasty investigation), Do-joon's doting mother leaps to his defence, taking time out from her work as an herbalist and unlicensed acupuncturist to initiate a quest for justice on his behalf. The woman's search for the real murderer takes her into the dark recesses of the city, its residents expressing shock over the horrible crime and revealing troubling secrets about the dead girl. What she eventually learns about her son's role in the girl's death proves too difficult to swallow, forcing her to perform a similarly gruesome act on an old junk dealer who had witnessed the earlier event. Because Do-joon is released from prison once the police capture another man (whom they now suspect of the crime), the junk dealer – having seen her son kill the girl through the window of his ramshackle hut – must be silenced, something that the hysterical mother accomplishes by way of a large wrench.

Like the films that preceded it, *Mother* not only hinges on a discombobulating mixture of surprise and suspense but also reveals Bong Joon-ho's thematic fixation on flawed, everyday 'heroes' who, when pushed to extremes and when faced with ineffectual systems of government, exceed the boundaries of what is thought to be 'permissible' behaviour and take the law into their own hands. Like *Memories of Murder*, this unusual thriller concerns the ways in which an inefficient bureaucracy serving the needs of a select few (including the political elite) can infect or plague the lives of those most in need of protection in a post-authoritarian society – a theme likewise explored in contemporaneous genre films such as Park Chan-wook's *Boksuneun na ui geot/Sympathy for Mr. Vengeance* (2002) and Na Hong-jin's *Chugyeokja/The Chaser* (2008). What these recent productions register is the growing disillusionment and discontent of an increasingly depoliticized Korean populace forced to perpetually wait for the full flowering of democratic reform under civil rule. Although Bong's earliest films, including *Incoherence* and *Barking Dogs Never Bite*, revolve around well-educated, middle-class men and women striving for professional success in a dog-eat-dog world (one in which bribery has become a social norm), his more recent works centre on the struggles of the working poor and the mentally challenged who fend for themselves in the absence of state protection or institutional safety nets, and often within fractured family units bearing the traces of past traumas (both personal and national).

As Bong Joon-ho's international reputation has risen, he has begun looking outside his homeland for creative opportunities to hone his skills as a film-maker. The director's participation in the 2008 omnibus film *Tokyo!* is thus indicative of his desire to be part of a global cine-community comprised of like-minded commercial artists, such as the French-born film-makers Michel Gondry and Léos Carax. 'Shaking Tokyo' – Bong's contribution to this multinational coproduction set in Japan's capital city – follows after Gondry's 'Interior Design' and Carax's 'Merde,' bringing the three-episode film to a close with the story of a middle-age *hikikomori* (or shut-in) who must overcome his physically-debilitating mental state if he is to experience romantic bliss with a pizza delivery girl (who has caught his eye after ten years of self-imposed isolation). Played by Teruyuki Kagawa, this socially-withdrawn Japanese character is like many of the Korean

underdogs populating Bong's larger body of work, insofar as he is forced to confront both everyday setbacks and extraordinary obstacles on the path to spiritual 'recovery' in a modern cityscape. As a short film about the diametrical split between inside and outside, individual and community, 'Shaking Tokyo' highlights the director's continued interest in binaristic configurations that collapse under the weight of a worldview sensitive to the spaces in between – the liminal zones and subterranean niches inhabited by blundering protagonists in search of some interpersonal connection that might alleviate their otherwise-unabated suffering. Regardless of whether Bong continues to deconstruct traditional film genres and usher forth unusual scenarios, one can trust that his overriding interest in the lives of people who exist on the fringes of Korean society will remain firm, and that the seriousness of his subject matter (from animal abuse to police brutality) will always be leavened by black humour and a winking self-awareness of the medium's potential to unite disparate audiences the world over.

David Scott Diffrient

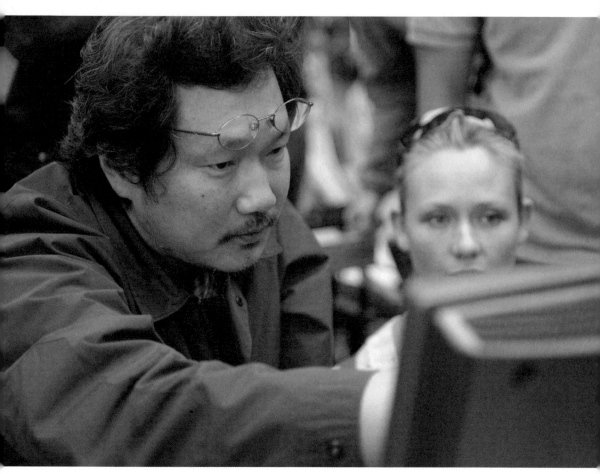

Hong Sang-soo on the set of *Night and Day*/BOM Film Productions Co/
The Kobal Collection, 2008

DIRECTORS
HONG SANG-SOO

While blockbusters like *Swiri/Shiri* (Kang Je-Gyu, 1998) and *Gongdonggyeongbiguyeok JSA/Joint Security Area* (Park Chan-wook, 2000) heralded Korean mainstream cinema's arrival on the world's stage, the films of Hong Sang-soo, Kim Ki-duk, Lee Chang-dong, and Im Sang-soo, all of whom made their directorial debuts between 1996 and 1998, provided the international festival circuit and the domestic arthouse with an artistic foil. Hong's first film, *Doejiga umul-e ppajin nal/The Day a Pig Fell Into the Well* (1996), with its elliptical narrative, despicable principals, and jigsaw structure, proved an early sign of the revitalization of a Korean industry then dominated by *chaebol*-produced, formulaic star vehicles, and his ten subsequent features, together with a short sponsored by the Jeonju Digital Project, have evidenced a surprisingly consistent application of themes and formal concerns.

Critics such as David Bordwell have classified Hong, along with Taiwan's Tsai Ming-liang, Japan's Kore'eda Hirokazu, and others, as an 'Asian minimalist'. They point to the writer-director's characteristic long-take, static, wide shots and to plots made up of casual conversation and 'hanging out'. Hong's films' worlds, to be sure, like his own professional ones – in addition to making films, Hong taught screenwriting at the Korean National Arts University – are populated by garrulous would-be artists and intellectuals, no adventurers, no detectives or drug-lords and, aside from a single scene of the aftermath of an off-screen explosion of violence at the end of his first film, nothing approaching traditional action. But unlike commercial cinema's typically sensitive writers and cold or eccentric academics, Hong's film-makers, painters, poets, and professors are exceptionally self-obsessed and emotionally immature, their concerns unusually corporeal – another drunken stupor, a good (or even middling) fuck, or both – and their manner of expression startlingly melodramatic.

Though often labelled 'realist', Hong's films in fact accrue a comedic force by juxtaposing mundanity and theatricality. At the start of *Yeoja-neun Namja-ui Mirae-da/Woman Is the Future of Man* (2004), for example, Mun-ho, a professor of Western art, and Heon-jun, a would-be film-maker, chat about a variety of plot-extraneous, humdrum topics: the definitional differentiation of 'gem' and 'treasure', the career prospects for film school grads, Mun-ho's catching his wife smoking in their bathroom, *et cetera*. But Mun-ho suddenly disrupts the conversation's flow when he first berates his friend for having once hugged his wife American-style then storms out of the restaurant. Heon-jun remains stunned by this behaviour for all of two seconds … until a striking waitress arrives with a chilli-rice plate. He peers into her eyes and asks if she would be in his next film.

This kind of extreme emotional non sequitur is typical of Hong's films. When in *HaHaHa* (2010) Sung-ock for the umpteenth time bumps into the plump Moon-kyung, a recently-fired film professor who has been stalking her, she calls him 'a *fat* snake'. Soon, however, they're 'doing it' in a love hotel. Her review of his sexual prowess? 'Others don't compare! I've never felt this good!' Out of the blue, he proposes they marry and move to Canada to open an instant photo stand. Even more surprisingly, she says she will consider it.

While *Silmido* (Kang Woo-suk, 2003), *Taegukgi* (Kang Je-kyu, 2004), and other box-office successes emphasized the heroic sacrifice of an idealized Korean male, art-films by Hong, Kim Tae-yong, and Park Chan-wook steadily deconstructed the masculinity of their main characters. Indeed, Hong's males' behaviour is often so hypocritical and infantile as to become comical or unsettling or both. Near the end of *Saenghwalui balgyeon/Turning Gate* (2002) out-of-work actor Gyung-su scrawls an anonymous message – felt-tip pen on poster-board – accusing a man he has never met, his new lover's husband, of cowardice, and attaches both his lover's incriminatingly-explicit note and, incongruously, a persimmon. But instead of leaving the contraption at the entrance to his intended victim's home where he might reasonably happen upon it, Gyung-su, like a child afraid of being caught with his hand too close to the cookie jar, hurriedly drops it in a nearby alley. And

when *HaHaHa's* even more childish Moon-kyung questions the propriety of his aging mother's skimpy tank top, she fetches a pink coat hanger, demands he lift his pants cuffs, and whacks him repeatedly on the calves. The grown man takes it like an obedient grade-schooler, sobbing hysterically – 'But mom, I didn't do anything wrong!' Afterwards he reflects, 'It was nice. I felt loved.'

The kind of love these men feel they require is that on offer from the most melodramatic of soap operas and romance novels. At the end of *Like You Know It All* (2009) another young director holds no cliché in reserve during some post-coital pillow-talk with an old flame whose considerably older husband, a respected painter, is on his way out of town. She is, he solemnly declares, the most beautiful woman in the world. And when she hints at even the slightest doubts about his sincerity, he pushes further over the top: 'You're my soulmate. If I'd married you I wouldn't be like this. I wouldn't look at other women. We'd build a tower of love, brick by brick.' To her credit the young woman seems hip to this fawning ploy and reminds the film-maker that she could not possibly endure a long-term relationship with someone so puerile: 'I'm only doing this today.'

In *Hae-byun-eui Yeo-in/Woman on the Beach* (2006), Joong-rae, another of the writer-director's philandering writer-directors, is appalled when Moon-sook, an attractive composer, admits that while living in Germany she had two or three Caucasian lovers. He calls her 'a disgrace' and crudely conjectures that even ugly Asian women must be at a premium in Europe. She looks at him like he is an idiot, so he defends himself with an illogical, irrelevant, and provincial 'You may think I have an inferiority complex about my small dick size, but people, ugly or not, should live in the country where they were born.' Moon-sook summarizes her reaction to this embarrassing diatribe by identifying Joong-rae as 'just another Korean man.' *HaHaHa's* no-nonsense blowfish-restaurateur seems to agree with this kind of broad assessment. When her son's new flame asks how Korean women can live with men like these, she flatly offers, 'I live alone.'

In many ways *HaHaHa* provides a précis of Hong's protagonists' more insufferable traits. When a dreaming Moon-kyung stumbles upon Admiral Yi Sun-sin, sixteenth-century naval commander and subject of a recent 104-episode KBS drama, at a Tongyeong park bench and falls blubbering to his knees – 'Oh, Admiral Yi, I love you! Be my strength. I'm so lost. They always lie to me, and they're so stupid.' – he defines the Hongian male: sycophantic, self-serving, self-obsessed, emotionally dense, and essentially insincere, despite exaggeratedly-melodramatic protestations to the contrary. The scene also recalls the encounter between a semi-fictitious film-maker and a space alien in Woody Allen's 1980 *Stardust Memories*. Like Allen's extra-terrestrial's, Hong's Admiral Yi's advice to his interlocutor is to persevere, to see with his own eyes and not just what others want him to see. When the director wonders whether then he will see things 'as they truly are', the Immortal Yi, like Allen's otherworldly visitor, corrects him: 'There's no such thing.'

Hong's films' unusual structures reflect both his characters' fundamental solipsism and the ontological uncertainty Admiral Yi points to. *The Day a Pig Fell into the Well* consists of four discrete segments, one focusing on a loathsome novelist, another on an ineffectual travelling mineral-water distributor, another an aimless ticket vendor in love with the novelist, the last the novelist's volatile mistress, who also happens to be the travelling salesman's wife. The characters' paths seldom intersect and, as a result, the film feels like an abstract puzzle, many pieces of which have gone missing, its structure foregrounding the essential incompleteness of any single point of view.

Hong hones this formal scheme in each of his subsequent features. When the second half of *O! Sujeong/Virgin Stripped Bare By Her Bachelors* (2000) starts with the same telephone conversation that opened the film an hour earlier, but from the other end

of the line, Hong's audience immediately understands that the film's two-part structure comments on the limited points of view of two people who shared a series of experiences. Part of the game of watching the second half of the film, then, is identifying the sometimes obvious, sometimes subtle differences in dialogue and action in repeated scenes and trying to integrate these redactions into a unified interpretive system, a game Hong complicates by making it difficult to identify precisely whose perspective, if anyone's, certain scenes may reflect. This formal experimentation makes viewing Hong's film an unusually intellectual (as opposed to a more dreamlike, cause-and-effect-driven, narrative) movie-going experience.

Likewise, when it learns midway through *Geuk-jang-jeon/A Tale of Cinema* (2005) that the film's first 40 minutes were in fact a student short ostensibly directed by a now-hospitalized former classmate of one of a newly-introduced set of characters, Hong's audience is jolted out of a conventional mode of spectatorship and into an explicitly-rational one. Because *A Tale's* second half's protagonist, a dumpy psychotic who believes he was the model for the short's endearingly-lanky romantic lead, contrives to repeat key plot elements of the film they have just seen, viewers may consciously compare the two narratives, the short's more conventionally cinematic tale and the distinctively Hongian 'reality' of what follows, and reflect both on the way cinema filters the world – beautifying, romanticizing, and unifying it – and, in turn, on cinema's potentially-detrimental influence on individual behaviour.

All Hong's films offer variations on this basic two-part format. Both *Turning Gate's* and *Like You Know it All's* film-maker-protagonists conduct two affairs, one after the other, the many links between the parts – unconscious, willed, and faked repetitions, as well as pure coincidences – emphasizing their inabilities to learn from past mistakes. *HaHaHa's* two professors are blissfully unaware they are telling each other the same story about the same sextet of acquaintances. *Ok-Heeui Younghwa/Oki's Movie* (2010), like Hong's debut, is divided into four parts, the last of which, a short film Oki herself directs and narrates, is itself split into two parts and chronicles two walks up Mt Acha that Oki took with two of the men in her life: a film professor and a film-school classmate. The similarities between and idiosyncrasies of the two episodes and Oki's reactions to them again suggest the repetitive nature of behaviour and the degree to which people try to force their lives to conform to traditional dramatic templates.

These thematic concerns and structuring patterns inform Hong's approach to production. The writer-director works with a small crew – ADs double as prop-masters and even make-up artists – on relatively-unaltered locations. No pre-production scripts, storyboards, or rehearsals. Instead, since *Turning Gate*, Hong has fashioned only short treatments. He composes each scene's dialogue only on the morning it is required, leaves the lines with the actors while he works out camera set-ups with his cinematographer, and then quickly runs through the material with them before shooting. Hong feels this kind of willed procrastination results in something spontaneous that he values, an exhilaration associated with the actors' first encounter with the script. 'This is the moment', Hong asserts, 'when the texture of the connections between the actors and me reveals itself.'

Hong's desire for the 'truth of the moment' in his dialogue and his actors' performance is also facilitated by his shooting in sequence whenever possible. He argues it is important to spend the extra time and money required to revisit recurring locations because 'something could have happened to me and my actors over the intervening weeks.' Because he realizes his own understanding of the world and his characters' place in that world changes from day to day, he does not want to feel trapped by months-old plans. Rather, Hong demands his films reflect the progress of his own personal evolution. This 'truth' – however incomplete, however messy – is the only one he feels he can rely on.

Bob Davis

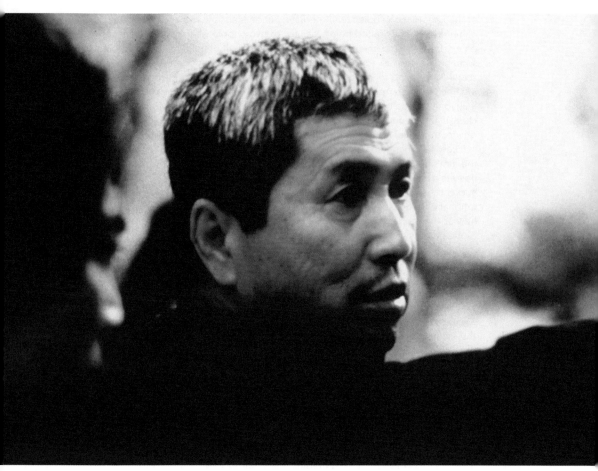

Im Kwon-taek on the set of *Chunhyang*/The Kobal Collection, 2000

DIRECTORS
IM KWON-TAEK

Few would disagree that the adjective 'turbulent' is an apt description of modern Korean history. One only has to look at the Japanese occupation of the Korean peninsula (1910-1945) or the Korean War (1950-53), or even the political suppression and massive economic growth, which took place from the 1960s to the late 1980s, to illustrate this. The Korean film industry, too, has experienced difficulties as it has been forced to adapt to these conditions, and it is a testament to Im Kwon-taek's talent and adaptability as a film-maker that he is the only film director to have lived and worked through much of this period. Indeed, if one was to look at the history of Korean cinema, one cannot ignore the significance of Im Kwon-taek and, while there have been a number of prolific and extraordinarily gifted film-makers such as Kim Ki-young, Shin Sang-ok, Park Kwang-su, and the number of very successful directors today, Im remains the only director to have embraced the different periods and difficulties of Korean history. At the time of writing, his 101st film, *Dalbit Gireoolligi/Hanji* (2010) is currently being released in cinemas and, although he is now 76 years of age, he remains as passionate and tenacious as ever to direct new features.

Im was born on 2 November 1934 but, according to his registration card, he was born on 2 May 1936 – during this time, many infants did not live long enough to live past their first birthday, so many parents deferred it until they were certain that their child would live longer.[1] Im's birthplace, Jangseong, South Jeolla Province, which is located towards the south west of Korea, is often referred to as 'the region of art' which is famous for its focus on art and culture. Given Im's focus on national culture in many of his films, particularly over the last two decades, this clearly made an impact on him.

During the Korean War, Im ran away to Pusan as it was not safe for him in his hometown, where he initially worked as a labourer and then at a shoe shop before moving to Seoul when the owners of the shop invited him to help them at their production company. Like so many film directors in Korea, this is where it all started for Im: an apprenticeship. He began working on *Janghwagong Ryeonjeon/The Jang-wha and Hong-ryeon Story* directed by Jung Chang-wha in 1955 and then continued to work on a number of films in various different capacities before making his directorial debut in 1962 with *Dumangang-a Jal Itgeora/Farewell Tuman River* (1962) at the age of 28. While it was a difficult film to shoot, the war film was a commercial success, which paved the way for his future films. Furthermore, as Korea entered a political dictatorship following the coup orchestrated by Park Chung-hee, political suppression swept though Korea as it embarked on a miraculous climb to economic recovery. 'Cinema was the only means of entertainment in this state of confusion and the Korean movie industry moved into its golden years'.[2] This meant Im was able to make a number of features, but many of them failed. He did, however, embark on a number of different genres, but his success was limited to action films, historical dramas to action films, historical dramas and war films.

In 1972, Park Chung-hee announced a new Yushin system, which enhanced his powers, and appointed him as president. The national assembly was dissolved, martial war was declared, and it put the film industry into a state of despair – all films were strictly controlled and censored. Effectively, the only domestic films to be made and released were government propaganda films, largely anti-communist. Ironically, however, Im, whose family was labelled as leftists, because of where he grew up and with his family's affiliation with left-wing ideology, was actually able to work within this system, as he embarked on a new chapter directing state films. Up until this point, he had made a staggering 45 films, but no film stood out and left Im searching for a new opportunity to make films that would resonate throughout his career as a film-maker. Although his films during this period were largely propaganda features, he was free from market demands and, thus, as long as they adhered to state policy, he was given artistic freedom, and hence the name 'quality films' (*usuyongwha*) given to these features.

His new-found success started almost immediately, as he was invited to the Asian Film Festival in Taiwan for his 53rd feature, *Jeung-eon/The Testimony* (1973) – unlike today, where Korean film directors frequently go abroad to attend festivals and promote their films, this was a rare privilege for a Korean film director and reflects the success that was bestowed upon him later in his career. Perhaps most notably, however, was his next feature, *Jabcho/Weeds* (1973), which Im refers to as his 'debut feature as a real director'.[3] While the film was not a success critically, or commercially, this did not matter to Im; what was more pertinent was Im's conviction to make a film that he was proud of, and this was a new beginning for Im – one that took him to new levels, and took him on a journey that has established Im as one of Korea's masters of cinema. The film, which follows the life of a woman, raised many eyebrows at the time – Korean films of this period, and even today to a lesser extent, are dominated by masculinity. These 'quality films' became a place where Im began to experiment with sustained shots, limited editing and utilizing the conventions of cinematic realism. While not all his later films necessarily adopted these techniques, this became a characteristic of Im's later work.

Im made a number of films during this period that adhered to the anti-communist ideology but, as the *Gisbal-eobneun gisu/No Glory* (1979) and *Jjagko/Mismatched Nose* (1980) demonstrate, Im was able to make subtle criticisms of society and therefore was not simply a puppet film-maker following the needs of the system. In *No Glory*, for example, Kim Kyung-hyun writes 'it represents liberal humanism as an intellectual pursuit that is scarcely maintained or honoured during the Park Chung-hee demonstration'. Kim later discusses the correlation between humanism and Im's subsequent work – a key characteristic of Im's later work – as evident in *Mismatched Nose*, which sees the protagonist (a South Korean solider) and the antagonist (a North Korean guerilla) escape from the mental asylum they are in together, rather than concluding in conflict, even though the South Korean soldier has been seeking personal revenge for some 30 years.[4]

The 1980s saw further political upheaval following the Park Chung-hee assassination in 1979 and, while there was a glimpse of radical political and social change, Chun Doo-whun led a coup and Korea returned to a dictatorship as Chun became president. Chun's presidency, however, placed a greater emphasis on international recognition, and encouraged film-makers to make a mark abroad and, given that there were very few directors around that could work within a system with so many constraints, Im's films that continued to articulate national history and culture through his vision of nationhood were ideally suited to the festival market, and the state provided funds for film-makers to go abroad and subsidies were also given to develop prints with English subtitles.

Im was the only director to really stand out on the international stage, and this period was a very successful one for Im as he established himself as a reputable director both within and outside Korea. Im received awards for many of his features during this period: *Mandara* (1981) won the Grand Prix at the 1981 Hawaii Film Festival; *Kilsodeum/Gillsot-teum* (1985) won an award at Berlin in 1986; *Ssibat-i/Surrogate Mother* (1986) received the Best Actress award for Kang Soo-yeon at Venice in 1987 – the first acting award given to a Korean actress at a major film festival – and *Aje Aje Bara Aje/Come, Come, Come Upward* (1989) won an award at Moscow film festival in 1989.

The period from the late 1980s and early 1990s was a massively important era for Korean cinema as it ushered in a movement known as the 'Korean New Wave', which challenged the political and social norms, and correlated with the growing unrest in the country that later resulted in greater democratic freedom in the political spectrum, and the freeing up of government censorship on the film industry. Although Im's films were not overtly political, his use of realist cinema together with a greater conviction to use this form to convey the 'real' Korea led a number of film-makers such as Park Kwang-su and Jang Sun-woo to make films that were politically subversive.

During the 1990s Im continued to achieve success. In 1990 he made an action film – the first in 21 years, *Janggun-ui adeul/The General's Son* (1990), which was an instant hit and he therefore went on to make two sequels. These were not so successful, however, and were received very unfavourably by the critics, but he had demonstrated his ability to engage in a variety of different generic forms of film-making. Im's next film was his most successful to date, *Seopyeonje/Sopyonje* (1993), which is characteristic of Im's iconic storytelling through the use of flashbacks and the abundant use of long takes and realist techniques. One of Im's most notable passions is to explore the uniqueness of Korean culture and this film perhaps best exemplifies this as it explores pansori, a traditional form of Korean music. After *Sopyonje*, Im then went on to direct *Taebaeksanmaek/The Tae baek Mountains* (1994), a film based on a novel free from anti-communist ideology which was released shortly after the first democratic elections in Korea.

The new millenium saw a period in which Im has found both success and disappointment. In 2000 Im made one his most experimental pieces, *Chunhyangdyeon/Chunhyang*, which continued his legacy to explore Korea's cultural and artistic heritage in the form of pansori (traditional opera). While *Chunhyang* continued to adopt Im's iconic long take, his next film, *Chihwaseon* (2000), abandoned this completely. Perhaps as a sign of the changes within the industry, Im moved away from sustained takes. The biographical film about the late Jang Sung-up – a painter in the late Jeoseun period – won the best director award at the Cannes Film Festival. However, these films together with the other films he made during this period – *Haryu Insaeng/Low Life* (2004) and *Cheon-nyeon-hak/Beyond the Years* (2006) – were all commercial failures. As the film industry underwent massive transformation – this era is often described as the post-shiri era following the injection of investment to fund blockbusters akin to Hollywood-style action films following the success of *Shiri* (1999) – it has been difficult for Im to make films that are deemed popular. Im told me in an interview in 2007 that 'the younger generation are tamed by Hollywood films – fast and quick – and lots of Korean directors make this kind of film, so it is very Hollywood-like, but I want to express the unique nature of Korean culture'.[5] It's not difficult, therefore, to see how Im struggles to make films in an industry that has perhaps more in common with Hollywood than the cinema of Im, but he has learnt to adapt and even try new mediums. His most recent film was entirely shot on digital – a new venture for Im – and, at 76 years of age, to continue to produce films and to attempt new forms is characteristic of his versatility and talent. The film, *Dalbit Gireoolligi/Hanji*, explores another aspect of Korean cultural heritage – a traditional form of Korean paper. In support of Im's new work, the film received funding from the Jeonju City, the Korean Film Council (KOFIC) together with financial support from the three big Korean distributors: CJ Entertainment; Showbox; and Lotte Entertainment. This unprecedented move by Korea's largest distributors is illustrative of the level of appreciation Im commands within the film industry.

While he has attempted many genres, forms and themes, what has remained largely consistent throughout much of his career, particularly the latter half, is his conviction to convey humanism. As he continues to make films, this will no doubt remain a central theme. It is impossible to know which film will be Im's last, but what is certain, however, is for as long as Im is able to continue his remarkable legacy, few could stop him.

Jason Bechervaise

Notes:

1 Biographical detail here is from Chung S.I (2006) *Korean Film Directors: Im Kwon-taek*, Korean Film Council (KOFIC). Seoul: Seoul Selection.

2 Ibid: 112
3 Interview with Im Kwon-taek cited in Chung S.I (2006) *Korean Film Directors: Im Kwon-taek*, Korean Film Council (KOFIC). Seoul: Seoul Selection.
4 Kim, H.K (2002) 'Korean Cinema and Im Kwon-taek: An overview' in David E James and Kyung Hyun Kim (eds) *Im Kwon-Taek: The Making of a national cinema*. Detroit: Wayne State University Press
5 Interview with Im Kwon-taek (2007) Available at <www.koreanfilm.org.uk/46.html>. Accessed 8 November 2012.

Kim Ki-duk on the set of *Bad Guy*/Kim Ki-duk Film/Kobal Collection, 2001

DIRECTORS
KIM KI-DUK

Among the several modern South Korean directors to have garnered an international reputation for challenging and controversial material, few if any have embraced, seemingly courted, controversy as forcefully, even as gleefully, as Kim Ki-duk. Over the course of fifteen features in less than fourteen years (Kim is nothing if not prolific), he has cultivated an unapologetically single-minded and intimate cinema, producing a series of variations on a theme that by and large revolve around a tightly-circumscribed series of images and motifs, narrative patterns and characterizations. A true renaissance man, Kim has also written all his films (as well as works for other directors, typically those like Jang Hun and Jeon Jae-hong who have worked as his assistants), worked as his own producer (as well as for others) in addition to working as an art director, production designer and actor on a select few of his own pictures. Moreover, he has since 2003 edited his own films, making his oeuvre among the most personal of any film-maker in contemporary world cinema.

Kim Ki-duk was born in 1960 in Bonghwa, South Korea, an inland county in North Gyeongsang Province that lies in mountainous terrain on the eastern edge of the country (a location that has, directly or indirectly, found its way into several of the director's films). After early jobs as a factory worker, seminarian, and soldier, and following a stint studying fine arts in Paris between 1990 and 1993, Kim returned to Korea and began working as a screenwriter. He won an award from the Educational Institute of screenwriting, in addition to two others, before completing his directorial debut *Ag-o/Crocodile* (1996) three years later. In an apt curtain-raiser for a body of work populated almost entirely by criminals, prostitutes, soldiers and other characters whose lives seem predicated on physical violence, emotional turmoil and alienation, the film follows the troubled lives of a makeshift family unit comprising a young criminal (named Crocodile), a homeless old man, a young boy and a woman whom Crocodile rescues from drowning, all of them living beneath a bridge over Seoul's Han river. This dark, austere, visually-arresting film set the tone for much of Kim's work as a director. Like many of his subsequent pictures, there is a central tension between society and a microcosm thereof – between a chamber drama built around intense relationships featuring a small number of characters variously living apart from society in an insular, hermetic milieu, and with that society itself, which always lurks around the periphery and makes itself felt as an intrusive entity. Moreover, the water-front setting also anticipates several key future films, and carries connotations not only of danger lurking below the surface (the crocodile below the water of Korea, the hidden danger subsumed but ready to strike) but also of transience and flux, impermanence and instability – of the fluid, ever-shifting boundaries between reality and fantasy, self and other, that typify Kim's cinema.

Crocodile also bears the traces of some of the films that have obsessed Kim, his discovery of which (whilst in France) originally turned his head to the power of film-making. Chief in this regard is *Cinéma du look* luminary Leos Carax, whose *Les amants du Pont-Neuf/Lovers on the Bridge* (1991) forms an overt reference point with its scenario of two vagrants living on Paris' oldest bridge. Like Carax, Kim makes the most of a derelict setting, using its emphatically-quotidian spaces as a point of departure in establishing Crocodile's world as at once known, recognizable, but also de-familiarized, a universe unto itself. This transnational influence is even more explicit in Kim's second film, *Yasaeng dongmul bohoguyeog/Wild Animals* (1997), which is set in Paris and features two characters (a soldier from North Korea and, in an overtly-autobiographical nod, a South Korean street painter) who drift into associations with the underworld as their lives become increasingly desperate. Once again social marginality is to the fore, here further reinforced through the focus on two illegal immigrants in a foreign country, although narratively the film is more expansive and naturalistic than is typical for Kim, and hints at an overt, quasi-narcissistic fascination with the milieu he depicts that tempers the otherwise-dark contours of the drama.

Subsequent films like *Paran daemun/Birdcage Inn* (1998) and *Seom/The Isle* (2000) – Kim's third and fourth works respectively – refined this particular vision, and began to show traces of the director's mature style bubbling to the surface. Both restrict themselves almost entirely to a single location (the former a brothel in a coastal town, the latter a small fishing resort in which the fishermen live in small floating cabins on a lake), and both are concerned with the subjectivity of women whose sexual availability and commodification defines their relationship to men and, by extension, to their own sense of self (this is something that Kim would return to rather less successfully in his twelfth film *Hwal/The Bow* (2005), which concerns a 60-year-old man who lives on a fishing boat with the teenager he has been raising from infancy in order to marry when she comes of age). The Isle also served to introduce Kim to a wider international audience, both with regard to its festival screenings (it received, amongst other accolades, a special mention at the Venice Film Festival) and the infamy it garnered following the cuts imposed by the BBFC (relating to scenes of animal cruelty) before the film was granted a certificate for a belated 2004 theatrical release.

Beyond *The Isle* Kim made several of his very greatest films – films that have not been as visible on the international stage as his most famous works but that demonstrate a social and political engagement not always in evidence elsewhere in his oeuvre. Amongst these, *Suchwiin bulmyeong/Address Unknown* (2001) and *Hae hanseon/The Coast Guard* (2002) stand out for their respective explorations of the military situation on the Korean Peninsula. The former offers Kim's most directly-political narrative, concerned as it is with several Korean and American characters living in and around an army camp in 1970, while the latter is set in modern Korea and deals with the tragic consequences for two characters when a soldier who is eager to kill a spy and reap the rewards instead kills a citizen within the militarized zone. *Address Unknown*, with its ensemble cast and heightened melodrama, in some ways breaks with the typical pattern of Kim's cinema. *The Coast Guard*, which was denounced by many in Korea, is the director's most intense narrative, and a potent study not only of a divided, fractured psyche (and country) but also of the extent to which indoctrinated behaviour is fundamentally anathema to humanity.

This particularly prolific period of his career also produced the avowedly-existential *Nabbeun namja/Bad Guy* (2001), another dark tale with echoes of *Crocodile* in its central focus on a violent, mute gangster and the apparently-wholesome girl he abducts and forces into prostitution. Indeed, the curious mixture of unflinching brutality and affective sentimentality made it Kim's best performing film at the Korean box office, although at the same time its portrait of submissive femininity accepting her debasement did little to offset perceptions of Kim as a misogynist.

It was at this juncture in his career that Kim's international reputation and rapid canonization was crystallized, something that occurred with the release of his ninth film: *Bom yeoreum gaeul gyeoul geurigo bom/Spring, Summer, Autumn, Winter…and Spring* (2004). This film played and won awards at several film festivals (including Locarno and San Sebastián), and offered a perceived contemplative spirituality that captured the popular imagination and reinforced occidental tastes and views. The narrative, broken up into five chapters corresponding to the titular seasons, plays out as a moral fable, with the natural cycle of the changing of the seasons finding its corresponding story in the growth and education of the protagonist, whose life is followed from childhood through to troubled adulthood and beyond. The setting of a small, floating hermitage located on a lake surrounded by mountains remains a potent stage for the drama (indeed, each chapter begins with gates opening onto the scene like theatrical curtains); and, as Tim Robey has observed, the millstone carried by the protagonist throughout the film (literally as punishment for torturing animals, then metaphorically following his murder of his wife) may be seen as an autobiographical imperative wherein Kim's status

as a 'bad boy' director is being atoned for throughout this film's focus on moving beyond and learning from violent mistakes and impulses.[1] The fact that Kim himself plays the criminal as a middle-aged man would seem to further reinforce such a precept.

In the wake of this distinctive film, Kim made two of his best works. *Bin-jip/3-Iron* (2004) is another intimate drama but, unlike one located squarely in the midst of modern Korea, in a range of various, contrasting houses that seem implicitly to constitute the multivalent face of the country. The protagonist, again a silent presence, spends his time breaking into houses whose occupants are away and spending time there, typically tidying round as well as enjoying the comforts on offer. In an upper-class home he comes across an abused housewife and former nude model, and the pair take up together, until the man is arrested and imprisoned. Subsequently, Kim's avowed interest in the blurred boundaries between reality and imagination comes strikingly into focus as the man's attempts to break free from his literal and figurative (corporeal) prison seems to yield the desired effect, leading to what is the director's most ambiguous denouement.

Even better than the underrated *3-Iron*, indeed perhaps Kim's greatest film, is *Samaria/Samaritan Girl* (2004). This story of a teenage lesbian who takes to prostitution follow-ing the death of her sometime-prostitute friend, and the turmoil this causes her single father, is notable for its sensitive handling of complex, potentially-controversial material, in which no judgement is brought to bear and the actions of almost all the characters, major and minor, admirable or flawed, selfless or selfish, are viewed with a clear-sighted distance and even-handedness that takes full stock of the complexity of humanity in all its messy, contradictory reality.

Recently Kim has seemed on the surface to be working ever more minute variations on a circumscribed series of themes and narrative patterns. *Shi gan/Time* (2006) carries broad echoes of the Japanese surrealist novelist Kobo Abe's 'The Face of Another' in its story of a woman who undergoes extensive plastic surgery to allay her fears that her boyfriend will tire of her face, and then begins her relationship with him over again as an ostensibly different person. Toying with the idea that identity and selfhood are only skin-deep, the film centres on fragile female subjectivity, something continued in *Soom/Breath* (2007), which traces the intense relationship between a bored, cheated-on housewife of a wealthy husband (echoes here of *3-Iron*), who begins visiting a death-row inmate following several suicide attempts on his part. She decorates the bare room in which they meet with photos of natural landscapes during the different seasons (echoes of *Spring, Summer, Autumn, Winter…and Spring*) and all the while they are watched via monitor by an unseen chief warden, a god-like figure whose desires control the amount of time the man and woman spend together and how far their mutual attraction extends. At the heart of the film is another exploration of interior human duality, of the funda-mental incompatibility of a harmonious or fulfilling union with another, at least until an inherent darkness or craving has been satiated, purged or articulated.

Subsequently, *Bi-mong/Dream* (2008) intensifies *Breath's* emphasis on the unspo-ken, almost preternatural bond that can develop between individuals and chain them together in heightened trajectories of emotion, longing and desire. The film concerns a man whose dreams seem to influence and direct the actions whilst sleepwalking of a woman he does not know. His regret over being left by his girlfriend rhymes with her anger over the partner she herself left and leads her to somnolently act out the man's latent dreams. It is a curious scenario, almost a meta-commentary on Kim's own cinema and its portraits of the sexes, and the director takes it very seriously indeed, something that does not help one to overlook the manifest improbabilities of the material (such as the fact that, even though the two protagonists attempt sleep deprivation, they still only feel tired at night). However, *Dream* does offer a pointed vision of disconnect, of how fundamentally people can be alienated from themselves; and, like *Breath*, it shows Kim moving more confidently beyond the realms of the controversial female roles in his

earlier work. He has frequently been reviled as a misogynistic director, but the women in *Breath* and *Dream* are more complex creatures. They are still defined by their relationships with men, but are able to act and feel far more on their own terms than their counterparts in his earlier work, who could generally only achieve peace and fulfilment through an acceptance of their imprisonment.

The majority of Kim's works have been described as 'non-person films'[2] for their insistent exploration of 'individuals whose personhood has been diminished or cast in doubt'.[3] They are not easy films to watch and digest: not only because of the frequently graphic depictions of violence, sexual abuse and animal torture but also because the director patently refuses to lay out or fully elucidate the reasons for his characters' personalities, behaviour and mindset. We often have little clue about why they are as they are; nor is there any tenable sense of any real interest on Kim's part toward this end, and it may be that this at least partially accounts for the fact that, like Takeshi Kitano in Japan, he has largely failed to find a significant audience in his native country. His is a cinema populated by aggressive, inarticulate loners, silent figures who struggle to communicate and connect with the world around them and who act and react physically to any threat or stimulus. As such, Kim's subtle style and technique tends to enunciate for them, and for this reason alone his work demands repeat viewings and a patient, sympathetic interest in looking beyond what are frequently controversial surfaces and facades to uncover the nascent concerns in which they factor, themes wherein a dialectical relationship between dark and light, violence and tenderness, is usually to the fore. Self-conscious though these provocations may at times be, there is nonetheless a real intelligence behind them, and Kim's treatment of such material places him alongside the likes of Park Chan-wook and Kim Jee-woon at the forefront of the extreme side of new South Korean cinema. Indeed the fact that Kim Ki-duk won the Golden Lion award at the 2012 Venice Film Festival for his latest film, *Pieta*, testifies to the director's importance in terms of not just South Korean Cinema but, rather, in terms of World Cinema.

Adam Bingham

Notes

1 Robey makes this point in a short essay that accompanies the Tartan DVD release of the film.
2 Ma Sheng-mei (2006) 'Kim Ki-duk's Non-Person Films,' *Asian Cinema*, Fall/Winter 2006, pp. 32-46.
3 Ibid: 33

GOLDEN AGE MELODRAMA

The 'golden age' of South Korean cinema generally encompasses the years from 1955 to 1972: The year 1955 is distinguished for the success of Lee Kyu-hwan's *Chunhyangjeon/ Chun-hyang's Story*, a period film which proved for the first time that a domestic production could return a profit in its home market. New talents and state support also fuelled the rise, and it corresponds with the early recovery period from the chaos and confusion of the Korean War (1950-1953) and the incontrovertible bifurcation of the nation. Conversely, the year 1972 marks the incipient decline of the number of spectators, as well as the number of production and exhibition of domestic films. This economic and creative fallout is attributed to the growing competition from television and the repressive state control over the film industry, which culminated with the promulgation of the Yushin (revitalizing reform) Constitution that guaranteed the continuance of the President Park Chung-hee's autocratic rule and the disavowal of freedom of expression.

Within this 17-year span of growth, melodrama was consistently the dominant film genre. Recognized for its dramatic excess that mobilizes extreme emotions, great tragedies, and prolonged suffering for maximum effect, the popularity of melodrama during this turbulent era is hardly surprising. For those who were fortunate enough to survive the Korean War, particularly the wounded veterans, the nation's desperate material and historical condition left them to endure further hardship, including hunger, homelessness, and an uncertain future. Families were uprooted, fractured, or destroyed, leaving behind a number of inconsolable widows and orphans. Hence, far from being a mode of excess, what we now consider a melodrama may be challenged as a genuine reflection of the violent circumstances of the time.

Often recognized as 'women's film', the greater size of the female population in the post-war years further accounts for the proliferation of melodramas. The reality of the demographic change is perhaps most vividly represented by the film *Mimang-in/The Widow* (1955), an independent debut feature detailing the socio-economic plight of a lonely war widow, by Korea's first woman director Park Nam-ok. A more traditional studio film that catered to the female audience is *Ja-yu bu-in/Madame Freedom* (1956) by Han Hyeong-mo, which is considered today as the leading example of melodrama in the late 1950s for grappling with women's sexual freedom and consumer identity within

Left image: *Madame Freedom*, 1956, SamSeong Film

a patriarchal system. With only a year separating *Madame Freedom's* release from *The Widow* and only three years since the Armistice Agreement, it is noteworthy that there is no sign of the war in the 1956 film and, instead, tends to the many challenges associated with the clashing of tradition and modernity: from class and gender roles and unity of the family to native values and language.

Compounding the tremendous loss and displacement suffered by the post-war generation were the effects of accelerated industrialization and urbanization that shifted the nation's population and funds to the city. This meant that more and more of the young men and women were migrating from the country into the city to find work as manual labourers in manufacturing and service industries rather than remain on the farm. In films such as *Don/Money* (1958) by Kim So-dong, not only do they portray the exodus of people from the country into the city as crippling the traditional society but also the urban corruption, such as black marketing, gambling and money lending, as having already infiltrated the countryside. The past is irrecoverable in this instance, but the loss of kinship and community is mourned and severely criticized.

With the absence of men due to the war, more women entered the workforce and lived away from home to experience newfound independence and mobility, financially and romantically, that threatened the adequacy of the traditional male subject. As such, in *Madame Freedom, Ji-oghwa/The Flower in Hell* (1958) by Shin Sang-ok, *Gimyakguk-ui Ttaldul/The Daughters of Kim's Pharmacy* (1963) by Yu Hyun-mok, among others, women are notoriously represented as deviant subjects whose sexual and monetary vice leads to their own ruin, as well as the destruction of the family and society. By serving as lessons to female spectators that they will be punished if they seek erotic or material fulfilment outside their family duties, these narratives seek to reclaim traditional femininity in order to restore men's dominant role. As confirmed by Han Hyeong-mo, Madame Freedom 'shows a woman turning back into a faithful housewife after her deviations, so even if the audience is opposed to any scenes of deviation, they will accept them since it is a lesson, which means the film could be a good, enlightening film.'[1]

The crisis of the Korean masculinity engendered by modernity and modernization was given more emphasis and pathos in male-centred melodramas best exemplified by the aforementioned *Money, Parkseobang/Mr. Park* (1960) and *Mabu/The Coachman* (1961) by Kang Dae-jin, and *Romanceppappa/A Romantic Papa* (1960) by Shin Sang-ok, in all of which the actor Kim Seung-ho portrayed the sacrificing and doting father. In addition to responding to the changing gender roles, the portrayal of the patriarch in these films as increasingly powerless and naive addresses a generational shift that speaks to the failure of the then octogenarian leader Rhee Syngman, whose authoritarian rule was brought to an end by a student-led uprising on 19 April 1960. Moreover, the change in focus from female- to male-centred melodramas, including *Hyeonhaetaneun Algo Itda/ The Sea Knows* (1961) by Kim Ki-young and *Obaltan/Aimless Bullet* (1961) by Yu Hyun-mok, also confronts the failure of the democracy movement and the rise of the police state since Park Chung-hee's military coup on 16 May 1961. Although better known as a noir or gangster film than a melodrama, the depiction of the tough guy in Lee Man-hee's *Geomun Meori/Black Hair* (1964) can be interpreted as a response to the demand for a macho image amidst the growing militarization of South Korea as bulwark against the threat of attack from the Communist North.

The challenge to traditional Korean gender identity was further exacerbated by South Korea's political and economic dependence on the United States. The dependency has also led to widespread dissemination of American culture and commodities that had a tremendous impact on South Korea's everyday life and cultural identity. During the colonial era (1910-1945), the cultural flow from the West was moderated and filtered by Imperial Japan. After Korea's liberation at the end of the Pacific War, the flow from the West, particularly from the US, was direct and torrential. Sounds, images, and words

from American media and by American GIs could be seen, heard, and read across the peninsula, and they could equally be encountered and experienced in many of the melodramas of this period. Dialogues between characters are sprinkled with American words and phrases, as are settings that are decorated with photographs of Hollywood stars, Coca-Cola bottles and western dress. Once again, in South Korean melodramas, those who are lured by western commodities and pleasures are squarely represented by the fallen women, with the worst being those who entertain foreign soldiers labeled and despised as 'yanggongju' or 'Western princess.' In *The Flower in Hell*, for example, the titular character Sonya is a beautiful seductress and prostitute who lives in a makeshift house near the US military base and her sexual transgressions leave her no room for redemption in the film's final climactic scene.

As depicted in *The Flower in Hell*, and unlike the *yanggongjus*, there were those who were able to do more than make ends meet by attaching themselves to the American presence. As described by Bruce Cumings, while the aristocracy were being replaced by the few entrepreneurs who accumulated wealth during the war, there was also a small but growing number of middle-class people who 'were fertilized by the inconceivable amount of American cash that flowed into the country, down from the presidential mansion, through the bureaucracies civil and military, coursing through the PXs and onto the black market, into the pockets of a horde of people who served the foreign presence: drivers, guards, runners, valets, maids, houseboys, black-market operators, money changers, prostitutes, and beggars.'[2] And yet it is the prostitute, or the *yanggongju*, that will succeed Sonya's character to reappear in *Aimless Bullet* and subsequent melodramas to serve as *the* allegory of South Korea's dependent relationship with the US.

In sum, melodrama was the dominant mode of expression in response to the social-cultural conflicts of the time. Far from being relegated as a women's genre, the melo-dramatic mode, recognized as excess, best mediated the post-war conditions of a traumatized nation that sought to recover from the Korean War and the onslaught of western, in particular American, influences in all fabrics of Korean traditional society. As symptoms of modernity, the crisis of masculinity, female sexual identity and self-realization, consumer identity, etc., were recurring themes that promoted a return to the past in order to maintain the unity of family and traditional gender roles. The maintenance of the traditional masculinity was central to the government's rebuilding of South Korea as a modern nation with ambitions to finally overthrow foreign control and occupation.

Sueyoung Park-Primiano

Notes

1 [Anon.] (1960) A dispute over the kiss scene / the film Madame Freedom as gauge / approval rating dominates, assembly members' wives oppose. Tong-a Ilbo, 10 June. Translated by author. Available in *Sinmun kisa ro pon Han'guk yŏnghwa, 1945-1957 (A Compilation of Newspaper Articles on the Subject of Cinema)*, Volume 2, Han'guk Yŏngsang Charyowŏn. Sŏul T'ukpyŏlsi: Konggan kwa Saramdŭl.

2 Bruce Cumings (1998) *Korea's Place in the Sun: A Modern History*, New York and London: W.W. Norton & Company.

A Day Off

Hyuil

Production Company:
Daehan Yeonhap Film Co., Ltd.

Director:
Lee Man-hee

Producer:
Jeon Ok-suk

Screenwriter:
Baek Gyeol

Cinematographer:
Lee Seok-gi

Art Director:
Jeong Su-gwan

Composer:
Jeon Jong-kun

Editor:
Heyon Dong-chun

Duration:
74 Minutes

Genre:
Drama

Cast:
Shin Seong-il, Jeon Ji-youn,
Kim Seong-ok, Kim Sun-cheol

Year:
1968

Synopsis

Huh-wook meets his girlfriend Ji-youn every Sunday. The film follows him over the course of one of these Sundays as he meets his girlfriend, who declares that she needs to get an abortion, as they are too poor to afford to bring a child into the world. Huh-wook must then go from friend to friend trying to get money for the abortion. Facing every increasing desolation and tragedy, Huh-wook is trapped in poverty.

Critique

This was a film that was thought to be lost, having been banned for not complying with censor's demands in 1968. Thankfully this modernist masterpiece was found in 2005 by the Korean Film Archive and recently released on DVD. Lee Man-hee had a prolific output and between 1961 and 1975, when he died of liver cirrhosis during post-production on his final film *Sampoganeun gil/The Road to Sampo*, he directed 51 films. A product of the Motion Picture Law, the 1960s saw a greatly increased output of work as studios scrambled to produce enough domestic pictures to allow them to import lucrative foreign films. Lee, like many of his peers, worked in a staggering number of genres over his short career. And thanks to recent retrospectives, he is becoming increasingly well known both domestically and abroad. Although he is better known for his war and noir films, and this is where his own heart lay, he is also a strong director in other genres. The melodrama of *Gwiro/A Road to Return* (1967) or the psychological horror of *Ma-ui gyedan/The Devil's Stairway* (1964) are both strong examples of his work.

As dark and as well made as Yu Hyun-mok's 1961 film *Obaltan/The Aimless Bullet*, *A Day Off* shares many of the neo-realist tendencies of that film. The city of Seoul, itself undergoing rapid changes due to the Park Chung-hee regime, is shot so as to increase the desolation that these characters feel. Both Hu-wook and Ji-youn are trapped, not only by the economic hardships many Koreans were still facing under the supposed improvements of Park's Five Year Economic plan that had opened the Third Republic in South Korea but are also largely framed in isolated shots of winter in Seoul, dead branches clawing their way in from the side of the frame. Like many youth films, the two protagonists are at odds with the environment around them. They pretend at financial stability and dream of the day they too can participate in Korea's growing prosperity. Every Sunday they meet in front of a coffee shop, not because they can afford coffee but because it is a symbol of leisure and luxury that eludes them. In the beginning of the film Huh-wook scams a taxi and a store owner out of a ride and cigarettes, playing them off against each other. They cannot find their place in the rapid modernization that is going on around them and it both alienates and isolates them in tragedy.

This film is tragic: no matter what move they make the young couple is doomed, much like the family in *The Aimless Bullet*. With

no escape from their poverty, it is all they can do to try and survive. The film is also filled with gorgeous cinematography from Lee Seok-gi, although the overly melodramatic score reduces some of the impact of the film. Shin Seong-il, who plays Huh-wook, gives a strong performance that is filled with quiet desperation. Jeon Ji-youn, Ji-youn, also gives a great performance as a young woman trying to remain strong in the face of a hard decision. However, her limited screen time really makes this Shin's film. Warned by a fortune teller in the beginning to avoid women or end up in tragedy, his strong screen presence is one that carries us through the episodic nature of the film. As Huh-wook moves from friend to friend, from bar to bar, and from tragedy to tragedy Baek Gyeol's melancholic script keeps the viewer in rapt attention. Perhaps one of the strongest Korean Golden Age films I have yet to see, this film deserves far more attention the world over.

Rufus L de Rham

A Romantic Papa

Lomanenseuppappa (Romanceppappa)

Studio/Distributor:
Shin Film Co., Ltd.

Director:
Shin Sang-ok

Producer:
Shin Film Co., Ltd.

Screenwriter:
Kim Hee-chang

Cinematographer:
Jeong Hae-jun

Art Director:
Chung Woo-taek

Composer:
Kim Seong-dae

Editor:
Kim Young-hee

Duration:
131 minutes

Synopsis

The caring husband and father of five children is affectionately nicknamed 'Romantic Papa' by his family to tease him about his old age and ways. Neither greedy nor ambitious, the father has depended on the modest income he earns as a middle manager at a life insurance company to support his large family. Now, with the children all grown up, he is unable to keep up with the rising expenses, as well as with the changing times. The eldest daughter is a college graduate and is planning to marry soon. The eldest son has quit college and is studying film direction in secret. The second daughter is a college student, but she is humiliated by her father's lack of means that keeps her out of sync with her peers' more comfortable lifestyle. The youngest son and daughter are both in high school, but they also complain of having to do without a new pair of shoes or an allowance. Yet, the father maintains his authority by guiding his family with his usual humour and equanimity; that is, until he is laid off from work and is forced to accept his diminished role in society and family.

Critique

A film adaptation of a radio drama series by Kim Hee-chang, *A Romantic Papa* was a popular and critical success. Produced and directed by Shin Sang-ok, one of the most protean and industrious film-makers in Korean film history, the film's sensitive portrayal of the aging patriarch's everyday life popularized family dramas and contributed to Shin's growing reputation as the master of genre films. Aided by the ideal casting of Kim Seung-ho as the sympathetic Papa, the film was awarded the best domestic film by The Ministry of Culture and Education and The Ministry of Public Relations, as well as the best actor prize by The Ministry of Culture and Education, the 7th Asia Film Festival, and the 4th Buil Film

Genre:

Family drama/comedy

Cast:

Kim Seung-ho, Ju Jeung-ryu, Choi Eun-hee, Kim Jin-kyu, Nam Koong Won, Do Kum-bong, Shin Seong-il, Um Aing-ran, Kim Seok-hun, Lee Bin-hwa

Year:

1960

Festival in Busan. Shin, who debuted as director in 1952 with *Evil Night*, was at the peak of his career at this time. Having founded his production company in the early 1950s, and accompanied by his wife and muse, Choi Eun-hee, Shin was a veritable economic and creative force. As a major studio with its vertically-integrated motion picture theatre, Shin Film Corporation boasted a stable of 300 employees at one time. Between 1959 and 1961, Shin produced and directed 13 films, and his passion for the medium is most humorously communicated in *A Romantic Papa* through its self-reflexive attitude.

A Romantic Papa begins with all of the characters introducing themselves to the audience by directly addressing the camera. This playful engagement with the audience expands the diegetic world into the real world while acknowledging the cinematic apparatus and its awareness of viewers. Moreover, one of the characters, the eldest son Eo-jin, is a film student, which provides ample opportunity to more naturally reference the film medium and its creative process throughout *A Romantic Papa's* episodic narrative. In one scene, Eo-jin is shown at work behind the camera in a film studio. In another scene, Eo-jin confesses to this father that he has dropped out of college and is studying to become a film direc-tor. This intimate conversation between father and son eventually leads to the father proudly demonstrating his knowledge of cinema by naming renowned western actors – namely, Greta Garbo, Emil Jannings, and Douglas Fairbanks. The most representative scene, however, is when Eo-jin's screenplay is read aloud before the entire family, and the father and mother take turns revising it to their tastes. This results in films-within-the-film, with the first film-within-the-film relating Eo-jin's script about young, star-crossed lovers; the second relating the father's scenario about an older artist whose integrity forces him to shun the affections of a young adoring female; and the third relating the mother's scenario about a daugh-ter who marries a man of nobility against her mother's wishes. This exuberant scene also anticipates Shin's highly-successful film *Seong Chun-hyang* (1961) in the mother's version of the script, which also depicts the famous story of the gisaeng's (a courtesan) daughter who remains faithful to her absent husband. In the film-within-the-film, Choi Eun-hee is cast as Chun-hyang and Kim Jin-kyu as her husband, just as they are cast as the daughter and son-in-law in *A Romantic Papa*, and just as they will be cast in *Seong Chun-hyang*. To be sure, these examples of meta-cinematic gestures offer evidence of Shin's breadth of film knowledge and his love of cinema. However, *A Romantic Papa* is most obviously appreciated as an allegory of President Syngman Rhee's downfall. Released only months before the student revolution of 19 April 1960 that led to the end of Rhee's authoritarian rule, the film's scene in which the younger son, Bareuni, defeats his father in an arm-wrestling match can reasonably be interpreted as political, especially since Bareuni declares, 'Father, you are the top authority of this family, and I will fight until the bitter end to win.'

Sueyoung Park-Primiano

Love Me Once Again

Miweodo dasi han beon

Studio/Distributor:
Han Jin Co. Ltd.

Director:
Jeong So-young

Producer:
Han Gap-jin

Screenwriter:
Lee Seong-jae

Cinematographer:
An Chang-bok

Art Director:
Lee Mun-hyeon

Composer:
Kim Yong-hwan

Editor:
Hyeon Dong-chun

Duration:
93 minutes

Genre:
Melodrama

Cast:
Shin Young-kyun, Moon Hee,
Jeon Gye-hyeon, Park Am,
Lee Choong-beom

Year:
1968

Synopsis

Hye-yeong finds herself swept off her feet by the attentive charms of Shin Ho. She fully expects to marry the suave and studious gentleman and thus she is shocked when not only his parents but also his wife come back to Seoul. Feeling betrayed to the core of her being, Hye-yeong breaks off their adulterous relationship and flees Seoul in shame. Not long afterwards, Hye-yeong gives birth to a son but it is not until eight years later that Shin Ho comes to find her. Having succeeded in business and now very well off, Shin Ho suggests that he is in a better position to raise their son, Yeong-shin, and provide better schooling than the struggling Hye-yeong can. After some soul-wrenching consideration, Hye-yeong decides to surrender her only child to his father. However, Yeong-shin has a difficult time adjusting to life in Seoul with his father, strict grand-parents and step-mother. Hearing of her son's distress, Hye-yeong also reconsiders her decision, but it may be too late.

Critique

At a time when Korean movies were beginning to experience dif-ficulties in gathering viewers in theatres due to the ever-increasing number of televisions in homes and the popularity of Hollywood movies, *Love Me Once Again* was able to strike a chord with audi-ences. At the time, accurate attendance records were not kept throughout the nation, however it is known that approximately 360,000 people attended screenings in Seoul. By today's stan-dards, that is not many but, at the time when the population of Seoul was at about 4 million residents and money was still tight, it was quite a coup. One of the reasons for the success of this film is undoubtedly the emoting of actress Moon Hee as Hye-yeong. While her tearful waterworks may seem too much and too often for today's audiences, it was quite common in most Korean films of the 1960s, including comedies, for the main characters, whether men or women, to be given several minutes of crying time on screen. Moon Hee was special and was one of a troika of popular actresses in Korean cinema in the late 1960s, which included Nam Jeong-im and Yoon Jeong-hee, until Moon Hee's retirement in the early 1970s. Her portrayal of Hye-jeong evokes sympathy for the character's impossible decision and empathy for the agony she endures as she struggles to re-earn custody of her son. The angst of separation from family and, in particular, separation from mother, was a common theme in films throughout the fifties and sixties and is frequently seen in even modern Korean films. This popular theme was undoubtedly another reason *Love Me Once Again* was so successful.

In fact, *Love Me Once Again* was so successful that the origi-nal film was followed by three sequels, released annually, which continued the story of Shin Ho and Hye-yeong. Whichever home poor Yeong-shin ended up at the end of one movie, it was sure to be reversed at the start of the subsequent film. The first three

of these films are readily available to be seen but the final chapter in 1971 unfortunately has been lost. All of the films in the original series were directed by Jung So-young. The story was remade in 1980, directed by one of the premier directors of the 1980s, Byeon Jang-ho, and his film also inspired one sequel. At nearly the same time, director Jang Il-ho filmed a trilogy entitled *The One Love* that was clearly inspired by *Love Me Once Again*. Finally, with 31 films under his belt and fifteen years of not helming films, director Jung So-young returned in 2002 to make his final film, an updated version of *Love Me Once Again* entitled alternately *Love Me Again Despite Hatred* or simply *Again*.

Searching for this film and its sequels in English can be challenging. Although the Korean title is easy to understand, it is almost impossible to translate. The result is a myriad of different English names for these movies. The two names of the 2002 version listed above is an example while the 1969 sequel is called on the Korean Film Database as *Bitter But Once Again*. The third in the series is called *Farewell My Love, part 3* and so on. As none of these films were assigned official English titles at the time of their release, perhaps the titles can be standardized if the films are ever considered for an English-subtitled release.

Tom Giammarco

Madame Freedom

Jayu-buin

Studio/Distributor:
Sam Seong Film

Director:
Han Hyung-mo

Producer:
Bang Dae-hun

Screenwriter:
Kim Seong-Min

Cinematographer:
Lee Seong-hui

Art Director:
Lee Bong-seon

Composer:
Kim Yong-hwan

Synopsis

Mrs Oh wants to work as a saleslady at a store that sells the latest in western fashions. As required by the protocol of the time for those of a certain class in South Korea, she gets permission from her husband. While working at this store, and through a woman's club of which she is a member, Mrs Oh becomes intrigued by, and eventually fully engaged with, the subculture in Seoul that is entranced with American and European fashions, Jazz and Mambo music, and relaxed sexual mores. Mrs Oh soon finds herself simultaneously juggling her job; helping a friend with her illegitimate scheme to make money selling foreign goods; and having not one but two affairs, one with a young college student boarder next door to her family home and the other with the wealthy husband of Mrs Oh's boss. While all this is going on, Mrs Oh's university professor husband finds himself pursued by a younger office lady who is part of a pro-bono class he teaches on Korean grammar. As a result, both Mr and Mrs Oh have to consider choices between personal fulfilment and family obligations; choices that might impact them for the rest of their lives.

Critique

Of the many benefits provided by the international success of the New Wave of South Korean Cinema in the 2000s is how much it sparked a renewed interest in South Korea's cinematic past, Han Hyung-mo's *Madame Freedom* being one among the gems.

Editor:

Han Hyung-mo

Duration:

125 minutes

Genre:

Melodrama

Cast:

Park Am and Kim Jeong-rim

Year:

1956

And nowhere more does *Madame Freedom* deliver and announce its relevance as a significant work in early South Korean cinema than during the wonderful dance club scene, where a Korean mambo band swings as if the music itself were generated from this East Asian peninsula rather than the island of Cuba. As scholar Kathleen McHugh noted, in her chapter in *South Korean Golden Age Melodrama: Gender, Genre, and National Cinema*: 'the experience of this scene for a Westerner is quite uncanny. What is initially striking about this scene is how *familiar* it is. The ambiance, the setting, and the blocking of the crowd and the performance shots resemble cinematic scenes from many night-club and cabaret films in Western cinema. Yet its generic reference seems to derive less from Hollywood than from Mexico, as this sequence is more strikingly reminiscent of the Mexican *cabaretera* film than of the Hollywood variant'[1]. Contrary to shorthanded com-ments about the supposed Americanization of South Korean film during this time, the reality is more complicated. This wonderful mambo scene underscores this, as do the efforts of the characters within the film to buy Parisian products as much as American ones. *Madame Freedom* complicates 'globalization' before the word gained simplified cliché status.

The film, in fact, complicates many things. I am not giving any-thing away here, if one is familiar with how post-Hayes Code films in the US required those individuals who stepped out of presumed social norms to be 'punished', but *Madame Freedom* also requires an eventual squelching of the feminist, sexual, artistic and capitalist desires displayed on screen. Yet this does not detract from the fact that the desires are indeed celebrated for much of the screen time. Most of the film wallows in these desires in a permissiveness that contradicts the ending's demands that succumbing to such desires will only destroy the family. Just as American director Sam Fuller argued that the supposedly anti-war film *Full Metal Jacket* was, as critic Jonathan Rosenbaum paraphrased him as saying, '. . . another goddamn recruiting film', there is a cultural permis-siveness within *Madame Freedom* that is just as much supported as challenged. From the dance-club scene, to the secret rendezvous at coffee shops, to Oh's disrobing of a traditional Korean hanbok for a more stylish western ensemble, to Oh's trysts with the young daddy-o student border next door, this is a film that titillates and celebrates outside the espoused morals of the time with as much of a wink of approval as a disgruntled sneer of disgust. *Madame Freedom* is a delight, a film ahead of as much as within its time, re-visioning the role of women and flaunting the changes rushing through South Korea as much as the censors would allow. Madame Freedom is an ambivalent morality tale. As we the audience gaze at the inner torment on display of the long takes of actresses' and actors' faces as they make decisions they might later regret, we, equally, gaze longingly at the changing styles of dress, music, and relationships that modernism carries to every country in its wake,

making *Madame Freedom* a perfect cultural document of the rush to modernization that was the Korea that, only recently, had South added to its name.

Adam Hartzell

Note

1 Kathleen McHugh and Nancy Abelmann (eds) (2005) *South Korean Golden Age Melodrama Gender, Genre, and National Cinema*, Detroit, Michigan: Abelmann Wayne State University Press.

Mr Park

Bakseobang

Studio/Distributor:
A Hwaseong Film Production

Director:
Kang Dae-jin

Producer:
Lee Hwa-ryong

Screenwriter:
Cho Nam-Sa

Cinematographer:
Lee Mun-baek

Art Director:
Won Je-rae

Composer:
Lee In-gwon

Editor:
Kim Hee-su

Duration:
138 minutes

Genre:
Melodrama/family drama

Cast:
Kim Seung-ho, Hwang Jung-seun, Kim Jin-kyu, Jo Mi-ryeong, Um Aing-ran, Kim Hye-jeong, Hwang Hae, Bang Su-il, Kim Hee-kap, Yu Gye-seon

Year:
1960

Synopsis

A proud and stubborn man, Mr Park has worked hard to raise his three children by repairing briquette stoves in his neighbourhood. The measure of his success is his children, in particular, his eldest son Yong-beom who works for an important pharmaceutical company in another town. With his beloved son away from home, Mr Park feels greater estrangement from his wife and two daughters who seem to be always against him. The elder daughter, Yong-sun, continues to see a former gang member, despite his obvious disapproval. The younger daughter, Myeong-sun, frequently returns home late from work after a rendezvous with her boyfriend. Adding to Mr Park's frustrations is his wife, who defies him by permitting their daughters to continue to date. Finding his home life distasteful, Mr Park consoles himself by escaping to a local bar to commiserate with a friend. But the troubles are only beginning for Mr Park, whose son and soul mate Yong-beom has been offered a promotion that may take him away to Thailand for five years. Moreover, his elder daughter has run away from home, and the younger one is depending on him to secure her marriage into an upper class family.

Critique

Released in October 1960, Kang Dae-jin's *Mr Park* is an adaptation of a popular radio drama of the same title that came to enjoy even greater success as a film. Along with Shin Sang-ok's *A Romantic Papa*, released in January of the same year, *Mr Park* set in motion the cycle of family dramas that was immensely popular in the 1960s. Kang is otherwise connected to Shin for whom he worked as assistant director for three years before debuting as director in 1959 with *Bujeonjajeon/Like Father Like Son*. With his interest in exploring the role of the father unabated, Kang will further contribute to the family drama cycle with his award-winning film *Mabu/The Coachman* in 1961. As demonstrated by these films, the family dramas of this decade generally focused on the father figure, and the daily challenges he faced at home and in the workplace or society at large. They are distinct from the female melodramas of the second half of the 1950s that gave attention to the sexual

transgressions of a single woman (e.g. *Flower in Hell*) or the mother figure (e.g. *Mimang-in/The Widow* and *Jayu-buin/Madame Freedom*). The success of the 1960s' family dramas is due in large part to Kim Seung-ho, who was typically cast as the less-than-perfect but always-earnest father. Kim epitomized the working-class man in these films, and his performance as Mr Park secured his second Best Actor award at the 1960 Asia Film Festival.

In *Mr Park*, the titular character is an obstinate but sympathetic man. He has tirelessly worked to support his family, and he expects nothing in return other than the well-being of his three children. He lives with his family in Haebangchon (Liberation Village), a ghetto for the people who fled communist North Korea, and we are introduced to this shabby neighbourhood in the first scene by Mr Park, who is shown hauling pails of water up a steep and winding path toward his home. Accustomed to hard labour, he then heads off to a neighbour's house to fix her briquette stove. When the grateful neighbour invites him into the main room to offer him a shot of expensive whiskey, we are privy to his profound discomfort and embarrassment at having to step with his grimy feet onto the clean floor. We are also exposed to his lack of pretensions when he confesses he has no taste for western alcohol. These early scenes immediately establish Mr Park's humble virtues that have no exchange value in the modern, materialist society. In fact, they soon become a liability when Mr Park meets his future son-in-law's aunt, who, as his sole guardian supported and educated him with the best that money can buy. She is a cosmopolitan woman who shuttles between her home in Hawaii and Seoul. And Mr Park becomes the subject of her derision when she sees his uncouth dress and manner, and she openly laughs at his ignorance of tea bags before telling him the marriage will not happen and kicks him out. Having never felt shame for his social status, the severity of the experience is a traumatic one for Mr Park. Arguably, this scene can be dismissed as melodramatic excess, but it is surprisingly effective in measuring the resultant change in Mr Park, who quickly realizes he is not the anchor but the very weight that is keeping the family from progress. And despite the spotlight on the father and son's intimate relationship, it is ultimately his new relationship with the daughters, especially with the elder daughter Yong-sun, that invokes his humanity and our pathos.

Sueyoung Park-Primiano

The Hand of Fate

Unmyeong-ui son

Synopsis

Margaret, aka Jeong-ae, is a North Korean spy who works at a hostess bar while passing off messages encoded as musical scores to North Korea. She quickly takes on a poor student Young-chul after he is beaten and accused of being a thief. She becomes his benefactor buying him clothes and food, and they soon become lovers. However Young-chul is an anti-espionage agent and

Production Company:
Han Hyeong-mo Production

Director:
Han Hyeong-mo

Producer:
Han Hyeong-mo

Screenwriter:
Kim Seong-min

Cinematographer:
Lee Seong-hwi

Art Director:
Lee Bong-seon

Composer:
Park Si-chun

Editor:
Han Hyeong-mo

Duration:
85 Minutes

Genre:
Drama

Cast:
Yoon In-ja, Lee Hyang,
Joo Sun-tae

Year:
1954

Jeong-ae becomes torn between her duty as a spy and her love for Young-chul.

Critique

Han Hyeong-mo is most famous for his marvellous film *Madame Freedom*, a classic Golden Age melodrama, and had worked for a long time as a cinematographer – even lensing the first post-liberation film *Jayumanse/ Viva Freedom!* (Choi In-Kyu, 1946). *The Hand of Fate* is a strange genre blend of a melodrama and an espionage thriller but, under the assured direction of Han, it works. Although competing at the time against the box-office giant *Chunhyang jeon/Chunhyang Story* (Lee Kyu-hwan), *The Hand of Fate* is notable for having the first onscreen kiss in South Korean film history. This was scandalous at the time and I have heard stories that the leads wore cellophane between their lips and the husband of Yoon In-ja, who plays Jeong-ae, sued the production company when the film was released. Furthering the scandal, this was a kiss between a South Korean and perhaps the biggest Other that Korea could produce at the time: a North Korean.

Of course, Jeong-ae is immediately seen on screen smoking and lives independently, both codes in classic Korean melodramas for an impure and scandalous woman. This is a tradition that was introduced during colonial Korea when debates about the New Woman were in the public consciousness. This figure embodied all of the negative features of emulation of both colonial and western influences, often portrayed as having bobbed hair, wearing western dress, and smoking cigarettes. This portrayal would continue to exist in Korean film long after modernization and industrialization began in force. These visual markers in the melodrama also mark the figure for punishment and tragedy. Jeong-ae is such a figure and, although Yoon provides her with a strong independent personality, it is a film still trapped within these melodramatic conventions.

The film is filled with wonderful montages and Han's background as a cinematographer is evident throughout. The strong use of shadows and framing, especially in the kissing scene, is evident of his skill and control over his films. Particularly striking is a sequence in which Jeong-ae is seen transcribing a message as the scene transitions into superimposed bombs dropping, the aftermath of her betrayal. The film moves at a fast pace and, while never escaping from its genre conventions, hits everything with a well-made note. The only negative aspect is the overacting during the final fight sequence, and this is due in a large part to the over-the-top character of Jeong-ae's spymaster. Until this point in the film, he had only been seen in pieces: feet in the hall, legs on the stairs, and a threatening ringed hand on a banister. However, when fully revealed he is more of a cartoonish villain than a true threat, and it does not help that if one has seen other Golden Age films you can guess how everything will end.

The film is still quite enjoyable, though, and Yoon's portrayal of Jeong-ae is worth tracking the film down for. Lee Hyan, playing

The Hand of Destiny, 1954, Han Hyeong-Mo Production

Young-chul, is a fine actor, but Yoon steals every sequence she is in, commanding the screen with her presence. Although she is a North Korean spy, she plays the role with humanity and tenderness. It is interesting that Han continues to create strong interesting women in his films, but never lets them escape the confines of melodramatic conventions. He is showing the audience what was going on in society, but wrapping it in a convention that was easily digestible. This struggle mirrors the struggle for Korean women who were attempting to escape the confines of tradition, though thankfully this struggle did not always end in tragedy.

Rufus L de Rham

The Money

Don

Studio/Distributor:
Kim Production

Director:
Kim So-dong

Producers:
Kim So-dong (Kim Production),
Kim Seung-ho

Screenwriter:
Kim So-dong

Synopsis

When Young-ho returns home from military service, he finds his family and neighbours heavily burdened with money concerns: His father, Bong-su, has laboured all his life as a farmer with little to show for other than the mounting debt; his sister Soon-hui is heartbroken at having to postpone her marriage several times; his girlfriend Ok-gyeong has moved in with Eok-jo and his wife to work for them as a barmaid and servant; and his mother is anxious over lapsed payments to the creditor. One night, Bong-su and his friends meet for drinks at Eok-jo's home and he ends up gambling away his hard-earned money, including the savings for Soon-hui's wedding. Deceived by Eok-jo's cheating ways, Bong-su is persuaded by him to try his hand at merchandising by selling the family cow and heading for the city. The trusting and simple

Cinematographer:

Sim Jae-heung

Art Director:

Gang Seong-beom

Composer:

Han Sang-ki

Editor:

Kim So-Dong

Duration:

123 minutes

Genre:

Drama

Cast:

Kim Seung-ho, Choi Nam-Hyun, Choi Eun-hee, Kim Jin-kyu, Hwang Jung-sun

Year:

1958

Bong-su is easy prey in the city as well, and he falls victim to a couple of cons. Just when he has lost all hope, Bong-su finds a bundle of cash near his home. But far from it being a sign of redemption, the money robs Bong-su of reason one last time with tragic results for him and his family.

Critique

Kim So-dong has only a handful of films to his credit as director, screenwriter, and producer, but the advancing of Korean cinema was a lifelong project for him whose efforts included teaching and writing on film art and criticism from 1955 through the early 1980s. To nurture and develop uniquely Korean themes, Kim preferred period films and films with a *nongchon* (farming village) setting. Akin to the German *Heimat* (homeland) films, the *nongchon* film portrays conflict between the rural and urban life, tradition and modernity, and the old and new generations. As Kim's fourth feature, *The Money* is one of the three films he directed with a *nongchon* setting, and the first to be produced by his newly-established production company. The film earned Kim the best director prize from the Korean film critics' second awards event, and it stirred much debate within the film community when the Ministry of Culture forbade its entry into the 5th Asia Film Festival for its bleak portrayal of contemporary Korean society. For such a portrayal, *The Money* has been compared to Italian neorealist films, but it has greater ties to the tradition of realism found in Na Un-gyu's films of the colonial period (1910-45). Na's film *Arirang* (1926), also set in a *nongchon* setting, is the most celebrated and representative work as the voice of the era. It was remade by Kim in 1957 as a tribute to the film-maker that most influenced Kim and his contemporaries.

 The Money opens and closes with a shot of the train that connects the countryside to the capitalist urban centre. The long take of the moving locomotive offers a panoramic view of the open farmland that has been contaminated by the sight of the railroad as a symbol of modernity. Early scenes showing the pastoral life are shot from ground level to emphasize the farmers' roots to the land and nature. From this perspective, farmers are shown breaking from work and sharing their meal with neighbours and friends. Parallel scenes of the chaotic city are shot from above to show the rootless masses as they speed to and fro without human contact. When the train arrives at its destination, it drops off two of the main characters: Eok-jo, who has returned home from a business trip in the city, and Young-ho, who has returned home after being discharged from military service. Their chance encounter at the station foreshadows the two characters' bound fate that will soon unravel, with Young-ho being forcefully taken away on the same train by the state police. As a merchant, Eok-jo is a frequent passenger on the train and he is chiefly responsible for integrating the feudal society into the capitalist culture. He is also the conduit through which the urban way of life is transported, including its malaise in such as murder, gambling, and theft. Eok-jo dominates the not-yet-fully integrated traditional society through

bills of exchange and promissory notes that he obtains through fraudulent means as a bar owner, a loan shark, and a card shark. His greed for money has him double-dealing everyone, breaking up the kinship in the close-knit community. With the exception of Young-ho, the entire farming community is blindly obsessed with possessing money. In particular, Young-ho's father, Bong-su, is the most desperate about possessing money, but he is also the least qualified to manage it. His every foolish attempt to make money not only increases his material loss but also his loss of reason. In this way, the film is a sharp critique of the modern individual that prizes money over family, community and kinship. The blaming of individuals rather than the system or institutions reflects the film's greater ties to the enlightenment films from the colonial era, rather than Italian neorealism. At the same time, it is also representative of the rapidly-changing Korean identity and Kim's attempt to reify original Korean values.

Sueyoung Park-Primiano

The Money, 1956, Kim Production

The Stray Bullet

Obaltan

Studio/Distributor:
Tae Han Film Co., Ltd.

Director:
Yu Hyun-mok

Producer:
Kim Seong-chun

Writer:
Lee Beom-seon
Screen play (Adaptation):
Lee Jong-ki

Cinematographer:
Kim Hak-seong

Art Directors:
Baek Nam-jun, Lee Su-jin

Composer:
Kim Seong-tae

Editor:
Kim Hee-su

Duration:
106 minutes

Genre:
Melodrama

Cast:
Kim Jin-Kyu, Choi Mu-Ryong,
Moon Jeong-Sook, Seo Ae-Ja

Year:
1960

Synopsis

Set in Seoul a few years after the end of the Korean War, this film portrays a family living in impoverished social and economic conditions. The first son, Cheol-ho, who works at a small accounting firm, is responsible for his senile mother, three siblings and his wife and daughter. The small salary Cheol-ho brings home barely supports the family and everyone is struggling to deal with the dark reality; his mother is bedridden due to the trauma of war; his younger brother, Yeong-ho, a veteran, cannot find a job; and his younger sister, Myeong-suk, becomes a prostitute. Cheol-ho himself is suffering from a terrible toothache but has difficulty sparing the money to get proper treatment. The desperate younger brother attempts to rob a bank and, on the day he is arrested, Cheol-ho's wife dies during labour. Traumatized by this series of unfortunate events, Cheol-ho walks the street aimlessly, finally wandering into a dental clinic to have his rotten tooth extracted. Still in pain from the extraction, he grabs a taxi but cannot decide where to go. All he can do is mutter to himself 'let's get out of here', a line his mother repeats sporadically on her sick bed.

Critique

Based on Yi Beom-seon's novel, *The Stray Bullet* is arguably one of the best films produced in the 1960s, a realistic rendition of the war trauma that cast a deep shadow over the lives of so many in post-war South Korea. This low-budget black-and-white film was released in April 1961, but banned by the Park Chung-hee military regime that overturned the government in the May 16 coup-d'état of the same year. It was invited to the 7th San Francisco Film Festival in 1963, but had to wait until 1980 to be re-released in South Korea. The director, Yu Hyun-mok (1925-2009), is an important figure in Korean realist cinema, known for his critical views on the anti-communist ideology and blatant nationalism that marginalized people like Cheol-ho and his family. The grim depiction of post-war South Korea was the main reason why the film was banned; however, the senile mother's repeated cry, 'let's get out of here, children', was apparently interpreted as 'let's go to North Korea' by the censors, a groundless accusation that was extremely hard to challenge when anti-Communism was (and still is) the most prioritized national policy.

The futility of war and the problem of survival in post-war Korea resonate in the story of Cheol-ho's sister Myeong-suk and her fiancé Kyeong-sik; critically wounded during the war, Kyeong-sik has abandoned all hope in a world that rejects the disabled, whereas Myeong-suk copes with reality by working as a prostitute. In this subplot, the gendered notion of able bodies and productivity is depicted with irony; that women undertake sex labour as a means to survive only confirms that masculinity has been seriously damaged by the war on both the mental and physical levels. One brilliant shot delineating this emasculation is when Cheol-ho

happens to spot Myeong-suk with an American GI through a bus window, then quickly turns away while rubbing his cheek to sooth the pain caused by his rotting tooth. He is powerless to provide better options for his sister; yet finds it painful to face the fact that the family relies on the money she makes from prostitution.

In *The Stray Bullet*, conscience and morality weigh next to nothing compared to the drive for survival. In fact, such things are rotting like Cheol-ho's back tooth. This moral decay eats away at the brother, Yeong-ho, who is asked to play a role as a veteran in a movie. The script infuriates and disgraces him, since it exploits the scar a wartime bullet left in his side, turning it into a spectacle. Yeong-ho decides to overturn his humiliation but uses the wrong approach: the handgun he wields during the robbery cannot change his unfortunate situation, though it held the key to life and death during the war. Confronting his brother, who has endured so much exploitation and mistreatment, Yeong-ho asks the self-directed question, 'what's this futile sacrifice for?'

Once Cheol-ho finally has had his rotten tooth removed, the family is in an even worse situation. What has been done cannot be amended, and he is left in the taxicab like a stray bullet not knowing where to go, yet possessed by his sense of duty as the head of the family. Should he head home, to the hospital or to the police station? Like his fellow North Korean refugees settled in Liberation Village (*haebangchon*), Cheol-ho and his family represent the violent tide of Korean history which divided the nation, society and families – a history that Yu, a North Korean refugee of the war himself, witnessed with his own eyes.

Jooyeon Rhee

The Widow

Mimang-in

Studio/Distributor:
Jamae Films

Director:
Park Nam-ok

Producers:
Jamae Films, Jeon Chang-keun

Screenwriter:
Lee Bo-ra

Cinematographer:
Kim Yeong-sun

Composer:
Jo Baek-bong

Synopsis

Shin is a war widow left alone with her young daughter Ju. With no money and family to turn to, Shin seeks help from her husband's friend Lee Sung-jin, who is a successful businessman. Lee's suspicious wife, however, demands that she stop seeing her husband, although she herself is having an affair with a younger man named Taek. By coincidence, Shin encounters them on a weekend outing to the beach when Taek rescues Ju from drowning. Fatefully, Shin runs into Taek again while en route to meet with Lee, at which time Taek expresses his interest in her. Complicating matters, Lee relates to Shin his discovery of his wife's infidelity and elicits Shin's response to his growing affection for her. Shin, instead, falls in love with Taek, and has him move in with her while she sends her daughter away to be raised by a neighbour. Together, they begin to rebuild their lives with Shin running her own dress shop made possible with the seed money from Lee, and with Taek working as a billboard painter. But their happiness is soon upended by Taek's chance meeting with the woman he once loved and thought to have perished in the war.

Editor:

Park Nam-ok
Duration:
75 minutes

Genre:

Melodrama

Cast:

Lee Min-ja, Lee Taek-gyun, Choi Nam-Hyun, Yu Gye-seon, Na Ae-sim, Sin Dong-hun, No Gang

Year:

1955

Critique

Park Nam-ok made history as the first woman director in Korea with *The Widow* (also known as *The Widow's Tears*) in 1955. Alas, it is the only film she ever directed despite her intention to do otherwise, as suggested by the opening credit that reads, 'Jamae Films First Production'. The name of the production company, Jamae Films, also relates how the film was realized with the money Park borrowed from her sister; hence, the use of the term 'Jamae' or 'sisters'. The screenplay was written by Park's husband, Lee Bo-ra, and shooting began shortly after Park gave birth to their daughter. According to legend, she carried the infant on her back throughout production since there was no one to look after her. The shoestring budget also meant that Park had to cook herself to feed the crew, and actors in the title roles were unknowns recruited from her circle of friends. The film was clearly a labour of love, and *The Widow* offers an honest and sympathetic portrayal of women's desire and subjectivity.

The film begins with the caption: 'There was such a widow in our town: She found sunflowers even while sinking into the quagmire.' With this prologue the optimistic nature of the widow, as well as the muddy mess surrounding her, is established early. Certainly Shin displays none of the usual melodramatic characteristics of the suffering woman who is bound to her past and immobilized by grief. Living in a communal household with fellow war refugees, Shin is determined to find a way to make an honest living to support herself and her daughter. Rather than follow her neighbour's example and depend on men for her livelihood, Shin secures a loan from a male acquaintance without losing her integrity. This does not mean Shin is content with her solitary life, or to remain devoted to the memory of her husband. When she meets Taek, Shin feels no compunction about loving another, much younger, man, or living with him without being married. She even sends her daughter Ju away to be raised by a neighbour when Ju rejects Taek as her new father, although this is not done without Shin feeling remorse. Remarkably, Shin is not depicted as a deviant for satisfying her sexual and emotional needs, and the developments in her life are presented naturally and without judgment. This is equally true for the supporting characters that do not represent the usual victims or victimizers to be found in female melodrama. The wife of Lee is only cheating to make up for her loveless marriage, and Taek's wanderings are attributed to his losing everything he loved in the war. Together, these characters represent the tragic lives of those who survived the war, only to face more challenges in an uncertain and suspect future. Given this unique perspective, it is truly regrettable that this film survives in such a poor and broken state. The sound is difficult to hear throughout, granted the original recording was likely of low quality. Approximately an hour into the film, the sound disappears completely, and the final scene is missing from the original. A film review at the time describes the final scene as Shin stabbing Taek for leaving her for another woman, but Park's own recollection in an interview states that the film ends

with Shin pushing a handcart with Ju on top, passing the dress shop and taking the road (see Cho Yoon-ju's 'Kkutnaji anneun, kkutnaji anneul yiyagi: Park Nam-ok gamdok-ui Mimang-in' [The never-ended, never-ending story: Park Nam-ok's *The Widow*], in *Ggaegan Yongsang Munhwa Jungbo* [*The Quarterly Film Culture Report*]. Spring 2000, p. 28. [trans. by author]).

Sueyoung Park-Primiano

KOREAN NEW WAVE

The Korean New Wave period roughly coincides with the rise of intense and massive struggle for democracy in the late 1980s that culminated in the abolition of the 32-year military dictatorship and in the establishment of a civil government in 1993. Film critics and historians still differ in their assessment of the New Wave – what or who exactly constitutes the Korean New Wave and whether it was a coherent movement – and its legacy, however, it is generally agreed that Park Kwang-su's debut feature *Chilsu wa Mansu/ Chilsu and Mansu* is the film that opened the door for a new cinema in 1988 and that the New Wave waned by the time Park released his fifth feature film *Aleumda-un cheongnyeon Jeon Taeil /A Single Spark* in 1995. In the late 1990s, the New Wave was eventually succeeded by the New Korean cinema that ushered in the 'Renaissance of Korean cinema' on both domestic and international level. Thus, in the case of South Korean cinema, the terms 'Korean New Wave' and 'New Korean Cinema' are not coterminous but are used to indicate two separate periods and two distinct film-making styles and trends. Whereas the late 1980s' Korean New Wave was more focused on challenging the status quo and the mainstream cinema of the moment and thus more political in their orientation, the 2000s' New Korean cinema is more focused on commercial viability and transnational appeal.

Like the French New Wave of the late 1950s and early 1960s, the Korean New Wave was led by a new generation of film-makers rebelling against the status quo of the 1980s' Korean society and film industry. However, unlike the French New Wave, it did not have a core group like that of Cahiers du cinéma whose members shared a strong camaraderie and wrote film criticism to promote their ideas for a new kind of film-making. In addition, even though the censorship by the military government slackened a little around 1988, the year of Seoul Summer Olympic Games, the New Wave film-makers were still bound by the confines of the political censorship. In fact, during the New Wave period, the young film-makers either chose to work within the industry trying to push the limit of censorship or chose to completely ignore the censorship and make underground activist films.

The first group includes such film-makers as Park Kwang-su, Jang Sun-woo, Lee Myung-se and Park Jong-won; the second group included collectives such as 'Seoul

Left image: *Black Republic*, 1990, Dong A Exports Co., Ltd

Visual Collective', mostly making alternative, independent documentaries, and 'Jangsan-gotmae' that made the radical leftist film *Paeop Jeonya/ Night Before the Strike* in 1990. There were also some film-makers from the previous generation who renewed their film-making practice and made films that can be considered 'New Wave' during this period. Veteran director Im Kwon-Taek and Chung Ji-young are the most prominent examples. Then, what are the major characteristics of the Korean New Wave? What constitutes its aesthetics and what is 'new' about its film-making practice? Since the Korean New Wave was a political as well as aesthetic rebellion, it is best understood in a broader political, social and cultural context of its time.

The 1980s was a period of major transformation in the political, social and cultural environment in South Korea with the rise of the *'minjung'* movement. When President Park Chung-hee was assassinated after an eighteen-year dictatorship in 1979, a ray of hope for democracy ignited. However, it was brutally crushed when the Kwangju Uprising in 1980 was violently suppressed, resulting in an unprecedented massacre. This failure urged a change of gear for political activism and anti-dictatorship struggle: from bourgeois struggle led by students and intellectuals to a more radical *minjung* movement. Now the labourers, peasants, urban poor and other marginalized people will be the driving force to lead a revolution. *Minjung* (literally meaning 'people'; in the context of the 1980s South Korea, *minjung* is a term that indicates 'the oppressed') became the central idea in the cultural movement in the 1980s and Korean cinema also began to show the influence of the *minjung* movement in the early 1980s. A number of film-makers adapted major works of *minjung* literature into films such as *Barambuleo joheun na/A Fine, Windy Day* (Lee Jang-ho, 1980), *Nanjang-iga sso-a-ollin jageun gong/A Small Ball Launched by a Dwarf* (Lee Won-se, 1981), *Eodum-ui jasigdeul je 1 bu/Children of Darkness Part I* (Lee Jang-ho, 1981), *Kkobangdongne saramdeul/People of Ko-bang Neighborhood* (Bae Chang-ho, 1982), *Baboseon-eon/Declaration of Fools* (Lee Jang-ho, 1983), and *Jangsa-ui kkum/Dreams of the Strong* (Shin Seung-su, 1985). In particular, Lee Jang-ho, who started his career by making big box-office hits in the mid-1970s, began to make socially-conscious films in the early 1980s depicting the sufferings of the have-nots and social outsiders. With *Barambul-eo joh-eun nal/Good Windy Day* in 1980, Lee opened the door for a renewal of social realism in mainstream cinema and continued to incorporate elements of *minjung* art and theatre in his subsequent films: *Children of Darkness Part I* (1981), *Gwabu-chum/Widow Dance* (1983) and *Baboseon-eon /Declaration of Fools* (1983). He reverted to more mainstream commercial film-making afterwards; however, these films can be considered as precursor to the New Wave. Many of the New Wave film-makers were strongly influenced by Lee's social realist films.

Social realism is nothing new in South Korean cinema. It was the main aesthetic thread that flourished in the 1960s' Golden Age of Korean Cinema with such films as *Obaltan/ Aimless Bullet* (Yu Hyung-mok, 1960) and *Mabu/A Coachman* (Kang Dae-jin, 1961). However, this tradition of strong social realist aesthetics was killed off during the 1970s when the military government tightened their grip on film censorship. In the 1970s and 1980s, censorship was lenient on sexual explicitness but extremely harsh on political issues, allowing no social criticism. Hence mainstream cinema before the New Wave mainly consisted of soft pornographic, erotic movies such as the *Aema Buin/Madame Aema* series, which continued throughout the 1980s, as well as light comedies and action films. And it was this escapist cinema that the New Wave film-makers aimed to replace with new, socially-conscious films. The Korean New Wave was, above all, a revival of realism depicting the harsh realities and daily struggles of the ordinary people.

The year 1987 marks a crucial turning point in the history of *minjung* movement. A nationwide, massive anti-dictatorship and democratic struggle continued for twenty days, 10-29 June. It was ignited by the deaths of two college students: one died under police torture and the other from splinters of a tear-gas bomb during a street

demonstration. It was such a massive demonstration, the government had no choice but to accept the people's demand for a constitutional amendment allowing for direct Presidential election. This achievement stimulated other social movements, especially labour strikes and struggles by peasants and urban poor. In this climate, *minjung* literature, art, and theatre increasingly dealt with the issues of labourers, peasants and urban poor, and mainstream cinema also began to pay attention to these issues.

A year later, in 1988, young film-maker Park Kwang-su released his first feature, *Chilsu and Mansu*, which signalled the start of a more socially-conscious cinema and the emergence of a new generation of film-makers in mainstream cinema. Based on a Taiwanese novel, *Chilsu and Mansu* was actually a screen adaptation of a successful stage play performed by a theatre troupe actively involved in the *minjung* cultural movement. The film tells a story of two young working class men, Chilsu and Mansu, trying to make ends meet as billboard painters in the bustling city of Seoul. Shot on location, the film had a documentary-like quality and realistically portrayed the ills of capitalism through the perspective of the two poor and struggling painters. The film also touches upon such sensitive ideological issues as long-term political prisoners. The film pushed the limits of political censorship; however, it passed the censors thanks to the celebratory mood of the Seoul Olympic Games. Park went on to make socially-conscious films like *Guedeuldo Ulicheoleom/Black Republic* (1990), *Beleullin lipoteu/Berlin Report* (1991), *Geu seom-e gago sipda/To the Starry Island* (1993), and *A Single Spark* (1995) and became the central figure of the Korean New Wave.

In 1988, another young film-maker came onto the scene. Jang Sun-woo's second feature, *Seong-gong Sidae/The Age of Success*, presented the harsh realities of capitalist greed for money in a satirical fashion. It received some criticism for its compromise with conventions of commercial film-making; however, it showed a new possibility of commercial cinema to realistically depict the lived experience of the *minjung*. His subsequent films – *Umugbaemi-ui salang/A Short Love Affair* (1990), *Gyeogmajang ganeun gil/The Road to Race Track* (1991), *Hwa-eomgyeong/The Avatamska sutra* (1993) and *Neo-ege naleul bonaenda/To You From Me* (1994) – explored the contradictions in Korean society from the perspective of social outsiders.

Park Jong-won made his debut in 1989 with *Guro Arirang*, a realist drama of four women textile labourers. The film is a realist depiction of the inhumane conditions of women labourers and their struggles and, as such, suffered severe cutting by the censors. Lee Myung-se's first feature film *Gaegeumaen/Gagman* (1988) is a black comedy that pokes fun at Korean society in an indirect way.

These young film-makers belong to a postwar generation born in the mid- to late 1950s. Free from direct experience of the Korean War (1950-53), they spent their college days under harsh military dictatorship in the 1970s. Most of them were involved in the student- and/or *minjung* cultural movement. Park Kwang-su was an active member of Yallaseong film club while attending Seoul National University; Jang Sun-woo was a student activist and film critic and was involved in the *minjung* cultural movement through theatre before becoming a film director. However, all of them chose to work within the mainstream commercial industry and tried to revive the lost tradition of social realism or critical realism.

The Independent documentary movement started in the early 1980s with the establishment of Seoul Cine Group or Seoul Filmic Group in 1982. They were working completely outside the system and made short films and videos of antigovernment themes and documented labour strikes and other protests. They refused to abide by the censorship rules and organized clandestine guerrilla screenings. Fiction films were also produced, such as *O! Ggum-ui nara/O Dream Land* (1989), considered the first anti-American film, and *Paeop Jeonya/The Night Before Strike* (1990), a politically-radical film depicting labourers organizing labour unions and strikes. The film offered a perfect

example of *minjung* cinema. The Seoul Cine Group also developed their own theories of the 'new' cinema they aspired to create by publishing four volumes of the journal *Yeolin Youngwha/Open Cinema* between 1984 and 1986.

The Korean New Wave cinema was a reaction against the escapism of the mainstream Korean cinema of the 1970s and 1980s. Influenced by the *minjung* social and cultural movements, the New Wave film-makers tried to directly reflect social realities in their films. The ultimate goal of the Korean New Wave film-makers was to revive the tradition of social realism in South Korean cinema and to use the medium of cinema for social changes and for raising *minjung* consciousness.

Nam Lee

A Petal

Kkoch-ip

Studio/Distributor:
Mirasin Korea

Director:
Jang Sun-woo

Producer:
Park Keon-seop

Screenwriters:
Jang Moon-il, Jang Sun-woo

Cinematographer:
You Young-gill

Art Directors:
Park Si-jong, O Hyeong-seok

Composer:
Won Il

Editor:
Kim Yang-il

Duration:
89 minutes

Genre:
Drama

Cast:
Lee Jung-hyun, Moon
Sung-keun, Sul Kyung-gu,
Park Chol-min, Choo Sang-mee,
Park Choong-seon.

Year:
1996

Synopsis

A 15-year-old suffering severe psychological trauma from the events of the Gwangju Massacre in May of 1980 runs from the small city. She attaches herself to a poor manual labourer who she thinks is her older brother. With her blank eyes and obvious pain and sadness, she frustrates the worker. He sexually and physically abuses her in an attempt to drive her away but she stays, too traumatized to deal with reality. Gradually a strange relationship builds between this disabled angry man, and the broken young girl. Slowly she is able to confront her traumatic past. At the same time, four friends of her brother are searching for the missing girl and have no idea where to find her. As they travel around the country searching, they run into many people who are affected by the political violence the defined the era.

Critique

The Gwangju Massacre is one of the most pivotal moments in South Korean history. From 18-27 May 1980, student protestors clashed with police and troops. During this time officially 144 civilians were killed, although unofficial estimates put the number closer to 2,000. This served to increase the fervency of the democratic movement against Chun Doo-hwan, and was also a moment in which anti-Americanism exploded. The US had to approve troop movements in South Korea, and the massacre showed the *minjung* movement that the US was more interested in making deals with dictators than helping establish true democracy in Korea. The movie had taken Jang Sun-woo 15 years to make, as the incident was full of controversy. However, in 1995, both Chun Doo-hwan and Roh Tae-woo were tried for treason and conspiracy under the recently passed "Special Act on 5–18 Democratization Movement" by Kim Young-sam, South Korea's first civilian president. Gwangju was in the public consciousness and on their television screen as one of the central events of the drama *Mo-rae-shi-gae/Sandglass* (1995), in my opinion the best and most important television drama in Korean history.

Jang's film, though, is something far more primal, violent and strangely beautiful. The girl wanders through the story like a phantom and, in her red dress against the drab backgrounds, she resembles a wound that will not heal. Jang himself has referred to the film as a *ssitkkim-gut*, a shamanist ritual meant to heal the soul. Not content to tell a story about the incident in an easily-swallowed melodrama, much in the way the recent hit *Hwa-ryeo-han Hyoo-ga/May 18th* (Kim Ji-hoom, 2007) did. Instead the pain, confusion and hurt caused by the event are used by Jang in this film like a weapon. The editing is jarring at points, and he mixes in horrific nightmarish animation along with black-and-white flashbacks to the event. Opening with documentary footage of the massacre, while a Korean pop song plays over the horrific images of institutional brutality, we segue into footage of Lee Jung-hyun singing the same song, with no idea of how badly her innocence is going to get shattered.

Lee's performance is astonishing and raw. Only 16 at the time of filming, the depth that she puts into this role would challenge even the most accomplished actress. Her treatment at the hands of the man, played by Moon Sung-keun, is horrific and does not make for easy viewing. Like many of Jang's works, this stark and violent sexuality stand outs, but the use of rape is more complex than the simple 'woman's body as a symbol for the nation' motif that plays out in much of Korean cinema. There is true trauma here on the parts of both parties and a healing that must be attempted. The *ssitkkim-gut* that Jang is attempting to perform on the nation through cinema necessitates forcing Korea to confront these images and its own history and not to bury it, not to forget the phantasm of a girl. This is done through the final flashback, which stands as one of the most intense and horrific scenes in Korean film history. Even having seen it several times, it still manages to make me feel angry, upset, and uncomfortable. This is Jang's method; his films are important because they force you to feel these things and separate you from the comfort that is normally afforded the audience. This is a film, like history, in which the characters and narrative is denied a catharsis. Coming at the end of the Korean New Wave, right before Chungmuro became more concerned with box office and star power, as well as the national narrative of *hallyu*, Jang's film is a reminder of the political and historical power cinema has. It is unfortunate that this film remains one of his hardest to see, as it is his best work and, perhaps, the most powerful film of the New Wave.

Rufus L de Rham

A Single Spark

Aleumda-un cheongnyeon Jeon Taeil

Studio/Distributor:
Age of Planning

Director:
Park Kwang-su

Producer:
Yoo In-taek

Screenwriters:
Lee Chang-dong, Kim Jeong-whan, Yi Hyo-in, Hur Jin-ho, Park Kwang-su

Cinematographer:
You Young-gill

Synopsis

Kim Young-soo is a college graduate on the run in 1975 from police, who are after him for his involvement in the democratization movement. He is obsessed with the death of Chun Tae-il, a political activist who burned himself to death five years earlier in protest against the abysmal conditions that textile workers were forced to work in. As he meets with Chun's friends and family, Chun's life is revealed from his beginning as a worker himself, through his political awakening, and finally his death, which helped spark the flames of the democratic movement. Kim's own reasons for writing the biography are also revealed, as he sneaks furtive meetings with his pregnant wife.

Critique

Park Kwang-su's debut film *Chilsu wa Mansu/Chilsu and Mansu* (1988) is a pivotal film in the Korean film industry as it is one of the first films to enjoy greater freedom of expression after the tight censorship of the late 1970s and early 1980s. He would go on to become one of the most politically-minded directors of the Korean New Wave, and would inspire many directors to push the

Art Director:

Ju Byung-do

Composer:

Song Hong-seop

Editor:

Kim Yang-il

Duration:

92 minutes

Genre:

Biography/drama

Cast:

Moon Sung-keun, Hong Kyung-in, Kim Seong-jai, Lee Joo-sil

Year:

1995

boundaries and use cinema to criticize and analyse Korean culture. *A Single Spark* would be Park's most commercially successful work, largely due to the topic. Chun Tae-il was a major figurehead in the democratic movements during the 1970s and 1980s who exposed the conditions at the sweatshops in Seoul, such as the rampant tuberculosis due to lack of ventilation and the use of amphetamines to force workers to work longer hours with no overtime pay. Chun's self-immolation became one of the most famous images in the fight for labour rights and, years later, would become one of the most indelible images to come out of Korean cinema.

Park structures the film so that Chun's life is revealed in a linear way as Kim discovers more about his subject. The scenes in 1975 are all shot in full colour, while the sequences concerning Chun in are shot in stark and beautiful black and white. Cinematographer You Young-gill had a long career that included many Korean New Wave films including *Gyeongmajang ganeun gil/The Road to the Race Track*, *Kkoch-ip/A Petal*, *Chologmulgogi/Green Fish*, *Geu seom-e gago sipda/To the Starry Island*, and *Ha-yanjeonjaeng/White Badge*. A long-time collaborator with director Park, You's skills are on full display here and, despite the horrible conditions they depict, the film is one of the best-looking films of the era. The juxtaposition of Chun's political awakening and Kim's underground intellectual on the run from the police serves to drive home the point that nothing much had changed in the five years since Chun's death. Indeed, historically speaking, it would get much worse before it got better. As Kim interviews people we see police chasing after student demonstrators, but the hope here is that if Chun is not forgotten his struggle would continue.

Moon Sung-keun as Kim is well contrasted to Hong Kyun-in (playing Chun). Kim is an intellectual pursuing a working-class hero and Moon portrays him as a literary figure whose political identity is based more in philosophy than practical activity. Hong gives Chun the youthful fervour of someone discovering just how cruel and unfair the rule really is and struggling against it. It is a much more physical and elemental role than the character of Kim, who is portrayed usually with pen, paper or books. Chun is portrayed as a commanding figure in touch with the earth (a sequence where he lies in an open grave as water pours in is beautiful) and, of course, fire. My one criticism is that the literary script by Lee does not always work in portraying in a natural way the the conditions of the workers and Chun's fight against them. Often this journey feels too compressed, but this is a result of the film focusing on two characters instead of one. It is also the result of intellectuals attempting to understand the working class; an alliance that was necessary during the democratization process in Korea but also an alliance that would not last. In a time when the Korean labour movement is still fighting against the government and people around the world are struggling for independence, this film still serves as a mirror for us to ask ourselves how much has really changed and what have we forgotten.

Rufus L de Rham

Black Republic

Guedeuldo ulicheoleom

Studio/Distributor:

Dong A Exports Co. Ltd

Director:

Park Kwang-su

Producer:

Lee Woo-suk

Screenwriters:

Yun Dae-seong, Kim Sung-su
& Park Kwang-su

Cinematographer:

You Young-gil

Art Director:

Do Yong-u

Composer:

Kim Soo-chul

Editor:

Kim Hyeon

Duration:

100 minutes

Genre:

Drama/society

Cast:

Moon Sung-keun, Park Joong-
hoon, Shim Hye-jin, Park
Gyu-chae, Lee Ill-woong, Yang
Jin-yeong, Kim Min-hee, Kim
Kyung-ran & Cho Ju-mi.

Year:

1990

Synopsis

Tae-yun is a student activist wanted by the government for leading demonstrations. To escape inevitable imprisonment, he heads to rural Korea and searches for work in one of the declining coalmines where he can blend in as a worker. Under a false name, Kim Ki-young, he ends up working at a small briquette company. As he tries to remain inconspicuous, he begins a friendship with Tae-shik, a young boy whose father is in prison for leading a demonstration, while his mother has run away. He also meets a tea-room waitress, Yongsuk, who develops a romantic attachment to him. Meanwhile, Songchol, pursued by hatred towards his father following the aban-donment of his mother, indulges in alcohol and women, including Yongsuk. Yongsuk, unhappy with her fruitless life as a waitress and prostitute, decides that she wants to run away with Tae-yun and so they agree to leave the village together. Songchol, however, has other ideas. In the meantime, Tae-yun cleverly fools the police about his real identity after he gets into a brawl with Songchuo, in order to protect Yongsuk, but it is not long before they discover who he really is, and then begin a frantic search for him.

Critique

Black Republic was made at the height of the Korean New Wave and Park Kwang-su was one of the leaders of this movement making a number of films during this period.

In terms of style, *Black Republic* is typically characteristic of films from this movement as it adheres to the realist conventions found in the Italian neo-realist movement, so there is an abundant use of the long-shot, hand-held camera techniques, and the limited use of editing. Take, for example, a scene when Songchol hits Yong-suk, and then Tae-yun joins in, in an effort to save Yongsuk from any physical harm. This kind of scene would often use a number of different shots and angles, but Park limits it to a very few, which provides the scene with greater authenticity – it feels less polished, but reflects the grittiness of the film, and is thus characteristic of the dark period which it depicts. Interestingly, in adhering to its documentary approach, Park also includes newspaper cuttings and TV news broadcasts in order to give the film a historical context. One broadcast documents the formation of the National Council of Korean trade unions in 1990.

In taking a closer look at the film's characters, the main character, Tae-yun, wonderfully acted by Moon Sung-keun, is an intellectual on the run from the authorities and, as he works and mingles with the working class, he meets people with a common aim – a vision for a democratic movement – and hence the Korean title, which translates as: 'Them, like us'. Tae-yun's interaction with the masses allows him to see the reality that, perhaps, many intellectuals had failed to acknowledge – the realities of the working class. This is, arguably, what makes *Black Republic* so poignant and, indeed, effective. Park was making the point that intellectuals missed the

needs of the masses and, in order to drive social change, they needed to acknowledge the realities of the lower class.

In accordance with so many of Park's films, the film's main characters represent a part of Korean society that was in need of social and political change. While Tae-yun, as we have seen, represents the student activist, Songchol signifies the other side of the political spectrum – the greedy capitalist characterized by his materialist values and a ruthless personality towards those around him. Yongsuk, meanwhile, is characteristic of the victim who, despite her best wishes, cannot escape the brutal system she entered, as illustrated in her failure to run off with Tae-yun.

Black Republic is not interested in entertaining its viewers; rather, Park's films of this period demand more thought than casual, passive viewing. Its audience are almost thrown into this world, and encouraged to engage with it as we seek its flaws. In line with this conviction to stir participation amongst its viewers, the film ends through narration as Park asks the viewers of the day to be part of tomorrow's society rather than to merely spectate. While the film probably has less political and social relevance today, Park's uncompromising approach to film-making, as *Black Republic* demonstrates, is both inspiring and unforgettable.

Jason Bechervaise

Chilsu and Mansu

Chil-su wa Man-su

Studio/Distributor:
Dong-A Exports Co. Ltd

Director:
Park Kwang-su

Producer:
Lee Woo-suk

Screenwriter:
Choe In-seok

Cinematographer:
You Young-gil

Art Director:
Lee Myoung-soo

Editor:
Kim Hyeon

Synopsis

Chilsu and Mansu are two working-class men struggling to make ends meet as billboard painters in the bustling yet repressive city of Seoul. The two team up to find temporary work when Chilsu walks away in defiance from his previous job after a confrontation with his boss. Chilsu dates a college girl pretending to be an art student and fantasizes about going to America. However, as a son of a houseboy/pimp for American soldiers in Korea, he has no hopes of achieving either the girl or his American dream. Mansu, although a talented painter, also has a family background that prevents him from getting a proper job under the current government's anti-communist paranoia: his father is a long-term political prisoner whose refusal to convert from communist beliefs costs Mansu a job offer abroad, among other things. On a hot summer day, the two guys decide to take a break from painting a beer ad atop a high-rise building. After a few drinks of *soju* the two begin to yell out their pent-up frustrations; however, their actions are misunderstood by a policeman and events take an unexpected turn.

Critique

Park Kwang-su's debut feature film marks the beginning of the Korean New Wave cinema. Park borrows the story of the two painters from a Taiwanese writer Huang Chunming's novel *The Two Sign Painters* and adapts it to the social and political conditions of Seoul in 1988, the year of Seoul Summer Olympics. By realistically

Duration:

108 minutes

Genre:

Drama

Cast:

Ahn Sung-ki, Park Joong-hoon, Bae Jong-ok

Year:

1988

depicting the troublesome lives of two marginalized working-class men, the film brings back the lost tradition of social realism to Korean mainstream cinema while satirically criticizing the absurd contradictions in Korean society.

The most prominent attributes of the Korean New Wave is its acute sense of social issues. In *Chilsu and Mansu*, Park not only portrays the sufferings of the lower-class young men but also high-lights the presence of the US Army and the ideological paranoia of the South Korean government of the time. The three social issues are intertwined in the characters of Chilsu (Park Joong-hoon) and Mansu (Ahn Sung-ki) because their hopeless lives are directly related to the social or political situation of their family, especially their fathers.

Chilsu's father worked as a houseboy at a US Army Camp near Seoul and he also worked as a pimp for the GIs. Ashamed of his father and his family background, Chilsu dreams of escaping to America and waits in vain for his sister's invitation letter from the US. Mansu, on the other hand, is having difficulty in finding decent jobs because of his father's ideological convictions. His father is a leftist prisoner who has been imprisoned for the past 27 years because he refuses to disavow his political beliefs. Mansu is offered a job working on a construction site in the Middle East but he cannot leave the country because of his father's background. As a nation divided by ideology, South Korea practised severe anti-communism, which included a guilt-by-association system affecting those who had families and relatives with leftist track records.

Although the censorship of the military regime had slackened a little in 1988 before the Seoul Olympics because of the world-wide attention that was placed on South Korea, bringing up the ideological issue was still a risky endeavour. *Chilsu and Mansu* is a significant film in the history of Korean cinema because it critiques the oppressive political system as well as economic inequality and social injustices in a straightforward fashion. In this respect, the film was in tune with the *minjung* social movement of the 1980s, a period of great political and social changes. After the Gwangju Massacre by the military regime in 1980, social movement for democracy intensified and finally achieved a civil government in 1993. In cinema, the 1970s and 1980s were a politically-dark period in which no social critique was allowed in film. Erotic films and light action films or comedy films dominated mainstream cinema. Thus, the virtue of social realism that characterized the 1960s' Golden Age of Korean cinema was lost and forgotten. It is *Chilsu and Mansu* that re-ignited young film-makers' passion for realism.

Not only in its subject matter but also in its style, *Chilsu and Mansu* goes against the conventions of mainstream cinema to create an alternative film language. The conventional shot/reverse shot is restrained and the narrative does not have a clear closure at the end. Also, as a realist film, most of the film is shot on location in a documentary manner. Furthermore, in the last scenes, Park

Chilsu and Mansu, 1988, Dong A Exports Co., Ltd

allows Chilsu and Mansu to shout their frustration, thus giving a voice to the marginalized class, which was very rare in the mainstream commercial cinema of the time.

Nam Lee

Declaration of Fools (aka Declaration of Idiot)

Baboseon-eon

Studio/Distributor:
Hwa Chun Trading Co., Ltd

Director:
Lee Jang-ho

Producer:
Park Chong-chan

Screenwriter:
Yun Si-mon

Synopsis

Framed as a fairy tale narrated by a child, *Declaration of Fools* tells a story of Ttong-chil, a crippled pickpocket, as he makes an aimless journey across South Korea accompanied by a taxi driver and a prostitute. The three met when Ttong-chil spotted Hye-young in a university village, fell in love with her, thinking she is a college student, and then tried to abduct her with the help of taxi driver Yuk-duk. The abduction fails and they discover that Hye-young is actually a prostitute. They form a family-like bond as they travel to find work and pursue seemingly-unattainable dreams of a comfortable, happy life. However, their camaraderie comes to an end when Hye-young decides to leave on her own in pursuit of her dream. Later they run into each other again at a fancy upper-class party: Hye-young with her rich partner; Ttong-chil and Yuk-duk as the serving waiters. When her prostitute past is revealed by one of the party guests, Hye-young is humiliated and assaulted by a group of rich men to the point of torture. Infuriated and indignant, Ttong-chil and Yuk-duk rise up to fight for her. Will they be able to rescue her?

Cinematographer:

Seo Jeong-min

Editor:

Kim Hee-su

Duration:

97 minutes

Genre:

Drama

Cast:

Lee Bo-hee, Kim Myung-kon, Lee Hee-sung

Year:

1983

Critique

It is ironic that *Declaration of Fools*, one of Korea's most inventive and experimental films of the 1980s, was a product of the director Lee Jang-ho's complete desolation and self-abandonment. Making the film under a highly repressive military dictatorship and its outrageous censorship, the director filmed it in just the opposite way to what he would normally do. It was a film that completely defied all the conventional rules of mainstream cinema.

Lee filmed it without a pre-written scenario and relied heavily on actors' improvisation. The film has very little dialogue; the first dialogue only comes in 42 minutes into the film. The soundtrack mixes diverse music and sound effects: from electronic video game sounds to Korean traditional farmer's music. In fact, *Declaration of Fools* occupies a unique place in Korean film history because it is one of the first films to incorporate *minjung* art both in its subject matter and its style.

In its subject matter, the film especially highlights the differences between the privileged class and the *minjung* in the party scene, in which Ttong-chil (Kim Myung-kon) and Yuk-duk (Lee Hee-sung) witness the brutality of the rich men torturing Hye-young (Lee Bo-hee) and finally rise up against them. In this particular scene, the rich men are represented with western clothes and music while Ttong-chil and Yuk-duk are represented with traditional farmer's music. In fact, many prominent artists of *minjung* theatre and dance movement, such as Im Chin-taek, Kim Myung-kon and Kim Kyong-nan, collaborated with Lee's film-making. Also, the film was loosely based on a novel, *Children of Darkness* (1980), which depicted in raw language the lives of marginalized people living in slums.

The film is a comedy that combines satire and slapstick gags. However, what is more interesting about the film is the fact that its narrative structure resembles that of *madang-kuk* (open-court play), a modernized version of the Korean traditional *talchum* (mask-dance) that is known for its revolutionary aesthetics. The open structure of the mask-dance theatre, as opposed to a linear narrative structure, and the incorporation of shamanic ritual are two of the crucial elements of *madang-kuk* that Lee uses. The film takes the form of a road movie, however, it unfolds in disjointed episodes and relies heavily on coincidences, and follows the way madang-kuk is organized: the protagonist (Ttong-chil) is introduced walking/dancing towards the audience followed by other characters who represent the oppressed (*minjung*); their dreams are told to the audience through scenes of the characters' imagination; then there is a confrontation with the oppressors (the rich men); the *minjung* fights and wins; they perform the ritual for the dead; and finally they achieve a sense of awakening.

Declaration of Fools is unique in that it provides an excellent example of a film in which the *minjung* aesthetic currents of the time, especially that of *madang kŭk*, are translated into a new cinematic language. The cinematic experiments of incorporating the aesthetics and subversive nature of the *minjung* theatre and dance served as a major inspiration for the new generation of film

directors, such as Park Kwang-su, Jang Sun-woo and Park Chong-won, who emerged in the late 1980s and led the rise of the Korean New Wave cinema.

Nam Lee

Potato

Gamja

Studio/Distributor:
Dae Jong Film Co. Ltd.

Director:
Byun Jang-ho

Producer:
Byun Jang-ho

Screenwriters:
Kim Ha-rim, Na Han-bong,
Lee Hee-woo, Hong Jong-won

Cinematographer:
Jung Il-sung

Art Director:
Lee Myoung-soo

Composer:
Lee Cheol-hyeok

Editor:
Park Soon-duk

Duration:
112 minutes

Genre:
Drama

Cast:
Kang Soo-yeon, Kim In-moon,
Lee Dae-keun, Kim Hyeong-ja,
Choe In-suk

Year:
1987

Synopsis

For years, Bok-nyeo had watched her parents try to scratch a living from the land while raising a family, but it was an endless and futile struggle. Unable to provide for themselves and their children, her parents decide to sell their eldest daughter off for a handful of coins. Bok-nyeo goes with her owner and is forced not only to care for him and his home while earning money for food but also to satisfy his every need. Failure in any of these areas results in a beating. Bok-nyeo works hard, as do all the women in the remote, mountain village where she was taken, but one woman, Durene, seems to be better off than all the rest despite doing the least amount of work. Spying on her, Bok-nyeo learns that Durene is providing sexual favours to the supervisor and thus earning extra pay. After being raped by the same supervisor and paid by the callous overseer for 'services provided', Bok-nyeo resolves that she will never go hungry. She also knows that she never need be the victim again.

Critique

The 1987 version of *Potato* is a near scene-for-scene remake of a movie with the same name made in 1968 and directed by Kim Seung-ok and both films were based on a now-classic novel written by Kim Dong-in in 1925. Like many of Kim's novels, the story follows the ebb and flow of fortune as the main character Bok-nyeo rises out of desperate poverty to be the wealthiest woman in the village, only to lose everything through a careless miscalculation. Ironically, Kim would suffer a similar change of fortune later in his life. Born into a rich family, Kim would squander his family fortune by 1930 partly due to a drug addiction and, later still, would work his way back to respectability.

The rise and fall of Bok-nyeo is fascinating to watch, particularly in the 1987 version. The reason is largely credited to Kang Soo-yeon and the subtleties she brings to the character. Although poor as dirt, Kang provides the heroine a sense of dignity that none of the other women in the movie come close to imitating. Most of the villagers are quite crude in their dialogue and behaviour and Durene, Bok-nyeo's chief rival, has a much harder edge. She appears to be sleeping with the supervisors out of lust and for the clothes and vanities their money buys. Bok-nyeo is simply doing it for the money, which she perceives as power and freedom from drudgery. There is an unforgettable scene earlier in the film where Bok-nyeo holds up the coins she was paid as compensation for the rape she experienced and there is a palpable change in her expression. A glint comes into her eyes as she realizes she is holding

more money in her hand than her parents sold her for. With that realization comes the knowledge that she can get what she wants through selling her body.

The 1968 version of *Potato* was far tamer than the remake because of restrictions and the obscenity laws the government had in place for the film industry at the time it was made. It was necessary that all sex scenes were implied, albeit strongly, rather than shown. Otherwise, the only other difference was a change of jobs for Bok-nyeo when she first learns about the arrangement between Durene and the supervisor. In the original film, Bok-nyeo and the women of the village are picking caterpillars out of fruit trees. In the remake, she is employed in harvesting salt from a marsh along the sea: a much more taxing, but far less disgusting job.

The women in this film always appear to be working while the men do very little. This was a trend of many Korean authors in the 1920/1930s who wished to realistically depict the suffering of women during the Colonial Era. Thus there are images of women working the salt flats while the men watch, women washing clothes while the men beg and women harvesting while the men mind shops or drink. This theme fits very well with the main focus of most Korean melodramas, historical dramas and horror films in the 1960s, 1970s and 1980s which held the suffering of women, emotional or physical, as central to the story.

Tom Giammarco

The Man With Three Coffins

Nageuneneun gil-e-seodo swiji An-neunda

Studio/Distributor:
Pan Films Co. Ltd.

Director:
Lee Jang-ho

Producer:
Lee Jang-ho

Screenwriter:
Lee Jang-ho

Cinematographer:
Park Seung-bae

Art Directors:
Sin Cheol, Wang Suk-yeong

Synopsis

A man travels to the DMZ (Demilitarized Zone) to scatter the ashes of his wife, hoping to be able to do so close to her hometown. Along the way he is burdened further by the death of two women that cross his path. Paralleling this journey, a nurse attempts to escort a dying chairman to his hometown located somewhere either north or south of the DMZ. Henchmen sent by the Chairman's son to prevent the news of the journey getting out are pursuing her. The two travellers move in and out of each other's journey along the frozen winter roads of Korea, drawn to each other through karmic destiny.

Critique

The Man with Three Coffins is based on the short story by Lee Je-ha titled 'Travellers Do Not Rest on the Road' and is a difficult film to parse as it is rooted in Korea's Buddhist and Shamanistic traditions. The story itself is structured in such a way that it resembles memories more than a traditional narrative. Scenes flow from one to another through time, and the episodic nature of a road movie only enhances this storytelling method. At its heart it is an intensely personal deconstruction of Korea's most unique feature: its forced existence as a divided nation that is still at war with itself. The

Composers:

Kim Byeong-su, Yang Dae-ho

Editor:

Hyeon Dong-chun

Duration:

117 minutes

Genre:

Drama

Cast:

Lee Bo-hee, Kim Myung-kon, Ko Seol-bong, Chu Seok-yang

Year:

1987

wounds that this leaves are all over this film, especially in the old bedridden man that the nurse struggles to bring home. Like the mother in *Obaltan/The Aimless Bullet*, the man was born in the north, but is bedridden and physically unable to make the journey home. This physical lack mirrors the political impossibility of reunification and his journey is destined to be unfulfilled. His son, a man with political ambition, cannot hope to survive in the division culture if his father is allowed to continue his journey. The division of the nation divides both the phantasmal family that exists only in memory, and the current family that is dysfunctional and attempting to survive in the brutal political field of South Korea.

Lee Bo-hee, who acted in several of Director Jang's films, is surrealistically given three roles to play: the nurse, the deceased wife, and a young prostitute who dies after sleeping with the man. She is destined, as we are reminded by voice-over, to meet her past-life husband along the river, carrying three coffins. These three coffins are figurative, of course, as he is only carrying the small box containing the ashes of his wife. Though, through karma, the two women he sleeps with during his journey north die in ways related to his wife's life and death. Both the casting of Lee as three women and the constant intrusion into the diegetic space by images and sound of the shaman's body and traditional bells serve to underline the karmic fate of reunification between the nurse and the man.

This is the crux of the story: going home, which, in a nation divided, cannot be separated from the desire for reunification. This desire cannot, of course, be fulfilled. For when a relationship cannot be completed if so destined through karma under the division culture, how can the desire to return home to the north ever be? The old man clutches his own talisman, a photograph of his family in the north, as his last hope of return to something that he is physically forced to leave behind, as his dream of returning is denied by their pursuers, themselves representative of South Korean politics through their relation to the old man's son. Lee Jang-ho paints a stark, yet beautiful, portrait of a nation divided. The continual return to Shamanism, a belief that goes back to ancient Korea and predates both colonialism and division, anchors the desire for reunion to the spiritual or mythical. The last sequence in the film involving a *mudang* (shaman) performing a *kut* is haunting and beautiful, but gives no real hope for future reunification either. This film remains very difficult to find, which is a shame as its complex breakdown of the division culture through spiritual and personal relationships deserves a wider audience. Director Lee's career ended after his last several films failed at the box office, but he was always pushing stylistic and narrative boundaries and with luck will be rediscovered by a new generation of cinephiles.

Rufus L de Rham

The Power of Kangwon Province

Kangwondo ui Him

Studio/Distributor:
Mirashin Korea

Director:
Hong Sang-soo

Producers:
Ahn Byeung-ju, Kim Su-jin

Screenwriter:
Hong Sang-soo

Cinematographer:
Kim Young-chul

Composer:
Won Il

Editor:
Hamg Sung-won

Duration:
108 minutes

Genre:
Drama

Cast:
Baek Jong-Hak, Oh Yun-Hong, Jeon Jae-Hyun, Kim Yu

Year:
1998

Synopsis

This film is divided into two parts. The first part begins with a tired-looking young woman, Ji-suk, standing on an overcrowded night train with her two female friends heading to a famous mountain resort, Kangneung, in Kangwon Province. Ji-suk has joined her friends to emotionally recover from her recent break-up with a married man but, in the resort, she meets another married man and ends up spending a night with him. This new affair does not go any further, however, since she is still trying to get over her former lover, Sang-kwon. The second part focuses on Sang-kwon, an indecisive part-time college teacher in his late thirties. A friend's suggestion to take a short trip to Kangneung comes at just the right moment, when he is desperately looking to escape from the bitter conclusion of his relationship with Ji-suk. After a very boring sightseeing excursion, Sang-kwon gets drunk and has reluctant and unsatisfying sex with a prostitute. Although Sang-kwon and Ji-suk happen to be on the same train and in the same resort, neither realizes the fact. A few months later, they meet again only to confirm the irreconcilable distance that divides them.

Critique

Hong Sang-soo quickly became one of the most important directors in South Korea with the release of his full-length low-budget debut work, *Dwaejiga umule ppajinnal/The Day a Pig Fell into the Well* (1996), which created a sensation with its brutally detached and pessimistic depiction of heterosexual relationships. *The Power of Kangwon Province*, Hong's second film, was invited to the 1998 Cannes Film Festival, where it won a 'Special Mention' for its equally objective portrayal of human entanglements that captures the essence of suffering in the embarrassingly-banal and honest filmic language Hong has mastered. Although each part supposedly renders the painful breakup from a woman's and a man's point of view, the monotonous ambience and casual dialogue does not create sympathy or convey the inner psychology of the characters, nor do the snapshots of episodic events seem pertinent to the couple's state of mind. Yet the seemingly-random episodes connect the couple in mysterious ways: Sang-kwon has his eyes on 'a woman with pretty eyes' when crossing a bridge, while Ji-suk passes the woman a few moments later on the same bridge. On another occasion, Ji-suk discovers a goldfish on the mountain path (!) while Sang-kwon's fish has gone missing from the small plastic container he put aside in Seoul. In fact, a feeling of connectedness lingers from the beginning, just like the night train that transports the unsuspecting Sang-kwon and Ji-suk to the same destination.

Hong's experimental construction of stories can best be described as "narrative cubism" (Chung and Diffrient, 2007)[1] for its process of fragmenting and re-assembling reality, leaving the viewer with an ambiguous impression. The parallel perspectives create a 'not too close but not too far' kind of gap between reality and perception, mirroring the physical distance between Seoul and

Kangwon; the landscape of mountains and beaches are perhaps more realistic in tourists' imaginations or photographic images than in what we see through Sang-kwon and Ji-suk's eyes.

As Sang-kwon and Ji-suk cross paths with each other, they circle objects and events that they witness spontaneously at different times. This spontaneity, in fact, can be attributed to Hong's well-known approach to screenwriting: he distributes scripts to actors on the day of the shooting, and may change them again during the day. His casting of amateurs with almost no acting experience prior to their appearance in this film is another factor that adds a strange combination of the alien and the familiar to the screen. There is nothing glamorous about actors like Baek Jong-hak (Sang-kwon) and Oh Yun-hong (Ji-suk); they do not stand out on the screen among their friends and strangers. Instead, they move around like the other tourists in the resort, exchanging conventional words about work and love as they stroll along the beaches and drink shots of cheap alcohol, *soju*.

Kangwon province is known as a romantic getaway for city dwellers that can spare a few days to recover from their accumulated fatigue and stress. No one in the overnight train to Kangwon shows any sign of vitality, however, and it is questionable whether either Sang-kwon or Ji-suk gained any strength to start their new lives on their return to Seoul. Rather, the power of the film resides in Hong's attention to detail, where even the smallest piece of an object speaks to the uncertainty of reality and truth in a direct and honest way.

Jooyeon Rhee

Notes

1 Chung, Hye Seung and David Scott Diffrient (2007). 'Forgetting to Remember, Remembering to Forget: The Politics of Memory and Modernity in the Fractured Films of Lee Chang-dong and Hong Sang-soo,' in *Seoul Searching: Culture and Identity in Contemporary Korean Cinema*. Frances Gateward (ed). New York: State of New York University Press, p. 129.

The Road to the Race Track

Gyeongmajang ganeun gil

Studio/Distributor:
Tae Hung Films Co. Ltd

Director:
Jang Sun-woo

Synopsis

R returns to Korea after living in Paris during his PhD studies and meets with J, a younger woman, with whom he lived in Paris. R had helped J with her dissertation and he wants to continue their relationship in Korea but she refuses. Frustrated he returns home to Taegu where he has to face his mounting responsibilities to his aging parents, his wife and their daughter. Unable to let go of J, he attempts to divorce his wife and continually returns to Seoul and attempts to convince J to sleep with him.

Critique

Jang is perhaps the Korean New Wave's greatest provocateur, pushing the boundaries of what the relaxed censorship laws would

Producer:

Lee Tae-won

Screenwriters:

Ha Il-ji, Jang Sun-woo

Cinematographer:

You Young-gill

Art Director:

Kim Yu-jin

Composer:

Kim Soo-chul

Editor:

Kim Hyeon

Duration:

138 minutes

Genre:

Drama

Cast:

Kang Soo-yeon, Moon Sung-keun, Kim Bo-yeon

Year:

1991

allow and taking every freedom to criticize South Korean society. A literary adaptation from Ha Il-ji's novel, this film is a powerful early example of Jang's work, of which many are literary adaptations. It is also one of the few films of Jang's that is readily available, which is unfortunate as his work is varied and important. It is easy to see how this film inspired Hong Sang-soo, with its depiction of middle-aged intellectual sexual frustration. In many ways darker than Hong's films, it rages against pseudo-intellectualism and comes at a time when Korea is dealing with the aftermath of rapid industrialization. This coincided with public debate about moral disintegration of Korean society and Jang's stylistic choices underline the snobbish vulgarity of the intellectual elite. The camera maintains a distance from the characters, while the long takes and repetitious dialogue force the audience to truly see R and J for what they are, scared humans trying to make sense of their place in the world.

The relationship between J and R is not as passionate as the one between J and Y that Jang explores in his 1999 film *Gojitmal/Lies*, a film which shares a similar structure to this. This film is not as explicit as this, nor is it as explicit as his 1994 film *Neoege Na Reul Bonaenda/To You, from Me*, but these films all use sex to criticize morality and values of modern society. J and R's conversations are sexually explicit and their relationship is abusive both verbally and physically yet they keep cycling back for more. Their entire relationship is a cycle, repeating conversations and sometimes phrases, which serve to lay bare the base sexual needs of R while constantly denying him release to the point of physical impotency. The characters are denied names, further distancing the connection with the audience, and cementing the feeling that they are ciphers through which Jang is exploring. It is clear in the film that they have a long history, but it is one based purely on sexuality. One can imagine their conversations in Paris were as shallow as the ones they have in cafes, cars and beds all around Seoul.

This repetition, and lack of a strong plot, unfortunately makes the long running time feel a bit *too* long. The above synopsis is essentially the entire story, and the film moves from one conversation to the next, all circling the same drain. Moon Sung-keun plays R well, and there is a perverse pleasure in watching him try to convince J to sleep with him and getting progressively more and more frustrated. Moon portrays a character that is charming and reprehensible at the same time, cementing my opinion that he is one of the best actors working in Korea. However, the verbal abuse that R constantly subjects J to makes it difficult to understand why she keeps coming back. Kang Soo-yeon, who would go on to star in Hong's *Oh! Soo-jeong/Virgin Stripped Bare by her Bachelors*, plays R with impudence and she teases and pushes J. The characters are not supposed to be likeable; rather, they are clearly created to show the duplicitous, snobbish behaviour that Jang felt was rampant in modern Korean society. Both characters are intellectuals, although J's credentials are stolen directly from R's work, a fact that shackles her into the endless cycles of abuse.

R decides his responsibility to his family, which he has avoided in his years abroad, is too difficult to face and he tries anything to take the easy way out.

Rufus L de Rham

Why Has Bodhi-Dharma Left for the East?

Dalmaga dongjjok-euro gan kkadakeun?

Studio/Distributor:
Bae Yong-Kyun Production

Director:
Bae Yong-kyun

Screenwriter:
Bae Yong-kyun

Cinematographer:
Bae Yong-kyun

Composer:
Jin Gyu-yeong

Editor:
Bae Yong-kyun

Duration:
175 minutes

Genre:
Religious drama

Cast:
Lee Pan-yong, Sin Won-sop, Hwang Hae-jin, Go Su-myeong, Yun Beyong-hui

Year:
1989

Synopsis

In a remote Buddhist monastery in the mountains, Hye-gok, a zen master, teaches and cares for Ki-bong, a young man seeking enlightenment, and Hae-jin, an orphan who was brought to the monastery to become a monk. Ki-bong must overcome his materialistic desires as he cares for the aging Hye-gok, while Hae-jin must come of age and understand his first brushes with death. At the centre of these journeys are two Zen *koans*/parables: 'What is my original face before my mother and father were conceived?' and 'When the moon takes over in your heart, where does the master of my being go?', the answers to which will grant everlasting peace and freedom from earthly passions. Both Ki-bong and Hae-jin must overcome several trials in their journey towards enlightenment.

Critique

One of the most beautiful Buddhist parables ever filmed, *Why has Bodhi-Dharma Left for the East?* is also a unique film in the Korean New Wave, eschewing many of its peers' concern with social issues for the Buddhist concepts of impermanence and enlightenment. While there are other Korean films dealing with Buddhism that were well received, Im Kwon-taek's *Aje aje bara aje/Come, Come, Come Upward* (1989) and *Pobun/Mandala* (1981) for example, there is none quite as masterful, or as meditatively Buddhist as this. The only other Buddhist film that I have seen come close to this is the lovely 2006 Sri Lankan film *Sankara* directed by Prasanna Jayakody. Bae Yong-kyoon has only directed one other film, *Geomeuna ttang-e huina baegseong/The People in White* (1995), and is a painter by training: a trait obvious in the studied compositions that make up the film. A film that is entrenched in Zen Buddhism, it acts as a *koan* itself, challenging the audience and bringing us along on the journey to enlightenment with Ki-bong and Hae-jin.

This is a dense work of art that requires multiple viewings to unwrap, and may be too dense for some. It helps if you have a working knowledge of Buddhist philosophies and Zen tradition, but a strong curiosity and willingness to accept the film's stillness will reap great rewards. With images that reflect Kuòān Shīyuǎn's *Ten Ox Herding Pictures* (the famous series of pictures that depict the ten stages of a practitioners journey to enlightenment) as well as being structured around the two *koans*, this is an intensely Buddhist film, but its message of nonattachment is universal. Ki-bong, like the monks in both of Im's films, struggles with the responsibilities of the modern world that run counter to his monastic life and

vows. The ox in the film parallels Ki-bong's path to enlightenment, breaking free of its pen at the moment Ki-bong is struggling with his desire to escape, as well as his earthly attachments. Later, the ox returns with a mysterious man at its side (which may or may not be Ki-bong), signifying the acceptance of his attachments and his path toward enlightenment. My favourite sequence is one in which Hae-jin falls into the water and struggles to free himself. Splashing everywhere, he appears to be drowning and it is only when he accepts the current moment and floats that he reaches the shore safely. This floating is accompanied by Bae's careful cinematography as the water sparkles and the moment becomes a microcosm of acceptance and nonattachment.

It truly is a beautiful film, from the carefully-framed scenes of the monks meditating to the startlingly asymmetrical shots of Ki-bong in the city as he collects alms to buy medicine for Hye-gok. The use of light and colour is also carefully controlled, and it is easy to see why this film took ten years to make. Bae wields the camera, the story and the staging of his characters as brushes. The sound design, from the chirping of the bird that haunts Hae-jin to the contrast of the moktok and the cries of the vendors, also invokes our senses, drawing us further into the meditative state that the film resides in. While Hae-jin's growth from a boy into a monk and Hye-gok's preparation for his own death are fascinating, I found myself most drawn to Ki-bong's struggles. He is the character through which the audience unlocks the questions that the film poses and represents the struggle between modern material attachment

Why has Bodhi-Dharma Left for the East?, 1989, Bae Yong-kyun Productions/ Kobal Collection

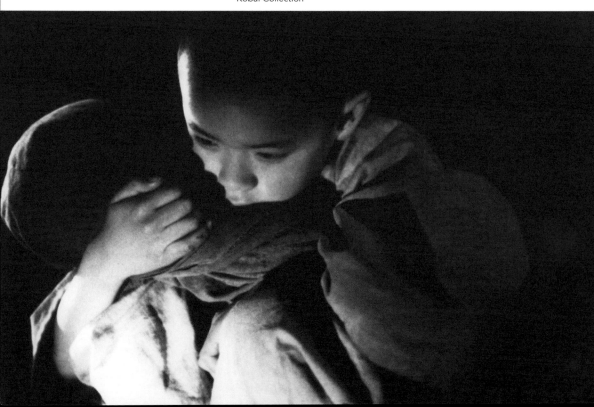

and spiritual growth that we as a society face every day. For those who think Kim Ki-duk's *Bom yeoreum gaeul gyeoul geurigo bom/ Spring, Summer, Fall, Winter and... Spring* (2003) represents Buddhism on film (it is about as Buddhist as *The Matrix* in my opinion), I urge you to see this film. It may challenge you but it is worth the struggle.

Rufus L de Rham

NEW
KOREAN
CINEMA

The term New Korean Cinema refers to the films and film-makers that emerged from Korea in the late 1990s following the Korean New Wave and represents a new era in Korean cinema, shedding many of the restraints of its authoritarian past and creating a new creative industry and community. In less than a decade, films were produced that have been the most popular films that Korea has ever produced domestically, and have taken a previously local cinema onto the world stage. While the 'old' Korean cinema remains largely unknown in the West, the 'new' Korean cinema is becoming increasingly celebrated, with festivals and distribution throughout Asia, Europe and the US and is signified by a growing fan base and academic interest.

The concept of New Korean Cinema is defined not by themes or by an ideology but through a film industry redefining and recreating itself. From a western perspective, the emergence of Korean films may have seemed to have been sudden but a series of events during the 1990s created the changes required. A national re-examination of identity, the arrival of a new generation of cinephile film-makers and the globalization of Korea's developing industries are some of the key contributions to creating the industry that emerged. The early nineties was a period of significant change in Korea – in 1993 the first democratically-elected president Kim Young-sam took office, prompting a national reassessment of the Korean sense of 'identity'. Two months after the election director Im Kwon-taek released *Seopyeonje/Sopyonje* (1993), a tale of a family of traditional pansori singers and their struggle to remain relevant in the modern world. *Sopyonje* was released on only one screen in Seoul and expected to draw only a limited interest locally and on the Festival circuit, but its release struck a chord with audiences and was seized upon as a symbolic reclaiming of Korean identity, becoming the first film with over a million admissions in Seoul alone. At this time in Korea local films accounted for a 15.9 per cent share of the market, a fairly low figure.

Aided by a presentation made by an advisory council in May 1994 which noted that the box-office receipts of *Jurassic Park* (Steven Spielberg, USA: 1993) was the equivalent of 1.5 million export sales of Hyundai cars (twice Korea's export figures at the time), the Korean government changed its attitude towards the film industry, choosing instead to actively promote it, rather than view its relationship solely as a regulator. Elsewhere

Left image: *Nowhere to Hide*, 1999, Samboo/Taewon/Kookim/Cinema Service/Kobal Collection

attitudes towards local distribution began to change. The Korean Screen Quota – a protectionist law in place since 1967 requiring theatres to show local films for 146 days of the year – had not been properly enforced since the 1980s, so a group called the Screen Quota Watchers monitored the number of days that Korean films were shown, bringing attention to theatres not fulfilling the quota. A requirement for distributors hoping to show the latest US blockbuster movies was an investment in local films, resulting in quickly-made low-budget films. Following a boom in the home video market, several major electronics companies such as Samsung and Daewoo created film divisions to finance production and the production facilities soon improved – the enforcement of the quota had emerged alongside an improvement in quality of local production facilities.

A key year for Korean cinema was 1996. The Pusan International Film Festival (PIFF) was launched, immediately assuming a role in promoting Korean cinema on the world stage. The first year included a screening of *Ag-o/Crocodile* (1996) the debut from director Kim Ki-duk, and it has proven to be invaluable in promoting new directors. Other directors who would distance themselves from the 'traditional' film industry emerged, paving the way for commercial film-makers to come. Hong Sang-soo's *Daijiga umule pajinnal/The Day a Pig Fell into the Well* (1996) marked the arrival of one of the new auteurs of Korean cinema and director Kang Je-kyu arrived with *Eunhaengnamoo/The Gingko Bed* (1996). Kang's follow up *Swiri/Shiri* (1999) would become Korea's first bona fide blockbuster smash and a symbol of the New Korean Cinema. A large-scale action movie with slick production values rarely seen outside of Hollywood, *Shiri* would become the highest-grossing Korean film in history. With a cold war plot involving the South Korean Secret Service's attempts to find a North Korean assassin – including a scene where a North Korean soldier questions the actions of the South – *Shiri* was a mainstream movie which became an event, ground-breaking in its execution and its politics.

Bridging the gap between the New Wave and the New Korean cinema, Director Lee Chang-dong emerged with *Chorok mulkogi/Green Fish* (1997) but it was his follow up *Bakha satang/Peppermint Candy* (2000) which proved the most significant – taking an unusual 'backwards' structure to tackle key moments in recent Korean history and chart their negative effects on Korean citizens. Symbolically it was released at midnight on the first day of the new millennium.

During the nineties 'cinema' became a major interest for Koreans, not limited to local films. European films (particularly French) became particularly popular and played alongside Hollywood fare. Film-based magazines, including 'Cine 21', and university film departments emerged. When Kim Jee-woon arrived as one of the earliest of the New Korean Cinema film-makers with his directorial début *Choyonghan Kajok/The Quiet Family* (1998), its combination of comedy and horror genres with blackly-satirical undertones was clearly the work of a cinephile. Kim, like many of the directors who would quickly emerge in the next few years, would continue to tackle genre cinema and become to be referred to as a 'genre auteur'. Kim's psychological horror film *Janghwa, Hongryeon/A Tale of Two Sisters* (2003) played well domestically and was distributed in the UK and US, giving Kim a strong international standing, which has continued to increase with subsequent films including the 2008 blockbuster *Joheunnom nabbeunnom isanghannom/The Good, The Bad, The Weird.*

Following the emergence of director Kim Jee-woon and the box-office clout of *Shiri*, the turn of the millennium saw debuts from several other key directors of the New Korean Cinema, all engaging in commercial genres while tackling less conventional subjects. Bong Joon-ho's debut, the blackly comic *Flandersui Gae/Barking Dogs Never Bite* in 2000 was received warmly from critics and audiences. With his sophomore effort *Salinui Chueok/Memories of Murder* (2003), Bong sharpened his observations and wry sense of humour, recreating a police investigation of a real-life serial killer case to examine its effect on the local community. Acclaimed by critics and audiences

alike, *Memories* established Bong at the forefront of the New Korean directors, a position he has maintained with the films that have followed – *Gwoemul/The Host* (2006) and *Madeo/Mother* (2009). Contrasting with Bong Joon-ho's genre-subverting output, director Ryoo Seung-wan arrived to great acclaim with his independent feature *Jukgeona hokeun nabbeugeona/Die Bad* (2000). Korea's foremost action director, Ryoo's films are inspired by seventies Korean and Hong Kong action cinema. Unlike Hong Kong or Japan, the New Korean Cinema has only produced a few 'martial arts' action films; those that have been made are inspired as much by the trend in Hollywood films as 'old school' martial arts films. Ryoo has mixed elements of both in his gritty *Pido nunmuldo eobshi/No Blood No Tears* (2002), the sports drama *Jumeogi unda/Crying Fist* (2005) and the revenge actioner *Jjakpae/The City of Violence* (2006).

The most widely recognized of the New Korean Cinema directors is Park Chan-wook, a film critic who made his directorial debut in 1992 with *Dal-eun...haega kkuneun kkum/Moon Is the Sun's Dream* (1992) followed by *Saminjo/Trio* (1997) a few years later. After a disappointing response to his films from both critics and the public, he was considered 'box-office poison' and returned to his work as a critic, re-emerging in 2000 with *Gongdonggyeongbiguyeok JSA/JSA: Joint Security Area*, an adaptation of a novel by Park Sang-yeon. *JSA* incorporates thriller elements while dealing with the controversial friendship between soldiers from North and South Korea. Boldly stepping further than the previous year's *Shiri* with a character-driven piece tackling the politically charged possibility of a North-South reconciliation, *JSA* became a box-office smash. With North-South relationships proven to be a box-office draw, numerous titles such as *Welcome To Dongmakgol* (Park Kwang-hyun, 2005), *Cheon gun/Heaven's Soldiers* (Min Joon-ki, 2005) and *Uihyeongjae/Secret Reunion* (Jang Hun, 2010) have followed suit. Following *JSA*, Park released his 'revenge trilogy': *Boksuneun naui geot/Sympathy For Mr Vengeance* (2002), *Oldeuboi/Old Boy* (2003) and *Chinjeolhan geumjassi/Sympathy For Lady Vengeance* (2005). When *Old Boy* won the Grand Prix de Jury at the 2004 Cannes Film Festival, it was the highest international award given to a Korean film, and the trilogy of films established his reputation in the West. Park's later film *Bakjwi/Thirst* would be given equally high acclaim, winning the Prix du Jury at the Cannes Film Festival in 2009.

Adding to the box-office power of the New Korean Cinema, genre films became incredibly popular. Romantic comedies had a massive resurgence, thanks to *Yeopgijeogin/My Sassy Girl* (Kwak Jae-young, 2001), which became Korea's biggest box-office comedy until it was eclipsed by *Minyeo-neun Goerowo/200 Pounds Beauty* (Kim Young-hwa, 2006), inspiring similarly titled releases such as *Eorin Shinbu/My Little Bride* (Kim Ho-jun, 2004) and similarly 'kooky' rom-coms like *Yeongeo wanjeonjeongbok/Please Teach Me English* (Kim Seong-soo, 2003). Gangster comedies proved popular, with *Jopog Manura/My Wife is a Gangster* (Cho Jin-gyu, 2001), *Doosaboo ilchae/My Boss, My Hero* (Yun Je-gyun, 2001) and *Gamunui yeonggwang/Marrying the Mafia* (Jung Seung-Hoon, 2002) becoming hits and generating sequels, while horror films headed into schools for the popular *Yeogo goedam/Whispering Corridors* (Park Ki-hyeong, 1998) series, and a number of the 'long-haired female ghost' films appeared, including an adaptation of the influential Japanese film *Ring* (Nakata Hideo, 1998) called *Ring/Ring Virus* (Kim Dong-bin,1999).

The New Korean Cinema has proven to be the emergence of an industry which has succeeded in balancing commercial sensibilities with auteur film-making. A prolific period of output, the last decade has seen the appearance of some of the most interesting cinema on the world stage. It is also the sign of an industry in a state of change – commercially, politically and artistically – and although there have been signs in the last few years that the industry is starting to slow, exactly where that change will lead next and what will symbolize the 'next' Korean cinema is currently unclear.

Martin Cleary

Friend

Chingu

Studio/Distributor:

Cineline 2

Director:

Kwak Kyung-taek

Producers:

Seok Myeong-hong,
An Chang-guk

Screenwriter:

Kwak Kyung-taek

Cinematographer:

Hwang Gi-seok

Art Directors:

Oh Sang-man, Lee Chi-u,
No Sang-eok, Yun Il-rang

Composers:

Choi Man-sik, Choi Sun-sik,
Im Ju-hui, O Hye-won, Choe
Seung-yeon

Editor:

Park Gok-ji

Duration:

116 minutes

Genre:

Drama/action/gangster

Cast:

Yoo Oh-seong, Jang Dong-kun,
Seo Tae-hwa, Jung Woon-taek

Year:

2001

Synopsis

Joon-suk, Dong-su, Sang-taek and Joong-ho are childhood friends growing up in Pusan in the 1970s. As young boys, they share common experiences such as a fascination with sex, comfort in a group environment and, as they try to make sense of the world, they bond as closely as brothers. As they become older, the differences between each of them becomes more apparent and, although they continue to support and help each other through their difficult teenage years, each of them tackles the world in a different way: Sang-taek is academic and shy with the opposite sex; Joong-ho does not appear to ever take anything seriously; Dong-su is quiet but frustrated with his family which breeds a hidden aggressiveness; while the short-tempered Joon-suk explodes in violence at the smallest provocation. As the differences between them grow, the friends find that the simple friendships they were able to keep in their younger years become more difficult to maintain with age.

Critique

A semi-autobiographical film from director Kwak Kyung-taek, *Friend* became a surprise box-office and critical success when its depiction of a group of male friends growing up in 1970s' Busan struck a chord with audiences, propelling the film on its release to become the highest-grossing South Korean film of the time, with over 8 million admissions and numerous nominations in the awards season.

On the surface *Friend* is standard gangster-drama fare, romanticizing a childhood period of innocence before contrasting it against a harsher, more cynical, experience during adulthood with a typical – occasionally melodramatic – examination of loyalty and friendship. Regardless of its real-life influences, as the group of friends begin to move their separate ways there is a nagging sense that *Friend* is simply conforming to this gangster-movie formula, as it is obvious from the outset the direction that each of the lives of the four main characters will take. The appeal of *Friend* is, however, less likely to be its relationship with the gangster genre – which, as anyone who has ever seen a John Woo film will recognize, is a way to make overt male sentimentality acceptable onscreen – but rather its effectiveness as a nostalgia piece aided by its accomplished film-making, stunning imagery and memorable performances.

Central to the appeal of *Friend*, its four leads each deliver sharply-observed performances – particularly Jang Dong-kun and Yoo Oh-seong as Dong-su and Joon-suk respectively, both of whom have the strongest roles. Seo Tae-hwa carries the central narrative as Sang-taek – the character who stands in for director Kwak – in a restrained and reserved role. Seo Tae-hwa fares the worst of the four, giving a perfectly fine performance but with an underwritten character, so he is largely present for comic relief and

to balance out the numbers in the group – before seemingly disappearing completely for the final third of the running time. Unfortunately, while director Kwak proves comfortable coaxing charged central performances and dealing with the male relationships at the centre of the film, there is very little female presence and the sole potentially-effective female role is underwritten and left wasted in the background.

Praised for its realistic and atmospheric portrayal of Busan – rarely depicted onscreen until *Friend* – the city becomes as much of a character as each of the individuals living there, and it is the key element in bringing all of the film-making elements together. The cast speaks with rough Busan accents while the surroundings of the city seem to dictate the lives of its inhabitants more than they do themselves – one part running ground and one part social prison. From the open harbour to the congested schools and theatres, *Friend* both idolizes and berates the city as much as it compares and equates childhood and adulthood with different eyes. While South Korea's repressive school system is depicted in an almost light-hearted fashion – a teacher discovers, to his terror, that he has physically beaten the son of a gangster in class – typical of *Friend's* representation of the idealized simplicity of the seventies, the 20-year time span leads the film into the late nineties and is noticeably less forgiving of the passage into adulthood during the economic depression. This may, of course, have been key to its appeal on its release, providing an onscreen catharsis for the thirty-something males who flocked to see it and who may have experienced difficult times themselves; but it is powerful stuff. The cinematography by Hwang Gi-seok evokes this perfectly: flitting between the quietly scenic, the nervously energized and the downright miserable, quiet scenes suddenly move with energy and eventually disrupt and engulf the innocence of the teenage gang. The outbreak of a fight in a theatre is shot with this stylish, excited energy – bursts of a fearful grimness threatening to deliver an ugly outcome. It is a stunning sequence and perfectly captures *Friend's* grim romanticism.

Martin Cleary

JSA: Joint Security Area

Gongdong Gyeongbi Guyeok JSA

Studio/Distributor:
CJ Entertainment, Myung Films

Director:
Park Chan-wook

Synopsis

During a covert military operation, deep in The Demilitarised Zone (DMZ), a South Korean soldier wanders from his squadron and steps on a landmine. A few hours later, two North Korean soldiers appear and show this wayward invader compassion. They remove the fuse. Sergeant Lee writes a letter of gratitude to these sympathetic soldiers. Sergeant Oh and Private Jung reply. When Sergeant Lee walks across The Bridge of No Return to meet his northern brothers, the trio have a great time. Sergeant Lee tells Private Nam. He also walks across the demarcation line and enters North Korea. The group swap stories, smoke cigarettes, show photographs,

Producers:
Lee Eun, Shim Jae-myung

Screenwriters:
Kim Hyun-seok, Lee
Moo-young, Jeong Seong-san,
Park Chan-wook, Park Sang-
yeon

Cinematographer:
Kim Sung-bog

Art Director:
Kim Sang-man

Composers:
Cho Young-wook, Bang Jun-suk

Editor:
Kim Sang-bum

Duration:
109 minutes

Genre:
Spy/action/war

Cast:
Lee Young-ae, Lee Byung-hun,
Song Kang-ho, Kim Tae-woo,
Shin Ha-kyun

Year:
2000

eat chocolate and listen to music. However, their amity comes to an abrupt end when a cantankerous North Korean lieutenant discovers their secret liaison. People die. As both sides blame each other for the disaster, the Neutral Nations Supervisory Commission (NNSC) intervene and bring in Swiss mediator Sophie Jean to investigate the confrontation. Her job is to resolve this controversial case with care, and avoid having this trivial conflict escalate into a war.

Critique

Before he cemented his robust reputation in the international spotlight with his rancorously nihilistic Vengeance Trilogy (*Sympathy for Mr. Vengeance/Oldboy/Lady Vengeance*), the burgeoning architect of New Korean Cinema set the filmic world aflame with a socially-attentive and culturally-significant political concerto that tackled the taboo topic of North/South reunification. Park Chan-wook's *Joint Security Area* (2000) is also an absorbing, compassionate, yet anguished memorandum to ill-fated friendship. Embracing the unreliable flashback framework of Akira Kurosawa's *Rashômon* (1950), this mnemonic parable begins with oppositional accounts of the polemical shootout at the DMZ. The capitalistic South claims that Sergeant Lee (Lee Byung-hun [*Dalkomhan insaeng /A Bittersweet Life*]) retaliated against Sergeant Oh (Song Kang-ho [*Salinui Chueok /Memories of Murder*]) and Private Jung (Shin Ha-kyun [*Minyeo-neun Goerowo/Save the Green Planet!*]) for kidnapping him, while the communistic North reports that Sergeant Lee invaded their republic to assassinate Sergeant Oh and Private Jung. When these contradictory reports cause political discord, Sophie Jean (Lee Young-ae [*Chinjeolhan geumjassi/Sympathy for Lady Vengeance*]) and the NNSC parlay with the surviving soldiers

Joint Security Area, 2000, C J Entertainment/Intz Com/KTB Network/Kobal Collection

and discover a more simplistic cause for this senseless confrontation – the soldiers experienced a forbidden brotherhood that outshone their countries bureaucratic control.

The sublime sequence that captures Park's passion for North/South harmony also highlights his sensibilities as an emotive cinematic storyteller. When the four friends converse about the contention separating their countries ('if war really broke out, would we have to shoot each other, too?'), they attempt to cement their fleeting friendship by taking a photograph. Adjusting the focal point of the camera, Private Nam (Kim Tae-woo [*Yeojaneun Namjaui Miraeda/Woman Is the Future of Man*]) focuses on the wall-hung portraits of Kim Jong-il and his father Kim Il-sung. As the camera moves down and zooms out, it shows Lee, Jung and Oh in a cheerful embrace. However, the prominent political portraits add a sombre air to their picture. Wanting to get a more accurate angle, Private Nam kneels down, tells the group to 'squeeze in a little' and zooms in, thus blocking out the perilous political leaders that have no place in their progressive and private fellowship.

It is such visually-arresting sequences that make *JSA* such a curiously tense experience. The film is a pugilistic punch in the face. It has style, simplicity, grace, humour, depth, verisimilitude and magic. This is why Park Chan-wook is such an illustrious and philosophical film-maker. He deals with subtext. He creates conflict. He makes you question the human condition. Makes you smile. Makes you laugh. Makes you cry. This is why his depiction of South Korean soldiers who are 'gonna open the dam to reunification' crosses all social, cultural and political boundaries (it is no faux pas that *JSA* was a contender for the Golden Bear at the 2001 Berlin International Film Festival). The people that inhabit *JSA* have humanity. They are not mere representations of life. They are life. This is why *JSA* was and still is a compelling gesture to friendship that transcends ideological war.

Curtis Owen

Nowhere to Hide

Injeong sajeong bol geot eobtda

Studio/Distributor:

Kookmin Venture Capital,
Samboo Finance Entertainment,
Taewon Entertainment

Director:

Lee Myung-se

Synopsis

Inchon, Korea. Underworld figure Sungmin stabs a man to death on the Forty Steps and leaves with his victim's briefcase while his associates take care of the target's subordinates. Detective Woo – the loose cannon of the department whose violent interrogation methods have led to pay deductions – and his more straight-laced partner Detective Kim are assigned to the case and methodically work their way through Sungmin's criminal contacts to establish his whereabouts. They discover that Sungmin has a girlfriend, Jungo, and try to use her as bait, leading to a final confrontation in a coal-mining town.

Critique

Lee Myung-se has insisted that his aesthetically-adventurous police procedural *Nowhere to Hide* is all about movement and energy,

Producer:

Chung Tae-won

Screenwriter:

Lee Myung-se

Cinematographers:

Jeong Kwang-seok,
Song Haeng-Ki

Art Director:

Lee Myung-se

Composer:

Jo Sung-woo

Editor:

Ko Im-pyo

Duration:

97 minutes

Cast:

Park Joong-hoon, Ahn
Sung-kee, Jang Dong-gun,
Choi Ji-woo

Year:

1999

and such a statement is reinforced by the fact that the film rarely pauses for a breather or narrative clarification. The basic premise is that of a team of cops chasing a criminal, and Lee is entirely in thrall to the perpetual motion of that chase: even when he takes a brief break from the action scenes to touch on the bond between Woo and Kim or their infrequent contact with their families, he fills the frame with a heavy downpour or falling snowflakes. The director reportedly studied world-cup soccer in order to prepare for his audacious action sequences, which are as meticulously designed as they are seemingly chaotic, with an extended fight sequence on board a moving train arguably the highlight amid many testosterone-fuelled set pieces. Critics have often compared *Nowhere to Hide* with the work of the Hong Kong auteur Wong Kar-wai, usually citing *Cung4 Hing3 Sam1 Lam4/Chungking Express (1994)* as an obvious influence on Lee's stylistic sensibility, but the similarities between the two film-makers are largely coincidental and based on a shared love of slow-motion and shutter-speed photography. The romantic longing and blurred nostalgia that permeate Wong's cinema are here replaced by a fiercely-contemporary urgency and a sense of time running out rather than gradually passing, while Lee's aesthetic approach owes more to the psychedelic yakuza thrillers that the Japanese film-maker Seijun Suzuki churned out for Nikattsu Studios in the 1960s. Details that would be significant in a more conventional thriller (the backstory and motives of the villain, the contents of the briefcase that he has stolen) are largely ignored in favour of capturing the momentum of the manhunt; captions inform the audience of the number of days it takes for Woo and his team to complete their assignment, but the period of several months is effectively compressed by Lee in order to maintain intensity and a sense of urgency.

Although *Nowhere to Hide* largely exists as a vehicle for Lee's apparently bottomless bag of cinematic tricks and devices, his stylistic excess is effectively anchored by two terrific lead performances. Park Joong-hoon is a hulking presence as Woo, a cop who makes up for what he lacks in intelligence with sheer guts and determination, indulging in childish humour to keep boredom at bay whilst on stakeouts. In contrast, Jang Dong-gun is a more thoughtful, conflicted presence as his partner Kim, prone to self-doubt, uncomfortable with Woo's habit of using excessive force to extract important information, yet ultimately loyal when the bullets and fists start to fly. Although not necessarily intended as an indictment of the levels of violence employed by the South Korean police department, the film did court controversy both at home and overseas for its non-judgmental attitude towards police brutality, and Park's committed portrayal of Woo suggests that his cop would have been just as capable as a mob enforcer or debt collector if he had not chosen law enforcement as his profession. Lee had specialized in romances for the domestic market such as *Naui sarang naui shinbu/My Love, My Bride* (1990) and *Jidokhan sarang/ Their Last Love Affair* (1996) before *Nowhere to Hide* put him on the international fast-track; a box office sensation in Korea, it was also a festival favourite in the United States, and Lee relocated

to New York to develop a follow-up project. Unfortunately, his American debut never made it beyond the development process and Lee returned to Korea after six years abroad, making up for lost time with the historical thriller *Hyeongsa/Duelist* (2005) and the dreamlike romance *Em/M* (2007).

John Berra

Peppermint Candy

Bakha satang

Studio:

East Film Company

Distributor:

Cineclick Asia, Swift Distribution, UPLINK Company, YA Entertainment (DVD)

Director:

Lee Chang-dong

Producers:

Jeon Jae-young, Myeong Gye-nam, Ueda Makoto

Screenwriter:

Lee Chang-dong

Cinematographer:

Kim Hyung-gu

Art Director:

Park Il-hyun

Editor:

Park Il-hyun

Duration:

129 Minutes

Genre:

Drama

Cast:

Kim Yeo-jin, Sol Kyung-gu, Moon So-ri, Kim In-kwon

Year:

1999

Synopsis

South Korea, 1999: middle-aged Yong-Ho meets several old friends at a reunion party, before standing in despair in front of an oncoming train on a nearby track and loudly proclaiming that he 'wants to go back'. Three months earlier, he had been ready to commit suicide when a man finds him and takes him to the hospital to see a woman named Sun-Im, his first love, who is close to death. In 1994 Yong-Ho runs a successful furniture store, but both he and his wife are having affairs; whilst in 1987 he is a newly- though not happily-married police officer who cruelly beats and tortures a man for information. In 1984 Yong-Ho joins the police force following dismissal from the military, and begins to display more violent tendencies. He also rejects Sun-Im, who earlier, in 1980, had tried and failed to visit him at his camp, something that presaged a tragedy for the then nervous soldier.

Critique

Films that play out in reverse – that begin at the end and progress toward the beginning – have achieved a significant measure of cinematic currency in recent years. Through works like Christopher Nolan's *Memento* (2000), François Ozon's *5 times 2* (2004) and Gaspar Noé's *Irréversible/Irreversible* (2002), the concept of tracing a story, in some cases a life, in reverse has posed a number of questions about the hegemony of conventional storytelling and helped reinforce the paradigmatic art cinema precept of knowledge, offering a heightened verisimilitude by asking precisely how and by what route do we come to know another person? How do we relate to others? And, indeed, how do we know and define ourselves in relation to the world and the people around us? After all, do we not meet people in real life and learn about them, as it were, backwards?

These stories present effects in search of their causes and, in so doing, they can better elucidate the complex determinants on personal and indeed national identity; and in both regards, *Peppermint Candy* – the second film by Korean New Wave luminary (and sometime South Korean Minster of Culture) Lee Chang-dong – presents a model of the personal and the political. It centres on the life of Yong-Ho, a suicidal middle-aged man who, at the point of being hit by a train, seems to cast his mind back over the last 20 years of his life, something that the narrative then follows (replete with transitional shots of a train moving backwards which seems

to mock the idea of life as a journey). As such, it is arguably Lee's most ambitious and expansive picture, encompassing as it does a panorama of recent South Korean history that begins on the eve of the new millennium in 1999 (in an uncertain economic climate in the country, as in Asia in general) before moving progressively back in stages through various years to arrive at 1979 when the country was still in the grip of a military dictatorship.

Given this scenario one can immediately trace a potentially-allegorical import to the film, wherein Yong-Ho, who moves from failed soldier to brutal cop to initially-blessed but ultimately-unsuccessful businessman, reflects the development of South Korea from military government and police state to democracy, economic miracle and economic meltdown. Indeed, Lee has said that his aim with the film was for young Koreans in particular to look to the past as a means of identifying the ills of their country, although, to his credit, *Peppermint Candy* is never a dry socio-historical tract, and seismic events in recent Korean history such as the infamous 1980 Gwang-ju massacre (when the government violently curbed student activism) are alluded to but never allowed to overtake the intimate, personal focus of the narrative.

Perhaps the acid test of a reverse narrative is the extent to which their reverse chronology acts as a structural gimmick, or even an attempt to mask the shortcomings that could be made manifest if the story was told conventionally. The structure of *Peppermint Candy* is notable for laying bare the mechanics of selfhood. Although it seems as though the loss of Yong's supposed true love in some way precipitates his malaise, the implicit point is that regrets typically follow on the heels of failure: that people will generally look back when it seems they cannot move forward, and whether one can point to a single, defining turning point in one's life. It is a notion that Lee problematizes, and which his often less-than-sympathetic protagonist perfectly embodies.

In five films over the course of thirteen years, Lee Chang-dong has slowly but surely forged a reputation as one of South Korea's most distinctive auteurs. Eschewing the sensational subject matter, complex generic DNA and stylized aesthetic of many of his contemporaries, he has revelled in a penetrating treatment of the vagaries of battered and bruised masculinity and fragile female subjectivity, and indeed on the tenuous union of the two (including his subsequent film *Oasiseu/Oasis* (2002), which re-united the two leads of *Peppermint Candy* for an unforgettable love story). From this perspective, Lee's sophomore feature is arguably his master-piece – a concise distillation of his film-making and one of the greatest examples of the new South Korean cinema.

Adam Bingham

Shiri

Swili

Studio/Distributor:

Kang Je-gyu Film

Director:

Kang Je-gyu

Producers:

Byun Moo-rim, Lee Kwan-hak

Screenwriter:

Kang Je-gyu

Cinematographer:

Kim Sung-bog

Art Directors:

Oh Sang-min, Park Il-hyun

Composer:

Lee Dong-jun

Editor:

Park Gok-ji

Duration:

125 minutes

Genre:

Action/drama

Cast:

Han Seok-kyu, Kim Yun-jin,
Choi Min-sik, and Song Kang-ho

Year:

1999

Synopsis

Yu and Lee are special agents of South Korea's secret intelligence service and they have emergencies on their hands. A shipment of a powerful new liquid explosive, CTX, has been hijacked by North Korean agents as part of a plot to re-unify North and South Korea and the North Korean agents are threatening to explode the CTX at strategic points throughout South Korea. The race is on for Yu and Lee and their fellow South Korean agents to find the bombs before they explode. Complicating matters further, one of North Korea's most deadly agents, Lee Bang-hee, has resurfaced in South Korea and has already begun wreaking havoc on the peninsula. While all this is happening, Yu is preparing to marry the love of his life, Yi Myung-hyun, a recovering alcoholic who owns an aquarium where fish such as the titular Shiri are sold, a fish that resides along the DMZ.

Critique

Shiri was not the only watershed moment for South Korean cinema in the 1990s – we must not forget the impact of Im Kwon-taek's *Sopyonje* – but it was a major one. It seemed to be the right film at the right time for South Korean cinema. And its timely release and strategic placement in multiple theatres explains its impact when the actual film may seem heavy-handed to many outside South Korea. *Shiri* hit just at the tail end of the 1997 IMF Crisis. Due to many complicated factors, in late 1997 South Korea's economy plummeted, requiring international assistance and acquiescing to many demands of the International Monetary Fund. The emotional impact of the IMF Crisis on the South Korean national psyche cannot be underestimated. A proud country that experienced such rapid growth prior to the IMF crisis was devastated by the loss of prestige incurred by the need for foreign hand-outs.

In this context, *Shiri* can be seen as a remedy for this moment in South Korean history. The film is presented in a contemporary time, which means it is purporting to be set in South Korea during the IMF crisis. But the film contains no visual signifiers of former business men downtrodden and despondent while out of work or any other evidence of a country in financial crisis. Instead, *Shiri* is a cinematic cornucopia of confident consumption. From the vast expensive aquariums, to performance of a stage musical before a packed house of patrons who obviously have the leisure time and disposable income for such expensive leisurely pursuits, to the pivotal scene in the wholesale club abundantly stocked to the rafters with consumer goods, to all the technological gizmos at the disposal of the Korean secret intelligence agency, this is not a cinematic country lacking in anything.

Such conspicuous consumption is juxtaposed with the severe deprivation in North Korea. Although Park Chan-wook's *JSA* provides a much more nuanced portrayal of the North/South divide, *Shiri* is evidence of the shift in the depiction of North Koreans made possible by the relaxing of South Korean censorship

laws beginning in 1996, when the Korean Constitutional Court determined governmental film censorship unconstitutional. Choi Min-shik's North Korean character is provided with a melodramatic soliloquy about the economic plight of North Koreans that would have been seen as too sympathetic for South Korean censors of years past. Ironically, since the economic plight of the everyday South Korean during the IMF Crisis is absent, Choi's North Korean character appears as the only point of empathy for those in the audience who still were, or had very recently been, struggling financially.

Within this entire political context resides a visible investment in production values for South Korean cinema. It is not just the film's Korean secret intelligence agents who were given expensive technological toys to play with; *Shiri* is evidence that the South Korean film industry had some of their own to play with too. Although there are clearly better-made action films, Kang and the team behind him were still able to produce an engaging action film that was fairly up to par with blockbusters from countries more experienced in the form, particularly the US. In fact, due to the pro-motional push, patriotic fervour, and strategic domination of South Korean theatres assisted by the screen quota system, Shiri was able to sink James Cameron's *Titanic*.

It is for all this and more – *Shiri* also being a international launch-ing pad for actress Kim Yun-jin who would eventually find herself on television and computer screens in the US in the hit series *Lost* – that *Shiri* is deservedly seen as a significant South Korean film on multiple levels of the film-going and film-making experience.

Adam Hartzell

Shiri, 1999, Kang Je Kyu Films/Samsung/Kobal Collection

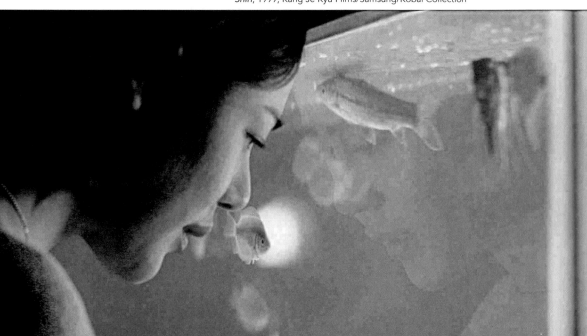

Silmido

Silmido

Studio/Distributor:

Cinema Service

Director:

Kang Woo-suk

Producer:

Lee Min-ho

Screenwriter:

Kim Hee-jae

Cinematographer:

Kim Sung-bog

Art Director:

Jeong Eun-jeong

Composer:

Cho Young-wook

Editor:

Go Im-pyo

Duration:

135 minutes

Cast:

Sul kyoung-gu, Ahn Sung-ki,
Huh Joon-ho, Lim Won-hee,
Jung Jae-young, Kang Sung-jin

Year:

2003

Synopsis

In 1968, an elite North Korean task force, identified as Unit 124, infiltrated Seoul. Their mission was to raid the presidential palace and assassinate the South Korean leader Park Chung-hee. Their mission was a failure. In response, the South Korean government set up their own secret task force, known as Unit 684, on the desolate island of Silmido. The men in training were convicted criminals, outcasts and vagabonds. Their cantankerous superiors subjected them to a gruelling training regime that pushed them to their physical and psychological limits. They became mindless killing machines whose sole purpose was to safeguard their nation and re-unify their homeland. Their mission: go to Pyongyang and slit the throat of the North Korean President Kim Il-sung.

Critique

Kang Woo-suk's *Silmido* harbours an identity crisis. Is it a factual political drama or a gung-ho action flick? Because it maintains a formalistic framework and lacklustre political aspirations, it feels more like a bombastic Bay/Bruckheimer action flick, with a breathtaking score from Hans Zimmer, rather than a gritty and impassioned variation on Robert Aldrich's politically-charged *The Dirty Dozen* (1967). The movie embraces inane montages of prolonged combat, overwrought confrontation and poor characterization (one cannot help but call forth the subversive musical mockery from *Team America: World Police*, Trey Parker, 2004). Another question arises in this Bay/Bruckheimer climate: does Silmido sabotage its raison d'être with its superfluous *mise-en-scène*?

There is no denying this Jekyll and Hyde movie does bolster, uphold and flirt with a prevalent political discourse (deep inside the chasm of its subconscious). Its thematic preoccupations are bureaucracy, betrayal and imposed conformity (the inhumane and animalistic nature of army life and the mindless obedience that comes with it). However, this is a senseless pretence. The melodramatic in-your-face action is clearly the star of this film. *Silmido* overrides its crippled political discourse with an array of fistfights, gunplay and explosions. It is nothing more than a slick, well-edited filmic fantasy that exploits history so that it can convey a compelling story about humanity, adversity, unity and compassion (much in the same way as *Taegukgi/The Brotherhood of War* did in 2004).

Film-makers like Kang Woo-suk should accept the 'based on a true story' dictum and not dream up falsities for the benefit of dramatic dexterity, emotional sentimentality and torrid entertainment. This is why the director had to place a disclaimer at the start of *Silmido*, which translates: 'Due to the lack of relevant information and censorship of certain sensitive materials, much of the movie's details and background were created by literary imagination.' Not hindering the reception of the film, *Silmido* went on to smash box-office records by being the first film to obtain over 10 million admissions nationwide, totalling a theatrical gross of over $60

million. Does this postmodernist perception of truth say something fundamental about the commercial aspirations of South Korean film-makers?

Curtis Owen

Take Care of My Cat

Goyangileul Butaghae

Studio/Distributor:
Malsupiri Film/Cinema Service

Director:
Jeong Jae-eun

Producer:
Oh Ki-min

Screenwriters:
Jeong Jae-eun, Park Ji-seong

Cinematographer:
Choi Young-hwan

Art Director:
Kim Jin-cheol

Composer:
Jo Seong-woo (M&F Creation)

Editor:
Lee Hyun-mee

Duration:
112 minutes

Genre:
Drama

Cast:
Bae Doo-na, Lee Yo-won, and Ok Ji-yeong

Year:
2001

Synopsis

Five young women have just graduated from an industrial high school in Incheon. This places them at a disadvantage economically because their school is not one that streamlines students into University. Although their relationships were tight during high school, they begin to fray when the ambitions of one, Hye-ju, psychologically disconnects her from the lives of the other four, as does the depression enhanced by the poverty of another member of the group, Ji-young. Tae-hee attempts to keep the pack together while she herself deals with the neglect she feels from her family, together with their expectations that she continue on with the family business while her younger brother is doted over by her father. Rounding out the pack are two Chinese-Korean identical twins who are making a go at jewellery design. Each of these young Korean women is trying to find their own space in society as they struggle to dislodge the limitations imposed upon them.

Critique

Take Care of My Cat is a type of film that does not come around enough: a quality film about young women at the verge of adulthood that does not have much of anything to do with boys. While Hye-ju does have a suitor, she does not define her future around him, and her friends are only upset that Hye-ju treats him rudely, not that she is making a mistake by not revolving her life around the desires of boys. Instead, this film focuses on the desires and dreams of the girls themselves as they struggle with the constraints imposed upon them economically, socially, and in the case of Tae-hee (Bae Doo-na), the patriarchal demands of her father. This attention to the details of alternate visions of the lives of South Korean girls is what one would hope for when the director's and writer's helm is taken on by a woman, and particularly a woman such as Jeong Jae-eun. Jeong appeared on the South Korean film scene as part of a triad of significant female directors, including Lim Soon-rye and Byun Young-joo. To date, Jeong has not had the same sort of success as Lim, whose *Woori Saengae Chwegoui Soongan/Forever the Moment* (date) was a commercial and critical success. There has been a long gap between her second feature film, *Taepungtaeyang/The Aggressives*, in 2005 and her most recent, *Malhaneun Geonchookga/Talking Architect* (2012). However, *Take Care of My Cat* made enough of an impact amongst a neglected segment of the South Korean audience – there was a grassroots campaign to bring it back to theatres when fans felt it was pulled out too soon – and has been lauded by enough critics

to warrant bringing up Jeong's name when discussing those who made a major contribution to South Korean cinema's success in the first decade of the twenty-first century.

The film weaves a tapestry of relationships heading off on different socioeconomic patterns, but the cat, passed from one party to another, acts as the thread that keeps the larger work together. Ji-young (Ok Ji-young) is a child of poverty whose lack of family stability keeps her from gaining the job for which she is qualified. This only adds to the feeling that she is losing connection with Hye-ju (Lee Yu-won), whose family can provide for her financially. At the same time, Hye-ju is finding that her high school is not enough for her to make headway into the professional lifestyle she desires. Tae-hee is the one who attempts to mediate between all the parties in this group of young women, because she can speak to both Ji-young and Hye-ju in ways they cannot seem to speak to each other. Underutilized, but nonetheless interestingly placed within the narrative, are the identical Chinese-Korean twins who demonstrate that modern South Korea is more heterogeneous than some have claimed. Like the Chinese-Koreans' grandparents, Taehee wants to make an immigrant of herself, demonstrated by her inquiries at a Merchant Marine community centre where Filipinos play pool. Tae-hee wants to leave South Korea because she finds, in an allusion to Cho Se-hui's classic novella *A Little Ball Launched By a Dwarf*, that there are acts of violence perpetrated by other means than fists, taking away one's freedom of choice is one as well.

Along with the gorgeous soundtrack and the creative integration of cellphones in the film, *Take Care of My Cat* is significant in Bae Doo-na's filmography because it introduced her to a wider international audience. Unfortunately, confined by their own limiting of cinematic choices for teenage girls and young women, international distributors did not seem to know how to market this excellent film, resulting in poor performance at international box offices. So, like many films, it sits there waiting to be rediscovered internationally by those who have been waiting for just such a film that respects young women rather than simply seeking to commodify them.

Adam Hartzell

The City of Violence

Jjakpae

Studio/Distributor:
Film-makers R & K

Synopsis

Detective Tae-su attends the funeral of an old school friend by the name of Wang-jae – both were part of a close-knit group of kids that grew up together. After reminiscing with Wang-jae's brother Seok-hwan about their childhood friendships, the two believe that there is something strange about the reportedly 'accidental' murder and begin their own individual investigations into what happened on that fateful night. After Tae-su starts to dig into the details surrounding the murder, he is attacked – which seems to confirm his suspicions that there is more to the murder of his friend

Director:

Ryoo Seung-wan

Producers:

Kang Hye-jeong, Ryoo Seung-wan, Jung Doo-hong

Screenwriters:

Kim Jeong-min, Lee Jae-won, Ryoo Seung-wan

Cinematographer:

Kim Young-chul

Art Director:

Cho Hwa-sung

Composer:

Bang Jun-suk

Editor:

Nam Na-yeong

Duration:

92 minutes

Genre:

Action

Cast:

Jung Doo-hong, Ryoo Seung-wan, Lee Beom-soo, Jeong Seok-yong

Year:

2006

than he was originally told and strengthens his determination to uncover the truth.

Critique

Commonly referred to as 'the action director', Ryoo Seung-wan's fourth feature – *The City of Violence* – is his first that can be described as a pure action film. Following the sports drama *Jumeogi unda/Crying Fist* (2005) – which displayed a more serious approach through overt drama, prompting a divided response from fans in the process – the serious dramatics are jettisoned in favour of straight action, with Ryoo tackling the genre armed with the thinnest revenge story from which to hang some incredible action set-pieces.

Regular collaborator Jung Doo-hong fills the role of Detective Tae-su, with director Ryoo partnering him as the hard-headed Seok-hwan. It is a significant onscreen relationship, given their ongoing working situation (Ryoo the Director, Jung the Martial Arts Director), and, onscreen, Jung dominates proceedings, proving to be a solid leading man. Characterization is thin throughout and actor Lee Beom-soo – despite relatively little screen time – creates the sole character of interest as the conflicted and misguided Pil-ho.

Despite a relatively low budget, *The City of Violence* makes up for its lack of dramatic heart purely through cinematic spectacle. Showcasing stunning Taekwondo-inspired martial artistry and stunt work, it is a feature-length show-reel for Jung Doo-hong's 'Seoul Stunt School', responsible for the incredible stunts and tasked with performing the imaginative action, including a jaw-dropping scene involving a group of breakdancers which escalates into a near full-blown riot.

While *The City of Violence* feels like Ryoo's most straightforward feature, it is also his most complete. There is his familiar imagery depicting the central protagonists pushing themselves into complete exhaustion, more effective here than in any of his previous films. Typically, there are multiple references to other movies – an example being a gang of baseball players with the name 'The Warriors' in a clear nod to the 1979 Walter Hill film of the same name (USA: 1979). Ryoo has declared his frustration with Tarantino comparisons – although it is almost impossible for modern audiences not to associate the climactic action found here with the 'House of Blue Leaves' scenes in *Kill Bill Vol. 1* (Quentin Tarantino, USA: 2003). Ryoo insists his influences are earlier – films such as *Irezumi ichidai/Tattooed Life* (Seijun Suzuki, Japan: 1965), Korean action cinema from the seventies, Jackie Chan films and the output from Hong Kong's Shaw Brothers studios – all of which can be seen onscreen. However the influences are interpreted, the action can be accurately described as 'old-school' in its physicality and aggressiveness – far from the CGI-heavy action of his earlier *Arahan Jangpung Daejakjeon/Arahan* (2004).

Surprisingly, given the director's propensity for 'fun' as displayed in *Arahan* and his previous internet film *Dachimawa Lee* (2001),

there is an underlying cynicism throughout *The City of Violence* that is even darker than the aggressiveness found in the earlier *Pido nunmuldo eobshi/No Blood No Tears* (2002) – a clear anger reflected in the narrative and depiction of Korea as a 'construction nation' and most clearly reflected in the film's now famous final line, delivered by the director himself – simply: 'Fuck.' Given the energy and spectacle of everything that precedes it, it is certainly a bitter sign-off.

Three scriptwriters are credited for *The City of Violence*, although the script is about as streamlined as it can be. The swift pace, like *Arahan*, threatens to peak early on, giving it an uneven feel – however the action sequences of the final 20 minutes are some of the most impressive seen in Korean cinema. Unless you are a native speaker you are likely to miss some of the jokes and subtleties such as the Chungcheong Province (Ryoo's birthplace) dialect used by the main characters throughout. Still, *The City of Violence* was picked up for distribution widely overseas as the spectacular action sequences require no translation.

Martin Cleary

The Good, The Bad, and the Weird

Joheunnom Nabbenun-nom Isanghannom

Studio/Distributor:
Barunson, CJ Entertainment, Cineclick Asia, Grimm Pictures

Director:
Kim Jee-woon

Producers:
Choi Jae-won, Choi Joon H, Kim Joo-sung, Kim Jung-hwa, Miky Lee, Lee Sang-yong, Seo Woo-sik

Screenwriters:
Kim Jee-woon, Kim Min-suk

Cinematographers:
Lee Mo-gae, Oh Seung-chul

Art Directors:
Cho Hwa-sung, Han Ji-hyeong

Synopsis

A supposed 'treasure map' is being transported on a train in 1930s' Manchuria. Bandit Park Chang-yi (The Bad) is tasked to steal this map but, before he can do so, it is stolen by petty thief Yoon Tae-goo (The Weird). Unbeknownst to both The Bad and the Weird, also drawn to the train is bounty hunter Park Do-won (The Good) who is there to take down Park Chang-yi and, if possible, to find and deliver the map to the Korean resistance. As Yoon Tae-goo eludes his pursuers he discovers the secret of the map and sets out in search of it, where he is hunted by the Japanese Army, the Korean resistance movement, Manchuria Bandits, The Bad and The Good. After initially being captured by The Good, Yoon Tae-goo and Park Do-won, using The Weird as bait to capture Park Chang-yi, must face off against their pursuers and a climactic Mexican standoff occurs between The Good, The Bad, and the Weird at the site of the 'treasure'.

Critique

The backdrop of 1930s' Manchuria provides an excellent setting to develop what the director, Kim Jee-woon, describes as a 'kimchi western'. In a similar vein to Takeshi Miike's *Sukiyaki Western Django*, the film pays homage to Spaghetti Westerns and the generation of film-makers that they inspired, updating and revamping without outright appropriation. The film is not a Korean director attempting a Spaghetti Western, but rather a carefully-constructed film in its own right that distinctly utilizes its cultural context to its advantage.

Composers:

Dalparan, Jang Yeong-gyu

Editor:

Nam Na-young

Duration:

136 minutes

Genre:

Action/adventure/Western

Cast:

Song Kang-ho, Lee Byung-hun,
Jung Woo-sung

Year:

2008

Manchuria is developed as a place where Koreans have come wanting a new life for mistakes made in the past, to get rich, or to escape the oppression of Japanese Imperial rule at home. The Weird finds himself distinctly not in the latter category, as he wants no part in the Korean resistance, nor to remember his sordid past; he only wants a new life and riches. As with many Westerns, the film provides a morality tale, with, however, the twist that it is essentially an inversion of the standard morality tale. While Park Chang-yi, The Bad, is still bad, and Park Do-won, the Good, is still good, there is a nuanced exploration of the grey area in between via Yoon Tae-goo, The Weird. Each character has a morality unto themselves and, while Park Chang-yi is presented as a chaotic self-serving character, it is Park Do-won who remains the most fearsome to Yoon Tae-goo. In a expository campfire scene midway through the film, Yoon Tae-goo and Park Do-won are having a conversation in which Yoon Tae-goo declares he fears The Good more than The Bad, in essence because of his strict morality, which, however, does not prevent him from killing anyone who gets in his way: as The Good states, 'even if you have no country, you still need money'. For Yoon Tae-goo, rather, he is just trying to get by. As he states, his class dictates the need to operate outside of rigid normative parameters: 'for people like me, it's the same living under the nobility or the Japanese.'

At least initially for Yoon Tae-goo, his 'morality' is defined by his luck in combat. Playing the fool, he does whatever is necessary to survive, yet is incredibly loyal to those who befriend him or who need his assistance. Both The Good and The Bad operate under similar codes of morality, ultimately creating the need for the comic

The Good, the Bad and the Weird, 2008, Barunson/Kobal Collection

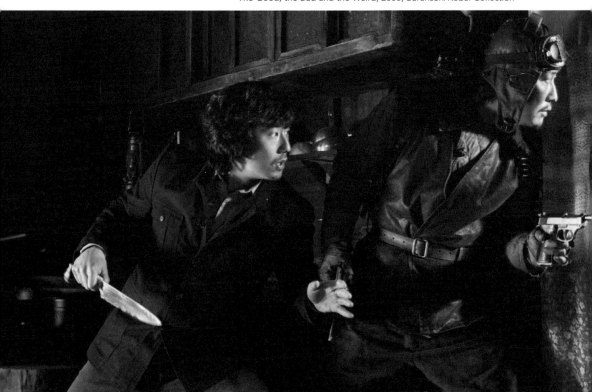

foil of the Weird to counteract their strict notions. In this way the film simultaneously inverts and pays homage to westerns while developing a unique Korean cinematic take on the genre.

Angus McBlane

Typhoon

Tae-poong

Studio/Distributor:

CJ Entertainment

Director:

Kwak Kyung-taek

Producers:

Park Seong-keun,
Yang Joong-kyeong

Screenwriter:

Kwak Kyung-taek

Cinematographer:

Hong Kyung-pyo

Art Director:

Gang Chang-gil

Composer:

Simon Leadley

Editor:

Simon K Park

Duration:

104 minutes

Genre:

Action

Cast:

Dong-gun Jang, Jung-jae Lee,
Mi-yeon Lee, David Lee McInnis

Year:

2005

Synopsis

As a young boy, Sin and his family attempt to escape the oppressive regime of their native North Korea by seeking a new life in the South. However, diplomatic complications prevent their amnesty request from being accepted, so the family is claimed by the North Korean government and labelled as 'defectors', leading to the deaths of the boy's parents. Swearing revenge on North and South Korea, Sin grows up to become a notorious pirate, hijacking international shipments in Southern Asia, but when his crew steals an American shipment consisting of the parts for a nuclear warhead, the South Korean government takes action for fear of an international incident. Top soldier Gang Se-jong is assigned the task of finding and apprehending the pirates, but the more he learns about his quarry, he increasingly empathizes with the vengeance-seeking pirate.

Critique

At the time of release, *Typhoon* was the most expensive movie to emerge from South Korea and the reported $15 million budget appears to be up on the screen: globe-hopping locations, car chases, shoot-outs, knife fights, elaborate sets and explosions are captured by swirling overhead cameras and relayed by fast edits, leading many critics to comment that *Typhoon* was a calculated attempt by the South Korean studio system to emulate the aesthetic of such Jerry Bruckheimer productions as *Crimson Tide* (1995), *The Rock* (1996) and *Con Air* (1997). Despite the blockbuster bombast, *Typhoon* is actually a rather dour affair, with the overwrought tone and Hong Kyung-pyo's gloomy cinematography turning what should have been a slickly-engineered thrill-ride into a pessimistic drama with some flashes of excitement amidst the melodrama. The emphasis on expensive spectacle in order to increase international distribution opportunities represents a significant step-up on the industrial ladder for director Kwak Kyung-taek, who made his mark with the semi-autobiographical gangland saga *Chingu/Friend* (2001) before delivering the boxing biopic *Chaempieon/Champion* (2002), but the largely impersonal *Typhoon* indicates that the writer-director is not particularly enamoured with the action genre. Admittedly, his screenplay tries to tackle the plight of the victims of the divide between North and South Korea, but *Typhoon* is primarily a populist action picture and, like the character of Gang Se-jong, the writer-director has to put his political conscience to one side in order to get the job done.

Kwak attempts to alternate the dramatic weight – and audience empathy – between its two alpha-male protagonists, keeping them apart for much of the running time in order to emphasize their fundamental similarities when they share the screen to exchange both words and bullets. In this respect, *Typhoon* is not nearly as successful as its Hong Kong contemporary *Infernal Affairs* (2002) or its Hollywood model *Heat* (1995) as Kwak does not provide sufficient balance between the modern-day pirate and the naval officer assigned to bring him to justice. Gang is introduced in the most rudimentary fashion – displaying his physical prowess whilst playing sports on the beach with his fellow officers as his exemplary record is read out over the action by his superior officer – and barely developed beyond his military skill-set aside from some final reel voice-over in which he states the obvious by ruminating on the common ground between Sin and himself. In contrast, the character of Sin comes complete with a heavy-handed back-story, which forms the basis for an extended flashback at the half-way mark, and a long-suffering sister with a miserable history of sex slavery and opium addiction. The scenes which find them recalling their tragic childhood – which has already been detailed in the flashback sequences – and conceding that North Korea is still their 'home' despite the deaths of their parents, causes the narrative to stagnate with subsequent bursts of action undermined by cliché (Gang failing to shoot Sin, even when he has him in his crosshairs, a last-minute air raid to save the day). As a Korean imitation of the patriotic heroics regularly served up by Hollywood players Michael Bay and Tony Scott, *Typhoon* is just as technically proficient and single-minded in its pursuit of box-office glory as its blockbuster templates and, as such, Kwak's film is effectively announces the logistical possibilities of Korean cinema circa 2005 at the expense of the raw vitality of the writer-director's previous work.

John Berra

Sympathy For Mr Vengeance

Boksuneun naui geot

Studio/Distributor:
Studiobox Co. Ltd/
CJ Entertainment

Director:
Park Chan-wook

Producer:
Im Jin-gyu

Synopsis

Deaf, mute Ryu, a factory worker for an electronics company run by the self-made Dong-jin, lives with and cares for his critically-ill sister who is desperately in need of a kidney transplant. As a result of the Asian economic collapse of the late 1990s, Ryu is made redundant from his job and is left unable to pay for his sister's operation for which no donor has been found, as Ryu himself is not a match. Forced to rely on his severance pay (10 million Won, roughly $7000), Ryu enters an agreement with a family of black-market organ traffickers who, instead of carrying through their deal – one of his kidneys and the ten million in exchange for a suitable kidney for his sister –, leave him unconscious, naked and without a kidney in a disused multi-story car park. Now unable to pay for the operation legally, the news comes through that the doctors have found a donor. Ryu's radical, left-wing girlfriend Young-mi devises

Screenwriters:

Park Chan-wook, Lee Jae-sun,
Lee Mu-yeong, Lee Yong-jong

Cinematographer:

Kim Byeong-il

Art Directors:

Oh Jai-won

Editor:

Kim Sang-bum

Duration:

129 mins

Genre:

Crime/drama/thriller

Cast:

Sang Kang-ho, Shin Ha-kyun,
Doona Bae

Year:

2002

a plan to kidnap and ransom the young daughter of the rich Dong-jin, Yu-seon. She states that 'kidnapping for a good reason is not a crime'. Ryu and Yu-seon develop a touching bond until the young girl is accidentally drowned – an event which sets in motion her father's revenge and sets Ryu on a course of revenge of his own.

Sympathy for Mr Vengeance, 2002, C J Entertainment/Studio Box/Kobal Collection

Oldboy

Oldeuboi

Studio/Distributor:
Show East/Egg Films

Producers:
Kim Dong-joo, Ji Yeong-jun

Screenwriters:
Hwang Jo-yun, Park Chan-wook,
Lim Chun-hyeong, Lim Joon-
hyung, Garon Tsuchiya

Cinematographer:
Jung Jung-hoon

Art Director:
Ryu Seong-hui

Editors:
Kim Sang-bum, Kim Jae-beom

Duration:
120 mins

Genre:
Crime/drama/thriller

Cast:
Choi Min-sik, Yu Ji-tae,
Kang Hyejeong

Year:
2003

Synopsis

Oh Dae-su, an average, if weak, man is arrested on the night of his young daughter's birthday for being drunk and disorderly. After causing some disarray in the police station, he is released and is promptly, and silently, abducted. For the next 15 years, he is kept prisoner in a private, secret cell by an unknown captor, during which time he is kept alive on a diet of fried dumplings and television, left to count the days, re-evaluate his life, and to try and work out just who is keeping him prisoner. After a year of imprisonment he learns of the murder of his wife and that he is the chief suspect. After a failed suicide attempt his thoughts turn to revenge, and a very different Oh Dae-su is born after he starts to train his body and his mind in order to take revenge – if he succeeds in escaping. However, before he can escape, he is released and abandoned in a suitcase on a rooftop in the same spot he was abducted fifteen years before. Oh eventually tracks down his captor, Lee Woo-jin, who gives him five days to discover the reason of his imprisonment, as, if he does, Lee Woo-Jin will kill himself rather than Dae-su. The race is on, and a life-shattering revelation awaits Dae-su.

Oldboy, 2003, Egg Films/Show East/Kobal Collection

Sympathy For Lady Vengeance

Chinjeolhan geumjassi

Studio/Distributor:

Moho Films/CJ Entertainment

Director:

Park Chan-wook

Producers:

Lee Tae-hun, Cho Young-wook

Screenwriters:

Jeong Seo-kyeong,
Park Chan-wook

Cinematographer:

Chung Chung-hoon

Art Directors:

Cho Hwa-sung, Choe
Hyeon-seok, Han Ji-hyeong

Editor:

Kim Sang-bum, Kim Jae-beom

Duration:

112 minutes

Genre:

Crime/drama/thriller

Cast:

Lee Yeong-ae, Choi Min-sik

Year:

2005

Synopsis

Geum-ja, a saintly young woman accused and imprisoned for the murder of a young boy, is released early from prison for good behaviour, spiritual transformation and for the fact that she puts herself at the service of her fellow inmates, earning her the nickname 'Geum-ja The Good'. Due to her seemingly-innocent demeanour and youth, she is a national sensation. Geum-ja is of course innocent of her crime and leaves prison intent on revenge. The real culprit is a teacher and child-killer, Mr Baek, who forced her to take the blame for the crime by abducting and threatening to kill her newborn daughter. Inside, Geum-ja performs a number of good deeds and favours to help her inmates. On her release, she visits these (now released) inmates and calls in her favours, receiving shelter, food and weapons in return. On discovering her daughter is now living with a family in Sydney, she goes to collect her and returns with her to take her revenge on Baek. With the help of an ex-convict and Baek's wife, she is able to capture him, by discovering a collection of children's trinkets and video tapes detailing his horrendous crimes. Geum-ja calls on the families of his young victims and the scene is set for a grisly and haunting climax.

Critique

Park Chan-wook's violent, bloody and highly-stylized 'Vengeance Trilogy' offers three films based not around a single continuous story but around themes of family relationships (in particular the parent-child relationship), guilt, revenge, catharsis and metamorphosis. The trilogy has paved the way for that most ubiquitous type of recent Korean film – the revenge drama. Films like Bong Joon-ho's *Madeo/Mother* (2009), Na Hong-jin's *Chugyeogja/The Chaser* (2008) and more recently Kim Jee-woon's *Akmareul Boattda/I Saw The Devil* (2010) all follow in the wake of the trilogy's violent and stylized, almost Shakespearean rumination on the nature of violent revenge and its moral, personal and political consequences. This is also, clearly, a body of cinematic work that is influenced by the political and social divisions encountered by Koreans over the past 20 years. The plot of *Sympathy for Mr Vengeance*, for instance, rests on a set of binary oppositions which are crucial to an understanding of the film: North versus South, Left versus Right, Communist versus Capitalist. The three films reflect and engage with, in a number of ways, the uneasy and violent movement towards democracy that South Korea has undergone since the 1970s, a period which has seen several allegations of corruption levelled at the country's political and economic leaders. The bloody acts of vengeance which occur in the films may be read as a cathartic expression of the anger and fury felt by the *national* family at the events of the past 30 years.

Park's trilogy also carries the cultural weight of Asian Manga comics (Park borrowed the original concept for *Oldboy* from a Manga Cartoon by Minegishi Nobukai and Garon Tsuchiya) and

western and non-western pulp fiction, combining these influences with the gravitas of the Shakespearean revenge tragedy. In *Sympathy for Mr Vengeance*, Park invites us to sympathize and empathize with both Dong-jinn and Ryu equally. Park's trilogy demonstrates the cultural influence of the West – in his films there is more than a slight trace of Hitchcock, Bergman and Peckinpah – as well as drawing upon a core set of East Asian events and cultural, historical influences. Of key importance is the 1997 Asian economic crash, which forms part of the foundations for the first film *Sympathy For Mr Vengeance*, as well as possibly drawing on the concept of 'han', which has been (over)used as a mechanism through which to convey a national sense of isolation when faced with great odds and a sense of un-avenged injustice. Perhaps more so, maybe, than in the other two films of the trilogy, there is a sense of universal victimhood in *Sympathy for Mr Vengeance*.

Ryu and Dong-jinn are both victims of the 1997 Asian economic collapse. Dong-jinn, a self-made man who has worked his way up from the bottom of the ladder sacrificing his familial relationships along the way, is forced, against his will, to slash his workforce – which includes the film's chief protagonist Ryu, a deaf mute who is caring for his dying sister. In a sense, the character may be seen to be a clear metonym for a Korea caught between the twin ideological extremes of Communism and Capitalism. He is unavoidably laid off, from his factory job by his employer, who, as an industrialist, is also a victim of the crash. Ryu is also manipulated and goaded into the kidnapping of Dong-jinn's daughter by his radical, left-wing girlfriend. Written into Ryu's character are clear connotations and suggestions of a Korea caught between conflicts of Left versus Right; North versus South; Communist vversus Capitalist. The fracturing of the (national) family unit is written large into the wider context of the trilogy. In *Sympathy For Mr Vengeance*, Park begins to explore this idea with the death of Ryu's sister, the separation of Dong-jinn and his daughter and the close familial bond which emerges between Ryu and the young girl before her untimely and accidental death. In *Oldboy* and *Lady Vengeance*, Oh Dae-su and Geum-Ja emerge from the imprisonment to discover their daughters have been adopted into other, western(ized) countries: Sweden and Australia.

Park also attempts to elicit a sympathetic and empathetic response to acts of revenge which seem at once justified and perverse and extreme (acts of revenge in the trilogy are nothing if not extreme – characters have teeth removed with hammers, others have their head wired up to an electrical generator while others are hacked to death). Aesthetically, *Sympathy for Mr Vengeance* is a very different film from the other two, using as it does a disorienting variety of long-shots, close-ups and zooms which are accompanied by a diegetic soundtrack of industrial noise contrasting with extended periods of total silence. This disorienting *mise-en-scène* contrasts with the slick, stylized *mise-en-scène* and balletic 'cool' violence of *Oldboy* and *Lady Vengeance*. Stylistically, *Sympathy For Mr Vengeance* avoids the comic book/noir violence of either *Oldboy* or *Sympathy for Lady Vengeance*. Instead it opts for a

social-realist approach in its depiction of the economic polarity of South Korea.

Like his contemporary Kim Ki-duk, Park's films have also been readily adopted by western critics and audiences. It is, therefore, no surprise that *Oldboy*, with its Manga origins and stylized comic-book violence won the Grand Prix at the 2004 Cannes film festival the year Quentin Tarantino presided over the jury. The film contains a number of (in)famous sequences which set it apart from *Sympathy For Mr Vengeance* in both style and tone. We are treated to Oh Dae-su eating a live octopus; there is also a highly-stylized fight sequence seen in profile in which Oh Dae-su decimates a large group of henchmen, armed only with a hammer; a sequence which brings to mind not only the panels of a comic book but also an beat-em-up computer game sequence, ending on a comical note as he exits a lift, leaving it crammed with a pile of bodies. It is this element of dark, gallows humour which sets the film apart from the other films of the trilogy. *Sympathy for Mr Vengeance* adopts a keener sense of social realism and avoids, for the most part, the sense of grisly levity which helps *Oldboy* stand out and which has endeared it to Western audiences, ensuring its cult popularity.

The final film, *Sympathy for Lady Vengeance* is less immediate in its depiction of grisly retribution but, nevertheless, offers a slow but intense climactic build up to its gruesome conclusion, contrasting a more tranquil *mise-en-scène* (which may be observed in the snowbound finale of both *Lady Vengeance* and *Oldboy*) with its more coruscating and extreme content. The trilogy as a whole offers a set of absurd yet believable and horrific images, ideas and plot twists which remain with the viewer long after the film has finished. In the finale of *Lady Vengeance*, Park elicits from the viewer a sense of sympathy for Mr Baek (*Oldboy's* Choi Min-sik) as he awaits his bloody fate at the hands of the families of his young victims. *Lady Vengeance* is a natural development of the thematic ideas which dominate the previous two films, shifting the balance from an emphasis on fatherhood and patriarchy to motherhood and saintliness. In fact, just as *Sympathy* builds around sets of key binary oppositions, so *Lady Vengeance* builds itself around the transformation of Geum-ja from saint to a black-clad leather dominatrix. There is more than a suggestion in this film that Park is drawing, again, not only on Eastern concepts of revenge but also on western Pulp and Noir fiction (notably *Mildred Pierce*), presenting an East Asian Noir femme fatale, an avenging angel who is both Madonna and Whore.

There is a sense in the films that the characters are carried along by their revenge; there is a sort of loss of control. Once they embark on their course of action there is no way back for them. Revenge comes in the form of a collective frenzy, seen particularly in *Lady Vengeance* and as a direct result of the separation and subversion of the parent-child relationship. Revenge is also transformative. In *Oldboy*, when Oh Dae-su is captured, he is a weak drunkard whose attention to his family is clearly negligible. When he is released, he is a different character altogether, his drive for revenge has changed him, turning him into almost a violent comic book

anti-hero/superhero. Similarly, Geum-ja emerges from her imprisonment not as 'the good-hearted' kind young girl she appeared to be but as a black-clad avenging angel. There is a sense in all three films that there is an absurdity, a fruitlessness in the drive for revenge; this is clear in the shocking denouement of *Oldboy* and in the finale of *Lady Vengeance* in which the final vengeful acts of the family and of Geum-ja seem not to bring the closure or satisfaction that had been hoped for.

Matthew Melia

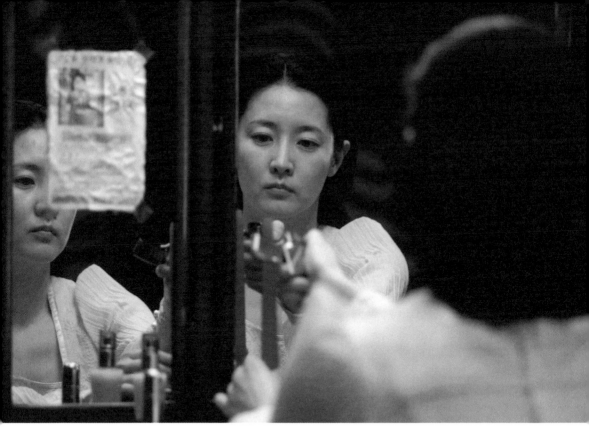

Sympathy for Lady Vengeance, 2005, Tartan Films/Kobal Collection

PERIOD DRAMA

What connects all the films discussed in this section is that they all depict a time in the past. As an audience, we understand this by identifying the clothes that the characters wear, the houses they live in, and even the language they speak. Yet things are not so simple when we try to conceptualize a name for these films; because the audience, the makers, and the critics may very well have a different understanding of what they should be called, the attempt to come up with a generic framework must be approached with caution. Most commonly, these films are called *sageuk* in Korean. The character 'sa'(史) derives from the word 'history'(*yeok-sa*), while 'geuk'(劇) is synonymous with drama, play, or film. In the most literal sense, then, '*sageuk*' can be translated as 'historical drama' in English. Simply put, the *sageuk* now has the currency to mean any film or television drama that is set between ancient history and the early twentieth century. But this is no catch-all definition, as the word 'historical' does not sit well with movies that deal with an unspecified and fantastical past, such as martial arts or folkloric films. For instance, whether to consider Chunhyang films – cinematic adaptations of a well-known folktale – as instances of *sageuk* is an issue not everyone sees eye to eye on. In some cases, a term with a broader meaning, '*sidaegeuk*' (period drama) is preferred over '*sageuk*' (historical drama) to round up those films that depict a pre-modern past, whether factual or fictional. Chunhyang films, in this sense, will comfortably fall under the label '*sidae-geuk*'. Just to add to the confusion, films concerned with a more recent past, such as the colonial period (1910-1945) and even the 1950s and 1960s, can also be called '*sidae-geuk*', mainly due to their period look. Therefore, while some may be reticent in calling *Modeonboi/Modern Boy*, set in the late 1930s, a *sageuk*, they may readily consider it a *sidaegeuk*. Even so, it should be noted that the distinction between historical drama (*sageuk*) and period drama (*sidaegeuk*) is often blurred. Interestingly, the Korean word *sidaegeuk* shares the same Chinese characters as the Japanese word '*jidaigeki*', a term that has close association with the samurai film. The only thing that '*sidaegeuk*' and '*jid-aigeki*' have in common, perhaps, is that as generic labels they are evolving, expansive and, thus, difficult to pin down. In order to understand Korean historical/period drama, therefore, it is more useful to study its history and look at actual examples, rather than wrangling over exact definitions.

Left image: *The King and the Clown*, 2005, Eagle Pictures/Kobal Collection

Early silent features that revived centuries-old classics – ancient folklore, oral myths and *pansori* (traditional opera) – appeared as soon as narrative film-making in Korea started in the early twentieth century. These folkloric adaptations, in my view, can be understood as an embryonic form of the *sageuk*. *Chunhyangjeon/The Story of Chunhyang* (1923) made by a Japanese theatre owner Hayakawa Koshu is the earliest record of a period drama. The film is an adaptation of the quintessential folktale, 'A Tale of Chunhyang', which dramatizes an inter-class love story of Chunhyang and her upper-class beau Mongryong. This damsel-in-distress-meets-Cinderella story has been adapted for the big screen nearly twenty times, with the most recent example being *Bang Ja Jeon/The Servant* (2010). After the success of *The Story of Chunhyang*, a string of other folktales received cinematic treatment in the colonial period. The arrival of sound technology injected a new boost to this trend in the mid-1930s and the first Korean sound film happened to be another Chunhyang film released in 1935 by Lee Myeong-u.

The historical genre became the driving force in resuscitating the national film industry during the post-liberation and post-war period. The phenomenal success of Lee Gyu-hwan's *Chunhyang-jeon/Chunhyang Story* (1955) spurred an explosion of costumed productions to the point that, in 1956, more than half (sixteen) of the total cinematic output (thirty) was period dramas. It is no exaggeration, therefore, to argue that what we now call the Golden Age of Korean cinema, the time between the mid-1950s and the late-1960s, would not have been possible without these popular *sageuks*. Moving away from folkloric adaptations, the historical drama rose to prominence by recreating a historically-grounded and charming past. In the forefront of the *sageuk* boom was director Shin Sang-ok, who came into the limelight with his version of the Chunhyang tale in 1961. By using 'colour' and 'cinemascope', Shin's *Seong Chunhyang* revived the heroine's life in vibrant colours and on a wide screen as never seen before. Keenly aware of the industrial aspects of film-making, Shin launched his own production company Shin Film, which would become one of the biggest film studios in Korea. It was a strong financial security and infrastructure that equipped him with the means to tackle a number of challenging historical projects, including the royal court *sageuk Yeonsan Diptych* (1962) and the period horror *Cheonnyeonho/One Thousand Year Old Fox* (1969). Towards the end of the 1960s, the traditional *sageuk* formula would assimilate with Hong Kong-influenced martial arts and monster/horror narratives, reflecting changing audience taste and industrial practice.

Entering the 1970s, the film industry went into a long depression. At this time, the acquisition of the import licence for foreign films seemed like a desirable survival plan for the studios, as foreign films were raking in far more money than domestic features in local cinemas. The government, under the dictator Park Chung Hee, would hand out a limited number of import licences to film studios that produced *usu yeonghwa* (good or quality film) or award-winning films; now the competition was on to churn out films that exerted a greater chance of fitting into this quota allotment. In the historical genre, this practice led to the arrival of explicitly-nationalistic heroic biopics. Jang Il-ho's *Nanjung-ilgi/A War Diary*, discussed in detail below, is a prime example of the 1970s' heroic biopic. A year later, the director Jang would release *Hogug Palmandaejanggyeong/The Tripitaka Koreana* (1978), a film that dramatizes the collective effort to make 80,000 wooden printing blocks containing Buddhist scriptures to protect Korea from the invading Mongols in the thirteenth century. While heroic biopics were generously endowed with state grants and film awards, especially the Grand Bell Awards, the audience response to these films was less than lukewarm. Unsurprisingly, the ideologically-tainted historical genre quickly fell from the public's favour.

With the change of government in the early 1980s, the film industry faced new opportunities and trials. Retrospectively, the 1980s' cultural scene is summarized by the '3-S policy' that promoted screen, sex, and sports, distracting the people with

jolly entertainments while dulling the public critique of the military regime. Welcoming the change in censorship, the industry took the opportunity to revitalize the market by producing *ero* films that could be shown at late-night screenings. Hence, the costume genre with a strong erotic content became dominant, often dealing with exotic sexual appetites and practices in pre-modern times. For example, the erotic *sageuk Eoh Wu-dong* was the second biggest Korean box-office hit in 1985. In it, the wife of a noble-man, Eoh Wu-dong, becomes a courtesan after her sadistic husband abandons her. An emancipated woman, Eoh uses her sexuality to manipulate men captivated by her charm, though tragically she commits suicide by the end of the film, pushing forward the message that a transgressive woman must be punished by death. The scene where she, played by the voluptuous Lee Bo-hee, seduces the King during a picnic was deemed too scandalous, and the chairman of the Ethics Committee resigned after the obscenity dispute.

The 1986 agreement of direct distribution by foreign-film companies (enacted in 1987) brought a seismic shift in the film industry, precisely because it invalidated the notori-ous import quota licence. A large number of Hollywood films flooded onto local screens and Korean cinema entered a new phase of recession in the early 1990s. The popular-ity of *ero sageuks* died out eventually. Tellingly, the 1990s is the only decade since the introduction of cinema where an adaptation of 'A Tale of Chunhyang' was not made, and only a handful of historical dramas were produced in the entire decade, including *Yeong-wonhan jegug/Eternal Empire* (1994). Partially due to the fact that the historical drama remained almost forgotten in the 1990s, its sudden comeback in the 2000s made an even stronger impact.

Since the early 2000s, expensive, visually-striking, and successful costumed pieces have been showcased to the audience. The new impetus of the *sageuk* was witnessed in 2003 with the release of five period films: *Cheonnyeon ho/The Legend of Evil Lake*; *Nangman jagaek/Romantic Warriors*; *Hwangsanbeol/Once Upon a Time in a Battlefield*; *Seukaendeul: Joseon namnyeo sangyeoljisa/Untold Scandal*; and *Cheongpung myeong-wol/Sword in the Moon*. Their box office results were promising, with *Untold Scandal* and *Once Upon a Time in the Battlefield* making it into the top-10 list of box-office hits of that year. The record-breaking success of *King and the Clown*, which is still the third-highest grossing Korean film ever, in early 2006 not only bolstered the position of the period genre in Korean cinema but expedited the history boom that stormed the wider cultural sectors, including television, publishing industry, and performance theatre. Two labels – 'fusion *sageuk*' and 'faction films' – were attached to the new cycle of historical drama. Fusion historical drama highlights an apparent mixing of the traditional and the foreign, and the past and the present. A film that cleverly recontextualizes an eighteenth-century French novel into the Korean setting while still striving for period authenticity, *Untold Scandal*, heralded the rise of fusion *saguek*. Historical faction films include those where the boundary between historical fact and fiction is blurred, and the narrative is often peppered with mystery and conspiracy. For instance, an adaptation of a graphic novel *Bulkkotcheoreom Nabicheoreom/The Sword with No Name* (2009) subverts the official history of Empress Myeong-seong, who was tragically murdered in 1895, by imagining her as a heroine of a forbidden romance.

The *sageuk/sidaegeuk* in the 2000s shares a number of narrative and aesthetic traits. Firstly, recent historical dramas, to varying degrees, have dispensed with the stiff and didactic historical tone. An apt example is Lee Joon-ik's *Once upon a Time in a Battle-field*, a film that heavily relies on slapstick and verbal humour in restaging a historic battle in the seventh century AD. Here, the history is drawn to ordinary people, recaptur-ing the lives of the lowly and the forgotten, such as the secret lives of the court ladies in *Gungnyeo/Shadows in the Palace* (2007). In addition, recent historical drama flaunts meticulous period *mise-en-scène* rendered through high production values,

made possible by the involvement of high-profile production and costume designers, as seen in *Hwang Jin Yi* (2007), which featured *haute couture* traditional costume designed by a renowned fashion designer Jung Kuho. Even though these films are set in the past, the visual images are reinterpreted into something modern and appealing for the current audience's taste. Through its narrative, new period drama also penetrates the issues that are relevant to contemporary Korea and, as such, the films can vie for maximum market returns. The genre is proving extremely versatile, ranging from a colonial biopic *Cheong Yeon/Blue Swallow*; a blockbuster action featuring ancient rocket missiles, *The Singijeon/Divine Weapon*; an uber-bloody murder mystery, *Hyeol-ui nu/ Blood Rain*; to a period romance with a gay subtext, *Ssanghwajeom/A Frozen Flower*. It is impossible to say whether the historical genre will continue to thrive; however, what is clear is that the *sageuk* has made an indelible impact on the national film industry in the 2000s and its legacy will certainly live on.

Yun Mi Hwang

A War Diary

Nanjung Ilgi

Studio/Distributor:
Han Jin Enterprises Co., Ltd

Director:
Jang Il-ho

Producer:
Han Gap-jin

Screenwriter:
Na Han-bong

Cinematographer:
Seo Jeong-min

Art Director:
Cho Kyung-hwan

Composer:
Jeong Min-seob

Editor:
Ree Kyoung-ja

Duration:
125 minutes

Genre:
Historical drama/heroic biopic

Cast:
Kim Jin-kyu, Jang Dong-he,
Hwang Hae

Year:
1977

Synopsis

An ambitious and expensive biopic of Admiral Yi Sun-shin from the sixteenth century, *A War Diary* closely follows Yi's major victories at sea, his trials, and eventual death in battle. The film begins with a scene where Yi designs the turtle ship and supervises the collective vigour to build one. Yi's provisional plan soon comes as a lifesaver when Japan invades Korea, starting the Imjin War. With his impressive turtle ship and war stratagems, Yi thwarts the enemy's advance at sea. Acknowledging his achievements, the Korean King Seonjo appoints him as the most senior naval commander. However, the ever-jealous fellow admirals fall victim to Japan's machinations and accuse Yi of contempt and mutiny. Yi is jailed but soon reinstated to fight in the frontline when the navy faces complete defeat during his absence. Returning to battle, he crushes some three hundred Japanese ships with only a dozen of his own. In 1598, Yi dies after being wounded by a bullet in battle. His last wish was not to have his death announced to the fighting marines, fearing they may lose morale. The film ends as the narrator venerates Yi Sun-shin's greatness and orchestral music soars in the background.

Critique

Few would argue that *A War Diary* is a cinematic masterpiece. Even so, the film is worth discussing in relation to the 'heroic biopic': a cycle of historical dramas that was prominent in the mid- to late 1970s. Heroic biopics, including *A War Diary*, featured (mostly) male sacrificial heroes who come to save the nation at a time of extreme difficulties, such as famine and war. The Korean film industry of the 1970s was facing an increasingly-hostile environment, particularly with the growth of television, the continued popularity of foreign imports, and the oppressive political milieu under the military government. As a last resort to hold ground, the studios churned out heroic biopics that would get state approval and help them earn the film import licence. This practice led to an ideological shaping of heroic biopics that fitted with the nationalistic agenda of the dictatorship. Together with Great King Sejong, whose life is dramatized in *King Sejong the Great*, Admiral Yi became one of the favourite icons of public indoctrination in this period.

 A War Diary has all the trademarks of a heroic biopic. Not only do the opening titles display an official stamp from the Navy Headquarters, suggesting they endorsed it, but the film displays images of bare-chested and sweaty men rowing a boat, equating the national with the masculine and the collective. Further, the wide shots showing the peasant class transporting heavy stones and chopping down trees bring home the message that ordinary folk should do their bit for the homeland. Yi is portrayed as a brave admiral and a superb human being in every way. While sympathetic to the hardships of the lower class, as in the scene where he personally visits the family of a nameless worker who died while

working at the construction site, he is not distracted or affected by personal feelings. Even when he hears the news that the Japanese have murdered his whole family, he immediately composes himself and carries on with his duties as a commander. Nothing will come between him and his determination to protect his country. Like the turtle ship that breathes sulphurous smoke and fires a cannon, he embodies the invincible power and relentless spirit, requisite for a true heroic figure.

For an action-driven film, *A War Diary* is relatively slow in pace and melodramatic in tone. The battle scenes are shot with full-scale boats and miniatures and then cleverly edited to incorporate close-ups and landscape shots. No expense was spared in recreating the battle ships and the costumes. Lee Hae-yoon, the godmother of costume designers who worked on about three hundred films in a career that spans four decades, provided her talent for this period war film. Unfortunately, like so many Korean films made in the 1970s, *A War Diary* is not easy to get hold of. Those interested may have to make a personal visit to the Korean Film Archive to watch it.

Yun Mi Hwang

Divine Weapon

Sin-gi-jeon

Studio/Distributor:

KnJ Entertainment,
CJ Entertainment

Director:

Kim Yu-jin

Producer:

Kang Woo-suk

Screenwriter:

Lee Man-hee

Cinematographer:

Byun Hee-sung

Art Director:

Min Eon-ok

Composer:

Jo Seong-woo

Editor:

Kim Hyeon

Synopsis

Forced to flee her father's house following an attack by foreign agents, the inventor's daughter Hong-li finds refuge among a band of merchants. Her importance to the nation quickly becomes known to her hosts, who are soon persuaded to help her in developing her late father's masterpiece – a weapon so terrible, so powerful, that it will keep even the mighty Ming Empire safely at bay. There is, however, a major problem in the attempts to create the weapon. Hong-li was forced to leave everything behind when she fled and a subsequent visit to her former abode has left the precious blueprints in the hands of Ming forces. With Ming armies amassing on the northern borders and the Chinese emperor demanding impossibly-high tributes for himself, his Queen and even his Queen's servants in the hopes of instigating a battle that will destroy the growing power of the Joseon Kingdom, the only hope for the nation's survival may rest in the hands of Lady Hong-li and her lowly allies.

Critique

Screenwriter Lee Man-hee, not to be confused with the famous director of the same name, seems to be making a career of writing scripts focusing on tumultuous times in history. He has written screenplays set in the 1970s (*When I Was Nine*), in the Korean War (*71: Into the Fire*) and in the period on the cusp of the Joseon Dynasty (*Divine Weapon*). While the movies set in this past century may be easy to understand, a film set early in the 1400s may be

Duration:

134 minutes

Genre:

Historical drama

Cast:

Jung Jae-young,
Han Eun-jeong, Huh Joon-ho,
Ahn Sung-ki, Jung Sung-mo

Year:

2008

more difficult for many viewers unfamiliar with some early Korean history.

Divine Weapon takes place shortly after the fall of the Kingdom of Goryeo and just before the period of relative peace and prosperity that defined the rule of King Sejong, the great-grandson of King Taejo formerly known as General Yi Seong-gye. Goryeo fell when General Yi disobeyed orders and, instead of taking his army to invade Manchuria as he was assigned, turned the army around and conquered the capital in 1388. He ruled through the existing monarch King U for awhile and then through U's son, 8-year old King Chang, for a short time before having them both executed and declaring himself King Taejo. This ended the 400-year-old dynasty and began the Joseon Period that ran from 1392 to 1910. However, the initial change of power did not sit well with many nobles and many who opposed the king lost their titles and land, if not their lives.

Seol-ju, the merchant aiding Hong-li, mentions that his father was a general of Goryeo but he has now become a lowly merchant. This is, of course, the source of his bitterness and explains his initial reluctance to aid the throne. While being a merchant does not seem a bad thing, the fact is that the merchant class throughout most of Korean history were viewed with suspicion. Most people of the time were poor tenant farmers or slaves and the rest were nobles of varying degrees. The merchant class could not easily fit in with either of the groups, especially if, like Seol-ju, they came from disgraced families.

The Divine Weapon, 2008, C J Entertainment/Kobal Collection

However, for a brief period under King Sejong the Great, the merchants flourished, able to trade freely with the Ming Dynasty and Japan and possibly have rare meetings with traders from Persia. King Sejong's rule is also famous for many technological and social advances. Sejong is most famous for overseeing the creation of 'hangul', the Korean alphabet still in use today. Much easier to learn and write than the Chinese characters that were previously in use, hangul made literacy accessible to everyone – although, of course, the lowest classes had no time to learn it. Sejong is credited with sponsoring advances in agriculture, inventing a rain gauge and sundial-like device and, as depicted in *Divine Weapon*, ordering the creation of the first missiles.

Creative licence is to be expected in any movie attempting to bring to life events from 600 years earlier and here, as in many Korean period dramas and films, the role of women is expanded. Here, Hong-li supervises the building of the weapon designed by her father, and Seol-ju's sister, Bang-ok, is an archer and given equal responsibility on the battlefield and on the mission to retrieve the lost documents. Knowing the place of Joseon women, this seems to be extremely unlikely. While, in the Goryeo Period, women could own property and enjoyed some of the same benefits as men, such as being able to remarry if they wished, in the Joseon Dynasty, the status of women decreased and, later in the period, a woman could not even leave the gardens of her home, let alone join a battle. However, this and other historical inaccuracies can be ignored for the sake of a good story.

Tom Giammarco

Goryeojang

Goryeojang

Studio/Distributor:
Korean Art Films

Director:
Kim Ki-young

Producer:
Kim Ki-young

Screenwriter:
Kim Ki-young

Cinematographer:
Kim Deok-jin

Synopsis

In an attempt to stave off starvation, Kuryeong's mother marries a man of meagre property and attempts to integrate into his already prodigious family. However, young Kuryeong soon finds his life endangered after his ten step-brothers overhear a prophecy predicted by the bitter village shaman that Kuryeong is destined to kill all of his new siblings. Mother and son move out of the house and onto a nearby piece of land but, as the years pass, resentment, drought and famine spread. Lame due to the ten brothers' attempt on his life, the adult Kuryeong works harder than anyone for his survival, but he is still looked down upon by everyone in the village, including the woman he loves. Kuryeong, instead, enters into an arranged marriage, but again his brothers conspire to ruin his happiness. As the famine worsens, human life cheapens and anything can be bought for a handful of potatoes. Desperate times call for desperate measures and the villagers find themselves turning to the old shaman and some ancient practices to end their hardship.

Art Directors:

Park Seok-in, Kim Hyeon-gyun

Composer:

Han Sang-ki

Editor:

Kim Ki-yeong

Duration:

110 minutes

Genre:

Drama

Cast:

Kim Jin-kyu, Joo Jeun-ryu,
Kim Bo-ae, Kim Dong-won,
Lee Yae-chun

Year:

1963

Critique

The title of Kim Ki-young's film, *Goryeojang*, is a term that refers to the ancient practice of carrying one's relatives to the top of a mountain when they reach the age of seventy, and abandoning them there. One of several traditional practices depicted in this film that may seem hard to fathom from a modern perspective, it was a means of ensuring that there would be enough food for the next generation in a time that required every member of the family to work in order to survive. It was a good parent that went willingly and a dutiful son who carried his aged parents to their deaths. Those who resisted were seen to be challenging divine will.

Master film director, Kim Ki-young, most famous for his 1960 masterpiece, *Hanyeo/The Housemaid*, crafted a bleak and dismal world in *Goryeojang*. The crude village is composed of dirt, straw and deadwood amidst rough mountains and dust that barely sustains life. The inhabitants have little in the way of hope beyond their daily struggle to live. However, not everyone in the village is equally hungry. The 'Ten Brothers,' as they are referred to throughout the film are a powerful, physical force in the village. They attempt to advance their extremely-limited ambitions through bullying and the monopolizing of resources. Kuryeong is their rival in this activity. He is buying up the land of the other impoverished villagers with small sacks of potatoes, barely enough to allow them to eat another week. The other force working in the village, attempting to control the inhabitants, and nature as well, is the shaman. While she may very well believe in the Divine Spirit and the ghosts that help her spout her prophecies, she is motivated by hatred of the brothers who forced her out of her marriage when they were children. The brothers fear her mystic powers and dealings with ghosts, so she acts as a check to their power, but both forces are willing to temporarily align for mutual benefit – food, money or the end of the drought.

In many of Kim's films, there is a threat from without that threatens to destroy family harmony and perhaps the family unit itself. In *Goryeojang*, that threat comes from within in the form of children. At one point, Kuryeong's mother sympathizes with Gannan and states that women suffer because of their children and explains that mothers stay hungry because their children eat everything – quite a different sentiment than when she later says to her son that she was glad to suffer for him. Gannan's nine children are a frightful brood, beating and clawing their grandparents for a single bite of boiled potato and devouring the family's seed potatoes, dooming the family even if the drought breaks. Equally frightening, as children and adults, were the Ten Brothers and the casual nature in which they destroy their own family as well as others. Their father was married a total of five times, but their grandmother tells Kuryeong's mother that no woman save her lasted in that house more than three days with those children. Later in life, with food supplies running low, they decide to starve their own father to death as he is not contributing to the survival of the family any longer. They cruelly mourn him as though he were dead, while he slowly starves to death in the corner.

Rats also make frequent appearances in Kim's films. Here, there is not a single rodent but there are frequent comparisons made between humans and rats. This is particularly true when people are discussing children. Families in this movie are composed of large numbers of offspring much like a litter of rats, and the manner in which Gannan's own brood raid her grandparents house calls to mind a hoard of vermin devouring everything they can get their teeth into.

It is unfortunate that so much footage is missing from the extant copy of this film. Were it complete, it would possibly rival *The Housemaid* as Kim's best work.

Tom Giammarco

Hwang Jin-yi
Hwang Jin-yi

Studio/Distributor:
Cine2000, SIZ Entertainment Co.

Director:
Chang Yoon-hyun

Producers:
Lee Choon-yun, Cho Sung-won, Hwang Gyeong-seong

Screenwriter:
Kim Hyun-jung

Cinematographer:
Choi Young-taek

Art Directors:
Jung Ku-ho, Kim Jin-cheol

Editor:
Nam Na-young

Duration:
141 minutes

Genre:
Period Drama/romance

Cast:
Song Hye-kyo, Yoo Ji-tae, Ryoo Seung-ryong

Year:
2007

Synopsis

Hwang Jin-yi is a retelling of the story of Hwan Jin-Yi, the famed gisaeng of the Joseon era who was also known as a poet. Jin-Yi grows up in a wealthy, aristocratic home and, as an adult, her childhood friend Nomi returns and becomes one of the head servants in her compound. Her life suddenly comes tumbling down when her mother reveals to her that she was in fact adopted and that her real mother was a gisaeng who has recently died. Confronted with a difficult choice, Jin-yi decides not to live a lie and turns her back on her life of ease to become a courtesan like her mother. Her beauty and strength of character enable her to adapt to her new surroundings but not without difficulty. It is not long before she catches the eye of a powerful magistrate but now she will be torn between her duty and her love, as Nomi is now a rebel in the magistrate's crosshairs.

Critique

In many respects, *Hwang Jin-yi* resembles the numerous Hollywood prestige productions that are made each year with their sights set on Oscar glory. Those that succeed are for the most part very strong, while the many that flounder in their lofty aims are sometimes arrogant and turgid affairs. Sadly, veteran director Chang Yoon-hyun (*Cheob-sok/The Contact*, 1997; *Telmisseomding/Tell Me Something*, 1999) fourth feature falls resolutely into this latter camp. This is a stately and respectable period film that is nowhere near as engaging as it considers itself to be. This is the sort of film that thinks it can get away with this dialogue such as: 'I don't know when I'll be back or if I'll return alive. If I die, bury me in the streets so that people may trample over me': words that would be more fitting and resonant in *Rambo First Blood: Part II* (Ted Kotcheff, 1985).

The story is a famous one in Korea and I must admit I was not previously familiar with it: perhaps this contributed to my difficulty in following the plot. The first and final acts are relatively easy to comprehend but the protracted midsection meanders

considerably. I more or less understood what was going on as there was not much to it, but the plotting was stodgy and quite messy, which clashed with the delicate *mise-en-scène*. *Hwang Jin-yi's* plot is a thin and uninvolving one, tightly stretched over an excessive 141-minute running time. From what I have read, Hwang Jin-yi's story (or legend as her existence is disputed) seems to be a very interesting one. It is ripe for cinematic adaptation and has indeed been brought to the screen many times but this version does little to explore her and her circumstances, opting instead to frame her life around the one of the fictional Nomi.

Song Hye-kyo, a very famous K-drama star, is radiant. She is a true beauty whose face begs to be seen on screen and this role was an attempt for her to break into more serious territory but a few minutes is all you need to decide that she should probably stick to what she is good at. K-drama, while often very entertaining, relies on repetition and exaggeration to emphatically get its point across. For a fallen-woman dramatic narrative such as this one, a lighter touch is required which Ms Song does not possess. She is never bad but she lacks depth and range, her expressions limited to serious, shocked/offended or demure. During one critical point of the film she pours a drink for a man in what is supposed to be a serene gesture but Song's movement is less a gentle stream than a choppy waterfall.

While ostensibly set in the world of gisaengs, *Hwang Jin-yi* does not work as an erotic period drama like the excellent Seukaendeul: *Joseon namnyeo sangyeoljisa/Untold Scandal* (2003) or *Bang Ja Jeon/The Servant* (2010). Despite its apparent focus on the life and times of its central protagonist it also fails as a revealing character study. From an aesthetic standpoint it just about succeeds as a handsome historical film but its complicated plotting and self-serious nature prevent it from being an engaging one. I suggest you steer clear of this soporific mess by choosing one of the many other superior Korean period efforts instead.

Pierce Conran

Modern Boy

Modeonboi

Studio/Distributor:
KnJ Entertainment

Director:
Jung Ji-woo

Producer:
Kang Woo-suk

Synopsis

Set in the Seoul of 1937, *Modern Boy* charts the adventures of Hae-myeong. Educated in Tokyo and now working for the colonial government, Hae-myeong belongs to the privileged class of the late colonial period. Basking in comfortable living, he drives a fast car and carries abundant cash, ready to spend it on pretty women. But everything changes when he meets Laura, a nightclub singer and dancer. He wholeheartedly pursues her but Laura, who also goes by the names Nan-sil and Natasha, remains elusive. What is more, when the lunchbox she prepared for him turns out to be a bomb, he is dragged into a web of deceit, mystery, and danger. Later, it is revealed that Laura/Nan-sil is a member of a radical resistance group that carries out terrorist acts. Effectively, Hae-myeong's

Screenwriter:

Jung Ji-woo

Cinematographer:

Kim Tae-gyeong

Art Directors:

Jo Sang-gyeong, Park Ju-yong

Composer:

Lee Jae-jin

Editors:

Eom Yun-ju, Wang Su-an

Genre:

Historical drama

Duration:

121 minutes.

Cast:

Park Hae-il, Kim Hye-soo,
Kim Nam-gil

Year:

2008

love for Nan-sil costs him his job, his life of comfort, and his friend-ship with a Japanese prosecutor, Shinsuke. When he finds out about her plan to blow up the war-commemoration ceremony, he insists that he do the job instead. As the jacket rigged with explo-sives is presented before the two lovers, the question remains, who will end up carrying out the suicide bomb mission?

Critique

Modern Boy belongs to a cycle of colonial period dramas that appeared in the mid-2000s that revisited the nation's most shame-ful and bleakest period. So far, the colonial past in cinema had often been a time where the tension between stereotypical social types, the admirable resistance fighters and patriotic thugs on the one hand and the evil Japanese and corrupt collaborators on the other, are resolved in blood, violence, and death. Now, the fresh take on colonial Korea is expressed in a number of film genres including martial-arts biopic *Fighter in the Wind*; medical horror *Epitaph*; Manchurian Western *The Good, The Bad, and the Weird*; and sporting drama *YMCA Baseball*. These films imagine the colonial period in a striking manner, capturing the everyday life of people, who remained in between the ideological divide. They also appeal to the audience with a colourful and retro-chic *mise-en-scène* that includes songs, lifestyles, and set designs. The characters appear in silk dresses adorned with beads and colour-fully-tailored three-piece suits, and sing and dance seductively in a smoke-filled jazz club. A period, mostly remembered in black-and-white photography, is now brought back to life as primary-coloured spectacle, complete with period glamour. For instance, a spy comedy *Once Upon a Time* features two professional thieves whose actions are guided by the acquisition of personal wealth and not liber-ation. Even here, however, a nationalist ideology enters into the text towards the end, closing the narrative by safely containing all kinds of subversion and misdemeanour. In this sense, recent colonial-period dramas are symptomatic of the ambivalent public imagination of the period, straddling a regrettable evidence of Korea's failure to achieve autonomous nationhood and an exotic or a exciting place full of consumer possibilities.

Modern Boy is based on an award-winning novel *Die Out or Survive?* which created a sensation for its frank and original depic-tion of Seoul in the late 1930s upon its publication. The film was the blockbuster-event film of the latter half of 2008, featuring big names like Kim Hae-soo and Park Hae-il, who appeared in *Memories of Murder* and *The Host*. With the help of high produc-tion values and CGI-assisted period recreation, the film paints a visually-stunning picture of the familiar, yet exotic capital city. The film invites the audience to sensually experience the times through the material fetishism of one 'modern boy', Hae-myeong, who wanders the urban cityscape in search of his love. The recreation of landmark places in Seoul, including the Seoul Train Station, the Sungnye Gate and the General-Government Building, is particu-larly stunning. The film charts the architectural history of Seoul

Modern Boy, 2008, C J Entertainment/Kobal Collection

by giving emphasis to these heritage sites. The mood of the film, however, drastically changes from one of humour and romance to melodrama and tragedy towards the end. The allure of the period and the burden of history eventually collide in a violent manner as the film tries hard to destroy, in an equally-spectacular manner, the meticulously-recreated world. Unfortunately, this big-budget period drama fared disastrously at the box office, obliquely revealing Korea's own conflicting memories of its colonial history.

Yun Mi Hwang

Spinning a Tale of Cruelty towards Women aka The Spinning Wheel

Yeoinjanhoksa mulreya mulreya

Synopsis

Beautiful and pure Gil Rye is given to a wealthy family for a 'spirit wedding' to their dead son, making her a technically a widow by marriage. Expected to remain chaste out of respect for her 'husband's' ghost, Gil-rye proves up to the challenge and attempts to please her in-laws. Her wealthy in-laws appreciate her kindness and give Gil-rye her own house and maidservants. However, a local low-life realizes that the house is inhabited only by women. He breaks into her house several nights and rapes her each time. Although her father-in-law sets a trap for the rapist, Gil-rye is expelled from the house. Forced to wander the countryside, she meets Yoon

Studio/Distributor:

Han Rim Films

Director:

Lee Doo-yong

Producer:

Jeong Woong-ki

Screenwriter:

Im Chung-hui

Cinematographer:

Lee Seong-chun

Composer:

Jeong Yoon-joo

Editor:

Ree Kyeong-ja

Duration:

100 minutes

Genre:

Drama

Cast:

Won Mi-kyung, Sin Il-ryong, Moon Jung-suk, Choe Sung-kwan, Park Min-ho

Year:

1983

Bo, the son of a formerly noble family that has been stripped of their land and titles. He is working for a rich landowner and Gil-rye becomes a serving girl in the same household. The two fall in love but their budding romance is threatened by their lecherous employer. Little do they realize that, although their current situation is uncomfortable and sometimes dangerous, their futures hold far worse.

Critique

I was not sure what to expect when preparing to watch the awkwardly-titled *Spinning a Tale of Cruelty towards Women*. The early eighties were an unfortunate time for Korean cinema. Although some of the restrictions that had hampered directors in the previous decades were being relaxed, the film-makers were taking advantage of this by filling their movies with overtly-sexual imagery – whether it was necessary for the story or not. In small doses, it is fine – in larger doses it becomes funny – but when it is overdone, it just becomes uncomfortable. The first 30 minutes or so of this film had me wondering if I would be able to get through it. Phallic-shaped rocks dotted the landscape and women make use of a giant wooden mortar to grind grain while giggling suggestively. In addition, the main character is raped twice in about ten minutes. However, I stuck through that part and my patience was rewarded with a surprisingly well-told story – particularly the final chapter.

Basically, the story can be divided into three parts. The first chapter finds our heroine given in marriage to a dead man. This was part of a traditional belief that a spirit could not move on if he or she died without a spouse. The living half of this type of couple was expected to behave as if his or her spouse was alive. Recent Korean films that have utilized this extinct tradition are *Gidam/Epitaph* (2007) and *Natsun Got, Natsun Sigan Soke-seo/Another Time, Another Place* (2008). Although certainly sexually unsatisfying, this is one of the happiest times in Gil Rye's life. It all comes crashing down after she is raped. Her in-laws recognize that she is innocent of any crime, which is why she is simply thrown out of the house. This film takes place somewhere in the Joseon Period and a much more extreme punishment could have been enacted.

The second chapter has a different tone from the first and last chapters, which are serious dramas. It has much more of a comedic element to it. Even lead actress Won Mi-kyung seems as if she is playing a different character than in the other two segments of Gil Rye's life. In the first chapter, she lives like the mistress of the household: confident, strong and dignified. In the final chapter when she is asked to bear the worst pain a human can bear, she does so again with strength and with dignity. However, all of her dignity and refinement seem to disappear completely in the middle chapter, where she acts like a comic relief character instead of the star. Her purity and naivety is exaggerated so that she appears to be almost a simpleton and somewhat wanton.

This film was directed by Lee Doo-yong, whose Hong Kong-inspired action movies of the 1970s I have always found to be

competent if uninteresting due to their pacing. His best-known work might be the oddly-titled *Dol-a-on oedali/Returned Single Legged Man* (1974) and *Dol-a-on oedali 2/Returned Single-Legged man 2* (1974). From viewing this film, I would say that director Lee seems better suited for melodramas than his action films. Lee remained active right up until 2002 when he tried his hand at a remake of *Arirang* in 2002, which, unfortunately, has never received a DVD release.

Tom Giammarco

Strokes of Fire

Chihwaseon

Studio/Distributor:
Cinema Service

Director:
Im Kwon-taek

Screenwriter:
Kim Yong-ok Do-ol

Cinematographer:
Jeong Il-seong

Art Director:
Ju Byeong-do

Composer:
Kim Young-dong

Editor:
Park Sun-deok

Duration:
120 minutes

Genre:
Period drama

Cast:
Choi Min-sik, Ahn Sung-ki,
Yu Ho-jeong, Kim Yeo-jin,
Son Ye-jin

Year:
2002

Synopsis

Strokes of Fire tells the story of the legendary painter Jang Seung-Eop (1843-1897?), who lived and worked through those turbulent times when the Joseon dynasty was under immense pressure from Western and Japanese imperial forces. At first, Jang's gift is not fully recognized due to his commoner background until he meets a liberal-minded Confucian scholar, Kim Byeong-Mun, who becomes Jang's lifetime intellectual mentor and emotional supporter. Through Kim, Jang is introduced to a well-established circle of painters where he further develops his artistic sensibility and skills. Despite his social background, Jang rises quickly to the point where he is commissioned to produce paintings at the royal court. However, the strict atmosphere there so dissatisfies Jang – whose bohemian lifestyle, especially his fondness for alcohol and women, is a source of his inspiration – that he runs away. Driven to continuously renew and transform his art, he wanders from place to place, seeking to fulfil his dream. Finally, having grown old and weak, Jang settles down in a pottery factory where he finds his last solace in the brightly-burning flame inside a kiln, thus bringing his long and exhausting journey to a close.

Critique

Im Kwon-taek received the Best Director's Award at the 55th Cannes Film Festival for this film. Similar to his *Chunhyang* of two years before, *Strokes of Fire* showcases the traditional art and culture of Korea. While *Chunhyang* can be regarded as a re-interpretation of the aesthetics of the traditional one-man theatre, pansori, *Strokes of Fire* interweaves Korean history with the life of Jang, whose private life, unlike his paintings, has been largely unknown to this date. The two major catastrophic historical events he lived through, the Kapsin Coup (1884) and the peasant uprising (1894-5), for example, are portrayed as failing because of the moral corruption of the Joseon government that undermined its ability to defend its sovereignty. A critical view of society is embedded in the character, Kim Byung-mun, played by a veteran actor, An Seong-Ki, and his circle of friends whose ambition is to influence the course of history. As Kim bitterly confesses to Jang, their will to change the historical tide turned out to be a reckless dream; by the end of

the nineteenth century Joseon was falling before Japanese power. The screenwriter took great liberties in re-constructing Jang's life, implicitly suggesting that the source of Jang's madness, anger and frustration was his politically-chaotic times.

Jang (Choi Min-sik) has a violent temper and often expresses his philosophy of art while in a drunken stupor, as if mocking those in power. Although Choi is a gifted actor, his acting range is reduced in this film by a script that exaggerates the aesthetics of traditional East Asian Art, leaving him very little space to interpret the character on his own. Nonetheless, this film's greatest accomplishment is its cinematography. The cinematographer Jeong Il-seong's wide shots are sublimely beautiful, capturing a landscape that mirrors the aesthetics of ink and brush paintings, and masterfully employing negative space to convey the balance between the fullness and emptiness of life.

One scene that conveys the suffering of life and death with dignified serenity is when Jang sets out on the road after his first love, So-un (Son Ye-jin), dies of illness at a young age. Jang has secretly admired So-un, a daughter of the government bureaucrat from whom Jang received his apprenticeship; yet Jang never had a chance to (or to put it more accurately, was never allowed to) express his feeling for her due to the class gap between them. After So-un's death, Jang starts aimlessly drifting around the mountains and plains; the camera focuses on him walking as the seasons keep changing in the background, signifying the passing of time. When Jang is finally ready to release the image of So-un from his mind, he is standing in a snow-covered open field staring at a white crane soaring high in the sky, reminiscent of the crane Jang painted for So-un right before she died. Did Jang represent a fatalistic view of human life and history when he literally let 'the fire dictate' his path or did he finally find some truth in the burning fire? There is no clear answer. Nonetheless, *Strokes of Fire* is a visually-stunning masterpiece filled with a deep empathy for people who live with passion.

Jooyeon Rhee

Surrogate Mother

Ssibaji

Studio/Distributor:
Shin Han Films Co., Ltd

Director:
Im Kwon-taek

Synopsis

A tomboy barely out of her teens, Ok-nyeo is secretly sent as a surrogate mother to Lord Shin. Her role is to provide a male heir that the wife Lady Shin has failed to produce. At first, Ok-nyeo and Lord Shin abhor the idea of such 'procreative' intimacy with a stranger, but soon become deeply attached to each other as the love-making continues. Ok-nyeo, who becomes pregnant, indulges in the pomp and pampering provided by the upper-class family and even dreams of becoming Shin's official wife, much to Lady Shin's chagrin and jealousy. Ok-nyeo finally gives birth to a boy but the baby is swiftly taken away from her and handed to Lady Shin, who declares him to be her own. Ok-nyeo is then sent away without

Producer:
Jeong Do-hwan

Screenwriter:
Song Gil-han

Cinematographer:
Koo Joong-mo

Art Director:
Won Ki-ju

Composer:
Shin Byeong-Ha

Editor:
Park Soon-duk

Duration:
95 minutes

Genre:
Historical drama

Cast:
Kang Soo-yeon, Lee Gu-sun,
Bang Hee, Han Eun-jin

Year:
1987

being given the chance to hold her son or say good-bye to Master Shin. A year later, the young surrogate mother hangs herself when her repeated request to see her natal son is denied by the Shin family.

Critique

Historical dramas with soft-core pornographic elements became a major trend in the 1980s. The arrival of *ero* films in this period shaped two divergent but closely-related *sageuk* cycles: 'international festival-oriented films' (*gukje yeonghwaje yeonghwa*) and '*tosok ero*', which I translate as 'folk erotica'. Blending local flavour and eroticism with humour, folk erotica drew local audiences into the cinemas, while a certain level of artistic ambition and requisite sexuality characterized the international festival films, which vied for global recognition by promoting traditional culture and customs. Folk erotica set in pre-modern Korea featured virile men and women with uncontrollable sexuality, as seen in *Byeon Gwang-swoi*, or a peasant girl selling her body for a living as in *Mountain Strawberries*. These films are characterized by a sensational subject, such as the appearance of a hermaphrodite in *Sabangji* and equally-salacious film posters displaying semi-nude photos of the female star. Although similarly packed with eroticism, the 'international festival *sageuk*' foregrounded native customs and traditions, catering to the curious eyes of a foreign audience. For instance, the evocatively-titled film *Spinning the Tales of Cruelty Towards Women* succeeded in making it into the '*un certain regard*' section at Cannes. What should be made clear here is that the two categories are not exclusive but, rather, two sides of the same coin. *Surrogate Mother* is a prime example of an internationally-lauded Korean period drama made by an eminent auteur Im Kwon-taek.

The film deals with an ancient custom that is alien even to modern Koreans, *ssibaji*, which literally means 'receiver of seed'. It features ample sex scenes and nudity, which ironically go in hand with the display of a suffering traditional woman. The film meticulously charts the ordeal that a surrogate mother must undergo. As a baby-producing machine, her body is subject to absolute control by the Shin family, where she is restricted in what she can eat and even how she should move. The scene where Ok-nyeo is trained to breathe in the energy of the moon as a way to promote impregnation is at once mystical and painful to watch. The film's moral stance on the cruel practice of surrogate motherhood is not entirely clear. Did Ok-nyeo kill herself out of indignation and protest or did she end her life of grievance because that was her only option? In other words, it is unclear whether the film criticizes or accepts these old systems and values. Even so, the film is beautifully shot and edited, like any other Im Kwon-taek film, where the authentic and atmospheric national landscape is perfectly captured. In all, *Surrogate Mother* marked the pinnacle of the 1980s' international film festival drive, when the star Kang Soo-yeon won the Best Actress Award at Venice in 1988.

Yun Mi Hwang

The King and the Clown

**Wang-ui Namja
(The King's Man)**

Studio/Distributor:
Eagle Pictures/Cinema Service

Director:
Lee Joon-ik

Producers:
Jeong Jin-wan, Lee Joon-ik

Screenwriter:
Choi Seok-hwan

Cinematographer:
Ji Kil-woong

Art Director:
Kang Seung-yong

Composer:
Lee Byung-woo

Editors:
Kim Sang-bum, Kim Jae-beom

Duration:
119 minutes

Genre:
Historical drama

Cast:
Kam Woo-sung,
Jung Jin-young,
Lee Jun-ki, Kang Sung-yeon

Year:
2005

Synopsis

Set in the Joseon Dynasty, Jang-sang and Gong-gil are two men from a group of travelling performers. Unhappy with the way Gong-gil is being prostituted by their boss, Jang-sang escapes with him one night and they wander the countryside until they find another group of performers to work with. This group, however, stages plays that satirize the King and they are all arrested. They could still win their freedom if they make the King Yeonsan laugh, but they are caught in the politics of the palace and freedom is not so easy.

Critique

Selected for the Official Korea entry for the Best Foreign Language film at the Academy Awards in 2006/7, *The King and the Clown* walked off with 21 awards from seven other film festivals and broke records for 2006 domestic film viewing. Its unexpected success was perhaps down to its breaking of taboos over homosexuality, a theme not often tackled in Korean cinema at the time, and perhaps also due to the fact that it mocked the powerful who are unable to accept satirical portrayals of their shortcomings, something that resonates with any audience.

To provide some historical context, King Yeonsan is well known for his two purges of the 'yangban' or educated class in the late fifteenth century. He filled his palace with hundreds of women simply for his own pleasure and bulldozed whole communities, beheaded ministers and exacted revenge on those who opposed him. A cruel ruler, he is perhaps an enticing character in Korean history that has the right hint of madness and tyrannical attitude to drive the story to its conclusion, as well as the excessive desire for carnal pleasure. In contrast, the entertainers are of the lower classes, uneducated, poor and perhaps more accepted by the King in this era for their lack of education, physical performances and bawdy humour.

One of the most important castings was that of Lee Jun-ki in the role of cross-dressing Gong-il. He is utterly convincing as a female entertainer, so much so that even the viewer is convinced at times he is really a woman. He does not overplay the role and turn it into a camp parody but, rather, keeps gestures and reactions subtle. This is something that enhances the performance of Kam Woo-sung as Jang-sang who is as protective of him as he would be of a woman. On the surface their relationship is a deep friendship but with a hint that it could be more than just friendship if either were to admit it. Indeed Jang-sang's righteous anger at how Gong-il is used and abused could easily be interpreted as jealousy like the King's. Gong-il, however, does not seem to acknowledge that what happens to him is entirely wrong, He knows what he has to do to survive, accepting what happens with innocence and calm, unlike Jang-sang, who will not suffer anyone to dictate his fate.

With elements of Shakespearean tragedy, the relationships between the King, his mistress and the two clowns are realistically

The King and the Clown, 2005, Eagle Pictures/Kobal Collection

complex. Played out against the increasing political tension in the palace, the King, desiring the feminine cross-dressing Gong-il, pits himself against the protective friend who may or may not have deeper feelings for Gong-il. Historically, Consort Jang Nok-su (Kang Sung-yeon) was seen to play a pivotal role in the King's behaviour, something the film also uses to its advantage.

Beautiful sets, superb subtle acting and a thoughtful and unob-trusive score make this one of the most accessible and successful period films. With its sensitive approach to sexuality and friendship it breaks the mould for period pieces, making it essential viewing for both fans of period cinema specifically and, more generally, those interested in South Korean films.

Kay Hoddy

The Wedding Day

Sijibganeun Nal

Synopsis

Master Maeng agrees to marry his only daughter Gapbun to an esteemed Kim family from the Bellflower Valley without even seeing the groom-to-be. Not long afterwards, a wandering scholar from the Bellflower Valley knocks on Maeng's door and, taking this opportunity, Maeng enquires about his future son-in-law. To his absolute horror, the visitor divulges that the groom-to-be has

Studio/Distributor:
Dong A Film Co., Ltd.

Director:
Lee Byung-il

Producer:
Lee Byung-il

Screenwriter:
Oh Yeong-jin

Cinematographer:
Lym Byung-ho

Art Director:
Yim Myung-sun

Composer:
Lim Won-Shik

Genre:
Historical drama

Duration:
78 minutes

Cast:
Jo Mi-ryeong, Kim Seung-ho,
Choe Hyeon, Kim Yu-hui

Year:
1956

a severe limp and this news quickly travels across town. Gapbun declares that she will not marry a cripple and attacks her father, who is now determined to get her out of the deal. Then Maeng comes up with a clever plan to have Gapbun's maid Ipbun pose as his daughter and be married off instead. Come wedding day, the groom Mieon turns up as a handsome youth who does not have a limp, much to Maeng's shock. It was Mieon who started the rumor of his disability as a way to find a wife that cared for the matters of the heart. Will Maeng be able to switch the brides once again and have Gapbun marry the desirable groom before it is too late?

Critique

The Wedding Day is based on a popular play by Oh Yeong-jin, who also wrote the screenplay. The film was a critical and financial success and is acknowledged as the first Korean picture to win an international film award, having been named the Best Comedy Feature at the 4th Asian Film Festival in Japan in 1957. Its director is Lee Byung-il, celebrated for his recently-recovered film, *Ban-Do-Ui-bom/Spring of Korean Peninsula* (1941). Lee had trained at the Nikkatsu Studios in Japan in the 1930s and then briefly studied film-making at the University of Southern California in the late 1940s. Such transnational exposure and training seems to have given him the confidence and command in film-making, which is well-demonstrated in *The Wedding Day*. Compared to other Korean films released in the mid-to-late 1950s, the film is technically superb and carefully designed. One should remember here that the Korean War which devastated the country had ended just three years prior to the film's release and that the national film industry was still struggling to pick up the pieces. In this sense, what *The Wedding Day* achieved, both in the narrative and the visuals, is no mean feat. It excels, especially, in presenting a peaceful country life and the idyllic atmosphere of pre-modern Korea, where maidens ride a swing in their traditional costumes and gather herbs from the fields. The film is aware of its aesthetic allure, where the camera uses both close-ups and panning shots to capture the period decor, from the burning incense to Gapbun's silky dress. Foregrounding the theme of a traditional marriage, the film charts the preparation needed for the joining of two families. It helps the contemporary audience get an authentic taste of the local custom, especially in the scene where Maeng, while trying to conceal his great excitement, listens to the long list of gifts that the groom's family had sent. The wedding ceremony itself has an exotic appeal, which partially explains why the film might have attracted positive attention at an international film festival.

 The Wedding Day is one of the first comedy films made in Korea. It heralds the arrival of Kim Seung-ho, who plays Master Maeng, as a comic actor. He proves himself extremely talented, portraying a man who is caught by his own machinations, bringing both humour and sincerity to the film. His interaction with his slightly senile and deaf father is a pure gem. While the film gently mocks the vanity and pride of the ruling class, Kim's nuanced acting balances out

the moral message and makes the film a highly entertaining piece of work. Starring in about 250 films, Kim would frequently return to his role as a sometimes-flawed but endearing patriarch in later films, sculpting a representative Korean masculinity of the 1960s. The Korean Film Archive released the DVD of *The Wedding Day* in 2006, complete with a booklet that contains information in English, a welcome point for non-Korean viewers.

Yun Mi Hwang

Untold Scandal

Seukaendeul: Joseon-namnyeo-sangnyul-jisa

Studio/Distributor:
Bom Films

Director:
E J-yong

Producer:
Oh Jung-wan

Screenwriters:
E J-yong, Kim Dae-woo, Kim Hyun-jung

Cinematographer:
Kim Byeong-il

Art Director:
Jung Ku-ho

Composer:
Lee Byung-woo

Editors:
Kim Yang-il, Han Seung-ryong

Duration:
123 minutes

Genre:
Historical drama/literary adaptation

Cast:
Bae Yong-jun, Jeon Do-yeon, Lee Mi-sook

Year:
2003

Synopsis

Set in the late eighteenth century, *Untold Scandal* exposes the face of a Korean aristocracy drenched in decadence under the guise of a strict Neo-Confucian ethos. The highly respected but two-faced Lady Jo sustains a malicious friendship with her cousin, a suave womanizer and pornographer Jowon. She asks Jowon to seduce a 15-year-old girl So-ok who is to become her husband Lord Yu's third concubine; yet, he is already in pursuit of a virtuous widow Lady Jeong. When Lady Jo promises sexual favours upon his triumph over Jeong, the two of them bet on a game of seduction and betrayal. Yet their relationship deteriorates when Jowon falls in love with Jeong, making Jo declare war on him. In the end, Jowon is stabbed in the back by Jeong's jealous brother-in-law. The heart-broken Jeong then walks into a frozen lake and drowns. After the pornographic paintings exposing her secret sexual life circulate around the high society, Lady Jo flees to China. Finally, So-ok, carrying Jowon's child, successfully marries into the Yu family. The film ends with a suggestion that So-ok will live like her predecessor Lady Jo, commanding power and respect.

Critique

Untold Scandal borrows the plot of the famed French epistolary novel *Les Liaisons dangereuses* (1782) by Laclos and transposes the setting to Korea. To the audience familiar with the French novel or its other adaptations, such as Stephen Frears' *Dangerous Liaisons* (1988) and Miloš Forman's *Valmont* (1989), the similarities found in these two radically different worlds – France and Korea in the late eighteenth century – provide a moment of pleasant surprise. The film marked a watershed moment for the historical genre when it became the third-highest-grossing Korean film released in 2003. What struck the audience and the critics alike, undoubtedly, was its attractive and expensive period design. Nearly half of the production budget was spent in recreating the lavish world of the aristocrats. Jung Kuho, a fashion designer-turned-production designer, even brought in genuine heritage artefacts to place in front of the camera in order to realize a convincing period look. Each frame, therefore, is filled with sumptuous furniture, luxurious decor, and expensive costumes worn by the privileged. One such example is Lady Jo's toiletry scene where she gets ready in the morning with

the help of her maids. Here the camera zooms in on the lavish make-up sets and bejewelled pendants and hairpieces, making sure the viewers get a good look at the intricate details of each artefact. The point of the film's visual appeal was heavily advertised in pre-release promotional materials. The film lures in the audience not only with the glamorous *mise-en-scène* but also with steamy sex scenes featuring mega star Bae Yong-jun, 1980s' sex symbol Lee Mi-sook, and Jeon Do-yeon, who would grab the Best Actress Award at Cannes a few years later. The aesthetic and marketing strategies adopted by *Untold Scandal* would become a benchmark for subsequent costume productions, from *Eumranseosaeng/ Forbidden Quest* (Kim Dae-Woo, 2006) to *Miindo/Portrait of a Beauty* (Jeon Yun-Su, 2008).

In terms of narrative, the film distinctly reworks the theme of the 'female subjugation' used in older costume dramas depicting the dynastic period. As in *Ssibaji/Surrogate Mother*, the familial obsession with female reproductive duties often results in tragic consequences, especially the suicide of the female character. *Untold Scandal* at first seems to present typical female characters confined within the patriarchal system: a wife having failed to provide a son now must concede to the practice of concubinage (Lady Jo); a young girl becomes a concubine to a much older man (So-ok); and a virgin widow is expected to live with her in-laws (Lady Jeong). Yet, the three women all end up, with the help of Jowon, destroying the family system and values through their scandalous affairs. A manipulative and sexually-voracious Lady Jo should certainly be punished but no tragedy befalls her, except for her having to leave her life of luxury behind. She successfully escapes to China, making way for her successor So-ok to continue her legacy. Such a revisionist narrative strategy is how the film amplifies the contemporary resonance and makes it more attractive to modern-day audiences.

Yun Mi Hwang

Yeonsan Ditypch: Prince Yeonsan /Tyrant Yeonsan

Yeonsangun /Pokgun Yeonsan

Studio/Distributor:
Shin Films Co., Ltd

Synopsis

The tenth king of the Joseon dynasty, Yeonsan (1576–1606) is one of the most infamous tyrants recorded in the official 'Annals of the Joseon Dynasty'. Historical records censure the psychologically-unbalanced and ruthless Yeonsan, who possessed no kingly qualities. His trauma is thought to have stemmed from the death of his mother Queen Yun, who was poisoned with the approval of his father and King, a tragedy that occurred when he was only a boy. Yeonsan uncovers the secrets behind his mother's death much later, when the blood-stained linen, which his maternal grandmother has kept, is delivered to him. He goes on a revenge spree, killing anyone and everyone who played a part in his mother's untimely death. He also tries to compensate for the loss by seeking corrupt pleasures and indulging in an extravagant lifestyle with his

Director:

Shin Sang-ok

Producer:

Shin Sang-ok

Screenwriter:

Lim Hee-jae

Cinematographers:

Bea Sung-hak, Jeong Hae-jun

Art Director:

Chung Woo-taek

Composer:

Jeong Yoon-joo

Costume Designer:

Lee Hae-yoon

Editors:

Kim Young-hee, Yang Seong-ran

Duration:

352 minutes.

Cast:

Shin Young-kyun, Do Geum bong, Kim Jin-kyu, Choi Eun-hee

Year:

1962

favourite concubine Jang Nok-su, a *femme fatale* and a power-monger. Eventually he repents and returns to his faithful wife, the Queen, and their children. Yet, this comes too late as a young military officer Park is already planning a demolition of the aberrant King's reign.

Critique

The dramatic story of King Yeonsan and Jang Nok-su has continued to fascinate the general public, evidenced in the number of retellings in radio dramas, popular fiction, and films over the years. In cinema, it was Shin Sang-ok who first helped make Yeonsan a household name in Korea. Less than a year after the success of his *Seong Chunhyang*, Shin adapted Park Jong-hwa's historical fiction *Blood in Golden Linen Cloth* written in 1935, visualizing the life of the notorious tyrant on an epic scale. He told the story of Yeonsan in two parts: *Prince Yeonsan* (133 mins) depicts Yeonsan's agony in confronting the ghosts of his past – his mother, the former queen, had been falsely condemned for her violent and jealous nature and was executed; the sequel *Tyrant Yeonsan* (192 mins) illustrates Yeonsan's increasingly-manic behaviour and sexual exploits, all happening with Jang Nok-su beside him, until the supporters of the next king overthrows him. *Prince Yeonsan* was not only a box-office success but also became the recipient of the Best Picture Award at the first Grand Bell Film Awards in 1962. Shin Young-kyun, who also won the Best Actor's Award at that year's Grand Bell, brilliantly plays the deeply-troubled Yeonsan who also elicits audience sympathy. The sex symbol of the 1960s, Do Geum-bong, reigns equally high as the ambitious and manipulative Jang Nok-su.

The Yeonsan Dityph is representative of the 'royal court *sageuk*' (*gungjung* or *wangjo sageuk*), which refers to films that foreground the conspiracy and intrigue inside the royal palace, where the power struggles between the royal family, faithful servants, and usurpers are played out. Shin showed great interest in reviving the lives at the royal court and continuously reworked the formula. In particular, Shin would reprise the spectacular and decadent sexuality of the royal court, represented by the orgy scenes in *Tyrant Yeonsan*, in his later film *Eunuch* (1969). The two Yeonsan films helped the *sageuk* to develop as a fully-fledged genre in the early 1960s, and biographical drama set in the royal palace or elsewhere became a trend for some years.

The Yeonsan Dityph also exploits the potential of colourful historical spectacle, striking a balance between imagination and authenticity in period reconstruction. Even though he sought consultation from historians, when it came to designing the costume for the King, the director Shin took the liberty of draping him in light violet. Although historically inaccurate, he did so when he realized that violet appeared more appealing than deep crimson on screen. Compared to another royal court *sageuk* released a year prior, *Lady Jang*, shot in black and white, the Yeonsan films are visually striking, showcasing shiny silk-based garments, spacious and well-decorated royal palaces, and dynamic camera movements

including high angle and canted shots. The dramatic orchestral music with a strong percussive base advances the ominous mood of the narrative, while the strong colour palette emphasizes the decadence of the monarch. Shin refined the look of the *sageuk*, in such a way, by balancing convincing historical narrative with imaginative spectacle.

Yun Mi Hwang

ROMANTIC COMEDY

Romantic films and melodramas have long been dominant genres in South Korean cinema – being among the few genres with subject matter deemed as non-provocative (politically or otherwise) within an industry historically subject to heavy government constraints and censorship. Consequently, romantic comedies have tended to be awarded similar levels of freedom to melodramas. However, it is only fairly recently that romantic comedies have been deemed as worthy, or 'proper', cinema, thanks in part to the influx of new, younger film-makers, with fresh and innovative ideas, forming part of the emergence of what has been deemed 'Korean New Cinema'. Having grown up with access to film content from around the world, with many schooled in film studies in the West, these new auteurs made a point of subverting social stereotypes and familiar storylines within films to bring a revitalizing freshness and plot innovation to virtually every genre, not least romantic comedy, and an 'explosion' within the romantic-comedy genre (the likes of which had never been seen) would take place within just a few years. A gradual shift in focus was already apparent in films such as *Misulgwan yup dongmulwon/Art Museum By The Zoo* (Lee Jeong-hyang, 1998), in which the main female character, Choon-hee (Shim Eun-ha), finds love by being herself and being accepted as the person she is, rather than by needing to change in order to fit into a more stereotypical female role within a patriarchal society, as would previously have been the case. *Art Museum By The Zoo* also intelligently parodies the very genre of which it is a part by having the main characters bond through writing a romantic-comedy script within the film – in which Lee Jeong-hyang deliberately references almost every classic romantic-comedy cliché – thus allowing the film to speak to the youth market, which had grown somewhat tired of standard, and rather predictable, romantic-comedy fare.

The 'explosion' can be dated to 2001 and the release of *Yeopgijeogin Geunyeo/My Sassy Girl* (Kwak Jae-yong) – a film which would subsequently have a huge effect on not only the romantic-comedy genre but also on a plethora of associated sub-genres. Based on the real life internet blogs of Kim Ho-sik, detailing his relationship with his girlfriend (which had a huge following among female teens and those in their early twenties), the film was targeted specifically at the blog's fan base and gave this audience demographic a subject matter which they could relate to and in which they were actually interested. A complete reversal of the stereotypical male and female roles within Korean society

Left image: *My Sassy Girl*, 2001, Shin Cine Communications

can be seen in *My Sassy Girl* – a feisty, aggressive and bullying (unnamed) female (played by Jun Ji-hyun), in a tumultuous relationship with a rather passive 'mummy's boy' male, Kyun-woo (played by Cha Tae-hyun), with the majority of the laugh-out-loud humour being based around the actions of 'The Girl', as well as others' reactions to her behaviour – and this further resonated with the younger generation of cinema goers, who were beginning to develop different attitudes regarding the place of women within society.

Thus began a trend for romantic comedies featuring forthright female characters holding the power and control within their relationships with weaker males, such as *Nae yeojachingureul sogae habnida/Windstruck* (Kwak Jae-yong, 2003), in which a 'sassy' policewoman forms a romantic relationship with a quiet, unassuming man, whom she mistakenly arrests. Similar 'sassy' girls can be found in other hybrid genres, as demonstrated by the gangster comedy romance *Jopog Manura/My Wife is a Gangster* (Jo Jin-kyu, 2003), detailing the story of a tomboyish female gangster who is pushed into learning to be more feminine in order to find a husband, and the comedy horror *Dalkom, salbeorhan yeonin/My Scary Girl* (Son Jae-gon, 2006) in which the beautiful exterior of Mi-Na (Choi Gang-Hee) hides a deadly and murderous secret. However, within the humour found in the subversion of male and female places within relationships, an underlying, almost virginal, purity to the main female characters is also noticeably prevalent in the majority of romantic comedies, due, in part, to Korean society's long-held attitude about sex before marriage, seen through the way in which overt public displays of affection were traditionally considered unseemly. For example, the characters in neither *My Sassy Girl* nor *Windstruck* ever even so much as kiss. In *Windstruck*, when Myeong-wu (Jang Hyuk) attempts to kiss Gyeong-jin (Jun Ji-hyun) she, instead, makes him close his eyes and burns his lip with a red-hot stick which has been lying in a fire – the underlying implication of the importance of female pre-sexual innocence and chastity repeatedly seeking to reinforce the belief that a woman being chaste and pure at heart was an ideal to be sought after and followed, and that doing so would eventually lead to a happy life within a stable, loving family. This carried through to films such as *Cheotsarang sasu gwolgidaehoe/Crazy First Love* (Oh Jong-rok, 2003), in which the main male character, Tae-il (Cha Tae-hyun), makes a pact with the father of the girl he wants to marry, Il-mae (Son Ye-jin), to keep her chaste and virginal until he has finished his studies, thus becoming an upstanding member of society worthy of asking for her hand in marriage, and at the same time ensuring that she remains worth being sought; and *Eunjangdo/Silver Knife* (Kim Sung-duk, 2003), which narrates the story of a girl, Min-seo (Shin Ae), who is given an ornamental silver knife by her father (a man with strong Confucian morals) on her twelfth birthday to enable her to protect herself from the sexual advances of amorous men, and keep herself 'pure' until she can find a husband.

As Korean society has gradually moved toward a more western-style, egalitarian view of marriage, relationships and alternative lifestyles, this too has been reflected in Korean romantic comedies. From as early as 2002 with *Cheoleobtneun anaewa paramanjanhan nampyeon geurigo taekwon sonyeo/A Bizarre Love Triangle* (Lee Mu-yeong), detailing the love and sexual relationship between Eun-hui (Cho Eun-ji), her comedian husband, Doo-chan (Choi Gwang-il), and her lesbian lover, Keum-sook (Gong Hyo-jin); through to the much more recent *Anaega Gyeolhon Haeta/My Wife Got Married* (Chong Yun-su, 2003), in which issues of monogamy versus polygamy are discussed, compared and contrasted, the noticeable change in attitudes to what constitutes family (and what is considered as acceptable, sexually, within relationships) has become increasingly apparent. *My Wife Got Married* also carries on the trend of the characterization of a strong woman. In-a, played by Son Ye-jin, who has the dominant, powerful role in a relationship/marriage with a passive and, in this case, a rather neurotic male, Deok-hyun, played

by Kim Joo-hyuck, boldly adds the addendum that, though happiness and stability can indeed be found in marriage, it does not necessarily have to be within the Choseun ideal of family – where a woman was very much seen as a subservient individual, expected to sacrifice her own needs for those of her husband and children. However, in these and, in fact, most of the films discussed above, even though both adultery and the differing attitudes to sex and relationships of the youth of today from those of older generations are often deliberated, there remains an ever-present inference at the core of each that marriage and commitment are still the ultimate female character/relationship goals.

It is only in the last few years that the idea of sex being pleasurable in its own right, and without a need for it to be leading to anything more long-term, and relationships not simply a means by which to move to the stability of marriage and family, have been seen in films such as *Jakeob-ui Jeongseok/The Art of Seduction* (Oh Ki-hwan, 2005), which follows the relationship of two serial seducers, (Min-joon and Ji-won, played by Song Il-kook and Son Ye-jin, respectively), neither of whom have any interest in marriage and are solely committed to the pleasure and power derived from the pursuit of new sexual conquests.

The increasing inclusion of depictions of sex, and the sexual aspects of love and relationships, in South Korean cinema has also led to the emergence of the sex comedy sub-genre, and though some of these films step away, somewhat, from the remit of a discussion of romantic comedy to become little more than bawdy coming-of-age stories, there are a number which still clearly fit within, and are based around, the romantic-comedy genre frame – possibly, the most obvious example of which is *Mongjunggi/Wet Dreams* (Zeong Cho-sin: 2002). Though it is indeed a coming-of-age tale about a group of pubescent teenage boys, the core of *Wet Dreams* is firmly centred around the romantic hopes and dreams of apprentice teacher Yu-ri (Kim Sun-a) and her love for, and efforts to win the heart of, fellow teacher Byeong-cheol (Lee Beom-soo) – feelings which (much like the pupils she teaches) began when, as an adolescent student, she developed a crush on Byeong-cheol, who was her homeroom teacher at the time. Though *Wet Dreams* does contain a fair amount of bawdy sex-comedy humour, based around the teenage boys' increasing need to learn about, and have, sex, it is split 50-50 with the much more innocent (and pure) comedy relating to Yu-ri's dreamed-of love affair – the film's conclusion, once again, pointing to the ideal of love leading to marriage, leading to happy-ever-afters.

Over time, sexual content has become somewhat more accepted in South Korean cinema, resulting in a gradual increase in the graphic nature of sexual references and imagery within even mainstream films. This has, of course, also had a knock-on effect in the romantic-comedy genre, leading to the emergence of yet another sub-genre: as recently as 2010, *Bang Ja Jeon/The Servant* (Kim Dae-woo) combines a romance based on the Korean folk tale *The Tale of Chun-hyang* with sexually-based humour and Hong Kongesque, Category III-level visuals and content, to create what can only be described as an 'erotic rom-com'. However, there is one more element to *The Servant*, and almost every other film mentioned in this essay, without which South Korean romantic comedies would simply be incomplete. That element is melodrama.

The melodramatic ideas of yearning, separation, heartbreak and loss could be said to be present in any romance, relationship or, in fact, life, and though this allows melo-drama to take its place as an integral part of the South Korean romantic-comedy genre – detailing, as it does, stories combining love, loss and laughter – that really is just the tip of the iceberg. In a country which has been subject to such political, social and economic turbulence and upheaval as Korea, references to these ideas almost cannot help but appear in virtually every film genre, and while the tales of romantic-comedy characters often contain veiled analogies to Korea's tumultuous history – a painful past (*My Sassy Girl*), separation by seemingly impassable barriers (*Windstruck*), or happiness tinged with

heartbreak and loss (*Crazy First Love*) – there are also instances where the references are much more overt, actually forming a major part of the plot. One such example is *Shu-peomaenyieotdeon Sanai/A Man Who Was Superman* (Chung Yoon-chul, 2008), which tells the story of jaded human-interest documentary maker, Soo-jung (Jun Ji-hyun), who endeavours to make a television programme about a man who claims to be Superman, (played by Hwang Jung-min), and gradually forms an increasingly-close bond with him in the process. *A Man Who Was Superman* utilizes the real-life events of the Gwang-ju uprising (1980), during which more than one hundred civilians were killed and many more injured, as a pivotal element of the storyline – the intimation that Korea is still coming to terms with its historical struggles being impossible to deny.

Like so many characters in Korean romantic comedies, Korea too has had a past full of turmoil, been split and separated, with seemingly-impassable barriers put in its path, and is ultimately still trying to smile through the pain, while attempting ensure that its present becomes a happy, stable future, filled with laughter and love.

Paul Quinn

100 Days With Mr Arrogant

Naesarang Ssagaji

Studio/Distributor:
Cinema Service

Director:
Shin Dong-yeob

Producer:
Jeong Ji-hun

Screenwriter:
Shin Dong-yeob

Cinematographer:
Hwang Cheol-hyeon

Art Director:
Jang Yeon-Seon

Composer:
Jo Byeong-seok

Editor:
Ko Im-Pyo

Duration:
95 minutes

Genre:
Romantic comedy

Cast:
Kim Jae-Won, Ha Ji-won,
Jin Tae-Hyun and Han Min

Year:
2004

Synopsis

Despondent after being dumped by her boyfriend on the hundredth day of their relationship, high school senior Ha-yeong despairs at the possibility of true love. Frustrated at her situation, in the street she dramatically kicks a soda can which lands on the head of passing motorist Hyeong-jun, causing the college student to crash his new car into a wall. Angry at Ha-yeong's foolishness and her inability to pay for the car's recovery, he suggests an alternative method of remuneration for the extravagant cost of the vehicle's repair: she must sign a contract to become his 'slave' for 100 days. Although shocked at the suggestion, Ha-yeong agrees and the opposing pair begin a mismatched and volatile relationship. But as the 100 days progress, comical situations occur amongst the constraint of servitude and polarized socio-economic backgrounds. As time develops, the pair start to develop romantic feelings for each other.

Critique

Adapted from an internet novel posted over two months in the summer of 2001 by a South Korean high-school girl, *100 Days With Mr Arrogant* is a film that will enrapture its predominately-adolescent target market. Meanwhile, more mature and cynical viewers may become less than enamoured with the film's flights of fantasy and audacious narrative trajectory. Like the adults in the film, who remain on the sidelines as periphery comic foil, the diegetic world and logic of the principal characters is a land puzzlingly extrinsic to those outside of the intended audience. The novel's author, Lee yun-sae, has gained immense popularity in South Korea and outward to East Asian territories by using the hook of writing from the viewpoint of young teenagers. This literary recipe termed under the author's pen name, as the 'Guiyeoni Syndrome' by South Korean popular media, has seen a rush of drama adaptations from her similarly-themed stories of romance set against a backdrop of teenage anxiety, such as *Neukdaeui Yuhok/Temptation of Wolves* (Kim Tae-gyun, 2004) and *Doremipasollasido /Do Re Mi Fa Sol La Si Do* (Kang Geon-hyang, 2008)

Romantic comedy aimed at a young female audience is by no means a new genre within South Korean cinema but the initial success of films such as *Yeopgijeogin Geunyeo/My Sassy Girl* (Kwak Jae-Young, 2001) and *Donggabnaegi Gwawoehagi/My Tutor Friend* (Kim Kyeong-Hyeong, 2003) has ensured a continuing fashion for teen-romance cinema sourced from internet novels. With a large transferable readership from the source novels, success at home and an auspicious reception within foreign territories, this burgeoning generic shift towards a predominately-female teen audience has played a considerable part in the promotion of South Korea as dominating media and cultural space within East Asia.

Despite the commercial popularity of these novellas and film adaptations, South Korean cultural critics tend to view them as

predictable and formulaic. Certainly, it comes as no surprise when the two seemingly-incompatible leads eventually find romance with each other and borrowing heavily from both *My Sassy Girl* and *My Tutor Friend*, *100 Days With Mr Arrogant* does throw up other habitual thematics. At one point Hyeong-jun hatches an elaborate plan to wrangle his way into Ha-Yeong's household by impersonating an after-school tutor and the arrogant swagger accompanying the conceited nature of the girl in *My Sassy Girl* is relocated to the male lead. In the context of transposing gender and class identity within South Korean society, this makes for a timely intervention and brings with it an initial promise of social critique. But an overtly-dramatic shift in tone, from hyper-kinetic 'gross out' comedy littered with mad-cap mugging and sexual innuendo to substantially straight melodrama halfway through the piece clouds this promise. Typical of its type, with parents and teachers largely left as the comic foil, mature concerns and voices of concerned dissent are pushed away to accommodate a world where adolescent fantasy takes precedence.

Counterpointing this, the final moments of the film suggest that through time the initial idealism of the relationship has eroded and some of Hyeong-jun's less-admirable characteristics have been picked up by Ha-Yeong. Perhaps if this had been alluded to earlier on and given more space to develop it would have made for a more refreshing take on the genre and, given the text a sharper edge. But by not taking such an ambitious route and sticking to tried and tested conventions, this is ultimately a film that will end up endearing itself to more people than it infuriates.

Dave McCaig

200 Pounds Beauty

Minyeo-neun goerowo

Studio/Distributor:
KM Culture Co., Realies,
Showbox Entertainment

Director:
Kim Yong-hwa

Producers:
Park Moo-seung,
Won Dong-yeon

Screenwriters:
Kim Seon-jeong, Kim Yong-hwa,
No Hye-yeong

Synopsis

Hanna is an overweight young woman with two jobs that make use of her angelic voice whilst disguising her physique: she is the secret vocalist for Ammy, a famous pop singer who actually lip-syncs, and a phone sex operator. Although her contributions to Ammy's albums and concerts have made the 'singer' a pop idol, the star is ungrateful and humiliates Hanna in front Sang-jun, the director of her record company, knowing that Hanna has a crush on him. The deeply-upset Hanna contemplates suicide but is interrupted by a phone call from one of her regular phone-sex clients, who turns out to be a top cosmetic surgeon; she threatens to inform the surgeon's wife about his phone-sex habit unless he operates on her and Hanna goes into seclusion for one year while the changes take effect. With the help of her best friend Chung-min, she creates a new identity for herself and emerges as Jenny, a Korean-American from California, auditioning once again for the job of Ammy's secret vocalist but earning her own recording contract from Sang-jun. Complications ensue as Ammy tries to track down her former secret vocalist to record her delayed follow-up album, bringing her into contact with Hanna's father, who has Alzheimer's, while

Cinematographer:

Park Gok-ji

Editor:

Park Gok-ji

Duration:

120 minutes

Genre:

Romantic comedy

Cast:

Kim Ah-jung, Ju Jin-mo,
Kim Yong-geon, Song Dong-il

Year:

2006

romantic sparks begin to fly between Jenny and Sang-ju as Jenny's debut single becomes a smash hit.

Critique

The release of *200 Pounds Beauty* in 2006 coincided with the publication of several articles in Time magazine commenting on the increasing popularity of plastic surgery in Asia, and South Korea in particular, with correspondent Chisu Ko observing that '[i]t wasn't too many generations ago that South Korean kids had no control over their looks. But today, kids drop into the plastic surgeon's office after school, and when they get home their folks can barely recognize them.' While the craze for cosmetic procedures may seem at odds with the traditional nature of Korean society, Ko notes that 'South Korea is even more competitive than it is conservative' suggesting that appearance and achievement are inextricably intertwined. This would seem to be a view that is shared by director Kim Yong-hwa and his co-writers, as *200 Pounds Beauty* focuses on a heroine who is only able to find 'herself' through physical reinvention, not to mention the teen audience that only accepts messages of honesty and self-belief when they are communicated through a beautiful pop idol. However, *200 Pounds Beauty* is not a serious examination of the many issues and debates surrounding plastic surgery and, instead, follows many American comedies in which major stars have gamely donned a 'fat suit' in order to elicit laughs from the mainstream audience: Eddie Murphy in *The Nutty Professor* (1996), the famously macrobiotic Gwyneth Paltrow in *Shallow Hal* (2001), Julia Roberts in *America's Sweethearts* (2001) and Courtney Cox on the television sitcom *Friends* (1994-2004) have all mined comedic mileage from plus-size padding. The versatile Kim Ah-jung in *200 Pounds Beauty* is no exception, often quite literally throwing her artificial weight around to establish Hanna/Jenny as both an underdog heroine and a 'victim' of a superficial society that priorities looks over personality and genuine talent.

The film runs through a series of expected but nonetheless amusing jokes before the moralizing sets in during the over-extended final third; the overweight Hanna causes unintentional damage like the proverbial bull in a china shop, while the remodelled Jenny is unrecognized by her best friend and father, granted leniency for causing a traffic accident by besotted police officers and worries that her cellulite will slip. Much of the humour works because the leading lady embraces her dual identities and uses her physicality to show the links between the two; even after surgery, Jenny shows signs of the awkwardness and embarrassment she felt every day as Hanna through her mannerisms and posture, never becoming entirely comfortable with her status as a rapidly-rising pop diva, even during rousing renditions of Blondie's 'Maria' and Janet Jackson's 'Miss You Much'. Although she is very much centre stage, the moral compass of *200 Pounds Beauty* is actually her manager Sang-jun (Ju Jin-mo), who finds himself credibly conflicted regarding his burgeoning feelings for his new

200 Pounds Beauty, 2006, KM Culture Co/Realise/Kobal Collection

star once he learns that she is not 'all natural'. As the film closes, Jenny has become a superstar and is taking control of her career both artistically and aesthetically while her interest in her manager seems to have waned, but Sang-jun's needs are left unfulfilled as he seems to have lost both his friendship with Hanna and his romance with Jenny. While it is mentioned that Jenny's confession brings her as many haters as it does fans, a closing scene of her best friend meeting with the same surgeon to discuss a full-body makeover does seem to promote plastic surgery as a means of self-improvement.

John Berra

Art Museum By the Zoo

Misulgwan yup dongmulwon

Studio/Distributor:
Cine 2000/Cinema Service

Director:
Lee Jeong-hyang

Synopsis

During his military leave, Chul-soo returns to the apartment that he shares with his girlfriend Da-hye. He bumps into the landlady, who informs him that the rent on the apartment is late so he pays it. He is surprised not to find Da-hye in the apartment but even more surprised is Choon-hee, its new inhabitant. Choon-hee is a wedding videographer whose love for In-gong, a high-ranking civil servant, is unrequited. Chul-soo soon learns that Da-hye has left him to marry another man. With nowhere else to go Chul-soo arranges to stay in the apartment with Choon-hee during his leave since she cannot pay him back straight away for the late rent. However, the clean and practical Chul-soo and the messy and whimsical Choon-hee could not be any more different and quickly get on each

Producers:

Lee Choon-yun

Screenwriter:

Lee Jeong-hyang

Cinematographer:

Cho Yong-gyu

Art Director:

Oh Sang-man

Editor:

Kim Sang-bum

Duration:

108 minutes

Genre:

Romance

Cast:

Shim Eun-ha, Lee Sung-jae, Ahn Sung-ki, Song Sun-mee

Year:

1998

other's nerves. Choon-hee is writing a screenplay for a competition and soon Chul-soo begins to help her as they each inject their own romantic disappointments into the narrative whose characters are renamed Da-hye and In-gong.

Critique

Lee Jeong-hyang's first feature, *Art Museum By the Zoo*, before she went on to make *Jibeuro/The Way Home* (2002) and *Oneul/A Reason to Live* (2011), stands the test of time as one of the seminal romantic Korean films of the late 1990s, just as the Korean film industry was coming into its own after decades of decline. The film has remained relevant because of its unique and considerate approach to characterization and the refreshing intertextual elements that enhance its premise. While unabashedly indulging in the staples of the romance genre, it still succeeds in crafting a dichotomy between the reality and the idealization of love, all the while questioning our relationship with its representation in the commercial works that fill our cinema screens.

Like many romance films of its era, *Art Museum By the Zoo* details a platonic romance, or at least the platonic stages of a budding relationship. However, unlike films such as *Palwolui Christmas/Christmas in August* (Hur Jin-Ho, 1998) and *Yeopgijeogin Geunyeo/My Sassy Girl* (Kwak Jae-yong, 2001) Lee uses sex as a tool that highlights the dynamic between the two protagonists. Not only does its looming presence in the narrative cause tension, such as the bed that Chul-soo shared with Da-hye in Choon-hee's flat, it also serves as a counterpoint to Choon-hee's unilateral approach to love, as she has never been able to get In-gong to notice her.

The most interesting element in *Art Museum By the Zoo*, and also the one that sets it apart from most of it contemporaries, is the screenplay Choon-hee is writing with the help of Chul-soo and its visualization on screen, which, rather than being a completed product, or a film-within-a-film, remains within the imagination of the narrative's characters. Rather than an attempt to be subtle, these sequences become very direct representations of Chul-soo's and Choon-hee's personal experiences with and views on love. The script and thus the imagined sequences portrayed on screen change along with these two character's lives.

Actors Shim Eun-ha and Lee Sung-jae (Choon-hee and Chul-soo respectively) are very good fits for their characters and deliver some of the best work of their careers. Shim only made three more films before quitting the industry while Lee, after a couple of great starring turns in Kim Sang-jin action comedies (*Juyuso seubgyuksageun/Attack the Gas Station*, 1999; *Shinlaui dalbam/Kick the Moon*, 2001), has mostly been relegated to the B-list, his quiet and composed style of bluster no longer being de rigueur in South Korean cinema. Ahn Sung-kee, the living legend of Korean film, does not have a very large role but, true to form, he delivers the goods.

The film hardly seems to have aged and is still very engaging, even if it does not have the same emotional punch of something

like *Christmas in August*. Then, again, neither does it have the same melodramatic pretensions, Lee choosing instead to ruminate on the meaning of love and the process by which it can come about. It is the kind of film that would never work in Hollywood; low-key, slow and sometimes meandering, it does ask for your attention. But, since *Art Museum By the Zoo* knows exactly what it wants to be, it is well worth your time; it is an essential work of 1990s Korean cinema.

Pierce Conran

Crazy First Love

Cheot-sarang Sasu Gwolgidaehoe

Studio/Distributor:
Popcorn Films/Starmax

Director:
Oh Jong-rok

Producers:
Han Seong-gu, Lee Cheon-hui

Screenwriter:
Oh Jong-rok

Cinematographer:
Chung Kwang-suk

Art Director:
Yun Hye-jeong

Composer:
Choe Seong-uk

Editor:
Go Im-pyo

Duration:
102 Minutes

Genre:
Romantic comedy

Cast:
Cha Tae-hyun, Son Ye-jin, Yoo Dong-kun, Sung Ji-ru, Lee Byung-wook

Year:
2003

Synopsis

Tae-il is in love with Il-mae – a girl who was raised by Tae-il's mother when her own mother died in childbirth. Il-mae's father, Young-dal (who is also Tae-il's teacher), has promised Tae-il his daughter's hand in marriage if he can pass a specific educational milestone; but each time Tae-il succeeds in the task he is set, Young-dal demands something more before he will even consider allowing Tae-il to ask Il-mae to marry him. As Tae-il studies for the law bar exam (the latest educational task set by Young-dal), he makes a further pact with Young-dal to protect Il-mae and keep her virginity intact in the hope of finally gaining her father's trust and secure his chances of eventually getting to be with her. However, when Il-mae starts dating another man, Tae-il and Young-dal realize they must directly intervene and, thus, join forces in an attempt to ensure that Tae-il and Il-mae finally end up together.

Critique

Crazy First Love begins with a fairly humorous cartoon introduction of the main characters, their history and relationships to each other, which is slightly marred by an overuse of cartoon depictions of breasts, complete with lactating nipples. However, no sooner does the live action get underway than we are subjected to a series of ill-conceived and contrived comedy scenes, mostly centring around the, frankly, unlikeable character of Tae-il (Cha Tae-hyun). The first, and most noticeable, criticism of Tae-il's character is that he seems virtually incapable of uttering a sentence without screaming the words in overwrought yells. These begin as just annoying but verge on becoming unbearable as the film progresses. Cha Tae-hyun's many starring roles, in which his performances have routinely been accomplished and nuanced, suggest that his performance here is a direct result of being instructed to play the character in such a way by director Oh Jong-rok, and the fact that the character of Young-dal (Yoo Dong-kun) is prone to similar outbursts would seem to confirm this further. Secondly, it cannot be denied that Tae-il's desires are utterly self-serving. He takes no heed of what anyone, especially Il-mae (Son Ye-Jin), actually wants or needs, and is reso-lutely determined that she will be his at any cost, regardless of how unwanted his amorous attentions are, or become. Add to that the

fact that it would be obvious to anyone (not least a character who supposedly has an IQ of 148) that Tae-il's actions, including ruining Il-mae's every evening out, embarrassing her at her place of work, following her around incessantly and repeatedly yelling at her abusively, would make any girl consider calling the police and demanding a restraining order. Instead, Il-mae puts up with it all, even trying to seduce Tae-il at one point – for reasons that are deliberately withheld from viewers until the final stages of the film; finally deciding that she should marry another man, for Tae-il's own good. Once again, this is fully explained towards the film's conclusion and, like many of the other story elements, is majorly illogical. In the film's final section, the story lurches into full-blown melodrama but, even here, any hope that some genuine emotion may emerge is dashed by the mirroring of heartbreaking scenes from much more accomplished films – Il-mae tearfully shouting her feelings for Tae-il when he is too far away to hear, for example, is a scene clearly copied from *Yeopgijeogin Geunyeo/My Sassy Girl* (Kwak Jae-Young, 2001) – and even though this section of Crazy First Love is easily the strongest, it too is destroyed by further attempts to add wacky, comedic elements which feel rather misplaced, especially within supposedly-heartbreaking scenes. The film concludes by attempting a somewhat 'happy' ending but, considering the full story which viewers are already aware of at that point, it serves only to leave a bitter taste in the mouth of being deceived.

Any attempt to address serious themes, be it the school system, references to the ideal of female pre-marital purity, or discussion of how striving to become well-educated and well-balanced will ultimately result in success, largely fails as a result of a lack of focus throughout, along with some severely suspect implications – including what Young-dal chooses to do to the students he has just beaten, and Tae-il's choice of punishment for Il-mae's suitors.

Though it must be said that a reworking of the logic within certain scenes is required, and though the plot is rather predictable Korean romantic comedy/melodrama fare, in other hands *Crazy First Love* could have been an engaging romantic comedy with some poignant moments. Sadly, what we end up with instead is a film lacking the romance and genuine humour it so desperately needs, which largely struggles to build any emotional resonance whatsoever. In short, *Crazy First Love* simply consists of ideas from other superior movies, linked by illogical character motivations and one-dimensional characterizations.

Paul Quinn

Everyone Has Secrets

Nuguna bimileun itda

Synopsis

Han Mi-yeong longs for romance and excitement in a relationship and her long-term lover simply is not cutting it. She bids him farewell in the park and sets out in search of her ideal man. That very day she lays eyes on Choi Su-hyeon and knows that she wants

Studio/Distributor:
Taewon Entertainment/Cinema
Service

Director:
Jang Hyun-soo

Producer:
Chung Tae-won

Screenwriter:
Kim Yeong-chan

Cinematographer:
Kim Young-chul

Art Directors:
Jang Yeon-seon, No Hyo-man,
Lee Jun-hyeong

Composer:
Sim Hyeon-jeong

Editors:
Kim Sun-min, Choe Gyeong-hui,
Lee Sang-min

Duration:
105 minutes

Genre:
Romantic comedy

Cast:
Lee Byung-hun, Choi Ji-woo,
Choo Sang-mee, Kim Hyo-jin,
Seonwoo Yong-nyeo

Year:
2004

him for herself. His handsome features and easy charm are only outshone by his heart-stopping smile. In fact, he may be a little too desirable, as Seon-yeong is not the only Han sister Su-hyeon has conquered with his grin. Han Seon-yeong has waited 27 years to fall in love and is still a virgin. She has always believed that love would come along and sweep her off her feet when she least expects it. Her time to fall in love may have come, as she certainly never expected to be attracted to the man her youngest sister has just proposed to. But there is one more Han sister, the eldest, Jin-yeong. Bored by a loveless marriage, Ji-yeong's romantic nature is re-awakened when she is introduced to Su-hyeon. Choi Su-hyeon seems to have his pick of the Han sisters, but are they what he is really after?

Critique

If there were any other actor in the role of Choi Su-hyeon, who seems willing to sleep with anything that has a pulse, at a drop of a hat, this movie would probably not work. After all, the lead male in a romantic comedy should ideally be loyal, devoted and madly in love with the female lead. Or, alternately, he should be some-one who starts out in a confrontational role and eventually comes around to recognizing his faults and the merits of the female lead and the two fall in love, despite a hundred or so minutes of screen time spent fighting with each other. Su-hyeon fits neither of these typical categories. He is not loyal at all, moving from one sister to the other through the course of the movie while never actually breaking up with any of them. Essentially, he has all three sisters as his lovers at the same time and seems ready to put moves on their brother and his girlfriend as well. Nor is he in the confrontational role and he cannot admit his faults if he does not think he is in the wrong. In fact, while his actions are certainly morally questionable, it is hard for the viewer to fault him. Much of this has to do with actor Lee Byung-hun's skill and charismatic personality.

Lee Byung-hun is able to walk a fine line in this movie. He comes across as confident without being arrogant and he is forward in his sexual overtures without ever seeming sleazy. That last part is of key importance for the overall success of *Everyone Has Secrets*. In any other movie, a character like Su-hyeon would be reviled but, here, it is quite the opposite. One can never quite bring them-selves to dislike him.

There are moments in this movie that reminded me of two beloved children's characters, despite the adult themes of this movie: Mary Poppins and Nanny McPhee. These two magical maids would swoop out of nowhere to assist children in need of love, affection and stability with the aid of a little magic. Then, their mission of mercy complete, they would disappear to spread joy to the next tyke in need. This same basic modus operandi applies to Su-hyeon with a few exceptions. The love and affection he is sup-plying is a little different from the platonic love of Ms Poppins and the magic he may or may not possess is not overtly used.

Every character Su-hyeon comes in contact with is better off for the experience, whether it be finding a true love, gaining self-confidence, awaking as a sensual being or mending a broken heart. *Everyone Has Secrets* is in no way typical of the romantic-comedy genre. The film has many elements that seem to place it in the realm of fantasy. This may in part be due to the fact that the source material for the film is a UK film called *About Adam* directed by Gerard Stembridge in 2000, and may well explain the fact that *Everyone Has Secrets* feels quite different from the typical Korean romantic tale.

Tom Giammarco

I'm a Cyborg, But Thats OK

Ssaibogeujiman Gwaenchanha

Studio/Distributor:
Moho Films/Cinema Service

Director:
Park Chan-wook

Producers:
Lee Tae-hun, Park Chan-wook

Screenwriters:
Jeong Seo-kyeong,
Park Chan-wook

Cinematographer:
Jung Jung-hui

Art Director:
Ryu Seong-hui

Composer:
Cho Young-wook

Editors:
Kim Jae-beom, Kim Sang-bum

Duration:
105 minutes

Genre:
Melodrama/comedy

Cast:
Su Joung-lim, Rain, Choi Hie-jin,
Lee Yong-nyeo, Yu Ho-jeong,
Kim Byeong-ok

Synopsis

Young-goon believes herself to be a cyborg. She came with no instruction manual, has no idea what she was made for, and must recharge herself until her big toe flashes. After plugging a radio transmitter into a cut on her wrist (carefully inserting the wires, taping over the wound, raising the antenna and connecting herself to the electrical mains) she is admitted to a psychiatric institution. Park Chan-wook uses this institution as the backdrop for Young-goon's exploration of her cyborg-self as she makes friends with vending machines and argues with flourescent lights, attends group therapy sessions and interacts with a cast of patients, each with a specific symptom of his or her own comic sickness: Il-sun wears a homemade bunny mask and can steal the character traits of the other patients; Duk-chun is so polite he will only walk backwards; Gop-dahn generates static energy by rubbing her feet together in order to fly; Sul-mi invents stories to replace the memories she loses every time she has shock treatment. Each serves as a trigger for a series of increasingly bizarre and fantastic set-pieces, as Young-goon attempts to rid herself of her sadness, her sympathy and charge herself enough to kill the white 'uns (doctors, nurses and orderlies) that had taken her granny away when she was younger.

Critique

I'm a Cyborg is about neither mental health nor cyborgs. To think of Park Chan-wook's film in such terms would be to do it a great disservice, as it fails both to demonstrate the complexities of the post-humanist discourse on cyborgs, and also fails to provide a sympathetic portrayal of the mentally ill. *I'm a Cyborg* depicts madness as comedic; the patients serve to prompt the film's departures into the fantastic as much as to raise any important questions with regards to mental illness. Indeed, any pretence the film might make to 'explain' the problems suffered by the character-patients serves only to mystify their conditions further; Young-goon is a cyborg, we are told, because her granny loved radishes and thought that mice were her children (and the film seems to think that these

Year:

2006

very different delusions are the same thing); Il-sun is an anti-social schizophrenic who thinks he is going to disappear into a dot – only he is not really a schizophrenic any more than he is a well- rounded character. None of the barely-explored backstories that Park furnishes us with seem to provide any explanation for the peculiar character traits that the film relies on. They merely serve as another departure into the bizarre, just at the character traits themselves serve as a thinly-disguised excuse to paint the cinematic fantasy sequences for which the film is memorable.

The film's narrative is, therefore, about nothing in particular, but this is no bad thing. It provides Park with the perfect opportunity to explore the functioning of the cinematic spectacle itself. Park's Vengeance trilogy had previously been driving in this direction, with the director's increasingly-preposterous narrative decisions prompting action set pieces of increasing complexity. In this respect, I'm a Cyborg sits more comfortably alongside the Vengeance trilogy than might be expected given its subject matter, with a recurring fantasy where Young-goon attempts to shoot her doctors by firing bullets through her fingers neither declared as real nor rejected as delusional. We get the sense that the film does not really care if such sequences as this are contextually correct or consistent with the narrative of the film; all that is important is that we, as an audience, indulge the fantastic. Not that we accept it as real or even desirable, but that we follow Park down the rabbit hole in order to see what the cinematic can offer us.

This is spectacle in Guy Debord's sense – *not as a collection of images; it is a social relation between people that is mediated by images.*[1] Young-Goon relates to the world through this spectacle.

I'm A Cyborg, but that's Ok, 2006, Joy Fund/Moho Films/Kobal Collection

We do not have to understand why she is angry, nor that she longs for an escape, nor even that she cares for Il-Sun. Any reaction or emotional response that might be constructed through dialogue or otherwise inserted into a narrative context is, instead, shown in its spectacular form. Anger becomes massacre; escape becomes an impossibly-green meadow; romance becomes rocket-booster feet and a 180-degree head turn. Everything in the film – character, narrative, thematic content – is developed by referring a disparate array of fantastic images to one another, and this is perhaps the only way in which the film can be said to address the machinic. *I'm a Cyborg* plugs Young-Goon into a huge series of tiny cinematic machines in order to construct what is perhaps the most sophisticated example of Park Chan-wook's cinema to date, organizing Young-goon's life as an immense accumulation of spectacles. *Everything that was directly lived has receded into representation.*

Phillip Roberts

Notes

1 Guy Debord (2009) *Society of the Spectacle.* Sussex: Soul Bay press.

Love in Magic

Yeonae-sulsa

Studio/Distributor:
CJ Entertainment

Director:
Cheon Se-hwan

Producers:
Lee Hyo-seung, Lee Geun-du,
Jo Yun-ho

Screenwriter:
Kim Gyoo-won

Cinematographer:
Hwang Chul-hyun

Art Directors:
Choi Ki-ho, Kim So-yeon

Editors:
Nam Na-young, Heo Seon-mi

Duration:
106 minutes

Synopsis

Ji-hoon is a playboy magician who beds women in motels between shows. During one of these occasions he is interrupted by a phone call from his assistant, who is using his break to view some illicit videos on the internet. He has stumbled upon a candid video of a couple and recognized Ji-hoon, so he calls to warn him. It turns out that the video was of a past experience and he must now track down who his partner was at the time. Hee-won is a young teacher who has just received a surprise marriage proposal from a long-time friend. She ponders the offer and what she wants in life until Ji-hoon bursts into her school to inform her of their unwitting sex tape. Now they must track down the invaders of their privacy before the video goes viral. The only obstacle is that they have to locate the right motel out of the seventeen they visited together.

Critique

Up until very recently, Korean films, compared to many of their world cinema counterparts, have been remarkably prudish. Many of the country's most notable and popular romantic films have played out with hardly a kiss to be seen, such as *Siworae/Il Mare* (Lee Hyun-Seung, 2000) and *Yeopgijeogin Geunyeo/My Sassy Girl* (Kwak Jae-Young, 2001), though, to be fair, both of those starred Jeon Ji-hyeon, who had a provision in her contracts that stipulated she was not to perform kissing scenes.

Love in Magic is a light romance that also attempts to be a bawdy sex comedy. A significant portion of the film takes place in love motels, where rooms are rented by the hour. Of course, much

Genre:

Romantic comedy

Cast:

Park Jin-hee, Yeon Jung-hoon, Jo Mi-ryung, Ha Dong-hoon

Year:

2005

of this is played for laughs as the gag is that nothing ever happens apart from some sexual innuendo. The problem is that this is representative of the film as a whole. Despite the film's erotic locales and numerous allusions to coitus, it remains a very sexless affair. Ji-hoon and Hee-won traipse through the sites of their previous rendezvous but, rather than adding a dose of sexual tension, the time they while away stalls the narrative.

This issue drags down the early stages of the film but soon things start to get better as Kim Gyoo-won's script, which he adapted from his novel, begins to steer away from traditional rom-com territory. Aside from the opening salvo, we are not privy to any of Ji-hoon's skills as a magician and it is easy to forget what his trade is, as his only currency seems to be that of a playboy. However, at the halfway mark, we are afforded the opportunity of watching his new magic show, titled 'Love in Magic.' It is a cunning and Brechtian sequence that stands apart from the rest of the film. Director Cheon Se-hwan gets to demonstrate his ability as the show-within-a-film, which we witness as spectators in the audience, succeeds in forwarding the film's narrative trajectory while also being remarkably entertaining.

Following this sequence, the highlight of the film, *Love in Magic* forges a new path, sewn together from different generic strands. On the one hand it becomes a thriller and on the other a surprising social exposé which elucidates the enduring importance of appearances and propriety in contemporary South Korea. Not all of it sticks, which is a common downside to these Korean hybrid films, but enough hits the mark to make for a much livelier second half.

The film has its fair share of sweet moments that are well-executed, as is often the case in Korean rom-coms. It is a solid entry in the rom-com genre and a good effort at combining other styles into the standard format. But for a more successful example I would point you to the recent *Ossakhan Yeonae/Spellbound* (Hwang In-Ho, 2011), one of the year's big hits, which is also about a magician. It is a high-concept affair which throws in some horror tropes and is much more coherent, but it is certainly films like Love in Magic that paved the way for it.

Pierce Conran

My Little Bride

Eorin Shinbu

Studio/Distributor:

Korea Pictures

Director:

Kim Ho-jun

Synopsis

When her grandfather appears to fall into bad health, 15-year-old Bo-eun finds herself strong-armed into an arranged marriage to Sang-min – a 24-year-old family friend she has known for most of her life. Under pressure from their families to honour the grandfather's wishes, the couple begrudgingly go through with the arrangement in order for the old man to keep a promise to Sang-min's own grandfather – that the two families would one day be united through marriage. While they manage to put aside their general irritation with each other long enough to wed and

Producer:

Choi Sun-sik

Screenwriter:

Yu Sun-il

Cinematographer:

Seo Jeong-min

Art Directors:

Yun Do-hwan, Kim Hyo-jin

Composers:

Choi Sun-sik, Choi Man-sik
Editor:
Park Soon-duk

Duration:

115 minutes

Genre:

Romantic comedy

Cast:

Kim Rae-won, Moon
Geun-young, Kim In-moon,
Han Jin-hui, Kim Hye-ok

Year:

2004

move in together, neither Bo-eun nor Sang-min plan on taking the marriage seriously and, instead, hope to continue to live their lives as independently as possible. With their situation kept as a secret from their separate social circles, Bo-eun pursues her crush on the Baseball team's star player and life carries on fairly normally – until Sang-min arrives at her school as a student teacher...

Critique

The second most popular domestic film of 2004 at the Korean box-office – falling behind *Taegukgi hwinalrimyeo/Taegukgi* (Kang Je-gyu, South Korea, 2004) – Kim Ho-jun's odd-couple romantic comedy *My Little Bride* is a loose remake of the Hong Kong film *Ngo liu poh lut gau ching/My Wife is 18* (James Yuen, Hong Kong: 2002), a popular vehicle for Ekin Cheng and Charlene Choi. The feature debut from director Kim Ho-jun, *My Little Bride* is slickly made and wisely keeps the running time under the two-hour mark. While it proved to be an easy sell at home, *My Little Bride* under-performed overseas – possibly due to the central 'schoolgirl-bride' premise which, marketing-wise, requires clarification of the tone but, in doing so removes some of its edge – yet it proves to be a superior version to the by-the-numbers original.

Central to *My Little Bride's* success are the performances of its cast, particularly those of its two leads. An actress since the age of twelve, Moon Geun-young's big-screen breakout came a year earlier in *Janghwa, Hongryeon/A Tale of Two Sisters* (Kim Jee-woon, 2003) and playing the character of Bo-eun she managed to establish herself as a top box-office draw and earn the nickname of 'the nation's little sister' in the process. Kim Rae-won – largely known as a television actor with a few films under his belt, including appearing with Lim Su-Jeong, the 'other' sister in *A Tale of Two Sisters*, in *Ai-en-ji/...ing* (Lee Eon-hie, 2003), received equal praise for his role as Sang-min, arguably the more difficult role of the two leads. While *My Little Bride's* schoolgirl-marriage premise provides a strong potential for fun, it also throws up the obstacle of how to handle the potentially-problematic issue of the (young) teen bride and the older man. Luckily, screenwriter Yu Sun-il is more than aware of this: after toying with our expectations by introducing Sang-min as a potential pervert, any problems are diffused by acknowledging the seriousness of the marriage (allowing the moral implications to fuel the interplay between the two sets of parents) while simultaneously demolishing any more troublesome implications by allowing the considerate and protective Sang-min to directly – but childishly – tease Bo-eun about their lack of a physical relationship.

My Little Bride's self-aware and smart script is elevated by the forgoing of any 'comedy' performances from the leads, who instead deliver their scenes in a naturalistic manner. This allows us to engage with them no matter how ridiculous the situations get – although it is aided no end by the genuine spark that appears between the two of them – and makes way for the supporting cast to deliver some even broader comedy. While the cast, including

Han Jin-hui and Kim Hye-ok, is strong throughout, Kim In-moon is particularly amusing as the Grandfather who is determined to set up the marriage, and Ahn Sun-young who – as a teacher with her eye on Sang-min – steals every scene she appears in.

My Little Bride never strays from the basic rules of the standard romantic-comedy format but proves that, with a sharp script, swift direction and a strong cast, there are still plenty of ways to wring some likeable characters and genuine laughs from the genre. It never gets too clever – there is not a whole lot of examination of the family and school structures that it toys with – but that is hardly a complaint for something that provides two hours of this much fun.

Martin Cleary

My Sassy Girl

Yeopgijeogin geunyeo

Studio/Distributor:
Shine Cine Communications

Director:
Kwak Jae-yong

Producer:
Park Geon-seob

Screenwriter:
Kwak Jae-yong

Cinematographer:
Kim Sung-bok

Composer:
Kim Hyeong-seok

Editor:
Kim Sang-beom

Duration:
137 minutes

Cast:
Cha Tae-hyun, Jun Ji-hyun,
Han Jin-hie, Hyun Sook-hee

Year:
2001

Synopsis

After an evening spent drinking with his friends, amiable college student Kyun-woo is waiting for his subway ride home when he saves a very beautiful – but also very drunk – girl of a similar age from being killed by an oncoming train. Taking responsibility for the inebriated young woman, Kyun-woo takes her to a cheap hotel where she can recover. From this chance encounter, an odd but affectionate relationship develops. This 'sassy' girl, who remains nameless, is bossy, rude, and prone to violent outbursts that are often directed at the largely-clueless Kyun-woo, but she is evidently vulnerable and can be considerate when in the right mood. Kyun-woo tolerates her behaviour, realizing that his friend is deeply troubled, and suffers numerous public humiliations (including being vomited on during the girl's bouts of drunkenness, and being forced to run in high heels) to uncover the reason for her inner sorrow.

Critique

The episodic structure of Kwak Jae-yong's enormously-popular romantic-comedy *My Sassy Girl* is entirely appropriate, as the film is based on a series of true stories by Kim Ho-sik that were posted on the internet before becoming the basis for a novel. As such, *My Sassy Girl* revolves around the tentative relationship between two characters and the incidents that occur to them, with events being presented from the perspective of its male protagonist Kyun-woo (Cha Tae-hyun) until the final third, thereby enabling the audience to be as equally intrigued and infuriated by the behaviour of the nameless object of his affection (Jun Ji-hyun). This leads to an irreverent tone that frees *My Sassy Girl* from the tired tropes of the romantic-comedy genre and allows for a more freewheeling tone and pace, while the girl's reactions to Kyun-woo's attempts to reach the warmth behind her angry exterior are as unpredictable as they are amusing, since we learn nothing of her back-story and see little of her home-life. Much of the slapstick humour is derived from the

'sassy' girl's dominance of Kyun-woo, and the submissive – or even masochistic – tendencies of the male protagonist could be seen as indicative of a crisis of Korean masculinity; she tells him what he will eat and drink in restaurants and bars, conceives games which will cause him physical pain and public embarrassment and asks 'Do you want to die?' whenever he makes a mistake. This dominance is carried into the broadly-realized fantasy sequences: visualizations of the screenplay treatments that the girl writes and then forces Kyun-woo to read which frequently feature her as an action heroine and Kyun-woo as a semi-reluctant foil in need of rescue.

It is unfortunate that the pace flags in the final third and the film lurches into melodramatic territory with fairy-tale trappings and musings on romantic destiny, not to mention sentimental pop music and soul-searching voice-over being employed to convey feelings that had previously been cleverly expressed through the contrasting physicality of the mismatched couple. The characters inevitably improve themselves through their somewhat unconventional relationship; Kyun-woo is honest and well-meaning but professionally aimless, and he gains both a sense of purpose and creative inspiration from their misadventures, while the girl is able to calm her temper and open up about her grief. While the conventional conclusion may seem to be a compromise, following the lively, spontaneous humour of the initial two-thirds, it may account for much of the film's pan-Asian appeal; the film was the second-biggest box-office attraction of 2001 in Korea, but was also a popular phenomenon in China, Hong Kong, Japan and Singapore, then remade by Bollywood in 2008 and adapted as a drama for Japanese television in the same year. *My Sassy Girl* was also remade by Hollywood in 2008 but, as the notion of a young woman behaving in an occasionally-outrageous manner is not as novel in the West as it is in the more restrictive society of Korea, the American version lacked the lightly-satirical edge of the original and was released straight-to-video in most territories.

John Berra

My Tutor Friend

Donggabnaegi Gwawoehagi

Studio/Distributor:
CJ Entertainment, Corea Entertainment and Discovery Venture.

Director:
Kim Kyeong-hyeong

Synopsis

Working as a tutor to a couple of young high schoolers, English Major Su-wan tires of their juvenile behaviour and quits her teaching job. Although disheartened with the occupation, she needs the work to pay her college fees. With this in mind, she agrees to tutor the son of one of her mother's privileged friends, Kim Ji-hoon, whose stay in America has ensured that, at 21, he still has to graduate from High School. Although Su-wan and Ji-hoon are the same age, they seem to have nothing else in common. She is studious with an earnest disposition whilst he appears to revel in obnoxious and delinquent behaviour. Although exasperated by Ji-hoon and his arrogance, Su-wan refuses to quit before he does. Frustrated by Ji-hoon's involvement with local gangs, his father confiscates his

Producer:

Jang Yeong-kwon

Screenwriter:

Choi Soo-wan

Cinematographers:

Ji Kil-woong, Na Seung-yong

Art Director:

Kim Hyeon-ok

Composer:

Lee Kyung-sub

Editor:

Go Im-pyo

Duration:

110 minutes

Genre:

Romantic comedy

Cast:

Kim Ha-neul, Kwon Sang-woo, Kim Ji-woo, Kwon Sang-woo

Year:

2003

credit cards and threatens to send him back to America unless he attains the 50 per cent grade average needed to finally graduate. Spurred on by these threats, he attempts to undertake a more attentive attitude to his studies. As a consequence, Su-wan becomes increasingly involved in his life and tutor and pupil begin to grow close.

Critique

Although promoted as a romantic comedy upon initial release, *My Tutor Friend* is indicative of the confidence within contemporary South Korean cinema to twist and blend accustomed genre boundaries. This is an increasingly-prominent factor in local mainstream cinema. For instance, *Jungdok/Addicted* (Park Young-hoon, 2002) is an assured mix of supernatural mystery and romance whereas *Swiri/Shiri* (Kang Je-gyu, 1999) combines the conventions of both Hollywood and Hong Kong action cinema within traditional local melodramatic forms. In commercial terms, much of this enthusiasm for genre mixing can be attributed to an increased emphasis on culture as economic discourse where generic diversification within film promotes multiple-address strategies as a device for boosting audience figures.

Sourced from an internet blog and released after the success of the similarly-themed *Yeopgijeogin Geunyeo/My Sassy Girl* (Kwak Jae-young, 2001), Director Kim's film certainly has a brash and sure-footed commercial edge. One that is re-enforced by incorporating the aesthetics of the globally popular cycle of the contemporary South Korean youth-based gangster cinema upon the foundations of romantic comedy. Such a populist combination helped to ensure geocultural success for the film and it remained at the top of the national box office for five weeks, gaining takings comparable to *My Sassy Girl*.

Alongside the undeniable influence of *My Sassy Girl*, there is no doubt that *My Tutor Friend* is also heavily indebted to the success of this local youth-based gangster cinema such as *Biteu/Beat* (Kim Sung-su, 1997) and *Friend* (Chingu, 2001]. The corruptive elements of provincial gangster 'culture' surrounds both the home and school life of Ji-hoon like an inescapable fog. But in first-time director Kim's film such aesthetic inclusions are skilfully employed so as to not overshadow the mismatched courtship and the comical situations that arise from the unlikely pairing of Ji-hoon and his 'country girl' tutor. Rather than mere commercial façade designed to maximize audiences, these influences provide a solid framework from which to question these corruptive elements that merge with family and patriarchal influence. Throughout the film Kim queries how far Ji-hoon is responsible for some of his less-endearing behavioural traits through the dominance of his Father's influence and profession.

As Su-woon sits with Ji-hoon and his family for dinner, his father recites a prayer thanking famous gangsters of the past for their privileged life and is later seen surrounded by henchmen in his office. These family connections and involvement are further

alluded to as the film progresses, and their inclusion suggests that the masculine posturing and spoiled lifestyle of Ji-hoon may have more than a little to do with his father's position in society and his willingness to favour his spoiled son with credit cards and expensive designer goods. While these actions and his ostentatious circumstances gain pop idol-like admiration from his classmates they rebuff his homely tutor, whose manic reactions to his behaviour account for much of the reverently-raucous humour within the film. Her efforts to teach him are initially met with displays of callow and defiant behaviour, such as blowing cigarette smoke in her face in lessons and boorishly proclaiming a preference for pornography over textbooks. Meanwhile, prolonged and excessively-violent, hyper-stylized gang fights, with Ji-hoon at the centre of the action, act as furthering a reliance on brutal aggression as external displays of masculine power: an external display that proves to be ever more fragile as the story unfolds. Despite Kim's more-than-competent restructuring of the source material, many critics bemoaned the dramatic turn from conflict to admiration between the two leads in the last third of the film. As Ji-hoon begins to develop feelings for his tutor and commit himself to finally graduating, the masculine posturing and comic frustration that arose from the clash of personalities endorsing the first two acts begin to subside. But as the film moves on there are more than enough surprising turns left in a journey that should please even the most jaded fan of the genre.

Dave McCaig

Rules of Dating

Yeonae-ui mokjeok

Studio/Distributor:
Sidus FNH Corporation

Director:
Han Jae-rim

Producers:
Tcha Sung-jai, Lim Choong-ryul, Yun Sang-o

Screenwriters:
Go Yun-hui, Han Jae-rim

Cinematographer:
Park Yong-su

Art Director:
Jeon Su-a

Synopsis

Choi Hong is a student teacher who enters a high school at the above-average age of 27 and is almost immediately hit on by her slimy fellow teacher Lee Yoo-rim, who turns out to be one year her junior. At first she does not respond well to his aggressive advances but does not go so far as to rebuff him. Hong is a little reserved and plays hard to get while Yoo-rim is brash, gregarious, and a heavy drinker, but there is a mutual attraction between them and an odd relationship begins to form, even though they are both in long-term relationships. Hong slowly opens up to Yoo-rim about her past and they find solace in each other's arms on the sidelines of their unfulfilled lives; but will they be able to keep their affair a secret, from their significant others as well as from their workplace, which does not tolerate scandal?

Critique

Han Jae-rim is best known as the director of the excellent Song Kang-ho-starring gangster film *Uahan Segye/The Show Must Go On* (2007) but *Rules of Dating*, his debut, is an equally layered and absorbing work, if not as bombastic and entertaining. In its marketing, the film was strangely sold as a romantic comedy but, while

Editors:

Park Gok-ji, Jeon Jin-hui

Duration:

118 minutes

Genre:

Romantic comedy/melodrama

Cast:

Park Hae-il, Kang Hye-jeong,
Lee Dae-yan, Park Grina

Year:

2005

such a label may have helped to sell tickets, it is quite far from the truth and has the potential to sour audiences who are not expecting a deconstruction of our innate narcissism and selfishness. However, despite the film's pessimism and its misleading marketing, it ended up becoming one of the most successful Korean films of 2005. The film's strengths and, likely, the reasons for its popularity boil down to two key points: the formidable cast and its adherence to realism, particularly the way in which it goes about portraying it.

Park Hae-il is an actor who for a long time annoyed me, frequently playing characters that got on my nerves. However, one day it dawned on me that he actually is a great actor; it is just that he has the misfortune of having the appropriate physical characteristics to play a jerk. Then, again, he is able to use his physiognomy to great effect as time and again he successfully portrays the most shallow and selfish brats in Korean cinema, from the prime suspect in *Salinui Chueok/Memories of Murder* (Boon Jong-ho, 2003) to the low-rent gangster in *Shimjangyi Dwoenda/Heartbeat* (Yoon Jae-keun, 2010). It was not until *Choejongbyungki Hwal/War of the Arrows* (Kim Han-min, 2011), in which he was almost unrecognizable beneath a goatee and long hair, that he was fully accepted by the industry, which promptly handed him the best actor accolades at all of that year's major awards shows. Having said this, in *Rules of Dating* Park Hae-il is in his element and this is one of his very best roles.

Kang Hye-jeong is best known to western audiences as the female lead in *Oldeuboi/Oldboy* (Park Chan-wook, 2003) and has built her career playing a series of quirky characters, notably in Welcome to *Dongmakgol* (Park Kwang-hyun, 2005) and *Heobeu/Herb* (2007). Unfortunately, this stereotyping restricted the roles she could take on in film and, of late, she has drifted into the land of K-Drama. In *Rules of Dating* she also plays someone who is a little off but this time her complex character is eminently believable. Kang does a fantastic job with this difficult role, yielding a delicately-nuanced performance.

Rather than idealizing certain key events, the film revels in the simple pleasures of everyday circumstances. The numerous bars and eateries with their plastic pitchers of beer or the innocent sight of Hong crawling out barefoot from a restaurant booth are the elements that colour the world of Han's film and it is all the more relatable because of them. To complement this atmosphere, a handheld aesthetic is employed which bores into the prosaic lifestyles of the narrative's protagonists. The style of the film draws on European art cinema, such as the French New Wave-style jump cuts frequently used in the editing.

At first it may not seem like there is much to *Rules of Dating* but stick around and you will be surprised at the rich depths it manages to reach. There is also something a little sick and twisted about the relationship that Han seeks to portray. Sometimes it is presented to us accompanied by a classic Hollywood-style score but the result, though magnificent, is a little unnerving. Perhaps this is because it hits a little too close to home.

Pierce Conran

QUEER CINEMA

In the last ten years there have been several gestures towards establishing a Korean Queer Cinema, one that accounts for homosexual themes in mainstream cinema, the short films of gay and lesbian festivals, a relaxation in film censorship, a trend in the homo-eroticization of male stars, and an emerging public awareness of the existence of queer Koreans. The Korean screen in particular seems to be awash with homosexuality yet whether 'Korean Queer Cinema' exists as a consolidated object is subject to much debate and is, rather, just beginning to emerge as an identifiable genre.

Not that long ago, in a ground-breaking article in a queer Asian cinema collection, Jooran Lee broached the concept of a Korean Queer Cinema both in retrospectively identifying gay and lesbian themes in the history of Korean cinema in films such as *Hwabun/The Pollen of Flowers* (Ha Kil-jong, 1972) and *Jangsa-ui kkum/Dreams of the Strong* (Shin Seung Soo, 1985) and in imagining a future in which we would see the development of an identifiable rather than sublimated queer Korean cinema.[1] Through the gradual relaxation of censorship of sexually-explicit material – although it should be noted that Wong Kar-Wai's *Happy Together* (Hong Kong: 1997) was banned in Korea and gay websites have come under attack – there now exists a handful of feature-length productions and an exciting and burgeoning short-film circuit that is expressively queer. The context for these shorts is predominately film festivals, particularly the triumvirate of Queer, Human Rights, and Women's film festivals that occur annually. However, I would suggest that the contemporary context of mainstream cinema, the one most frequently used to talk about a 'Korean queer cinema', is still one of fantasy rather than reality. In these terms, 'Korean queer cinema' is a genre which is still emerging and negotiating its status as queer, like the spectre of *Yeogo goedam II/Memento Mori*, (Kim Tae-yong & Min Kyu-dong, 1999) it haunts Korean cinema and anticipates in its wake a wider political and cultural shift of understanding, acceptance, and progress. There are numerous and significant films appearing year after year that seem to qualify themselves as queer texts from *Beonjijeompeureul hada/Bungee Jumping of Their Own* (Kim Dae-seung, 2001), *Wang-ui namja/The King and The Clown* (Lee Jun-Ik, 2005), to *Hellowoo Maireobeu/Hello My Love* (Kim Aaron, 2009) but this overlooks on the one hand films that are properly queer from a politics of production and reception (not many), and, on the other, films engaging with queer identities and being made by queer film-makers as

Left image: *No Regret*, 2006, Generation Blue Films/Kobal Collection

in the case of *Huhwihaji anha/No Regret* (Lee Song Hee-il, 2006). There are a significant number of films in which homosexuality is a major plot strand, *Jeoseuteu Peurenjeu/Just Friends* (Ahn Cheol-ho, 2009) and/or representational, *Antique* (Min Kyu-dong, 2009), sometimes subsumed by genre (horror in the case of *Memento Mori*), or actually entirely sub-textual, barely there for most audiences (like the unspoken love in *The Unforgiven*, Yoon Jong-bin, 2005).

A common outside perception of queer cinema often assumes that visibility equals progress, that cinema and politics neatly mirror one another, but by and large the majority of homosexual representations in Korean cinema, of which there are many, are just that, representations, meaning that they do not necessarily engage with homosexuality as a political and cultural identity or assume a queer reception practice. However, that is not to say that at this stage any visibility is good visibility. Acts of representation, of seeing oneself onscreen, is a starting point for a queer cinema; that often means that many of the films are contradictory, trying to work things out, finding a mode of expression and a politics and, by definition, seemingly uneven and inchoate when compared to their global cousins. Korean queer cinema is very much a movement in progress and it demands our patience and sensitivity.

A particular contradiction that needs attention is that many of the commercially-orientated films are inclined to make sense of male homosexuality through a tension that often filters the experience of it through female protagonists and their viewpoints while, at the same time, attempting to awkwardly articulate queer desire and experience. Women are often the means through which 'the secret' or 'experience' of homosexuality comes to be known. It is handled in a way that problematically denies the gay protagonist his (always his) voice, although this may not always be interpreted in a negative light since it is seems to point out the silences and avoidances and the need to speak about homosexuality in Korean society. An example of the way in which such tensions can be worked out is demonstrated by the short film *Yeopseo/The Postcard* (Kim Jun-pyo, 2007). *The Postcard's* young gay man tries to strike up a relationship with a postman by writing postcards to himself that will be delivered by the postman in which he declares his love for the man in the uniform. His postcards bear no name, only an address that points towards being an act of secrecy that is carried over into the silence that marks both the film's gay protagonists. These postcards and what is written on them are mediated through the two female post office clerks who assume the man is writing to one of them; in other words, they would never assume or think of homosexuality as a possibility – it just does not exist. The film does not end with a consummation of the two men but with them sitting in a public bath back to back as a visual rendering of their homo-ness and separation and one that mirrors each other's inability to speak and articulate desire. Like Korean queer cinema itself, the ending hints at a beginning rather than something fully realized. It is a film about silence, shyness, reluctance, and secrecy. It is an obvious sign of the progress yet to be made.

I do not want to deny the existence of a more fully-fledged Korean Queer Cinema but it is important not to overstate the fact based on naive assumptions related to representational quantities in mainstream cinema. *The King and The Clown* does not readily translate into political progress for Korean queers. The relationship between sexuality and cinema is not necessarily reflected in the broader context of homosexuality in Korean society, which, by reports from LGBT organizations, is getting better but still has a long way to go. There are countless stories of homophobia since there is no recognition, rights, or legal protection for queers, which makes for a difficult and depressing situation; LGBT people are often referred to as *iban* or second-class citizens. National and institutional homophobia is most clearly demonstrated when celebrities and stars make the brave leap to come out. In 2008 the actor and model Kim Ji-hoo came out on television, in an LGBT-themed show called *Coming Out* (2007) and, following this,

he was subsequently the target of homophobia: he was dropped from his modelling agency, and sacked from his television programmes. His existence was censured and he committed suicide later that year. However, it would seem that progress is being made in small steps and Korean film, both independent and mainstream, as well as television, will have an important role to play in how both Korean queers and the wider public come to terms with increased visibility and the demand for tolerance, recognition, and equality.

Films about homosexuality do not necessarily make queer films and the term queer itself all too easily becomes empty of meaning, depoliticized and deconcontexualized from its original intention. Queer began as an Anglo-American political reclamation of a homophobic word that became an important identity and critical tool for both activism and theory. However, by calling the right Korean films queer carries an explicit criticism of the widely-held assumption of queer being most commonly white, Western, and male and, as such, is useful in maintaining queer's intention as an anti-essentialist manoeuvre. Queer films should be engaged on different levels in relation to practices of production and reception that do speak meaningfully to queer Koreans through an engagement with desires, identities, politics, and histories. In the current context this has mostly taken place in the short-film productions, for example, *My Father's Song* (Lee Ji-sun, 2002), *Dongbaek Ggot/Drifting Island* (So Joon-moon, 2005), *La Traviata* (Lee Song Hee-il, 2005), *Mogyok/The Bath* (Lee Mi-rang, 2007), *You Used to Smile That Way* (Sun Park, 2009), and also evident in the documentary productions *Goyangideul/Cats* (Kim Jee-hyun, 2008), *3xFTM* (Kim Il-rhan, 2008), and *Jong-ro-eui Gi-jeok/Miracle on Jongno Street* (Lee Hyuk-sang, 2010).

In the context of 'Korean Queer Cinema' as a debate, there are two issues that currently need addressing – the problem of romantic comedy and the problem of mainstream reception's avoidance of homosexuality in queerly-themed film. The first hindrance is that homosexuality and homoeroticism, which is always male, is most frequently an aspect of Korean romantic comedy in which the homosexuality is clearly evacuated of any progressive elements. *Hello My Love*, a film more balanced in its approach than others, is still typical through the common set-up in which there is a *ménage a trois* between two boys and a central female protagonist where there is rivalry for the affections of one of the male leads. Even films outside the romantic genre, for example *Rodeu-mubi/Road Movie* (Kim In-shik, 2002), often held up as a groundbreaking queer Korean film, rarely conceive of male-male relations without recourse to a love triangle in which a female protagonist filters the experience for the audience and offers the possibility of something not quite fully gay. This scenario recalls some of the earlier debates in Asian queer cinema around Ang Lee's *The Wedding Banquet* (1993). The contextualization of homosexuality and homoromanticism in Korean romantic comedy also assumes a female audience, which suggests that matters of homosexuality belong to the domain of female reception and female genres. While it is unfair to define the rom-com's sassiness as simply 'girly', it is precisely a feminization that contours the representation of gay characters through the 'cute boy' lens of passive spectacle derived from the Japanese *yaoi* 'boys in love' milieu. The Korean live adaptation of Sayangkoldong *Yangkwajajeom Aentikeu/Antique Bakery* (Min Kyu-dong, 2008) is an obvious contender here, set in the context of a patisserie sublimating sex for choux pastry, and satiating the desires of Antique's female customers and those of its female audience. *Antique* manages to accommodate queer spaces such as the disco and deal with homophobia and closetedness (in a light-hearted way) but, overall, the feminization and the French-ness associated with cake-making render homosexuality safe and knowable as something feminized and European. The problem here is not the feminization of gay men, since that is an important aspect of queer culture's gendered dissonance and challenge to effeminophobia, but, rather, that it becomes the main, and sometimes only, signifier of homosexuality in mainstream Korean cinema.

Critical reception is the second problematic issue. In an issue of the KOFIC publication *Korean Film Observatory*[2] there is coverage of three queer or possibly queer films which are *Dasepo sonyo/Dasepo Naughty Girls* (Lee Je-yong) – a webcomic adaptation from 2006; *No Regret* (a queer indie); and *Cheonhajangsa Madonna/Like a Virgin* (Lee Hae-jun, Lee Hae-young) – a comedy that may or may not be about a transgender Madonna fan from 2007. In Darcy Paquet's coverage of *Dasepo Naughty Girls* there is no mention of the gay content or fluid sexualities, merely allusions to an unspecified diversity and transgression. The pages devoted to the comedy *Like a Virgin* are no better. In that film, a young overweight boy who loves Madonna (need one say more) feels that he is a girl trapped in a boy's body. The film is not addressed as one concerning gender identity and sexuality but rather concentrates on issues surrounding class and the failure of an unemployed father. The emphasis here orientates the film towards an examination of class politics, which is subterfuge, but it strikes at a real problem beyond cinema in that, culturally, there is still difficulty in seeing Korean homosexuality as something that actually exists. In these two articles there is no mention of homosexuality. However, there is no way of denying the upfront nature of homosexuality in Leesong He-il's *No Regret* and, in a contradictory fashion, the write-up presents both a regressive position ('how weak homosexuals can become feminized') and a progressive one ('the serious issues explored in the film'). But, like *Hello, My Love*, this queer film is understood through its relation to another female genre, the hostess melodramas of the 1970s, rather than seeing it as a new type of Korean cinema, that is, a Korean Queer Cinema.

Gary Needham

Notes

1 Jooran Lee (2000) 'Remembered Branches: Towards a Future of Korean Homosexual Film' in Andrew Grossman *Queer Asian Cinema: Shadows in the Shade*. Binghampton: Hawthorn Press, pp.273-282.
2 *Korean Film Observatory* No.21, 2007.

A Bizarre Love Triangle/ Taekwondo Girl

Cheoleobtneun anaewa paramanjanhan nampyeon geurigo taekwon sonyeo

Studio/Distributor:
Egg Film /New Line Korea

Director:
Lee Moo-young

Producer:
Ji Yeong-jun

Screenwriters:
Jung Hee-sung, Bangnidamae, Park Chan-wook, Lee Moo-young

Cinematographer:
Ko Su-bak

Art Directors:
Eo Gyeong-jun, Lee Tae-seob

Composer:
Jang Young-kyu

Editors:
Kim Sang Bum, Kim Jae-beom

Duration:
93 min

Genre:
Drama/comedy/gay and lesbian/science fiction

Cast:
Cho Eun-ji, Gong Hyo-jin, Choi Gwang-il

Year:
2002

Synopsis

On a space colony of the future, a wedding guest narrates the three intersecting character points of *A Bizarre Love Triangle* that consists of Oh Doo-chan, a successful comedian who himself never laughs; Bae Eun-hui, an aspiring, yet horribly-failing, actress; and Hwang Keum-sook, a twice-convicted felon and Taekwondo instructor. Eun-hui and Keum-sook meet each other in high school when Bae is abandoned by her father in the care of an impoverished step-mom she barely knew. Keum-sook quickly becomes Eun-hui's protector, going to lengths that lead to jail time for Keum-sook. Doo-chan meets Eun-hui during a telethon for Eun-hui's fatherless sick child, a chance meeting that leads to their marriage. This marriage soon turns sour due to Eun-hui's annoying behaviour and inability to fulfil her thespian dreams. When Keum-sook is released into Eun-hui's life at this tumultuous moment, the shuffling of relationships begins to take form in atypical ways.

Critique

A Bizarre Love Triangle is yet another film that is difficult to critique without revealing plot surprises. But since the promotional materials expose the lesbian relationship, and such is hinted at enough fairly early on in the film when Keum-sook catches and chomps the cucumber thrown by Doo-chan (Choi Gwang-il), (as if Keum-sook is masticating a critique of patriarchy and pleasure), it is not much of a spoiler to reveal that Hwang Keum-sook (Gong Hyo-jin) is a lesbian and that she has a crush on Bae Eun-hui (Cho Eun-ji). For a country where it is still difficult to be publicly gay, (although some improvements have been made in this area), Keum-sook is presented as the most confident and strong of the film's three primary characters. Although portrayed as a tomboy, Keum-sook is not presented in a caricatured butch role. She has depth. She has doubts about her ability to secure Eun-hui's affections yet is confident in her means to physically defend herself. Keum-sook is as open to crying when she feels her love will never be realized as she is to being tough in her female masculinity.

Eun-hui, the anchor of the love triangle, is such an annoying person in her whining and her ineptitude, one wonders why either Keum-sook or her husband Doo-chan would ever find her attractive. It is this aspect that keeps the film from being exemplary, yet the main actors do a fine job in spite of these problems. Cho demonstrates her skill in the ironic fact that it takes a good actress to portray a bad one. Gong is her usual intriguing self, having played a believably-tough girl before in films like *Conduct Zero*. Choi's deadpan comedy works in the role of Doo-chan, a comedian whose shtick is loud clothes and lines delivered without expression. (Not as catatonic as Steven Wright, but similar.) His few jokes in character are indeed funny, so you do not feel as if the film is forcing you to just accept his success.

One bit of cultural knowledge that might be helpful to know when watching *A Bizarre Love Triangle* is the protected status of blind masseurs in South Korea. Since 1913, blind Koreans have had a monopoly on the occupation of massage therapy. If you are not legally blind, it is basically illegal for you to offer massage services for payment. (Interesting side note, this law was upheld by the Constitutional Court of South Korea on the same day in 2008 that the illegality of adultery was also upheld, continuing the greater suspense South Koreans might experience when witnessing adultery in their films.) Although she is Keum-sook's sugar momma and one of her motivations is to get a new pair of eyes, the masseur retains her dignity in that her disability is neither caricatured or metaphoric, similar to how Keum-sook's female masculinity is more than just a butch stereotype.

Besides the problems of Eun-hui's histrionics, the science-fiction aspect of telling the story from the future falls flat. In spite of those problems, the film is fairly entertaining. Where it solidifies its significance in South Korean cinema history is its pioneering portrayal of lesbian characters.

Adam Hartzell

Antique

Sayangkoldong Yangkwajajeom Aentikeu

Studio/Distributor:
Soo Film, Zip Cinema/Showbox/
Terracotta Distribution

Director:
Min Kyu-dong

Producers:
Min Jin-soo, Lee Yu-jin,
David Cho

Screenwriters:
Min Kyu-dong, Kim Da-yeong,
Lee Kyeong-ui

Cinematographer:
Kim Joon-young

Composer:
Jang Young-kyu

Editor:
Kim Sun-min

Synopsis

Antique is based the popular Japanese *yaoi* manga, *Seiyo Kotto Yogashiten/Antique Bakery*, which had also previously been adapted for television in 2001. Sticking quite closely to the original manga, most of the action in *Antique* takes place in a bakery, and concerns the relationships between four men: Jin-hyuk, the manager and owner of the bakery; his temperamental pâtissier, Sun-woo; young apprentice and ex-boxer, Kim-bum; and, finally, an old family friend and bodyguard, Soo-young, who has nowhere else to go. All four men have personal issues which affect their lives: Sun-woo not only suffers from gynophobia, which means that he cannot be around women, but also has a 'demonic charm', which means men automatically fall in love with him; Jin-hyuk is haunted by a childhood trauma as a result of being kidnapped as a child and hates all sweet things as a result; Soo-young is gradually going blind; and Kim-bum suffers from anger issues as a result of having to give up his profession as a boxer. In order to move on with his life, Jin-hyuk needs to track his kidnapper down and resolve his childhood trauma. The bakery is in fact a trap for Jin-hyuk's kidnapper, who is obsessed with cakes and pastries, force-feeding them to his victims and, therefore, the cause of Jin-hyuk's present hatred for all things sweet. While the film focuses on the homosexual and homosocial relations between the four men, the narrative trajectory is concerned with the naming and shaming of Jin-huk's kidnapper, adding a bitter aftertaste to the film's sweet subject matter.

Duration:
109 minutes

Genre:
Queer/musical/yaoi/food porn

Cast:
Joo Ji-hoon, Yoo Ah-in,
Kim Jae-wook, Choi Ji-ho

Year:
2008

Critique

Antique is delightful, amusing and frothy, as sweet as the cakes that Sun-woo whips up in the kitchen and that Jin-hyuk is unable to eat, with the hint of darkness functioning as a counterpoint to all the sugary sweetness. The addition of musical numbers, almost as frothy and camp as the film itself, gives the film a surrealistic edge. The performances are strong, with Joo Ji-hoon perfectly cast as the traumatized Jin-hyuk and Kim Jae-wook bringing a lightness of touch and deft comic timing to the role as the pâtissier of 'demonic charm' who harbours deep feelings for his employer. Like other more mainstream South Korean queer films, *Antique* works as much within the conventions of *yaoi* culture as it does queer cinema. As such, it could be argued that *Antique's* queerness is a ploy to appeal to a large and mainly female fan base rather than to articulate an authentic gay experience and/or to speak to a queer audience. While there is little doubt that this is problematic in terms of definitions of queer cinema as something made by an openly gay director and/or marketed specifically at LGBT audiences, *Antique* does portray 'queerness' in a positive light, not as something that needs to be overcome but, rather, as a particular identity formation which is not there merely to solidify the needs of the ideology of compulsory heterosexuality as a norm. Indeed, seen in the light of Director Min's other films, including *Memento-Mori* and *Kkeutkwa Sijak/My End is My Beginning*, both of which are largely concerned with lesbian relationships, *Antique* should not be seen merely as an attempt to cash in on the popular yaoi culture but rather as part of a larger project exploring the many sides of human sexuality. The element of darkness that underlies this exploration of desire is also a persistent theme in Director Kim's horror films, as demonstrated by his contribution to the omnibus film *Mooseowon Iyagi/Horror Stories* (2012) (the section-titled 'Beginning'), which is not surprising given the interconnection between horror and sex. However, the shift in narrative direction and generic form is par for the course in South Korea cinema, articulating the presence of tragedy lying just beneath the surface of everyday life. *Antique* satisfies all the senses, provoking laughter and tears and, most of all, a desire for sweet confections like the ones that constitute its food-porn aesthetics.

Colette Balmain

Antique, 2008, ZIP Cinema/Soon Film Com./Kobal Collection

Boy Meets Boy

Sonyeon, Sonyeoleul Mannada

Studio/Distributor:
Chungnyeon Films

Director:
Kimjo Kwang-soo

Producer:
Song Tae-jong

Screenwriters:
Kimjo Kwang-soo,
Min Yong-geun

Cinematographer:
Kim Myung-jun

Art Director:
Cheon In-ok

Composer:
Kim Dong-uk

Editor:
No Seung-mi

Duration:
35 minutes

Genre:
Queer/romance/musical

Cast:
Kim Hye-seong, Lee Hyeon-jin,
Yea Ji-won, Ahn Seong-geon,
Kang Dae-woong

Year:
2008

Synopsis

It seemed like it is going to be one of those days for Min-soo. Dropping a roll of film has led to him being chased by a gang of bullies and eventually losing his precious camera. Now on a moving bus, he has dropped the container of film again and that wayward cylinder of plastic has rolled under the foot of a gorgeous young man with a physique to die for. What is this feeling that Min-soo is experiencing? Is it fear of humiliation as everyone watches him get up to retrieve his film? Or is there something else that is making his heart pound faster? The young god Seok-yi picks up the film and holds out his hand to offer it back to its rightful owner. Min-soo awkwardly takes it but his fingers brush up against the strong hands of the stranger, sending feelings of electricity shooting through him, and Min-soo dashes off the bus before he embarrasses himself further. Walking home, he senses that Seok-yi is following him and his fear begins to turn to excitement, anticipation and joy. What would happen if he were to turn around and greet him? What would he say? Is the other boy interested in him in the same way? Maybe a visit from Cupid will settle things.

Critique

Boy Meets Boy is something of a rarity among the already-uncommon genre of Korean queer films. There is no violence, no 'curing' of a homosexual character, and no tragic deaths that neatly help avoid the issues. Instead, Kimjo Kwang-soo has crafted a sweet tale that can be universally understood regardless of gender or orientation. Who among us has not experienced the excitement, anticipation and thrill of a crush? And how much more exciting is that when, like Min-soo and Seok-yi, the crush has the potential to be reciprocated?

As much as I like the innocence and sincerity in which Kimjo Kwang-soo treats his two main characters, the inclusion of Cupid, played by Yea Ji-won, may have been a misstep that drags the film down slightly. Here we have a sweet, honest tale featuring the emotions of two young men, but the appearance of a singing Cupid sends the film momentarily into the realm of fantasy. True, her appearance is quirky and provides a brief moment of bemused surprise, but she overstays her welcome with her song. Cupid sings about what type of men to avoid and how to know if a person you meet on the street is interested in you. However, her song is punctuated with some non-whimsical animation that seems to contradict the inexplicable appearance of the god, or in this case goddess, of love. The musical animation in and of itself is not bad and if it were screened as a separate short it would probably be more successful. Sandwiched between Min-soo's tale it interrupts the action, is disharmonious with what has gone before, and adds nothing to the plot. It does add some much-needed running time to the film, however, and I suspect that is why it was included.

Kimjo Kwang-soo is one of Korea's few openly-gay directors. Although *Boy Meets Boy* is his directorial debut, Kimjo, whose

name is sometimes simply written as Kim Kwang-soo, has been involved with films since he graduated from Hanyang University's Department of Performing Arts. He gained experience with production, planning and advertising films and is listed as the executive producer of such varied films as *Wanee & Junha, The Red Shoes and Boys of Tomorrow*. Kimjo claims that *Boy Meets Boy*, a film for which he is also credited as writer, is based on his own experience. If this is the case, it seems that two of his three other short films, *Chingu sai?/Just Friends?* (2009) and *100 Degrees C* (2010) may also be from the story of his youth, as the names of protagonist, Min-soo, is the same for all three films.

Tom Giammarco

Bungee Jumping of Their Own

Beonji jeompeureul hada

Studio/Distributor:

Noon Entertainment/Cineclick Asia

Director:

Kim Dae-seung

Producer:

Choi Nak-kwon

Screenwriter:

Go Eun-nim

Cinematographer:

Lee Hu-gon

Art Directors:

Jang Chun-seop Jung Young-soon Park Jae-hyeong

Composer:

Park Ho-jun

Editor:

Park Yoo-kyeong

Duration:

101 minutes

Genre:

Melodrama/romance

Synopsis

In 1983, Seo In-woo falls instantly and unexpectedly in love with In Tae-hee when she asks to borrow his umbrella during a rainstorm. Attending the same university, In-woo pursues Tae-hee and a relationship slowly develops between them. As their relationship deepens, In-woo must go for his obligatory two-year military service and the two make a deal to meet at the train station to say goodbye. Tae-hee never shows up and the film jumps ahead by 17 years where In-woo is now married with a daughter and a high-school teacher who has the respect of the faculty and the students. One of his male students, Hyun-bin, reminds him more and more of Tae-hee and both In-woo and Hyun-bin have to struggle with their growing attraction to each other. They must overcome their own hesitations, as well as the homophobic actions of the administration and the students.

Critique

I am hesitant to define *Bungee Jumping of Their Own* as a queer film. While it has queer elements, and is perhaps one of the first mainstream Korean films to directly address homosexuality, all of this comes out of narrative that constantly accepts the main homosexual relationship between In-woo and Hyun-bin only as an extension of the more normative straight relationship between In-woo and Tae-hee. This is accomplished through sound bridges that connect In-woo's memories of his early relationship with the current one with this student. Props, such as Tae-hee's lighter, also serve as further diegetic links between the two love stories, as do repeated questions that are asked of In-woo by both Tae-hee and Hyun-bin. This all serves the movie's conceit that In-woo and Tae-hee are soul mates and are destined to be together in their past, present and future lives, which in some ways does attempt to normalize the homosexual relationship. However, neither party is truly happy nor accepting and the constant references to the past heterosexual relationship at the expense of showing the build-up of the new relationship functions to subjugate homosexuality within the film to heterosexuality.

Cast:

Lee Byung-hun, Lee Eun-ju, Yeo Hyun-soo, Hong Su-hyeon, Lee Beom-soo

Year:

2001

Kim Dae-sung, a long-time assistant director under Im Kwon-taek, avoids the histrionic sentimentality that plagues many Korean melodramas and, instead, the film revels in human moments of humour and sadness. The opening half of the film is played with a lot more humour than the more serious social-issue-oriented second half, but this serves to highlight the acting skills of Lee Byung-hun (who plays In-woo) as he deftly moves from humour to sadness to maturity. The late actress Lee Eun-ju is also in fine form here as Tae-hee, which is a necessity as both relationships to the film are reliant on her words and mannerisms. Yeo Hyun-soo is fine in his role at Hyun-bin, and the sequences in which he begins to question who he is as well as his attraction to In-woo. The strongest sequences of social importance, as well as being the scenes that deal most explicitly with homosexuality, are the sequences in which Hyun-bin and In-woo are bullied at school. This underlines the stereotypes and misinformation that fuel homophobic attitudes and are scarily reminiscent of the current rash of homophobic bullying that caused suicides in the United States.

I find the ending of the film offensive and something that works to undo the earlier (if somewhat clumsy) attempts at normalizing homosexuality. I understand its place in the larger narrative of soul mates and reincarnation, but it severely undoes the scenes of happiness that precede it. However the film is well made. The melodramatic beats are all there and if it is your inclination to cry in romantic films you may want to pack some tissues for viewing. The story is engaging for the entire runtime, mostly due to the strong performance of Lee Byung-hun. The sequence where he goes to a psychiatrist to find out if he is gay or not is interesting, especially given the psychiatrist's assertion that attraction to the same sex should be considered a normal part of being human. It may be that *A Bungee Jumping of their Own* cracked the dam that would allow these later far more explicitly-gay films to be made, and for that it deserves to be remembered. However, those looking for Queer Korean film should look to the masterful *Huhwihaji anha/No Regret* (Leesong Hee-il, 2006) or the more recent *Jongroui Kijuk / Miracle on Jongno Street* (Lee Hyuk-sang, 2011), both of which are far better films.

Rufus de Rham

Frozen Flower

Ssanghwajeom

Studio/Distributor:

Opus Pictures

Director:

Yoo Ha

Synopsis

Hong Rim begins his life in the palace as a young boy training to become part of an elite unit of guards for the personal protection of the king. Overhearing the young child state that he would die in the service of his monarch, the youthful prince takes him under his wing. The special bond they shared in their youth turns to physical love as the two mature and they continue their intimate relationship even after the king marries. His marriage is purely political in nature, ensuring the safety of his kingdom of Goryeo by marrying

Producer:

Lee Tae-hun

Screenwriter:

Yoo Ha

Cinematographer:

Choe Hyeon-gi

Art Director:

Kim Gi-cheol

Composer:

Kim Jun-seok

Editor:

Park Gok-ji

Duration:

133 minutes

Genre:

Drama

Cast:

Zo In-sung, Joo Jin-mo, Song Ji-hyo, Shim Ji-ho, Im Joo-hwan

Year:

2008

a princess of his much larger and more powerful neighbour to the west. However, the Chinese emperor demands tribute from Goryeo and orders the king to produce an heir; otherwise their veiled threat indicates that China will annex Goryeo to keep the stability of the region. Unable to bring himself to sleep with his wife, the king turns to his best friend and lover, Hong, to act as a surrogate. At first resistant to the idea, Hong Rim finds himself falling in love with the Queen and she returns his feelings. With a dark conspiracy closing in, threatening to destroy the monarchy from without, jealousy and betrayal threaten to destroy it from within.

Critique

At the time of its release in theatres in Korea, *Frozen Flower* caused quite a stir. The media was declaring it the first time such a big star has played an explicitly-homosexual character and taken part in same-sex love scenes in a film intended for mainstream viewers. Although top star Hwang Jeong-min played such a role in the 2002 film *Rodeu-mubi/Road Movie*, he was not a well-known actor at the time. *Huhwihaji anha/No Regret* in 2006 was not widely screened in general theatres and the popular *Wang-ui namja/The King and the Clown* kept the relationship between the main characters so discreet that there are some fans to this day who question whether the two performers were actually in a gay relationship. There is no question here, as the relationship between the king and his guard in this film and their love scene is fairly explicit. Zo in-sung, who plays the role of Hong-Lim, is considered as one of the top Hallyu stars with a fanbase stretching across Asia. In his younger days, on television shows like New Non-Stop, he gained a reputation as a teen idol. Taking such a role could have shocked his fans and potentially hurt his career, but Zo was willing to risk it. He had been taking steps to break away from his romantic, pretty-image with films like *A Dirty Carnival* and this was one more step towards showing that he could handle diverse parts in films. Making the gay relationship central to the plot of a mainstream film and using the popular star proved groundbreaking and helped make inroads into other media. In 2010, SBS-TV broadcast the television drama *Beautiful Life*, which featured a gay Korean couple at the centre of the story. Although there was some protest among the older generations, the drama remained on the air. I do not believe it would have been possible to air had Zo or another popular actor not taken part in *Frozen Flower*.

However, despite its success in the box office and its influence attributed to it in opening up gay stories to mainstream audiences, *Frozen Flower* was heavily criticized by gay rights activists. The main reason for this, according to critics, is that the film perpetuates the stereotype that gays can be 'cured' if they simply choose to spend a night with a woman. However, such a critique seems to ignore the fact that bisexuality exists. Hong Rim was almost certainly bisexual and had honest feelings for both characters. We can see this at least twice in the film when he returns to the king's bed after sleeping with the queen and embraces his sleeping lover.

Frozen Flower, 2008, Opus Pictures/Kobal Collection

His face is wracked by guilt and it is clear that he still loves the king even as he is developing affections for his lover's wife. Furthermore, a scene at the end of the film, right before the credits roll, seems to indicate that Hong would have eventually chosen to be with the king.

There is another possibility as well. When the king is clearly suffering at the apparent betrayal by his lover, another of his guards comes forward and offers to stay the night in the king's bed. The king and the Kingdom of Goryeo were said at one point to be one and the same and this second guard indicates that to serve the king is to serve the nation. Hong Rim felt the same in the beginning. It could be argued that he was not gay at all, but merely fulfilling his duty and demonstrating his love of country through loving his king. However, in the end, the question of Hong Rim's sexuality is unimportant. What is important is the long term effects this and other recent movies have had towards society gradually coming to accept and show more understanding towards gays in real life.

Tom Giammarco

Just Friends?

Chingusai?

Studio/Distributor:
Generation Blue Films

Director:
Kimjo Kwang-soo

Producers:
Peter Kim, Kimjo Kwang-soo

Screenwriters:
Kimjo Kwang-soo,
Min Yong-geun

Cinematographer:
Kim Myeong-joon

Composer:
Kim Dong-wook

Editor:
Nam Na-yeong

Duration:
30 minutes

Cast:
Yeon Woo-jin, Lee Je-hoon,
Lee Seon-joo, Lee Chae-eun

Year:
2009

Synopsis

A young man, Seok-i, visits his lover, Min-soo, at the military base where Min-soo is doing his compulsory military service. During the visit, Min-soo's mother turns up, putting paid to their romantic encounter, at least for that night. The next day, she goes to Church, promising to be away for two or three hours. Seok-i and Min-soo take advantage of absence to make love only to be interrupted mid-coitus when she returns early. Seok-i leaves that night, upset by Min-soo's mother's reaction to their relationship. Later that year, Min-soo goes to see Seok-i at the restaurant where he works in order to take him home to 'officially' meet his mother.

Critique

Just Friends is the second in a trilogy of gay short films based upon his personal experience from Director Kimjo, the first of which is *Sonyeon, Sonyeoleul Mannada/Boy Meets Boy* (2008) and the last *Love, 100 Degrees C* (2010). While the protagonists in all three shorts are called Min-soo, they are different characters and depicted by different actors, allowing an expression of different moments of gay identity. In *Love 100 Degrees C*, Director Kimjo returns to the coming-of-age drama of *Boy Meets Boy*, but this time it is a much harsher reality, with Min-soo a partially-deaf school boy finding love and relief at the hands of a masseur at the local bath house, away from his bullying younger brother, over-bearing mother and the aggressive attention of older boys in his school. While *100 Degrees C* offers no solution or happy ending (the strains of Danny Boy playing as Min-soo huddles against his wall in his bedroom), *Just Friends?* has a happier ending. As in the other films in the trilogy, the strength of *Just Friends?* lies in its brevity and the authenticity of the relationship between Seok-yi and Min-soo. The narrative is sandwiched between two song-and-dance sequences which take place during the title and credit sequences. This spectacle of 'popular' queerness associated with camp and excess functions to highlight the normalcy and everyday-ness of the relationship between the two men as they battle and eventually overcome discrimination. At the beginning of the film, Seok-yi scratches out 'lover' as his relationship to Min-soo for the visit permit and writes 'friend' and Min-soo's mother is horrified by their relationship, flying to the safety of the Church to pray for her son. The overcoming of these societal and familial obstacles to homosexuality is signified by the fact that Min-soo comes to take Seok-yi home to meet his mother at the conclusion. While the relationship between the two and its intricacies and nuances are beautifully realized, the addition of a 'song' which Min-soo sings for acceptance from his mother seems awkward and somewhat out of place, if not unnecessary, making the implicit message of accep-tance of difference seem somewhat heavy-handed.

Yeon Woo-Jin, who is better known for his roles in South Korean dramas, is perfectly cast as Min-soo, as is Lee Je-Hoon as the

tortured Seok-yi. Both actors portray the relationship in a realistic and heartfelt manner. Unlike the more commonly-known Korean Queer Cinema films which tend to utilize 'queerness' as a plot device, *Just Friends?* articulates the experience of being queer in contemporary South Korea, which, despite its economic success, remains a deeply conservative culture, as demonstrated by the fact that the directors of *Yeogo goedam II/Memento-Mori*, Kim Tae-Yong and Min Kyu-dong, were forced to remove direct references to homosexuality in order for the film to be theatrically released domestically. This conservatism is also shown by the fact that *Wang-ui namja/The King and The Clown* has been interpreted as a queer film, although it has very little to do with homosexual identity or queerness and seems to be based solely the fact that the two men kiss once.

Director Kim is one of the important contemporary directors of Korean Queer Cinema, not only in terms of his short film trilogy but also as a result of the fact that he collaborated with Director Lee Song Hee-il on *Huhwihaji anha/No Regrets* (2006), widely regarded as South Korea's first openly-gay film. *Just Friends?* demonstrates the lived reality of gay men in contemporary South Korea and is a refreshing alternative to mainstream films which utilize queerness as a plot device, removing queer identity from the political and social realm.

Colette Balmain

No Regret

Huhwihaji anha

Studio/Distributor:
Generation Blue Films/
Fortissimo Film

Director:
Lee Song Hee-il

Producers:
Peter Kim, Kim Jo Kwang Su

Screenwriter:
Lee Song Hee-il

Cinematographer:
Yun Ji-woon

Composer:
Lee Byung-hoon

Synopsis

Su-min is a member of South Korea's underclass, a young man with no parents and no prospects. Determined to improve his life, Su-min goes to Seoul where he works on a factory production line during the day and as chauffer for drunken businessmen at night while he takes evening classes. One of his clients is Jae-min, the son of the wealthy boss of the factory where Su-min works during the day, who is struggling with his sexual identity in the patriarchal world of business predicated on compulsory heterosexuality and the construction of a very specific type of hetero-masculinity. Jae-min immediately falls for Su-min, much to Su-min's chagrin, and tries to convince him to stay overnight with him. Su-min initially repels Jae-min's advances, his pride and independence not allowing him to reciprocate. Soon after, Su-min is made redundant from his factory job and ends up working in a gay host bar, appropriately enough called 'X-Large', where Jae-min tracks him down. Eventually Su-min gives in and the two men begin a relationship, which Jae-min's mother attempts to derail by arranging for Jae-min to marry his 'girlfriend'. The conflict between Jae-min's duties to his father, to the company, and his love for Su-min threaten to end in tragedy, as the film takes a dark turn towards the end.

Editors:

Lee Song Hee-il, Lee Jung-min

Duration:

114 minutes

Genre:

Lesbian & Gay/youth/
melodrama

Cast:

Lee Young-hoon, Kim Nam-gil,
Kim Dong-wook, Kim Jung-hwa

Year:

2006

Critique

No Regret is a beautifully-acted film, realized through the strong central performances by Lee Yeong-hoon as Su-min, the reluctant object of desire, and Kim Nam-gil as Jae-min, his obsessed lover-cum-stalker. Director Lee Song does not shy away from showing the more unpalatable side of male prostitution while at the same time stressing the strength of the bond between the men who work at X-Large, who look out for each other and care for each other in a manner directly opposite to the corporate ideology of the state, which defines masculinity and worth in capitalist terms. It is, in fact, societal hypocrisy and a postmodern consumerist ideology that are placed under a microscope here. While the work in the host bar is well paid, money does not equate to success outside of the bar, as demonstrated by the death of Ga-ram, who is also in love with Su-min. The twisted wreckage of his brand-new car attests to the cold hard truth of a capital economy, as does the scene where Su-min wanders the deserted roads, carrying Ga-ram's ashes. Moments of emotional poignancy are expressed with an economical touch. *No Regret* has surprisingly high production values for a low-budget film, highlighting the incompatibility between the world of the male prostitute/dancer and the official corporate world of contemporary Seoul through a contrasting cinematic palate of subdued lighting (the bar) and harsh mechanical lighting (the factory). When Su-min and Jae-min eventually come together and the setting shifts to the countryside, the bright colours and natural lighting of nature provide a counterpoint to the dingy spaces of the bar and the fluorescent places of the factory, signifying (sexual) freedom and visualizing the strength of the love between the two men in warm natural tones. While, as is the case with a great deal of South Korean films, the film veers sharply off course towards the end into a dark melodramatic and almost tragic filmic space, this shift in genre style and aesthetic functions to metaphorically stress the barriers that both men have to overcome in order to be together. Jae-min's last gesture towards Su-min, a proprietary hand over Su-min's crotch, which is seen by the policeman who comes over to the car after they crash, signals Jae-min's exit from the closet of patriarchal compulsory hetero-masculinity and arguably a potential 'happy' ending for the men.

 No Regret has been much lauded as the first South Korean film to deal directly with homosexuality, paving the way for contemporary queer cinema in South Korea. Here, queerness is at the centre rather than a plot device, or sublimated sub-plot, in a normative narrative of heterosexuality. At the same time, Director Lee Song draws a series of parallels between various marginal groups in contemporary Seoul – the non-unionized workers in the factory/the hosts in the bar/ the unwanted and abandoned orphans – stressing the continued trampling over people's human rights in the economic miracle of latter-day Seoul. It is not surprising, therefore, that his second film, *Talju/Break Away* (2010), a film about a group of young men who abscond from military service, continues to stress concerns over human rights abuses.

There is little doubt, however, that the film's success was as much to do with its insertion within the popularity of *yaoi* culture (boy love) as with its queer theme. The fact that both the male stars portray an androgynous, almost feminine beauty makes them objects of desire for the female/hetero gaze as much as for the male/homo gaze. However, the brutality of day-to-day life for Su-min and his friends, unflinchingly shot, provides a powerful counterpart to the more melodramatic side of *yaoi* culture. *No Regret* is a powerful depiction of queerness, beautifully acted and directed, and marks an important moment in the emergence of South Korea queer cinema, both domestically and globally.

Colette Balmain

Pollen

Hwabun

Studio/Distributor:
Dae Yang Films Co. Ltd.

Director:
Kim Kyung Keun

Producer:
Eom Yong-hun

Screenwriter:
Ha Kil-jong

Cinematographer:
Yu Young-gil

Art Director:
Park No-dal

Editor:
Lee Gyeong-ja

Composer:
Shin Jung-hyeon

Duration:
85 minutes

Genre:
Mystery/queer Cinema

Cast:
Ha Myung-joong, Nam Kung Won, Choi Ji-hee, Yun So-ra

Year:
1972

Synopsis

Hyeon-ma owns a large home in the Seoul area which is inhabited by his mistress Se-ran, her sister Mi-ran and their maid. He brings his male secretary Dan-ju home with him one day, during which Mi-ran is ridiculed following her first menstruation and runs away from the residence, which is known as the 'Blue House'. Dan-ju is sent to recover her and it is not long before they develop feelings for each other. He quits his job and runs away with Mi-ran but, since he is the authoritative Hyeon-ma's lover, the liaison is scarcely tolerated. It is not long before Hyeon-ma tracks them down and beats Dan-ju in a jealous rage before imprisoning him in the house. Under pressure from creditors following the bankruptcy of his company, Hyeon-ma temporarily flees the country, leaving Dan-ju behind. Though a shell of his former self, he becomes a source of desire for the residence's women and his presence soon sows discord among them.

Critique

Ha Kil-jong's blistering debut feature is one of the earliest Korean films you will find that deals in any way with homosexuality but it is also one of the bluntest critiques of the Korean government among domestic cinema of the 1970s, when censorship and oppression were near their peak. Ha received a masters degree in film directing from UCLA and, on his return to Korea in the early 1970s, he was viewed as someone who could revitalize the industry. *Pollen* (aka *The Pollen of Flowers*) was not well-received upon release but now stands as one of the greatest Korean films of its era.

One of the more striking aspects of *Pollen*, and likely one that Ha acquired during his time in California, is a certain appreciation for classics of world cinema. The film brings to mind Antonioni's distinct framing of characters in *L'avventura/The Adventure* (1960), albeit with closer framing, and also Bergman's abstract compositions in *Persona* (1966). The film's most direct reference is to Pasolini's *Teorama* (1968), which features Terence Stamp as a mysterious

stranger who comes to a family home and proceeds to seduce everyone in it before abruptly disappearing.

Pollen is not afraid to announce itself, as it explicitly refers to Korea's presidential residence, which shares its name with the film's principal location (The Blue House). As such, the whole film can be read as an allegory and vicious repudiation of the goings-on in the halls of power. *Pollen's* representation of homosexuality is particularly brazen since, given the film's location and the hierarchy of the characters that inhabit it, logic dictates that Ha is painting the country's despotic president, Park Chung-hee, as a repressed homosexual. However, rather than being featured as a means to explore sexual identity, the motif seems instead to indicate the hypocrisy of authority and the restrictive society of contemporary South Korea, not to mention a little belligerence on the part of the director. Furthermore, the sexual politics of the film, as Dan-ju services the female inhabitants of the Blue House after becoming its prisoner, serve to symbolize what keeps such a regime running. The residence's hostage stands in for the country's repressed trauma, both hidden by and fed on by the powers that be.

Ha's film is a carefully-woven narrative full of mordant wit that is threaded together with often-frenetic but vivid cinematography and editing. It also features striking *mise-en-scène*, not least during one of its best sequences when a party takes place in the house. An intense and downbeat energy abounds as the well-to-do guests seem bent on their own self-gratification; they are in a trance, stuck to each other but vacantly staring off in silence as they shuffle to a pulsating beat which is both psychedelic and funereal. These people are lost in their desires, drunk on their own power and oblivious to the world they feed on, yet they seem bored and listless, they are jaded hedonists unsure of how to exploit the spoils they have accrued.

Ha only made six more films, the most famous among them being *Babodeul-ui haengjin/March of Fools* (1975) but his impact on the industry is formidable and he was one of the few filmmakers that directly challenged the government. Unsurprisingly, he is rumoured to have been picked up and beaten at some point during the decade as a result of his negative onscreen representations of Korea's established order. *Pollen* was the brilliant start to a career that was sadly cut short in 1979 but which provided the country's least-known period of cinema, recently dubbed 'The Darkest Decade' during a retrospective at the 14th Udine Far East Film Festival, with some of its most searing works. If you have a chance to see it, since it is quite rare, be sure not to miss *Pollen*.

Pierce Conran

Road Movie

Roadeu Mobi

Synopsis

Dea-shik is a gay man and famous ex-mountain climber, who now chooses to live at a lower altitude: the outskirts of South Korean

Studio/Distributor:

Sidus

Director:

Kim In-shik

Producer:

Tcha Sung-jai

Screenwriter:

Kim In-shik

Cinematographer:

Kim Jae-ho

Art Director:

Choi Ki-ho

Composer:

Lee Han-na

Editor:

Lee Jae-Woong

Duration:

115 min.

Genre:

Drama/gay and lesbian
Cast: Hwang Jung-min,
Jung Chan, Seo Rin

Year:

2002

society. Suk-won is a stockbroker who has lost practically all he had in the Asian IMF crisis. This financial upheaval reveals tensions between Suk-won and his wife and the class expectations she has of their life together. Suk-won's financial fall leads him by default to join a group of homeless men, one of whom is Dae-shik who becomes his protector, saving Suk-won from committing suicide on more than one occasion. Eventually Suk-won and Dae-shik take a road trip to Dae-shik's hometown. Along the way they pick up a prostitute, but not for the reasons prostitutes are often picked up. She soon discovers her advances towards Dae-shik will go unwanted. Together in Dae-shik's hometown, the mysteries of Dae-shik's past are slowly revealed as each party in this unique threesome discovers aspects of themselves that may have gone undiscovered had they not stumbled upon each other.

Critique

If one is not ready for the queer content of *Road Movie*, Director Kim In-shik definitely thrusts it in your face immediately, providing an opportunity for the homophobic viewer to rush out of the theatre, return the DVD, or close the webpage and clear their cache. Hopes are that those less immature in their views of sexuality will stay around with the rest of us. For those who stay around, they will be rewarded with a queer story in the tradition of stories about the outsiders in all of us, even those who consider themselves insiders.

In this case, it is the insiders who traded away their financial livelihoods (and that of others) in the Asian IMF crisis that began in 1997. When Dae-shik (Hwang Jung-min) takes Suk-won (Jung Chan) under his wing, Suk-kwon eventually protests that he is different from Dae-shik and the homeless beggars appropriating rail yards and subway stations as bedrooms and living rooms. Yet the IMF crisis demonstrated how close Suk-won was to these outsiders, should the losses from legalized gambling strip him of his private safety nets.

One cannot talk about *Road Movie* without talking about a film to which it alludes, Yee Kyung-dong's mid-1990s' road movie *Sesang Bakkeuro/Out to the World*, where we also have three outcasts, two males and a woman. Like *Road Movie*, one of the men is homosexual (although not the main focus and his sexuality is conveyed in a blink of an eye) and the woman is also a headstrong prostitute. *Road Movie* is indebted to the aesthetic asphalt laid by *Out to the World*, a film, as Kyung Hyun Kim put it in his required reading *The Remasculinization of Korean Cinema*, that made '. . . space for the crude representation of anti-heroes that defy and criticize social norms'. *Road Movie* extends this trend of the outcasts throwing themselves outside society just as society would itself throw them out by taking their journey on the road. Yet the South Korean country is a virtual island, since its peninsula connects with the Asian continent via North Korea where the border is not permeable. So these characters cannot find complete freedom on the road, forced to look within when they reach the blocks in their outward passage.

Although other films had portrayed queer South Koreans, *Road Movie* was the first to focus primarily on a queer character. And the sympathy for this character is not based on pity, but on Dae-shik being the most admirable of the characters within the film. In this way, along with a refusal to engage in effeminate stereotypes, *Road Movie* normalizes queer desire in a country's cinema that had yet to provide much space for their queer citizenry. Interestingly, as if evidence that South Korea was ready for its queer close-up, another film released later in 2002, Lee Moo-young's *Cheoleobt-neun anaewa paramanjanhan nampyeon geurigo takwon donyeo/Bizarre Love Triangle*, features a lesbian character who is as equally developed as the most sympathetic character in the triangle because she too is the most commendable of the threesome she finds herself stuck within. Some might find it frustrating that *Road Movie* follows the road required of early international Queer Cinema in the character's fate at the end, but that should not negate the inroads it still made.

Adam Harzell

The Scarlet Letter

Juhong geulshi

Studio/Distributor:
L J Films/Showbox

Director:
Byeon Hyeok

Producers:
Min Jin-soo, Lee Yu-jin,
David Cho

Screenwriter:
Byeon Hyeok

Cinematographer:
Choe Hyeon-gi

Composer:
Lee Jae-jin

Editor:
Ham Sung-won

Duration:
115 minutes

Synopsis

The film starts on a deceptive note as a typical police procedural before taking a dark melodramatic turn. Captain Lee Ki-hoon starts an investigation into the brutal murder of the beautiful Kyung-hee's husband who, seemingly, was killed during a burglary at the couple's home. However something seems off kilter and Ki-hoon is not convinced by Kyung-hee's story about returning home to find her husband dead. At the same time that Ki-hoon is uncovering evidence that Kyung-hee was unfaithful, his own personal life is unravelling when his attempts to keep apart his wife, Soo-hyun, and his mistress, Ga-hee, fail. What makes the situation worse is that Ga-hee is an old school friend of his wife. His problems at home begin to affect his investigation of the murder and, soon, both Ki-hoon's personal and professional life collapse. In a flurry of violence, and with a cinematic crescendo, the film draws to a horrific and emotional conclusion as desire becomes obsession and love turns into hate.

Critique

The Scarlet Letter borrows its title from Nathaniel Hawthorne's 1850 gothic narrative of sin, guilt and repentance. In Hawthorne's original text, the 'sin' is adultery and the birth of a child outside of wedlock which leads to the ostracization of the book's protagonist, Hester Prynne, from so-called polite society, allowing an implicit critique of societal and religious hypocrisy. In a similar way, *The Scarlet Letter* critiques conservative South Korean patriarchal ideology and the suppression of 'queer' sexualities in contemporary South Korea. The film functions on multiple levels: as a twisted revenge thriller; as an exposé of police corruption;

Genre:

Queer/revenge thriller/erotic drama

Cast:

Han Suk-kyu, Lee Eun-ju, Sung Hyun-ah, Uhm Ji-won

Year:

2004

and as a beautifully-constructed mediation on sexuality in which 'queerness' operates to deconstruct systems of patriarchal order and normative heterosexuality, subverting from within. Han Suk-kyu is mesmerizing as the controlling and brutal Ki-hoon, whose hyper-masculinity hides a lack of morals and empathy for those he loves and those he is meant to protect. Lee Eun-ju, in her last role, is luminous as his lover, who is forced to repress her love for Kyeong-hie, and Uhm Ji-won is perfectly cast as the dutiful wife whose world comes collapsing down when she discovers her husband's infidelity. The last 20 minutes of *The Scarlet Letter* in which Ki-hoon and Ga-hee are trapped in the boot of Ki-hoon's car are perhaps the most brutal 20 minutes, physically and emotionally, ever captured on screen. And it is in these 20 minutes that the truth is revealed about the two women's relationship, unfolding through a series beautifully composed flashbacks which are both erotic and evocative, the tenderness between the women providing a visual counterpoint to the more aggressive heterosexuality as performed by Ki-hoon. While positioning *The Scarlet Letter* within Queer Cinema may be seen as problematic by some, the contrast between the female/female relationship and the male/female relationship provides a study of love and desire outside of normative paradigms albeit within what can be construed as a mainstream revenge narrative. Just as Queer cinema in South Korea is still finding its feet and stage, representations of lesbianism are few and far between, tending to be found more commonly with closeted narratives of horror and high-school – the *Whispering Corridors* (1998-2009) films being the most noted examples. *The Scarlet Letter* is an exception to the trend in that it depicts lesbianism outside of the strict confines of the competitive high-school system and the close bonds between young girls that grow during those formative years. The fact that *The Scarlet Letter* has become associated with the sad and far-too-early death of the beautiful and talented Lee Eun-ju in 2005 has perhaps cast a long shadow over an exceptionally extraordinary piece of cinema that deserves a much wider audience than it has so far reached.

Colette Balmain

The Scarlet Letter, 2004, L J Film

Wanee & Junah (Alternate Title: Wanee and Junha)

Wa-ni wa Jun-ha

Studio/Distributor:
Generation Blue Films/Warner
Brothers Korea

Director:
Kim Yong-gyun

Producer:
Gwangsoo Kim Jho

Screenwriter:
Kim Yong-gyun

Cinematographer:
Hwan Gi-seok

Art Director:
Lee Jin-ho

Composer:
Kim Hong-jib

Editors:
Ham Sung-won, Kim Sun-min

Duration:
114 min

Genre:
Drama/part animation
(by Lee Jung-hyuk)

Cast:
Kim Hee-sun, Joo Jin-mo,
Cho Seung-woo, Choi Kwang-il

Year:
2001

Synopsis

Wanee works for an animation studio, the workload of which appears to be taking its toll on her eyesight and hands. Yet this workload also offers an escape from her ambivalence about her boyfriend, Junah. Junah's own ambivalence is career-related: a writer wobbling along that age-old artistic tightrope of whether or not to compromise one's aesthetics for the sake of the necessities of an income. Wanee and Junah live together, lovers but not married, which at the time this film was made was still a taboo situation in South Korea. Wanee's ambivalence about the relationship is due partly to a secret patiently revealed within the film. Bookended by two lovely animation sequences, *Wanee and Junah* revolves around many taboos that pull us through this narrative of the life choices we have kept at bay in our youth but, come the arrival of our 30s, we are soon forced to finally reconcile.

Critique

Is it enough to have Gay, Lesbian, Bisexual, Transgender and or Intersexuals in a film or involved in the making of the film to warrant calling it a 'Queer Film'? Or does the film have to present a particular aesthetic or ethic that has emerged from Queer Culture and the various Queer Rights movements across histories and nations? Jung-woo (Choi Kwang-il), the Gay character in *Wanee and Junah*, has limited screen time, but his queer presence is integral to the wider mood and theme of the film: that of challenging mainstream conceptions of romantic relationships. As a result, a strong argument can be made that, intentional or not, *Wanee and Junah* is a New Queer Film as has been argued by the esteemed film scholar B Ruby Rich. (Let me take a moment to clarify here that, yes, the Korean name is phonetically 'Jun-ha', but the film has been marketed as 'Wanee and Jun*ah*' to English-speaking audiences for whatever reason and is maintained here.)

Jung-woo's relationship with his boyfriend is fully accepted by his colleagues and the narrative of the film. In no way does any negative judgment intrude. And it is Jung-woo's struggles with his boyfriend asking for space due to the heterosexist expectations of his boyfriend's mother, (she wants him to get married to a woman), that provides a turning point for Wanee. She actually sees herself in the position of Jung-woo's boyfriend. Seeing Jung-woo hurt, Wanee confronts how she is similarly hurting her boyfriend Junah.

In this way, Wanee's relationship with Junah is 'queered', but such queering of relationships does not stop there. Further transgressions beyond heterosexual unions of similar class/types occur. The film briefly shows a growing courtship between a deaf woman and a hearing man where it is the hearing man who is presented as the insecure party. Besides Wanee and Junah living together as unmarried, Wanee is the breadwinner, further flipping the gender

script. Junah represents a Korean variant of 'soft masculinity' (see Sun Jung's *Korean Masculinities and Transcultural Consumption: Yonsama, Rain, Oldboy, and K-Pop Idols*) expressed better by the likes of actor Bae Yong-joon (aka Yonsama) who was a major factor in the Korean Wave of TV dramas that spread throughout East Asia. These are men who make efforts towards emotionally understanding their partners. Plus, in Junah's case, they cook well. And, of course, rounding out these challenges to relationship norms is the taboo regarding the main secret that Wanee hides throughout the film. To reveal it would be a partial spoiler, so I cannot go into detail of the importance of this particular trope's place in South Korean dramas and that of other countries of East Asia, such as Japan. (For those who eventually see the film and would like to know what I am talking around, check out Elizabeth Birmingham's contribution to *Manga and Philosophy: Fullmetal Metaphysician* entitled 'No Man Could Love Her More')

Another interesting aspect of the film that stretches outside of the primary theme is the depiction of the animation studio. With the exception of Wanee and Jung-woo, it is primarily a young place where employees seem more interested in having fun than working. This is actually where the film feels forced, since the scenes do not flow well but appear too earnestly portrayed. Yet, the gorgeous animated sequences that bookend *Wanee and Junah* are presented as diegetically done by this animation-studio-as-character (when actually animated by Lee Jung-hyuk), and this at least shows us the studio is capable of tremendous quality, in spite of all that badminton they play. In the end, *Wanee and Junah* is a significant film on two levels: its international importance to the New Queer Cinema canon and its mesmerizing use of animation to propel a compelling story.

Adam Hartzell

When Korean cinema became a heavyweight on the international scene around the beginning of the millennium, it quickly made a name for itself as a prolific, versatile and dependable purveyor of genre cinema. There is hardly any cinematic territory that the industry's film-makers have not explored and, more often than not, Korean films feature a combination of established generic conventions, but always with a twist. That said, one grey zone in Korean film is the musical, a mode of film-making that has featured only sporadically in the nation's output. Though, unlike some of the newer narrative styles, musicals have appeared throughout Korean cinema history, going back as far as 1947 when *Pureun eondeok/The Blue Hill* (Yu Dong-il), the country's first musical, was produced. Unfortunately, this, as well as the majority of Korea's scarce examples of this style of film-making, has been lost.

One of the most enduring genres of cinema, musicals have enthralled audiences for decades by drawing in spectators with a potent and heady cocktail of different entertainment formats, namely cinema, music and theatre. Films like *Singin' in the Rain* (Stanley Donen & Gene Kelly, 1952), *West Side Story* (Jerome Robbins & Robert Wise, 1961) and *The Sound of Music* (Robert Wise, 1965) are as popular as ever. Although the history of film begins with an image and in the absence of sound, the musical does have some claim to being the medium's strongest link to the forms of entertainment that predate it. Musicals also have a large presence outside Hollywood and, perhaps more than any other genre, the musical tends to take after a country's culture and history. Bollywood, the largest film industry in the world, is the most notable as it produces hundreds of musicals every year yet they are nothing like the musicals we are used to in the West, both thematically and stylistically. The structures, narrative styles and *mise-en-scène* vary from country to country but the most obvious difference between musicals from different national industries is the music itself. By and large musicals are informed by their respective indigenous musical styles.

Assessing the history and significance of the musical in Korean cinema is a difficult task. First of all, of the small number of Korean musicals produced during early Korean cinema precious few remain. Those that do still exist include *Cheongchunssanggogseon/Hyperbolae of Youth* (Han Hyung-mo, 1956), *Ja-yubu-in/Madame Freedom* (Han Hyung-mo, 1956), *Monyeo Gita/Mother, Daughter, and Guitar* (Gang Chan-u, 1964),

Left image: *Beyond the Years*, 2007, KINO2 Pictures/Kobal Collection

The Glorious Blues aka Yeonggwangui blues (Seong-bok Park 1966), *Geuriumeun Gaseummad/Longing In Every Heart* (Jang Il-ho, 1967), *Yeokjeonbuja/Father and Son* (Gwon Cheol-hwi, 1969), *Geudae byeonchima-o/Don't Turn Away From Me My Love!* (Kim Yeong-hyo, 1974), and *Ibyeol/Farewell 2* (Lee Hyung-pyo, 1974), though only the first of these is considered a musical; the others are, instead, viewed as musically-themed features. This highlights a crucial difference between the use of music in Korean film compared to Hollywood or some other industries. In early Korean cinema, the majority of the songs and music used were examples of traditional folk music.

This leads to the next problem of evaluating the Korean musical. While music features prominently in early Korean films, it will either be diegetic, where it occurs within the narrative sphere of the film, or extra-diegetic, where it exists in the background and the film's characters cannot hear it. Musicals make a point of crossing this line as a protagonist will frequently and unrealistically burst into song, accompanied by an invisible band or orchestra. This style of film-making is accepted in terms of the suspension of disbelief in cinema, which is a sort of unspoken contract between the spectator and film-makers whereby we accept the implausibility of certain narratives. However, in early Korean cinema this was not very common and, as such, there are comparatively few musicals. The musically-themed works of classic Korean cinema almost all occur within a music-oriented context with musician characters. The most easily accessible of these Korean musically-themed films to be made before the late 1990s' resurgence of the industry are Im Kwon-taek's magnificent pansori features, which include *Seopyeonje/Sopyonje* (1993), *Chunhyangdyeon/Chunhyang* (2000) and the less-well-known *Cheon-nyeon-hak/Beyond the Years* (2007). Pansori is a traditional style of storytelling that dates back to the seventeenth century and was at its most popular during the nineteenth century. It features lengthy stories, known as 'madangs', which are melodically sung and accompanied by percussion without interruption.

Sopyeonje (1993) is considered to be Director Im's masterpiece and by many to be the greatest of all Korean films. It was an enormously-popular work that earned the distinction of being the first locally-produced film to cross the one million admissions mark in the country. It is a melancholy story that takes place mostly on the road and the medium of song becomes a heartrending motif that symbolizes memory, hope, sadness and, in its darkest moments, despair.

'Chunhyang' is the most famous of the pansori 'madangs' and has been adapted umpteen times, notably by Shin Sang-ok as *Seong Chun-hyang* (1961) or more recently as the erotic period drama *Bangjajeon/The Servant* (2010). In 2000, Im offered his own rendition, simply titled *Chunhyang*, in which he combines the story, here filmed as a handsomely-produced period romance, with a modern day stage pansori performance that serves as a way to segue into the fictional past. The performance within the film is an attempt to revive a dying tradition and to motivate college-age youths to reconnect with their country's past, painful as it sometimes may be. The irony is that thirteen years after it was made his film seems all the more poignant precisely because the folkloric tradition of *pansori* has become progressively less relevant to modern Koreans.

The country underwent enormous change and growth following the end of Chung Doo-hwan's authoritarian regime in 1988. Globalization was a key policy point throughout the 1990s but then the IMF crisis of 1997 badly hurt the nascent economy. In the late 1990s the economy took off again, as did Korean cinema as we know it today. *Hallyu*, cars and consumer electronics launched the country into the twenty-first century and its citizens happily followed along, enjoying the benefits of modern, consumerist trappings modelled on the Western style of consumption. Many of the elements of the old Korea were left behind. Some, including regressive social rights and authoritarianism, were rightly pushed into a distant past but along with them went a number of important cultural elements.

As before, there are numerous Korean films that feature music prominently whose narratives are filled with singers, musicians, composers, music executives and their ilk. These films, while varied, are very different from their earlier counterparts. This has much to do with the improved production values and general evolution of the industry but, once again, the crucial component is the music itself, which has changed dramatically. Gone are the traditional folk songs and the dying practice of pansori, which are, instead, replaced by popular ballads from the 1980s, current indie bands and, above all, K-pop, the flagship component of the cresting Korean wave (or *hallyu*).

2011 saw the release of a few K-pop-themed films that included the K-horror *Hwaiteu: Jeojooui Mellodi/White: The Melody of the Curse* (Kim Gok & Kim Sun) and the romance-drama *Mr Ahidol/Mr. Idol* but neither was able to connect with audiences. Perhaps this comes down to the Korea's cinema patrons' thirst for something more authentic. Im Kwon-taek's *pansori* films and even the earlier musically-themed films of the industry all relied on traditional music which spoke of the country's often turbulent history. As well produced as today's commercial music has become, it does not have the same emotional or cathartic impact that would appeal to a broad cross-section of society.

Korean cinema is known to be profligate in its use of generic tropes, David Scott Diffrient has referred to it as 'generically promiscuous'. Melodramas, romantic comedies, K-horrors and revenge thrillers may be those most readily associated with the peninsula but the industry has dabbled in just about every genre and style under the sun. From westerns (*Joheunnom Nabbeunnom Isanghannom/The Good, the Bad and the Weird*, Kim Jee-woon, 2008) to conspiracy thrillers (*Mobidik/Moby Dick*, Park In-Je, 2011) and every conceivable permutation you could imagine, you can find something to suit all tastes in the industry's output. Then it should come as no surprise that Korea has its very own contemporary musicals. As with much of the country's genre output, these musicals fall in line with Western influences though, again, there are only a select few of these and they are furious amalgamations of disparate generic codes, like *Gumiho Ga-jok/The Fox Family* (Lee Hyung-gon, 2006), a horror/comedy/musical focused on a circus family; *Samgeo-ri Geuk-jang/Midnight Ballad of Ghost Theatre* (Jeon Kye-soo, 2006) another, more vaudevillian, horror/comedy/musical that takes after *The Rocky Horror Picture Show* (Jim Sharman, 1975); or *Dasepo So-nyeo/Dasepo Naughty Girls* (E J-yong, 2006), a musical sex comedy set in a high school.

The Fox Family features a panoply of different generic codes but it is primarily a family melodrama constructed through a series of musical vignettes. At first, it evokes the western with its setting, sound effects, music and *mise-en-scène* before quickly switching gears with a shift towards broad comedy. The film deliberately aims for cult territory, immediately echoing *Jigu-reul Jikyeora/Save the Green Planet* (Jang Joon-hwan, 2003), a seminal, modern Korean film which also features Korean star Baek Yoon-shik.

Ghost Theatre verges on pastiche as the styles it employs are not indigenous to Korea though, true to form for Korean cinema, there are some local elements thrown in such as the Japanese soldier, the spectral presence of the grandmother and the obligatory melodrama. It takes place in a theatre, which, after a fashion, is an acknowledgment of its influences. This construction is interesting since why should a film set in a cinema be a musical? Hybridity falls into this idea again, and perhaps also a tacit understanding that the musical is not indigenous to Korea. It has been expropriated from foreign influences, hence the colourful references.

Dasepo Naughty Girls, from director E J-yong (*Seukaendeul, Joseon-namnyeo-sangnyul-jisa/Untold Scandal*, 2003; *Yeobaeudeul/Actresses*, 2009), is a quirky and episodic film that was based on a very controversial online comic book. E's film begins with a montage that sets the scene in the multi-denominational school by having a group of dancers dressed in pink passing through various classrooms and giving us brief musical

interludes from different religions. Buddhists, Hindus, Muslims and Christians all join in the musical segment but when the troupe passes the traditional Korean classroom, they crouch down and hide from the teacher. The film shows off a multi-cultural Korea, but one that has lost touch with its roots.

Curiously, all three of the above films were made in 2006 and, while they all took after western influences, their disparate styles made them difficult to market and consequently they all became commercial flops. Perhaps because of this, there have not been very many western-style musical sequences in Korean cinema since then.

Despite the fact that western-style musicals and K-pop have both failed to attract audiences one would think that the spectators may be looking for the opposite, the more traditional music of the past, but that has not been the case either. The declining fortunes of Im's pansori triumvirate highlight the general shift away from folk music in cinema. *Sopyonje* became the most successful Korean film of all time at the time of its release in 1993. In 2000, *Chunhyang* was a modest success while his 2007 effort *Beyond the Years*, incidentally his one hundredth film, had a disastrous showing. The only form of music that has thrived in cinema in the last fifteen years is karaoke, a bridge between the old and new. Karaoke, with its late night setting and typical association with the consumption of large amounts of alcohol, offers heightened emotional circumstances that frequently give us a window into a character's state of mind. Singing has always been an act of emotional honesty for protagonists in Korean cinema and, thus, karaoke has replaced more folkloric traditions of Korean music as the film industry's de facto aural gateway into the nation's traumatic history. Perhaps this is why the musical has never truly caught on in Korea, as local audiences prefer something that is relatable, realistic and honest at the same time. In the end, the country's wounds can only be palliated from within, not via the proxy influence of something either alien (Western musicals) or manufactured (K-pop).

Pierce Conran

Beyond the Years

Cheon-nyeon-hak

Studio/Distributor:
Kino 2

Director:
Im Kwon-taek

Producer:
Kim Jeong-won

Screenwriter:
Lee Cheong-joon

Cinematographer:
Jung Il-sung

Art Director:
Joo Byeong-do

Composer:
Yang Bang-eon

Editor:
Park Soon-duk

Duration:
106 minutes

Genre:
Musical

Cast:
Cho Jae-hyun, Oh Jeong-hae,
Ryu Seung-ryong, Oh Seung-
eun, Im Jin-taek

Year:
2006

Synopsis

Years ago, Dong-ho travelled the countryside of Korea with the man who adopted him as a child and his 'sister', Song-hwa. Together the three would entertain at taverns and villages in order to earn a little food to eat and a place to sleep for the night. Their 'father' worked the children hard trying to train Song-hwa to be the best pansori singer and Dong-ho would accompany her on drums. However, fate had other plans and Dong-ho had other ambitions. As a young adult, he grew tired of constant poverty. Although he had fallen in love with Song-hwa, and the feelings were recipro-cated, he could not stay after fighting with his 'father'. Dong-ho left and joined a travelling performing in Seoul, where he becomes involved with an actress, while Song-hwa continues singing, even after she becomes blind. The two continue to carry a torch for the other, even at periods in their lives when they are married to other people. Although he frequently loses touch with Song-hwa, destiny keeps throwing them together but, at every turn, their love seems doomed.

Critique

Often called the sequel of director Im Kwon-ta's 1993 masterpiece *Seopyeonje, Beyond the Years* is more like a retelling of that story with expanded details. Instead of leaving the question of whether or not Song-hwa recognizes Dong-ho when they meet at the inn and sleep together in the earlier film, the newer version removes that scene completely. The two meet frequently, just not at the inn.

The inn is an interesting place, standing as a crumbling ruin of past glory. In Sopyeonje, the music of pansori, a traditional opera-like singing usually accompanied by just a drum or a simple stringed instrument, was shown as being old-fashioned and even somewhat reviled by people in a society that was rapidly modern-izing after the Korean War. In this film, that is never expressly said, although it is clear that pansori singers are earning and working less as the years progress and the travelling troupes of performers were all but extinct by the end of the sixties. Instead, the inn and the village it stands in seem to take on the role of showing how the past has been forgotten and abandoned by the present. The beautiful, wide river that flowed in front of the tavern and along the town dried up when a dam was built upstream and with it went the town's economy. When constructing the dam, heavy equipment damaged the roots of the ancient trees and their deaths led to the cranes that made the region famous leaving the area. A clear case made by director Im that 'development' does not always equal 'progress.'

Beyond the Years is set primarily in the late 1960s and early 1970s, but the time period does not really matter as politics neither play a part nor invade the timeless places Dong-ho and Song-hwa inhabit. However, the time was important for another reason. There are many scenes which feel like they are straight out of a movie

from this period – the way the shots are blocked in particular. Director Im was very active in this period, pumping out multiple films per year to comply with the infamous Motion Picture Law which required production companies to produce a minimum of fifteen films a year.

The title, *Beyond the Years*, is not at all the same as the Korean title, which makes reference to the cranes mentioned above. From Korean, the title would translate as '1000-Year Cranes.' These tall, graceful water birds often appear in traditional art, as well as on the 500 Won coin, as a representative of a long, or sometimes eternal, life. That explains the 1000-year reference. However, it was also believed that cranes mated for life. The connection the birds share represents the star-crossed spirits and undying love of Song-hwa and Dong. Watch for their appearance, particularly near the end of the movie.

It would be negligent not to mention that this film was Im Kwon-ta's one hundredth film. Im began his career in 1962 with two action/dramas that year, *Dumangang-a Jal Itgeora/Farewell Duman River* and *Jeonjaenggwa No-in/War and Old Men*. His career has now spanned five decades and his one hundred and first movie, *Dalbit Gireoolligi/Hanji*, was released in theatres in 2011.

Tom Giammarco

Chunhyang

Chunhyangdyeon

Production Company:
Tae Heung Film

Director:
Im Kwon-taek

Producers:
Lee Tae-won, Kim Dong-joo,
Seok Dong-jun

Screenwriters:
Kim Myoung-kon, Kang
Hye-yeon, Cho Sang-hyun

Cinematographer:
Jung Il-sung

Art Director:
Min Eon-ok

Composer:
Kim Chong-gil

Editor:
Park Soon-duk

Synopsis

Chunhyang is the daughter of Wolmae, a retired gisaeng, who is pursued by Mongryong, the son of a nobleman. Despite their class difference the two fall in love and secretly marry. Shortly after Mongryong is summoned to the capital to finish his education and he promises Chunhyang he will return as a court official. A new governor is appointed to the region, and this corrupt man himself soon becomes infatuated with Chunhyang. Refusing his advances and upholding her love for Mongryong, Chunhyang is jailed and tortured for her insult. Her only hope is that Mongryong fulfils his promise and returns to save her.

Critique

This is not a traditional musical as one typically thinks of the genre, but one rooted in the pansori tradition of Korea. *Pansori* is a traditional narrative music genre in Korea where a sorikkun (singer) is accompanied by a gosu (a drummer who plays the buk) and they perform tales that sometimes take many hours to complete. 'Chunghyangga' is the most famous of these and is one of five out of the original twelve madang (stories) that still survive today. It has been filmed over a dozen times and is notable for being both the first sound picture in Korea and one of the early post-war successes that revitalized the Korean film industry. Here master director Im Kwon-taek returns to this narrative tradition he had previously explored in his 1993 film *Seopyeonje/Sopyonje*, to bring one of his greatest films and a masterpiece of Korean film-making.

Duration:
115 minutes

Genre:
Period Drama/musical

Cast:
Yi Hyo-jeong, Cho Seung-woo, Lee Jeong-heon, Kim Seong-nyeo Kim Hak-yong

Year:
2000

Chunhyang is interesting in that it is framed by a pansori performance of the story, and the sorikkun serves as the film's narrator. The story flows along with the sorikkun's telling and, often, characters repeat the dialogue that the sorikkun gives them, especially during sequences of narrative importance. The film is luscious to look at, with vibrant colours coming not only from the natural beauty of the countryside that surrounds the region but also from the hanbok that the kisaeng and others wear. One sequence in which Chunhyang and Mongryong meet and lounge around in bright red leaves while dressed fully in white is particularly stunning. The pansori-style narration drives the story forward with gusto and, during Mongryong's journey back to his hometown, it is so intense that we break from the filmed story to the actual narration itself performed in a modern theatre in front of a crowd. The power of storytelling is so strong here that this does not break the viewer out of diegetic flow of the story but, instead, brings us into a unique hybrid of traditional narration and visuals in a way that only cinema can.

The film is also filled with passion, and Yi Hyo-jeong and Cho Seung-woo portray the relationship between Chunhayng and Mongryong with youthful vigour and energy. Despite the simple and straightforward plot, the two young leads make their screen debut here and their chemistry is captivating. Their teenage sexual couplings along with their flirting are sensual and fun; you believe that Chunhyang would really wait for Mongryong. Yi plays Chunhyang much like the character has always been portrayed: the very embodiment of virtue and loyalty. Her innocence is assured both visually in her obvious devotion to Cho's Mongryong, and aurally as the sorikkun sings her character into our hearts. Veteran cinematographer Jung Il-sung has worked with Im many times and is at the top of his game here, playing with the colours with abandon. The production value made this one of the most expensive Korean films ever made at the time, and used something like 8,000 extras and 12,000 costumes. It was also honoured as being the first Korean film to compete at Cannes film festival, although unfortunately it did not win any awards. This is Im's best work in the later part of his career, and a true spectacle that combines cinema and traditional storytelling in a uniquely Korean way.

Rufus de Rham

Chunhyang, 2000, C J Entertainment/Taehung Pictures/Kobal Collection

Dasepo Naughty Girls

Dasepo Sonyo

Studio/Distributor:
Ahnsworld, Mirovision

Director:
Lee Je-yong

Producer:
Ahn Dong-kyu

Screenwriters:
Lee Je-yong, Choi Jin-sung

Cinematographer:
Chung Chung-hoon

Art Director:
Lee Hyeong-ju

Editor:
Choi Jae-keun

Duration:
104 minutes

Cast:
Kim Ok-bin, Park Jin-woo,
Kyeon Lee

Year:
2006

Synopsis

'No Use High School' is an institution that is renowned for its sexual aberrations: students are both sexually adventurous and ambiguous, while S&M activities are even encouraged by the academic staff. 'Poor Girl' lives in a shack with her sick mother and younger brother, and has been forced to turn to prostitution as a means of paying off the family debts; she is attracted to Anthony, a wealthy transfer student from Switzerland, who prides himself on his appearance and his ownership of luxury items. He, in turn, is struggling to rationalize his interest in 'Two Eyes', the transgendered brother of Cyclops, who is the school's lone virgin due to only having one eye. After being recorded performing an exotic dance in a fetish club, 'Poor Girl' becomes an internet sensation and finds sudden fame, although she is unsure of how to feel about the unexpected attention, while private meetings with the Principal of 'No Use High School' are somehow transforming unruly pupils into model students with no interest in sexual promiscuity.

Critique

Lee Je-yong's adaptation of the internet comic 'Multi Cell Girl' is a colourful musical comedy which establishes its irreverent tone from the opening scene: a replacement teacher walks into a full classroom and announces that the usual teacher is absent due to contracting an STD from sleeping with a teenage prostitute. The replacement teacher addresses a particular pupil and suggests that she should get herself checked out, only for the student to reply that she does not sleep with teachers. The substitute counters that the STD that her teacher has contracted is, in fact, syphilis, causing the student to swiftly leave the classroom for the local clinic. This starts a mass-exodus as almost the entire class leaves, indicating that sexual activity in this particular high school is of an incestuous nature. Only two students remain; 'Poor Girl' and Cyclops. 'Poor Girl' exits because she has to meet a 'client', while Cyclops is left to bemoan the fact that such announcements emphasize the fact that he is the only virgin in the student body. Although *Dasepo Naughty Girls* definitely has sex on the brain, implying a variety of acts and kinky preferences with wild abandon, it does not actually feature any nudity and, instead, works as a spoof of hormonally-charged teen movies and as a satire of political correctness rather than as an explicit cinematic tour of under-age deviancy. Scenes involving 'Poor Girl' that set-up the possibility of sexual humiliation instead result in her clients asking her to play video games with adult content or to dress up like the characters from the animated television series *Bishoujo Senshi Sailor Moon/Sailor Moon* (1995-2000) and engage in teen gossip. Lee previously directed *Seukaendeul: Joseon-namnyeo-sangnyul-jisa/Untold Scandal* (2003), a handsomely-mounted Korean adaptation of *Dangerous Liaisons*, and he was possibly attracted to adapting 'Multi Cell Girl' as a means of further examining the hypocrisy surrounding sex in Korean society within a more contemporary context.

Structurally, *Dasepo Naughty Girls* is a shambles; Lee and his team obviously wanted to employ the scattershot approach to their source material, and it mostly works as a hybrid of episodic narrative and gonzo film-making, even if the dilemmas of some characters (Cyclops and 'Two-Eyes') are abruptly dropped to focus on those of others (Anthony and 'Poor Girl'). Aside from taking aim at the conventions of teen drama, Lee also references Asian soap operas, even including the sub-plot about a brother and sister who may been separated by adoption that has served as the basis for many day-time dramas. Appropriately enough for a film that flirts with the politics of shock but ultimately seeks to impart moral lessons regarding moral fibre and materialism, Lee's musical numbers are actually quite traditional, with characters commenting on their social positioning or conflicting emotions through song, and the way in which the lyrics appear on-screen in the karaoke-style is a nice touch. Through the character of 'Poor Girl', the film comments on the economic climate in Korea, as she turns to prostitution to pay the bills and to buy her brother new trainers, while her mother has fallen for a pyramid scheme that is only likely to bring further problems, although the director maintains the light tone even when the family is harassed by debt collectors or forced to share a horrible communal lavatory. As befits a film based on an Internet property, the characters exist as much online as they do in the real world, adopting multiple identities within chat rooms and bulletin boards, while an early scene finds both Anthony and his diplomat father trying to conceal their cyber-sex activities, only to discover that they have actually been flirting with one another. Some stretches are uncomfortable rather than amusing, but Lee mostly succeeds in serving up a vibrant satire while also eliciting enthusiastic performances from his clean-cut cast, even if some of them do not seem to be entirely in on the joke.

John Berra

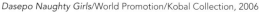

Dasepo Naughty Girls/World Promotion/Kobal Collection, 2006

Emergency Act 19

Gimgeubjochi 19ho

Studio/Distributor:
Source One Productions

Director:
Kim Tae-gyu

Producer:
Suh Se-won

Screenwriters:
Kim Seong-dong,
Lee Seung-guk

Cinematographer:
Hwang Seo-sik

Art Director:
Hwang Chang-rok

Composers:
Seok Seong-won, Ju Young-
hoon

Editor:
Park Soon-duk

Duration:
95 minutes

Genre:
Comedy

Cast:
Kim Jang-hoon, Hong
Kyung-min, Kong Hyo-jin,
No Ju-hyeon, Ju Young-hoon

Year:
2002

Synopsis

Popular singers are being elected to high political offices around the world. With Michael Jackson now in the White House, Korean officials worry that Seoul will have its statesmen replaced with musicians. To prevent that from happening, the Emergency Act 19 is enacted. This act bans singing and calls for the immediate arrest of anyone who calls him- or herself a singer. Pop musicians across the nation are rounded up and sent to prison while people whose popularity has waned turn themselves in to promote their image as performers. Those that resist have trumped-up charges levelled against them, such as drug-use, assault and even rape, to convince the public to turn their idols in on sight. But not all fans are so easily convinced. Kim Min-ji refuses to believe that her favourite singer Hong Kyung-min deserves to be arrested, so she harbours him and, against her will and with Kim Jang-hoon, the three plot a resistance against the government.

Critique

Ninety-nine percent of the time, I would argue, Korean cinema manages to cross cultural borders and deal with topics and emotions that can be universally understood. However, here is a movie that falls into the rare one percent of those films that would leave a viewer unfamiliar with Korean pop-culture in the early years of this century baffled by the parade of cameo appearances and in-jokes that comprise *Emergency Act 19*. Shin Ji's weight issues, Kim Gu and Psy's drug reference, accusing someone of dressing like Kim Gun-mo and the plethora of one-hit wonders trying to get themselves arrested would no doubt leave most international viewers feeling as if they were missing a large part of the comedy behind the film.

However, for someone who is familiar with Korean pop-singers, the endless guest appearances and name dropping is like a visit from an old friend. The trip down memory lane is full of singers who appear much younger, such as Lee Hyo-ri in her Finkl days, while many others who appear in this film have fallen out of the spotlight and leave you wondering whatever happened to Lee Sang-jin of 'NRG', an ever-present face on television in the early 2000s, or the collective membership of 'Click B'. The name dropping, to those in the know, is hilarious as the fates of singers not appearing in the film are listed. If you are fans of K-Pop singers of all decades, then the above are the reasons to watch this film. Otherwise, the movie has very little to offer.

This career-ending film stretches credulity to breaking point and beyond. Michael Jackson and Madonna in the White House? President Kim Dae-joong, the president of Korea at this time of this movie and the face of the democratic movement during some of the darkest years of Korean politics, cracking down on singers and restricting freedoms? That goes against everything he stood for. It is also insulting how the film seemingly disrespects the struggle

towards democracy by beginning with real photos of the tragedy at Gwangju and the student riots in Seoul of the 1980s. This is a comedy designed to give face-time to various singers and comedians, many of whom were already over-exposed at the time. Comparing its theme of musical freedom to something like the Gwangju demonstrations gives itself undeserved airs of grandeur.

Yes, this movie was a career-ender as mentioned above. Director Kim Tae-gyu had only two films to his name, his debut film a forgettable comedy called *Majimag bang-wi/Weekend Warriors* (1997). The two screenwriters listed on the film have no further, or prior, credits. Producer Suh Se-won's story was far different and he did anything but disappear from the headlines. Not only was Suh a producer, director and former actor, he was one of the most influential men in the world of Korean entertainment, particularly with his popular talk show. However, he wound up fleeing Korea ahead of a summons by the Prosecutor's Office and placed on Interpol's wanted list. He and several other entertainment executives were under investigation for, among other things, 'PR Fees', which were in effect bribes and sometimes allegedly sexual in nature. He eventually returned to Korea, but in poor health. He spent some time in prison in 2005 and, after his release, kept a low profile. In 2010 he directed a low-budget comedy, that received a limited release, called *Jutgarak/The Rhythm of Chopsticks*. Whether or not this is the start of a comeback for Suh, who has been involved in film in some respect since his debut in 1979, remains to be seen.

Tom Giammarco

Highway star

Bokmyeon dalho

Studio/Producer:
Studio 2.0

Directors:
Kim Hyun-soo Kim, Kim Sang-chan

Screenwriters:
Kim Sang-chan, Seon Seung-yeon

Producers:
Lee Kyong-kyu, Park Se-jun

Cinematography:
Yoon Hong-sik

Art Director:
Kwon Jin-mo

Synopsis

Dal-ho's only dream is to become a famous rock singer. To make a living in a small town, his rock band is forced to play trot (Korean oldies) in clubs instead of rock 'n' roll. One day, opportunity knocks and he gets a chance to make a debut album. When small-time recording company head Jang offers Dal-ho a contract, he eagerly grabs the opportunity, believing that his time has finally come. After he signs, Dal-ho discovers that he will not be fronting his rock band after all. Instead, he will be singing trot. Unable to back out of his contract, Dal-ho takes to the stage behind a wrestling mask to hide his embarrassment, and ends up an overnight sensation. The wannabe rocker seems to have found his true calling, but doing music more suitable for nursing homes than packed stadiums. With the help of Jang and Seo-yeon, a female love interest, Dal-ho attempts to understand and appreciate the intricacies of trot. However, he skyrockets to stardom when young and old are electrified by his trot stylings and the curiosity of discovering who exactly the singer behind the mask is. Based on a Saito Hiroshi novel, the film is co-directed by first-timers Kim Hyun-soo and Kim Sang-chan.

Composer:

Ju Young-hoon

Editor:

Kyung Min-ho

Duration:

114 minutes

Genre:

Musical

Cast:

Cha Tae-hyun, Im Chae-moo,
Lee So-youn. Jeong Seok-yong,
Lee Byeong-jun, Seon U, Park
Yeong-seo

Year:

2007

Critique

Highway Star is an example of the performance-oriented film used to bridge the generational gap between the nostalgia for the old and the progression of the newer musical forms and groups in Korea. Though a rather shallow attempt at repackaging familiarity for a younger audience, the film is a perfect example of the strong links Korean pop music shares with television, film, and advertising, an exercise in discussing the very same conditions in the film that are being used in the film-making itself.

Until recently, Trot music has been relegated to obscurity almost universally by the younger generation of Korea, while serving as a strong symbol of national identity and nostalgia by the 40-and-up generation who grew up listening to trot singers like Tae Jin–ah, and Song Dae Gwan. The younger generation had previously considered Trot music to be a backward symbol of the unsophisticated culture of the older generation. This is until the latter half of the last decade when a few younger singers gained success with trot music. However, with the advent and increasing popularity of younger trot-style singers and groups like LPG, Epik High, and Super Junior (a thirteen-member boy band designed to make young girls swoon) the genre has been making a resurgence in recent years. *Highway Star* brought even more interest in the traditional Korean music genre. The theme of repackaging and updating cultural links to the past is nothing new. However, the similar style and themes *Highway Star* shares with films of roughly the same period are difficult to ignore. Both *Radio Seuta/Radio Star* (Lee Joon-ik, 2006) and *Minyeo-neun Goerowo/200 Pounds Beauty* (Kim Yong-hwa, 2006) are films that beckon to a similar past as *Highway Star*, using music and performance as a means to link the old with the young, the classic with the modern, and the forgotten with the popular. Reflective of this would be the cast no doubt selected in similar fashion: Cha Tae-hyun as Dal-ho the young, fresh rock and roll singer turned trot master; Lim Choi-mu as Mr Jang, the CEO of the record label, bent on turning Dal-ho towards the crossover genre of new trot and the super stardom that mass appeal brings with it.

The crossover success of younger trot singers like Jang Yoon-jeong and boy band Super Junior have come about almost entirely because of the strong links that Korean pop music shares with television and advertising. Music-performance shows air regularly on Korean television, featuring up-and-coming stars, super stars, or old-style ballad singers. Television music shows like SBS's *Popular Song*, KBS's *Music Bank*, and *Show! Music Core* are all examples of the way in which Korean music, television, advertising and film work in unison and often become indistinguishable from one another. The mediums rely on one another in a symbiotic relationship of simultaneous promotion and creation of a national star-making machine. Film and television actors release albums and singers regularly feature on television shows. Cha Tae-hyun, for instance, has gained notoriety in Korea as the lead of romantic comedies like *Yeopgijeogin Geunyeo/My Sassy Girl* (Kwak

Jae-young, 2001) and *Parangjuuibo/My Girl and I* (Jeon Yun-su, 2005), but the popular actor, who has proven himself a pop-chart-worthy singer, has recorded two albums. *Highway Star* served as the perfect star vehicle for Cha to merge his acting and singing careers. In many ways, Cha Tae-hyun is an example of using an icon or idol that appeals to the younger generation in order to reintroduce a quasi-traditional symbol of national unity and nostalgia.

Though a pure commercial endeavour made to attract everyone from the older Korean generation to the influential teenage demographic, *Highway Star* is an interesting, albeit, over-simplistic look at anonymity, created star identity, and a revelation of what is behind the stage after the curtain drops. Although the film itself attempts to deal with these all-too-common themes on the screen, the production, scripting, and casting only serve to reinforce the nature of Korean star culture by falling victim to the same traps of multi-media, multi-genre star-making. In an idea lifted almost exactly from *200 Pounds Beauty*, the climactic unveiling of the singer at the end and Dal-ho's subsequent updated rock performance of one of his trot hits speaks volumes about the functions of the film as a trope on the repackaging of familiarity and an exercise in creating multi-generational unity via a money-making amalgam.

Thomas Humpal

Highway Star, 2007, Celestial Pictures/Kobal Collection

Hyperbola of Youth (Double Curve of Youth)

Cheongchunssanggog-seon

Director:
Han Hyung-mo

Producer:
Han Hyung-mo Production

Screenwriter:
Kim So-dong

Cinematographer:
Lee Seong-hwi

Art Director:
Park Seok-in

Composer:
Park Si-chun

Editor:
Han Hyung-mo

Duration:
100 minutes

Genre:
Comedy/musical

Cast:
Hwang Hae, Ji Hak-ja, Lee Bin-hwa, Yang Hun, Yang Seok-cheon, Kim Hee-kap, Bok Hye-suk, Ji Bang-yeol, Go Seon-ae, Gyeong Yung-su

Year:
1956 (Released in 1957 per newspaper reviews.)

Synopsis

A visit to an unconventional doctor by two former college buddies results in their trading places as remedy for their respective illness. Myeong-ho is a poor, middle-school teacher who suffers from malnutrition, and Bu-nam is the eldest son of the president of a profitable trading company who suffers from overindulgence. For two weeks, Myeong-ho takes Bu-nam's place at his luxurious home, eating double plates of steak and playing music just exactly as his friend would. In turn, Bu-nam has to endure extreme poverty at Myeong-ho's one-room shack, performing all of his friend's house chores on a diet of a half-bowl of barley. Their physical and emotional difficulty in adjusting to such divergent socio-economic conditions is the source for many of the comic elements, as well as an opportunity to inject romance into the narrative between the two friends and each other's younger sister. Enhancing the farcical goings-on in the two households is the singing and dancing as added spectacle.

Critique

A master craftsman of commercial films, director Han Hyung-mo is acknowledged for his range of contributions in advancing film technology and genre formation in the 1950s. His innovations led to many firsts: the first to use the crane and dolly shot; the first to try Cinemascope; and the first to apply the 'playback' system that permitted pre-recorded sound to be replayed and synchronized on the set. It was this last technical achievement that made it possible for Han to also be the first in producing musical films, beginning with his acclaimed *Jayu buin/Madame Freedom* (1956) that prominently featured song and dance performances. This was immediately followed by the romantic comedy *Hyperbola of Youth* that also spotlighted popular songs and musicians of the time. Han had a nose for tracking popular trends, and he was an expert at gauging audience expectations. It is not surprising, then, that he would collaborate with the popular music composer Park Shi-chun in *Hyperbola* after first putting him in charge of the original soundtrack for *Unmyeong-ui son/The Hand of Destiny* (1954). In *Hyperbola*, Park is also given the small, yet pivotal role as the wise and cunning doctor that prescribes unusual treatments and brokers relationships. Moreover, two of Park's most popular compositions ('Parting at Busan Station' and 'Moonlight in Shill') are performed by the famous comedian Kim Hee-gap who makes a cameo appearance as a coolie to sing a medley of songs. Also making a cameo appearance as the three singing nurses is the popular harmony-singing group The Kim Sisters who began their career by entertaining US troops, not unlike The Andrews Sisters who sang to troops during World War II. This is before the sisters hit it big enough to go on tour in the United States and perform in *The Ed Sullivan Show* in 1959. Last, but not least, the theme song was performed by two popular recording artists, Baek Sul-hee and Won Bang-hyun.

As if the aforementioned names and performances were not bankable enough, Han also cast the famous comedians Yang Hun in the lead as Bu-nam and Yang Seok-cheon in the smaller role as the rich daughter's fiancé. The two Yangs were a popular comic duo going by the names 'Fatty' and 'Skinny', and their physique and pratfalls in this film recall the other physical comedy team, Laurel and Hardy. Apart from the lively cast and music, Han's *mise-en-scène* offers an eyeful of post-Korean-War Busan, a port city located on the south-eastern tip of the peninsula, from aerial views of the city and street activities to shots of passing boats, the bridge and the beaches. As for interior views, they include the set of an affluent home, designed and furnished in western style. Such sets were rare to see outside of foreign films, and they record the influx of western goods and images as objects of desire. In fact, Myeong-ho even confesses to Bu-nam's sister that he feels like he is in a foreign country on his first day at his friend's home. They also stand in stark contrast to the shots of abject poverty along the steep hill where scores of makeshift shacks served as home for the many people displaced from the war, identical to Myeong-ho's family. In this way, Han was not insensitive to the desperate conditions following the war, but he made sure to uplift his audience with a happy resolution. With this inventory of attractions, *Hyperbola* was listed among the top-five domestic films at the box office, despite the indifference displayed by the film critics. When the film did grip the film critics' attention, it was solely in protest against the Ministry of Culture's decision to have it replace Kim So-dong's *Don/The Money* (1958) for submission to the 5th Asia Film Festival in Manila.

Sueyoung Park-Primiano

Midnight Ballad for Ghost Theater

Samgeori geukjang

Studio/Distributor:
LJ Film

Director:
Jeon Kye-soo

Producers:
Lee Seung-jae, Eom Yong-hun

Screenwriter:
Jeon Kye-soo

Synopsis

So-dan's beloved grandmother left the house for the Ghost Theatre one rainy evening explaining that there was a film she saw long ago and had to see one more time before she died. When the frail old woman does not return, So-dan sets out to find her at her last-known location. Taking a job in the ticket box, young So-dan joins the odd characters that make up the staff of the crumbling old theatre that is in danger of being torn down in favour a new multiplex. As So-dan begins spending nights there, she comes to realize that her co-workers are not the strangest beings inhabiting the premises. The old cinema is haunted by not one but four ghosts of actors of from the early days of Korean film. This troupe of players had made a film in the days of Japanese colonization which is hidden somewhere in the theatre. Although the spirits warn her that an unspeakable evil will be unleashed if the film is ever shown, So-dan becomes convinced that the lost film holds the key to finding her grandmother and saving the theatre from destruction.

Cinematographer:

Kim Youngmin

Art Directors:

Baek Gyeong-in, Amy Lee

Composer:

Kim Dong-gi

Editor:

Kim Hyeong-ju

Duration:

120 minutes

Genre:

Musical

Cast:

Kim Kkot-bi, Chun Ho-jin, Park Jun-myeon, Jo Hee-bong, Park Yeong-soo

Year:

2006

Critique

Midnight Ballad of Ghost Theater touches on the early years of Korean cinema. The decade between 1925 and 1935 is often referred to in Korean film histories as The Golden Age of Silent Films. Silent films were so popular in Korea that they were able to compete successfully for a short time with the new talkies and separate film awards were given for silent and talking pictures. However, the era in which these films were made was anything but 'golden'. Korean-made movies were subject to strict censorship from the office of the Japanese Governor General to ensure that there was nothing that would incite challenge to the occupation of Korea or that would be considered 'offensive' to viewers. For example, director Hong Gae-myeong's 1928 film, *Hyeolma/The Bloody Horse* had more than 3,500 feet of footage cut because its subject was considered offensive. Later, the Japanese government would turn the Korean film industry into a tool for propaganda. However, there were also undeniable benefits from Japanese interference. Without the technology, skills and investment of the Japanese, Korean cinema would not have begun as early as it did. Director Jeon, in this film, seems to be saying that perhaps it is time to let go of the resentment associated with this time period and move on. The past is history, to be remembered but not something over which one bears a grudge.

Director Jeon Kye-soo demonstrated exceptional creative talent and attention to detail when writing the screenplay for this movie. There is nothing within that is accidental. As this is the case, things that seem like inconsistencies become mysteries as the viewer tries to make sense of them. What, for example, is the reason behind So-dan's sleepwalking and why is the theatre owner being tormented by the ghosts inhabiting the old building? For that matter, the owner of Ghost Theatre claims to be the director of the cursed film, although he would have to be nearly a hundred years old for that to be true. And why does he seem to be frequently terrified of young So-dan? Some of the elements in *Midnight Ballad for Ghost Theater* are reminiscent of *Alice in Wonderland* or *the Wizard of Oz*. Like Alice, So-dan finds herself interacting with bizarre, slightly menacing characters and the similarity with the cinematic interpretation of Baum's work is that each of these characters has a counterpart among the living staff of the theatre with the sole exception of the owner. Where is *his* ghostly counterpart?

A substantial portion of this film is spent around the mystery of the lost film, its discovery and subsequent screening. This, of course, was inspired by recent events. It was less than a decade ago that the Korean film historians were saying that no Korean movies made prior to 1950 remained in existence and many more from between the 1950s and 1970s were also considered lost, potentially forever. Then, gradually, mostly through the work of the Korean Film Archives (KOFA), movies from the 1930/1940s like *Eohwa/Fisherman's Fire* (Ahn Chul-yeong, 1939) and *Jib-eobsneun cheonsa/Angels on the Street* (1941) and even lost, more recent,

classics such as the first Korean-made animated feature, *Hong Gil-Dong* (Shin Dong-heon, 1967), have been rediscovered. Some of these films were turning up outside Korea's borders, as many directors had fled the strict Japanese rule in Korea and went to Russia, Manchuria or Shanghai. Others were found domestically as small, privately-owned theatres were being demolished to make way for the ever-growing number of Megabox and CGV multiplexes that have come to dominate the movie landscape. The horror movie discovered in *Midnight Ballad for Ghost Theater*, billed as Korea's First Horror Film, is completely fictitious and that honour probably goes to Kim Yeong-hwan's 1924 film *Janghwa Hongryeon jeon/The Story of Janghwa and Hongryeon*. However, that does not mean that there are not more movies out there waiting to be found.

Tom Giammarco

Mr Idol

Mr Ahidol

Studio/Distributor:

Daisy Entertainment

Director:

Ra Hui-chan

Producer:

Kim Seong-cheol

Screenwriters:

Lee Gyu-bok, Ra Hui-chan

Cinematographer:

Park Yong-su

Art Director:

Baek Gyeong-in

Editor:

Mun In-dae

Duration:

114

Genre:

Drama/music

Cast:

Park Ye-jin, Ji Hyun-moo, Lim Won-hee, Kim Su-ro

Year:

2011

Synopsis

Goo-joo, a successful music executive, makes her return to South Korea after a three-year absence following the death of a member of Mr Children, the K-pop band she was managing at the time. While at the airport she loses her bag, which mistakenly winds up in the hands of a young travel guide named Yoo-jin. Goo-joo is immediately offered a job with a top talent agency that she declines in order to reassemble the band she had left behind. She and her assistant manage to track down the remaining members of Mr Children but now they need to go about the difficult task of replacing the lead singer. In order to do this they stage an open audition.

Yoo-jin, who sings for a low-key indie band managed by a small bar owner, returns Goo-joo's bag but soon they cross paths again as his group's manager ask his band to take part in her audition. Goo-joo tries to persuade him to audition alone but he is reluctant to leave his other band members behind.

Critique

K-pop is the dominant entertainment industry in Korea at the moment and it only makes sense that it should find its way into Korean cinema. In 2011 there were two such offerings: the K-horror *Hwaiteu: Jeojooui Mellodi/White: The Melody of the Curse*, which was an interesting project that was sadly lobotomized when the studio demanded an entire reshoot; and *Mr Idol*. The latter's narrative supposedly takes aim at the cut-throat aspect of the business but it is really a film that is designed to appeal to the industry's fans rather than to criticize it. The problem is that these fans did not show up, as *Mr Idol* was one of the year's most resounding flops. So why didn't they?

Make no mistake, *Mr Idol* is a bad film but plenty of awful features have met with success in Korea, just as they have in any of

the world's other film markets. But this is not the first K-pop-themed feature to crash and burn at the Korean box office, which seems to indicate that perhaps the K-pop and Korean cinema worlds do not mesh well together.

Mr Idol was directed by Ra Hee-chan, a Jang Jin protégé who previously served as an assistant director for him on *Baksu-chiltae deonara/Murder, Take One* (2005) and was the director of *Bareuge salja/Going By the Book* (2007), which was written by Jang. The Korean film industry, in its development of directors, is quite reminiscent of Japan's classic system where young talents were frequently mentored and worked as assistant directors before being handed the reins to their debuts. Kim Ki-duk, though not a studio hand, has trained some of the best directors working in the country today, such as Jang Hoon (*Yeonghwanun Yeonghwada/ Rough Cut*, 2008; *The Front Line*, 2011) and Jang Chul-seo (*Kim Bok-nam Salinsageonui Jeonmal/Bedevilled*, 2010). Perhaps the most famous and successful example of this form of training is Lee Chang-dong, who was Park-kwang-su's protégé when he made *Geu seome gago shibda/To the Starry Island* (1993) and *Areumda- woon Cheonnyeon Jeon Tae-Il /A Single Spark* (1995).

It may be that Ra will prove me wrong when he makes his third film but, on the evidence of this effort, it seems that he may be something of an anomaly. The wit and clever staging of *Going By the Book* is nowhere to be seen so it begs the question, did he learn anything from his mentor?

Also gone from his previous work is the presence of the formi- dable Jeong Jae-yeong in the lead role; Ra's stars, Park Ye-jin and Ji Hyun-woo have zero chemistry but what is worse is that they are simply unlikeable. Park got her career off to a great start with *Yeogo goedam II/Memento Mori* (1999) but she has steadily carved a niche out for herself playing austere and cold characters. In 2011 she also starred in Head, which was a decent film reminiscent of *Minyeo-neun Goerowo/Save the Green Planet* (2003) but her pres- ence almost derailed it. Ji on the other hand is impressively listless and bland, and is undistinguishable from the many other lithe metrosexual males that litter modern Korean media.

However, the cast also boasts the film's strongest points with the presence of Kim Su-ro, always dependable as the bad guy, and Lim Won-hie, one of the funniest supporting actors in the industry, even if he does not always choose the best projects.

I imagine that there is the potential to make a worthwhile and commercially-viable feature based in the K-pop world, as there is plenty there worth exploring – be it from a negative or positive perspective. However, until someone takes the challenge seriously, I fear we will continue to see sloppy work like *Mr Idol*, a tone-deaf musical drama with the emotional weight of a pebble.

Pierce Conran

Radio Star

Radio Seuta

Studio/Distributor:
Morning Pictures

Director:
Lee Joon-ik

Producers:
Jeong Seung-hye, Lee Joon-ik

Screenwriter:
Choi Seo-hwan

Cinematographer:
Na Seung-yong

Art Director:
Hwang In-jun

Composer:
Bang Jun-suk

Editors:
Kim Jae-beom, Kim Sang-beom

Duration:
115 minutes

Genre:
Drama/comedy/musical

Cast:
Park Joong-hoon, Ahn Sung-ki,
Choi Jeong-yoon, Jeong Gyoo-
soo, Jeong Seok-yong

Year:
2006

Synopsis

Back in 1988, Choi Gon was living the high life as the launching of his solo singing career resulted in his earning the award for Best Singer. Unfortunately for Gon, one-time recognition proved to be the highlight of his career. Foolish personal choices and a hot temper gradually removed him from the fast track of the main-stream music industry so that now, in 2006 at the age of 40, he and his manager, Kim Min-soo, are just shadows of their former glory. Gon is especially tragic, wearing the same clothes he was wearing at the height of his career and maintaining the same overly-aloof star attitude that he had when he was idolized by thousands of fans, whereas, now, he would be lucky to be recognized. In a last-ditch effort to help his clueless client and friend, the faithful man-ager arranges for him to become a radio DJ in a very rural area. While the upper-echelon of the music industry in Seoul believe that they have heard the last of their problem child, the move to the soon-to-be closed radio station may prove a boon to the luckless Gon. While his programme begins with just a handful of followers, it becomes an Internet sensation and may prove the key to jump-start Gon's career, if he can learn to play by the rules.

Review

It is very difficult to locate Korean musicals of the 1970s and 1980s but, to get an idea from a modern film as to what they were like, *Radio Star* provides an excellent example. In all but the earliest of the Hollywood musicals, songs and dance were used to advance the plot in some way, or at very least to move a character from one scene to another. Not so in early Korean musicals. First, the songs were rarely accompanied by any sort of dancing and, second, they contributed nothing to the plot nor offered much insight into the characters. The songs, while enjoyable, often stopped the story dead in its tracks. In Lee Hyeong-pyo's 1974 film *Farewell 2*, lead actress Patty Kim belts out song after song. Her character was a professional singer and each song was performed onstage and the movie-going audience is shown either Ms Kim standing behind a microphone or travelogue-style scenes that served to match the mood of the song. Lee Joon-ik chose to do much the same during the time songs are heard in *Radio Star*. We the viewers are shown either the listener's reactions to the songs or scenery of Korea that reflect the feeling of the lyrics. Most of the songs are from earlier decades, before the days when K-Pop became an international sensation. The scenery we see with these songs is either peaceful, rural settings or sleepy village markets and streets. More modern songs are given a different treatment and one song in particular, the sole English-language song, overlays footage of the bustling metropolitan areas.

The song in question is 'Video Killed the Radio Star' by the Buggles. While the lyrics in part refer to character Choi Gon and the epiphany he is undergoing in that part of the film, the line 'We

can't go back, we've gone too far' really stood out for me, espe-
cially with the imagery accompanying that line of the chorus.
I am certain that it was not mere coincidence that 1988 was the
year chosen in which Choi Gon would win the prize for best singer
and start the film. 1988 was an important year in the development
of modern Korea, not merely because of the Olympics held in
Seoul that year but also because of the social changes and democ-
ratization that occurred under the scrutiny of the international
press. Looking at the images and listening to the lyrics, it is clear
that neither Korea nor any nation in the world can go back and this
point is driven home by a character near the end of the film who
joyfully announces that their small city, far from Seoul or other large
cities, is actually no different from the capital city and has under-
gone enormous changes over the past 20 years.

I would be remiss not to mention the performances of veteran
actors Ahn Sung-ki and Park Joong-hoon who play the roles of
manager Kim Min-soo and Choi Gon respectively. Ahn in particular
is excellent, portraying a type of character we rarely see from him.
However, it is the band No Brain who steals the show with their
role as the fictional band East River. No Brain is one of Korea's
most popular underground bands and the members play music
that could be considered the antithesis of K-Pop – pure, passion-
ate, hard rock.

Tom Giammarco

Sopyonje
Seopyeonje

Studio/Distributor:
Tae Heung Films Co., Ltd

Director:
Im Kwon-taek

Producer:
Lee Tae-won

Screenwriter:
Kim Myeong-Gon

Cinematographer:
Jung Il-sung

Art Director:
Kim Yu-jin

Composer:
Kim Soo-chul

Editors:
Park Soon-duk & Park Gok-ji

Synopsis

The film begins as it follows Dongho, a man in his thirties, as he
arrives at a village inn. He becomes lost in thought as he fixates
on the traditional form of Korean music, pansori. Im takes us back
to his childhood, when his mother, a widow, gets involved in a
relationship with a widower named Yubong. Given Yubong's low
social status as a musician, the widow's family is unlikely to grant
their blessing and, thus, they all leave the village, together with
Yubong's adopted daughter, Songwha. The widow, pregnant with
Yubong's baby, dies during childbirth and Yubong is therefore left
to raise Dongho and Songwha alone. He teaches them pansori,
and so Dongho is taught how to drum and Songwha learns how to
sing. They travel throughout rural Korea perfecting their music but,
as western influence comes more prevalent following the end of
the Korean War, they struggle to find an audience and a financial
income to support them. Dongho, dissatisfied with his miserable
life, leaves home, but later regrets it as he searches for his family.
The film interweaves between the present and past as Dongho so
desperately tries to find his family, and reunite with his sister once
again.

Critique

Sopyonje, directed by one of Korea's most enduring film directors,
Im Kwon-taek, is his ninety-third film – he has recently completed

Duration:

113 minutes

Genre:

Historical Drama/musical

Cast:

Kim Myung-kon, Oh Jeong-hae, Kim Kyu-chul, Sin Sae-gil, An Byung-kyung, Choi Dong-joon, Choi Chong-won, Gang Seon-suk, Ju Sang-ho & Lee In-ock.

Date:

1993

his one hundred and first feature. Given Im's exhaustive list of features, it is perhaps a challenging task to highlight his best work. While not everyone would necessarily agree that this is Im's finest piece of work, few would disagree that *Sopyonje* is arguably his most iconic piece of work, and certainly his most successful. It was a surprise box-office hit for Im and set the record as the most successful Korean film in its history, which was later surpassed by a number of films over the last decade.

What, therefore, makes *Sopyonje* so special? There are a number of reasons for this. Im has tackled a number of genres over the years, but what has often stood out is his conviction and passion to convey humanism through the uniqueness of Korean culture and history. The film's primary focus, *pansori*, is a traditional form of Korean music that derives much of its meaning from a Korean sentiment known as 'han'. In the film's subtitles this is often referred to as pain or grief, but defining it in English can be problematic. Broadly speaking, it refers to personal suffering that is inherent throughout much of Korean history, particularly amongst women. This is reflected in the character of Songwha, who is forced to endure 'han' as she endeavours to fulfil her father's desire to become an accomplished pansori singer. In order to reach the perfection her father so desperately seeks, he tells her that she has to overcome her 'han', and it is only at the film's conclusion, when she finally meets her brother, that she is able to accomplish this. Songwha, therefore, symbolizes the Korean nation, and those who have endured 'han'. For a non-Korean audience, 'han' is particularly difficult to understand, not least because the concept of 'han' is embedded in the Korean nationhood. *Sopyonje*, however, is able to give the international audience a flavour and a visual form of reference as to what this concept actually means.

Stylistically, *Sopyonje* is emblematic of Im's realist aesthetic that has symbolized much of his later work. Much of the realism found in Korean cinema can be traced back to the Italian neo-realist era, and therefore films that exhibit the conventions of this period will often use long takes, little editing and so on and so forth. *Sopyonje* is characteristic of this movement with its wide-pans and sustained shots – a musical scene involving Yubong, Dongho and Songwha has a duration of five minutes with no cuts, and the camera does not move. Yet, Im also moves away from these traditions of realism, as exhibited in the final reunion scene between Songwha and Dongho, which adopts more aggressive editing techniques, and close-ups, rarely used during the film. This may seem at odds with the film, but in order to convey 'han' in its purest form, Im resorts to a convention not commonly associated with realism in an endeavour to provide the film with an authentic portrayal of 'han' and, given the film's tremendous popularity in the domestic market largely due its representation of 'han', Im succeeded in conveying this. This is characteristic of Im's ability to both conform to and challenge conventions of cinema as his films seek to represent Korea and its culture to both a domestic and international audience.

Sopyonje and Im Kwon-taek may share forms in contrast to the fast-paced cinema of Korea today, but the film's significance in its

representation of 'han' and the Korean nation has and will continue to stand the test of time.

Jason Bechervaise

The Fox Family

Gumiho Gajok

Studio/Distributor:
MK Pictures

Director:
Lee Hyung-gon

Producers:
Shim Jae-myung, Lee Ha-na,
Kim Hyeon-cheol

Screenwriters:
Jeon Hyeon-jin, Park Eun-ah

Cinematographer:
Choi Jin-woong

Art Director:
Jeong Eun-jeong

Composer:
Lee Byung-hoon

Editor:
Gwon Gi-suk

Duration:
102

Genre:
Comedy/musical/supernatural

Cast:
Joo Hyun, Park Joon-gyu, Ha
Jeong-woo, Park Si-yeon, Ko
Joo-yeon

Year:
2006

Synopsis

A family of fox spirits descend from the mountains for a once-in-a-thousand-years opportunity to become humans. In order to do so, each must eat a fresh human liver at a specific moment of time, in just 30 days. The family consists of the father, a son, his beautiful daughter and his youngest daughter, the least adept at taking form but unquestionably the smartest. They initially attempt to attract humans for their sacrifice by forming a circus troupe, but their lack of human interaction ensures that the show is a disaster due to the show's macabre nature. In light of this, the family venture out into society in search of suitable human targets: the eldest daughter through erotic dancing, whilst father and son attempt to seduce desperate women at dances. These efforts are again hampered by the fox spirits' absence of social decorum and etiquette with comical consequences. The eldest daughter ensnares a con man, who offers to help the family in their quest for human sacrifices purely for the purposes of self-preservation. Meanwhile a deranged policeman is on the family's case, wrongfully suspecting them of a series of axe murders in the region. Events and individuals converge on the night of the thousand-year sacrifice with some unexpected twists in store.

Critique

Lee Hyun-gon's *The Fox Family* takes the principles of genre-mixing, or what film critic Jim Collins called 'ironic hybridisation', and stretches this to breaking point. *The Fox Family* mashes together a seemingly-divergent series of generic elements, from the song and dance number of the classical musical, the cultural specificity of folk tales, stalking serial killers and gory horror, along with liberal amounts of riotous slapstick comedy. It is to Lee's credit as a storyteller that these elements somehow converge to produce a coherent and thoroughly enjoyable experience. The foxes of the title refer to the *Gumiho*, the nine-tailed fox which features prominently in the oral folk and fairy tales which are specific to a Korean cultural tradition. These fox-like monsters can take human form at will, and will usually have nefarious intentions for the unsuspecting humans they encounter. Solitary creatures in myth, in Lee's film we are offered an entire family of shape-shifters, Father, Son and two daughters, who long for the opportunity to become well-rounded members of the human world, albeit unfortunate sacrifices will have to be made in the process. Once in a thousand years this opportunity presents itself, and *The Fox Family* charts the families' ill-fated and outright inept attempts to lure in the necessary human victims for their dream to become a reality.

The family's initial master plan is to form a travelling circus quartet, offering a wildly theatrical and dazzling performance in order to mesmerize their audience or, rather, stun their prey. Of course, this is the beginning of a series of often-hilarious disasters from a family of mountain monsters who are ill-prepared and ignorant about the civilized human world they seek to occupy. The circus performance itself offers a standout scene in the film, consisting of a gruesome horror show; arterial spray and dismembered limbs are centre stage and, naturally, not quite what the crowd were expecting. Undeterred, the family head out into the world intent on luring in their four human sacrifices, from a variety of inappropriate social situations – be it a massage parlour, building site or strip club. Interspersed with these exploits are a series of jarring, but well-executed song and dance numbers; the family members themselves feature heavily, but we also get a chorus line of homeless tramps through to a group of body-popping riot police. This all adds to the overall atmosphere of inventive lunacy and willingness to play with generic expectations which permeates throughout *The Fox Family*.

But, in amongst the formal madness on offer, at the centre of *The Fox Family* is an understanding of a critical generic convention of a creature feature: the foxes are not the real monsters. Whilst the father and his children may be socially inept with blood-thirsty animalistic drives, they are bonded together in a familial dynamic which may seem dysfunctional but is grounded by the family's love and sense of community. Their aspiration for human form is a collective primeval drive, but this does not override the family's commitments to one another. Similar in theme to Bong Joon-ho's *Gwoemul/The Host* (2006), the monstrous and grotesque visuals are a subterfuge for exploring the nature and problematic of the contemporary South Korean family.

This theme is foregrounded by the continual juxtaposition of the fox family's struggle for social acceptance with the grotesquery of their human counterparts. The irony is self evident in the film: whilst the foxes crave entry into the social sphere of humanity, the film offers a series of human caricatures that are completely devoid of life. From a suicidal teen, a callous con man, to an axe-wielding serial killer, the human world is populated by individuals with little or no redeeming qualities; they have little respect or interest for life in general. Of course, such lofty themes are framed by the pitch-black humour and overall zaniness of the film which fixes the audience's empathy squarely with the naive Fox Family in their clumsy pursuits of happiness. As brave and uncompromising as it is graphic and silly, *The Fox Family* fits within a cycle of South Korean genre films which deal with broader cultural concerns.

Spencer Murphy

SCIENCE FICTION

Korean cinema has no tradition of science fiction. Nonetheless, in the past decade there has been an increased willingness from film-makers to explore genres which have been largely absent from Korean cinematic history. While there had previously been only a few films released containing science fictional elements, 2003 provided a watershed year with the release of films such as Jang Sun-Woo *Sungnyangpali sonyeoui jaerim/ Resurrection of the Little Match Girl*, Kim Mun-Saeng's *Wondeopul deijeu/Wonderful Days* aka *Sky Blue*, Min Byung-Chun's *Naechureol Siti/Natural City* and Jang Jun-hwan's *Minyeo-neun Goerowo/Save the Green Planet*. Whilst these films cannot all be said to be strict science fiction genre pictures, and certainly do not all have the same concerns, they have been part of an emergent domestic approach to science fiction and have inserted themselves into a wider international science-fiction history garnering a burgeoning international audience.

The question that must be asked of this new Korean engagement is how has it taken recognizable science fictional iconography from the American, Japanese and global science-fiction approaches while simultaneously relocating and re-articulating these traditions so that they make sense to a domestic Korean audience. As science-fiction author Gord Sellar argues, 'it seems [Korean science fiction] is at least a doubly "acquired language": its foreign tropes and modes of cognitive estrangement, along with its attendant (foreign) cultural baggage, must both be absorbed and retooled locally for the coherent transplantation of [Science Fiction].'[1] This retooling consists of taking these international forms, this 'foreign cultural baggage', and reinserting them into the legacy of Korea's colonial past and its divided present.

The early 1990s, however, provide the starting point of what would culminate in the development of science fiction genre pictures in the 2000s. With domestic cinema on the verge of collapse in 1993 and the relaxing of censorship laws throughout the late 1980s as military rule waned, the new civilian government provided support for the Korean culture industry by encouraging foreign investment through large conglomerates and developing cultural policies which were to encourage the revitalization of the market. As more investors began to look to Korea as an attractive market, the film industry rebounded at the turn of the millennium; as Darcy Paquet argues: 'a bubble of sorts was created in film finance, and the free availability of money would encourage

Left image: *Yonggary*, 1999, Younggu-Art Movies/Kobal Collection

the rise of budgets and salaries, and a willingness to attempt expensive genre pictures that had never before been produced in Korean Cinema, such as science-fiction titles *2009 Lost Memories* (2002) and *Natural City* (2003).'² This increased financial viability of the Korean film industry signals science fiction as a new way to approach contemporary fears and anxieties.

The alternative history picture *2009 Lost Memories* provides a vivid engagement with contemporary concerns about the colonial legacy of Korea, re-imagining the nation as falling under a fictional post-World War II Japanese Empire. Given the attempted eradication of Korean Culture by the Japanese colonial rulers until Korean liberation in 1945, the film provides a pertinent commentary on Korea's relationship to its past Imperial masters, using a recognizable science-fictional trope, time-travel, in order to explore Korea's position in the international community. Even more significant for a modern Korean audience is the 2002 film *Yesterday* which explores the tensions of a reunified Korean nation utilizing the present divisions between North and South, and Korea and its Vietnamese neighbours in order to construct a vision of a futuristic Korean state coming to terms with its own identity.

Further to these localized concerns, a specific set of generic conventions link up with the broader concerns of science-fiction cinema, exploring such ideas as globalization, environmentalism, and technology. A less regionally-specific concern with the globalized world can be seen in Natural City's monolithic cityscape or *Wonderful Days/Sky Blue*'s ECOBAN, with both films exploring international anxieties over urbanization and industrialization, centring the action through a juxtaposition of mega-city and slum. As Korea lacks a tradition of science-fiction cinema, it runs into the problem of cultural translation, which is most evident in *Natural City*, a poor clone of *Blade Runner* (Ridley Scott, 1982). This lack of tradition forces Korean science fiction to attempt to translate generic conventions and concerns which, while part of the broader concerns of science fiction, may not directly relate to the contemporary Korean situation and, instead, forces the narrative to only refer to these conventions instead of developing a 'Korean' take on them: *Natural City* lacks cultural specificities. *Wonderful Days/Sky Blue* provides a parallel to this in that it owes far more to Japanese anime than it does to the Korean film industry. Instead, the film is much more globally oriented via its driving environmental concerns and is constructed around current global anxieties towards climate change. In *Wonderful Days/Sky Blue*, the environmental concerns are isolated through the setting in which the city, ECOBAN, runs on pollution and the leaders' woeful disregard for alternative sources of energy. There are clear similarities with Japanese anime, particularly the work of Hayao Miyazaki. The lack of integration between the mega-cities and slums in these two films betray the broader concerns of the developed world in relation to the developing world, rather than any specifically Korean problems. While *2009 Lost Memories* and *Yesterday* provide a closer exploration of Korean cultural specificities, *Natural City* and *Wonderful Days/Sky Blue* are stripped of this specificity and instead rely on an engagement with the broader thematics of science fiction as a whole.

In this respect, *Save the Green Planet* is more successful in relocating and re-articulating science-fictional elements within a Korean context. The film shows a willingness to collapse carefully-delineated generic conventions and overstep the genre boundaries that are more prevalent in the Hollywood science fiction from which it borrows. A hybrid melodrama-comedy-paranoia-torture movie, the film capitalizes on the relaxation of Korea's censorship laws in order to introduce a hyper violent horror aesthetic into the Korean melodrama. It utilizes the sub-genre of alien-paranoia science-fiction film to develop a self-critical engagement with social codes of conduct. As Jeeyoung Shin notes, 'these hybrid cultural forms provide an important means for [Korean] self-definition, a self-definition that not only distances itself from a xenophobic and moralising adherence to local cultural "tradition" but also challenges Western cultural hegemony.'³

If science fiction is largely viewed as a 'Western' enterprise concerned with American or British specificities, the development of a hybrid approach to science fiction by some Korean film-makers adapts and reflects on not only internal conflicts but broader international themes isolating the attempt for Korean self-definition in the contemporary global marketplace of ideas.

This perhaps explains the success of Bong Joon-Ho's *The Host*, in both the domestic and international markets. *The Host* collapses a series of generic conventions, introducing a multitude of science-fictional tropes into the more recognizable legacy of giant monster movies in Korea such as *Taekoesu Yonggary/Yongary: Monster from the Deep* (Kim Ki-duk, 1967) and *Ujugoe-in wangmagwi/Space Monster, Wangmagwi* (Kwak Hyeok-jin, 1967). The film melds a popular monster-movie narrative with a virus outbreak narrative in order to explore the revolutionary undercurrent of Korean technocratic society as well as its concerns with pollution and environmentalism. In this respect, *Gwoemul/The Host* provides not only a continuation of the localized Korean monster film but develops a response to the history of Japanese and American giant-monster films. In the classic monster-movie narrative in the Japanese or Hollywood tradition, the monster represents an external threat which must be neutralized using the latest military or scientific technologies. This would provide a commentary on America's Cold War fears or Japan's nuclear anxieties, where the advancement of capitalist technology provides the respective societies with powerful weapons and resources with which to destroy the monstrous Other. In contrast, *The Host* offers the monster-attack narrative in an inverted form, in which the monster represents an internal threat brought on by the advancement of Korean capitalism (the monster is created by pollution in the Han River). The high-tech response that the American military provides only serves to escalate the situation, poisoning the cityscape further with the introduction of the experimental chemical weapon 'agent yellow'. The growing revolutionary backlash to this response can be read in relation to the American military involvement in Korea from the Korean War onwards that treats internal Korean conflicts as little more than a feature of its own foreign policy adventures. Tellingly, the ultimate destruction of the monster in *The Host* is not achieved through outside military or political intervention, but by local and rather more low-tech means, with actor Song Kang-ho spearing the monster in the mouth with a signpost. Here, Korea appears to be solving its own problems.

The huge domestic and international success of *The Host* demonstrates that there is a space in the Korean popular imaginary for science fiction (or at least films with science-fictional elements), and despite a slight drop off in the production and relative success of Korean science fiction since 2006, we may note the potential for further growth in home-grown science-fiction cinema presenting a distinctly Korean vision of this most international of genres. Early approaches to science fiction struggled to come to terms with the question of integrating the broad international concerns and traditions of science fiction, with films such as *Natural City* and *Wonderful Days/Sky Blue* failing to capitalize on local attitudes and anxieties. However, films such as *The Host*, *Save the Green Planet*, and Park Chan-wook's *Ssaibogeujiman Gwaenchanha/I'm a Cyborg* (2006) provide examples of greater engagement with Korea's recent political history and a more successful integration of broad science fictional thematics into Korean cinema and society.

Angus McBlane and Phillip Roberts

Notes

1 Gord Sellar (2008) 'Another undiscovered Country: An analysis of the Effects of Culture on the Reception and Adoption of the Science Fiction Genre in South Korea Throught the Examination of 21st Century Korean SF cinema'. 4th International Congress of Korean Studies. Sept 22-24,

2008. Paper available at <http://www.ikorea.ac.kr/congress/> or <http://www.gordsellar.com/2008/09/17/forecast-flash-update/sellar-anotherundiscoveredcountry/>. Accessed 15 November 2012.

2 Darcy Paquet (2005) 'The Korean Film Industry 1992 to the Present' in Chi-Yun Shin & Julian Stringer (eds) *New Korean Cinema*, Edinburgh: Edinburgh University Press

3 Jeeyoung Shin (2005) 'Globalisation and the New Korean Cinema' in Chi-Yun Shin & Julian Stringer (eds) *New Korean Cinema*, Edinburgh: Edinburgh University Press

2009 Lost Memories

2009 Loseuteu Maemorijeu

Studio/Distributor:

CJ Entertainment, Indecom
Cinema, Tube Entertainment

Director:

Lee Si-myung

Producers:

Stanley Kim, Kom Yoon-young,
Shinichiro Nakata

Screenwriters:

Lee Sang-hak, Lee Si-myung

Cinematographer:

Pak Hyun-chul

Art Director:

Kim Ga-cheol

Composer:

Lee Dong-jun

Editor:

Kyung Min-ho

Duration:

136 minutes

Genre:

Action/drama/mystery/sci-fi/
thriller

Cast:

Lee Myung-hak, Jang
Dong-gun, Ken Mitsuishi,
Toru Nakamura, Seo Jin-ho

Year:

2002

Synopsis

In the year 2009, a terrorist attack occurs on a group of individuals at a cultural event sponsored by the Japanese Empire and cultural group, the Inoue Foundation, in Kyongsong (Seoul). Japanese Investigation Bureau partners Sakamoto, of Korean descent, and Saigo, of Japanese descent, are dispatched to deal with this threat and, upon further investigation, find that it has been committed by the Joseon Liberation Army, the Hureisenjin, who are in search of the Lunar Soul, a mystical object which provides a gateway in time. The Joseon Liberation Army is a group of Korean Nationalists who believe that history has gone awry and that Japan did not actually win World War II via the atomic bombing of Berlin, rather, the Japanese Empire has played a dangerous game involving Time-Travel and the manipulation of History by preventing the assassination of Ito Hirobumi in Harbin in 1909. As Sakamoto and Saigo increasingly uncover the depths of the struggle between the Inoue Foundation and the Joseon Liberation Army, they are forced to choose sides in a battle which threatens Japanese control of Joseon and the very existence of Korea.

Critique

Alternative history film *2009: Lost Memories* provides an interesting vision of a Korea that never was but could have been. Predicating its narrative on the prevented assassination of the Japanese General Itto Harubumi and, therefore, altering the entire timeline of the Korean Liberation following World War II, Imperial Japan remains in control of Korea. This initial movement develops the narrative in terms of the conflict centred within Sakamoto, an agent of the Japanese Bureau of Investigation (JBI) who is of Korean descent. Alternating between the ideology of the JBI, which promotes State Power in the service of the Japanese Empire, and the Joseon Liberation Army (CLA), which promotes a nationalistic ideology in service of Korea, both the JBI and CLA find themselves trying to regain 'ancestral' lands and to 'right' history.

Constructing the narrative around these seemingly-disparate ideologies, the film highlights the tensions surrounding Korea's history with the Japanese Empire, in particular the attempted eradication of Korean Culture by the Japanese occupying forces prior to liberation at the end of the World War II. A vivid example of this is provided roughly thirty minutes into the film as Saigo, Sakamoto's partner at the JBI, comments to Sakamoto that he does not see him as Korean, as some suspicious colleagues do, seeing him, rather, as Japanese through and through. Their relationship dovetails as Sakamoto is pulled towards his Korean identity and the rejection that he faces from Saigo comes to a head when Sakamoto shoots his former partner in order to secure that history is 'righted'.

Of particular interest here is that both the ideologies of the JBI and CLA are predicated upon a similar nostalgia and memory of trauma, with Saigo commenting that the CLA is 'nostalgic, can't face reality' while never turning this critique back onto the

Japanese Empire, which itself had to go back in time in order to 'right' it. The Japanese want to right 'history', their history, so they send someone back, Inoue, to prevent the assassination of Itto, altering their history and keeping control of Korea; the bombs were never dropped on Hiroshima and Nagasaki. Yet the Koreans also want to protect 'history', they want to restore their 'history' which was altered due to the Japanese intervention. Curiously, the Korean War and the enforced Division of Korea into North and South is never mentioned. We find in both the Japanese and Koreans a tension between things as they 'should' be and things as they 'are', with each group a product of trauma: the continued occupation of Korea for the CLA and the atomic bombings of Hiroshima and Nagasaki for the JBI and Inoue Foundation. Trauma serves as the impetus for both groups to behave the way that they do; their ideologies are, in fact, nearly identical.

This aspect of the films serves to deepen it from being a generic high-budget action film. However, rather than providing a careful or even subtle exploration of this guiding thematic, the film opts to utilize the trope of time travel in order to situate itself. At the point when the viable option of time travel is introduced via the mystical Lunar Soul, the film's appeal drops tremendously as it seemingly uses it as a crutch in order to forcefully render its point of 'righting' history rather than providing a subtle or even explicit exploration of memory, nostalgia and trauma.

Angus McBlane

Arahan

Arahan Jangpung dae-jakjeon

Studio/Distributor:
Good Movie Company (Current Sidus FNH Corporation)

Director:
Ryoo Seung-wan

Producer:
Kim Mi-hee

Screenwriters:
Ryoo Seung-wan, Eun Ji-hee, You Sun-dong

Cinematographer:
Lee Jun-gyu

Art Directors:
Jang Gen-young, Kim Gyeong-hui

Synopsis

Sang-hwan is relatively inexperienced as a traffic cop and finds that he has extremely bad luck in his attempts to maintain the law and assert his authority. While pursuing a bag thief, he is literally knocked off of his feet by a young woman called Eui-jin in her attempts to stop the crook, using a mysterious power of focused 'chi' energy called a 'Palm Blast'. Amazed by the mystical power, Sang-hwan becomes obsessed with learning the skill himself and he tries to convince Eui-jin's teachers – a group of Tai-Chi Masters that includes her father – into showing him how to harness his own energy into powerful fighting techniques. As this is happening, another old Master makes a return to the city seeking revenge by claiming a key which will give him an unstoppable power – plans which Sang-hwan finds himself caught in the middle of…

Critique

After his acclaimed low-budget independent debut *Jukgeona hokeun nabbeugeona/Die Bad* (2000) and his first studio film, the dark and gritty *Pido nunmuldo eobshi/No Blood No Tears* (2002), director Ryoo Seung-wan released Arahan – a playful mixture of action, special effects and the type of broad comedy showcased in his internet-released feature *Dachimawa Lee* (2001). Viewed by

Composer:

Han Jae-gwon

Editor:

Nam Na-yeong

Duration:

114 minutes

Genre:

Action/comedy/drama/martial arts/science fiction

Cast:

Ryoo Seung-bum, Yun Soy, Ahn Sung-ki, Yoon Joo-sang, Kim Jee-young

Year:

2004

most as an unashamed commercial project, *Arahan* received mixed reviews but performed fairly at the domestic box-office and very well overseas, where it achieved cult status after festival screenings and DVD releases, introducing Ryoo's work to the markets usually reserved for Hong Kong action cinema.

His second collaboration with Jung Doo-hong (who assumes the dual role of Martial Arts Director and the villain Heuk-woon), *Arahan* was intended as a love letter to Jackie Chan films and, while its pacing and extended action sequences borrow largely from seventies kung-fu cinema such as *Long xiao ye/Dragon Lord* (Jackie Chan, Hong Kong: 1982), the CGI visuals are fashioned by modern kung-fu films such as *The Matrix* (The Wachowski Brothers, USA: 1999) and *Cheung gong 7 hou/Shaolin Soccer* (Stephen Chow, Hong Kong: 2001). Ryoo regular Ryu Seung-beom (incidentally the director's younger brother, unrecognizable from the role he would play in Ryoo's next feature *Jumeogi unda/Crying Fist*, 2005) clearly enjoys hamming it up as Sang-hwan, delivering great comedy timing and performing many of his own stunts.

Interestingly for a largely traditional kung-fu narrative, Ryoo makes some key – but not immediately obvious – choices. *Arahan* delivers two villains: the first, a gang that Sang-hwan fights in revenge at the film's mid-point; the second, a 'super-villain' introduced quite late in the day. Typically, a kung-fu hero faces his enemy after some initial training, only to be defeated – he is then forced to recuperate and learn from his mistakes before going on to win the inevitable rematch. In *Arahan*, Ryoo allows Sang to defeat the enemies from his 'normal' life early on – there is no 'failure' other than disappointing his teachers, which he is not too bothered about, so no lessons are learnt and Sang-hwan remains noticeably immature. Then, when faced with an even-bigger threat from the 'super-villain' – who is more misguided than evil, believing that his actions are for the greater good of the world – Sang-hwan again celebrates victory but learns no lessons; his immaturity remains.

Ryoo has been described by some critics as a nihilist director – which may be interpreted in his refusal to allow Sang-hwan (typically 'the chosen one') to grow up. There is the sense that regardless of his intentions – good or bad – that the status quo is never really affected. The comedic action of the first half of *Arahan* becomes tonally darker in the second and is commonly criticized as being overlong. This may be less poor pacing than Ryoo working out his frustrations: *Arahan* takes elements from the director's own influences but stops short of creating anything new – the extended action of the final scenes simply rework different versions of the same types of action repeatedly. Here, another familiar theme of Ryoo's work surfaces – exhaustion. By the time the finale is complete he has pushed the characters, the choreography and the viewer to their limits and, when Sang-hwan recovers, he has mastered a technique but his immature character has not changed. The long final act ensures that *Arahan* remains a film appreciated largely by fans of CGI-assisted action, but may reflect a more frustrated and cynical Ryoo than is given credit for. After all, much is

Arahan, 2004, Fun and Happiness/Good Movie Company

made of Sang-hwan's 'potential' – a back-handed compliment that Ryoo received for his previous features – but he is unable to create any real change.

Martin Cleary

Ditto

Donggam

Studio/Distributor:
White LEE Entertainment

Director:
Kim Jung-kwon

Producers:
Lee Dong-gwon, Kim Athanh-jon, Im Dong-mun

Screenwriters:
Jang Jin, Heo In-a

Synopsis

So-Eun, a student in 1979, gets a short wave HAM radio to impress the boy she is in love with. When playing around with it one night she meets In and they become friends, as they are similar age and at the same university. In offers to lend her a book on HAM radio and they decide to meet up, but it proves to be impossible as they are actually separated by more than just distance; by time as well.

Critique

The idea of a relationship across time is not a new one in cinema and, in the early 2000s, was a popular theme both in Korea and the West. *Frequency* (Gregory Hoblit) a US film whose release was one month prior to Ditto also uses the idea of communication between past and present via HAM radio, but falls into the tense-thriller category. In South Korea, though, the theme remains almost resolutely sentimental with releases such *Siworae/Il Mare* (Lee

Cinematographer:
Chung Kwang-suk

Art Director:
Kim Jeong-tae

Composers:
Angelo Lee, Song Jae-won

Editor:
Kyeong Min-ho

Duration:
110 minutes

Genre:
Melodrama/romance/science fiction

Cast:
Kim Ha-neul, Yoo Ji-tae,
Park Yong-woo, Ha Ji-won,
Kim Min-ju

Year:
2000

Hyun-seung, 2000) and, indeed, *Ditto* could simply be viewed as such if you do not know anything of Korean history. Add the historical aspect in, though, and you see there is more depth to the story and sentiment expressed.

The two time periods the main protagonists live in are both important in South Korean History – 1979 when Park Chung-hee ruled the country and 2000 when the economy was just beginning to recover after the Asian crisis and democracy in Korea was finally back on track. The two decades, whilst both on the brink of major changes, are vastly different in outlook and atmosphere and it is easy to see how *Ditto* becomes an important film in illustrating how far Korea has come in so short a time. So-Eun (Kim Ha-neul) becomes a representation of Korea's past: innocent and at the mercy of events taking place around her, gradually realizing how her actions can affect the future and the new friend she has made. In (Yoo Ji-tae), of course, represents the modern Korea, aware of the past yet not appreciating the sacrifices made so that he can have the life he has. His future feels limitless and free, while So-un's feels far more bleak and hopeless.

Director Kim keeps the context of the film almost timeless by using pieces of classical music to illustrate the mood and elucidate the characters' feelings, while chart music of the time is kept to the minimum. The difference between the two periods is emphasized through dress, language, and the relationship between male and female students – indeed, it is this that gives away the separation in time between So-eun and In faster than the mode of dress. For example, during the failed meeting at the clock tower between So-eun and In, we hear a conversation in the modern classroom to do with girls and drinking which almost seems shocking, juxtaposed as it is with the restrained nature of courtship in the 1970s – an aspect emphasized by So-eun's shy nature and simple home surroundings and its contrast with In's modern home, packed with electronics and luxury items.

Ditto is a sweet, sad story that relies heavily on two main characters for its impact, not just romantically but socially and politically too. More than a simple love story, it is an illustration of how our past and future are entwined together and that neither should be taken for granted. The past is unable to be changed and the future is inevitable.

Kay Hoddy

Il Mare

Siwore

Studio/Distributor:
Sidus Uno Film/Spectrum

Synopsis

Il Mare, Italian for 'the sea', is a beautiful beach-front house where Eun-joo has lived for the past year or so. On moving to an apartment in the city, she leaves a Christmas card in Il Mare's mailbox for the next tenant, wishing them happiness there and asking them to forward any of her mail to her new address. She also dates the card December, 1999' and apologizes for the paw prints by the

Director:

Lee Hyeon-seung

Producer:

Tcha Sung-jai

Screenwriter:

Yeoh Gee-na

Cinematographer:

Hong Gyeong-pyo

Art Director:

Kim Gi-cheol

Composer:

Kim Hyeon-cheol

Editor:

Lee Eun-su

Duration:

96 Minutes

Genre:

Sci-fi/romance

Cast:

Lee Jung-jae, Jun Ji-hyun, Kim Moo-saeng, Jo Seung-yeon, Min Yun-jae

Year:

2000

door, explaining that they were already there when she moved in. Separately, Sang-hyun moves into Il Mare and, on checking the mailbox, finds Eun-joo's card. As the house has only recently been built, and he is the first person to live there, he replies to her card stating that there must be some address mix-up and notes that the year is actually 1997. A couple of days later, a stray dog leaves paw prints in some spilt paint by the door and this, combined with further correspondence via the mailbox, leads Eun-joo and Sang-hyun to the realization that they are indeed living in different times – Sang-hyun in 1997; Eun-joo in 1999.

Critique

As soon as we are introduced to Eun-joo (Jun Ji-hyun) and Sang-hyun (Lee Jung-jae), it is clear that both are dealing with issues of abandonment. Eun-joo is clinging to the hope that she can rescue her relationship with her (ex)boyfriend and, in the early stages of the mailbox correspondences with Sang-hyun, she seems to almost see him simply as a comfort. None of the heartache she feels is actually her fault – her decisions, and her acceptance of others' decisions, were what she believed were the right things to do at the time – but her fear that she is the one to blame, and the feeling she has of needing to fix what she sees as her mistakes has stayed with her. Her statement 'I guess I was expecting too much, again' really hits the nail on the head in describing the effect that the hurt she has suffered has had on her belief in hopes and dreams and, when she finally realizes what she truly wants, she is once again left racing to fix a situation which she blames herself for causing.

Sung-hyun's most obvious issues stem from his father leaving him when he was a child but reference is also made to previous relationship heartaches, and though it is left to viewers to draw their own conclusions as to the specifics involved, it is clear that, as a result, the baggage he carries affects the current choices he makes to a large degree. Twice, he sits by Eun-joo (that is, the 1998 Eun-joo who obviously is not aware of who he is) at the train station and is unable to say anything and, when she asks him for help in one of her letters, he agrees but instantly steps back from the relationship, ending his reply by saying goodbye. His willingness to set aside his needs and desires is partly so that the girl he loves can find happiness, and partly to prevent himself from being hurt more than he already has been.

Eun-joo and Sang-hyun are essentially suffering from the same problem, albeit from two very different perspectives. Eun-joo cannot leave the past behind, no matter how hard she tries – her past relationship haunts her and even her new relationship is two years in the past – and Sang-hyun spends most of his time pining for the future, both in terms of his relationship with Eun-joo and also in his career. Neither scenario brings them any comfort, and it becomes increasingly obvious that the only chance they have of finding happiness is if they put the past to rest, stop relying on hopes that in the future everything will miraculously be okay, and start focusing on the present.

The direction and cinematography used throughout the film are utterly stunning. The beautiful beach on which Il Mare is situated is used to full effect – long, luxurious sweeps of the camera and the breathtaking panoramic sunset scenes evoke a feeling of longing, even before the main characters appear for the first time. Director Lee Hyeon-seung and cinematographer Hong Gyeong-pyo fill the screen with sumptuous exterior and interior shots and take pains to ensure that even the smallest details play a memorable part – from the floating away of a pair of mittens to the releasing of a fish into the sea, the tiniest apparent trivialities regularly mirror the characters' unspoken feelings. As for the mailbox itself, its design is utterly inspired and, dare I say, magical.

Il Mare (the fourth South Korean film to have its international rights bought by a US film company) is unashamedly romantic throughout but totally confounds viewer's expectations. The plot never resorts to being sappy; warmth exudes from the characters, the dialogue and the screen imagery; and the whole films feels like it could be real – quite something, considering the other-worldliness of the story.

Paul Quinn

Natural City
Naechureol Siti

Studio/Distributor:
Jowoo Entertainment,
Tube Entertainment

Director:
Min Byung-chun

Producer:
Lee Dong-jun

Screenwriter:
Min Byung-chun

Cinematographer:
Min Byung-chun

Art Director:
Cho Hwa-sung

Composer:
Lee Jun-kyo

Editor:
Kyung Min-ho

Synopsis

In a future where cyborgs and other artificial beings are part of everyday life, military officers R and Noma are tasked with bringing to justice those cyborgs that operate outside their programming and have begun to revolt. Following the discovery by one of the commando model cyborgs, Cypher, that they can outlive their three-year life span via mind transfer to a human host, and his colleagues questioning his sanity because he loves a cyborg doll, R ventures into the black market in order to find out more about the mind-transfer technology, as it could save his beloved Ria. There he comes into contact with the cyborg's target, Cyon, a prostitute and fortune teller living in the Slums. He finds himself torn between protecting Ria and tracking down the cyborg that is targeting Cyon, perhaps to use the technology himself to transfer Ria into Cyon and thus save her life.

Critique

This film provides one of the first instances of a strict science-fiction film in Korea which explores familiar tropes within the genre. Basing its narrative around the notion of love for an 'artificial being' which is disposable, cyborg rebellion and mind-transfer technology, *Natural City* finds itself drawing from a wide variety of other, more successful films in order to construct its aesthetic and narrative. Heavily influenced by the cyberpunk genre and noticeably borrowing heavily from *Blade Runner* (Ridley Scott, 1982) and the book which inspired it, Philip K Dick's *Do Androids Dream of Electric Sheep* (1968), the film appears at a loss as to how to construct a science-fiction film without outright appropriation.

Duration:

114 Mins

Genre:

Sci-fi/action/drama/thriller

Cast:

Yoo Ji-tae, Lee Jae-un,
Jung Doo-hong, Seo Rin

Year:

2003

The familiar mega-city and slum divide found in cyberpunk, as well as the city itself being constructed to resemble *Blade Runner's* famous cityspace, provides little originality to the tale and there is a clear lack of subtlety in the investigation of the theme of love for an 'artificial being'. With R spending much of the film angrily attempting to find a way to save Ria as she sits quietly, or dances, with an expressionless blank face, it is hard to imagine what in particular has drawn R to Ria and the film never explains this aspect clearly nor readily invites the viewer to do so. The cyborg's disposability and the turmoil that that causes, while explored through the renegade cyborg's vitriol at their former masters and their desire to rebel and survive, rarely finds itself raised beyond one-dimensional villainous over-characterization.

The most interesting aspect of the film is found in the first five minutes, when, during the opening credits, the construction of a cyborg, as found in the opening credits to *Kōkaku Kidōtai/Ghost in the Shell* (Oshii Mamoru, Japan: 1995), is nearly shot-for-shot inverted to show the remorseless and anonymous destruction of an artificial being. While this is somewhat capitalized on during the course of the film, as it sets the tone for the renegade cyborg's anger, it is little redemption for a film that clearly has no idea what it wants to be. Instead, it relies heavily on the already-established science-fiction cinema of America and Japan without leaving a distinct impact.

Angus McBlane

Resurrection of the Little Match Girl

Sungnyangpali Sonyeoui Jaerim

Studio/Distributor:

Kihwik Cine

Director:

Jang Sun-woo

Producer:

Yoo In-taek

Screenwriters:

Jang Sun-woo, In Jin-mi

Cinematographer:

Kim Woo-hyung

Synopsis

Following his friend Lee becoming a professional gamer, disenchanted delivery boy Ju yearns to follow in his footsteps. On his way from Lee's leap into becoming a professional gamer he encounters a mysterious young woman selling lighters and decides to buy one. Curious about the phone number on the lighter, he decides to call the number and enters into what appears to be an Alternative Reality Game (ARG) called the 'Resurrection of the Little Match Girl' in which the obstacle is to let the mysterious young women freeze to death while thinking of her beloved. However, in order to get her to fall in love with him, Ju must also protect the mysterious girl from other players as well as the group known as the 'system'. As he progresses through the game and gains help from Lara, a more experienced player, he faces off against the 'system'. Treated as a virus for disrupting the game and attempting to protect the Match Girl, Ju challenges the 'system' as she is kidnapped by them to be reprogrammed after she slaughters those who scorn her lighters. With the help of the designer of the game, Ju, now furnished with the powerful weapon Mackerel, and accompanied by Lara, enters the stronghold of the 'system' to attempt to win the heart of the Match Girl and ultimately the game.

Art Directors:
Lee Cheol-ho, Chol Jeong-hwa

Composer:
Dal Pa-Lan

Editors:
Han Seung-ryong, Kim Hyun

Duration:
125 minutes

Genre:
Action/comedy/sci-fi

Cast:
Lim Eun-kyeong, Kim Hyun-sung, Kim Jin-pyo, Jin Sing

Year:
2002

Critique

Adapted and heavily expanded from the Han Christian Andersen tale 'The Little Match Girl', the narrative of the *Resurrection of the Little Match Girl* is quite literally constructed via the Quest narrative of contemporary video games, most notably role-playing games. This videogame-style narrative informs many of the ways in which technical elements are constructed as well as the construction of characters and non-player characters (NPC). In many respects the viewer enters into the narrative through the avatar of Ju and attempts to play the game with him. Player stats, levelling up, even multiple endings – good and bad – are incorporated into the visual style of the film. Very clear references are made to arcades, pro-gaming and even *StarCraft* (Blizzard Entertainment, 1998) which attempt to draw the viewer further into this videogame fairy tale.

However, the many videogame elements of the film find themselves in stark contrast to the opening of the film, which outlines the Andersen tale via a cleverly-used throwback to silent era films that provides a grainy and blurry overlay to the tale of the Match Girl's death. This 'opening cinematic', however, is rather subdued in relation to the remainder of the film and provides a point of comparison with the 'original' Match Girl and her resurrection. While, for the first half of the film, the Match Girl remains the subdued girl of the original tale, as constructed in the opening sequence, upon her 'resurrection', after being rescued by Ju, she becomes a violence-seeking anti-hero, killing those who spurn her by not buying her lighters. Two sequences following this transformation are of particular note and in both she goes on a rampage brutally killing everything and anything following her 'resurrection': in one, accompanied aurally by 'Ave Maria', and in another by a track with the lyric 'She came from the planet Blam'. While both of these sequences and her transformation in character are rather over the top, they can, however, be analysed through director Jang Sun-woo's choice of title, and orient the film around 'Resurrection'. The tale is resurrected for the video game age, and the Match Girl herself must also be 'resurrected' to fit the narratives and conventions of contemporary videogames. While the film does play around with the notion of reality to a certain extent, it does so once again in a very over-the-top manner and visual style associated with many mainstream videogames. Whether or not this over-the-top narrative and visual style is a distinct critique of or homage to contemporary pop culture, as Jang Sun-woo is more well-known for arthouse-style films, or even an homage to earlier films such as *The Matrix* (Andy Wachowski and Lana Wachowski, US: 1999) and the Hong Kong films from which it borrowed, what is distinctly presented is an adaptation of a literary classic filtered through the lens of videogames and extended by absurd proportions.

Angus McBlane

Save the Green Planet

Jigureul jikyeora!

Studio:

Sidus Pictures

Distributors:

Koch Lorber Films, Tartan, I-On
New Media, Palisades Tartan,
Tartan Video (DVD)

Director:

Jang Jun-hwan

Producers:

Cha Seoung-jae,
Choi Moon-su

Screenwriter:

Jang Jun-hwan

Cinematographer:

Hong Kyung-pyo

Art Directors:

Jang Geun-yeong,
Kim Kyeong-hie

Editor:

Park Gok-ji

Duration:

118 minutes

Genre:

Drama/comedy/fantasy/science
fiction/thriller

Cast:

Shin Ha-kyun, Baek
Yun-shik, Hwang Jeong-min,
Lee Jae-yong, Lee Ju-hyeon,
Gi Ju-bong, Kim Dong-hyun

Year:

2003

Synopsis

A young man named Byeong-gu believes that the world is about
to be destroyed by aliens. He kidnaps the boss of a multi-national
corporation in the belief that he is an extra-terrestrial who can put
him in contact with the alien high prince, although it transpires
that his company is responsible for a serious illness being con-
tracted by Byeong-gu's mother. He then keeps his prisoner tied
up in the basement of his remote mountain house and tortures
him for information. Byeong-gu's partner soon tires of the scheme
and leaves, whilst a young police officer and a retired detective
take over the case, with the latter finding his way to Byeong-gu's
house. However, after staying the night, he finds himself in danger,
following which the net closes in on the kidnapper and his actions
become increasingly desperate.

Critique

At the time of its release, Jang Jun-hwan's offbeat and deter-
minedly-idiosyncratic feature debut *Jigureul jikyeora!/Save the
Green Planet* was largely overlooked and underrated in the West.
Amidst the critical euphoria surrounding the dark, violent, high-
concept revenge narrative of Park Chan-wook's *Oldeuboi/Oldboy*
(2003) (a film with several key narrative beats in common with *Save
the Green Planet*), and the exotic, contemplative, Buddhist-derived
otherness of Kim Ki-duk's *Bom yeoreum gaeul gyeoul geurigo
bom/Spring, Summer, Autumn, Winter…and Spring* (2004), it
appeared and disappeared with scant commentary; not exactly dis-
missed but certainly not fully recognized or appreciated. However,
Jang's film now appears a somewhat sharper, more pertinent work
that either Park or Kim's self-consciously stylized and provocative
offerings. The film's narrative focus on a young, troubled protago-
nist who believes that the ills of the world are the result of extra-
terrestrial activity and that said aliens will soon destroy the Earth
(leading him to kidnap and torture the head of a multi-national
corporation in the belief that he is an alien) opens up all manner of
potentially-problematic twists and turns, none of which the director
shies away from. He is never condescending toward the audience,
refusing to soften the edges of his complex lead character; and
perhaps most impressively he treads a very fine line between lead-
ing us into an emotional investment in the kidnapper only to twist
the knife and force us to step back and really think about what he
is doing and why. Similarly, he also establishes the ostensible victim
as a typical corporate scrooge, before giving pause for thought
about the nature and details of his fate. For this director, good and
evil, human and inhuman are amorphous concepts and fluid poten-
tialities that reside within anyone.

Save the Green Planet is, then, notable for the affective extremes
on offer. Indeed, in its potent melding of different genres and
abrupt, at times marked, switches in tone, it resembles nothing
so much as a Hong Kong new wave film of the 1980s. It is a work

whose mix of action, sentiment, horror, science fiction and broad comedy would delight Tsui Hark or Sammo Hung, who themselves often sought to cannibalize disparate and diverse generic elements in what is generally regarded as cultural postmodernism, a veritable tale of sound and fury signifying nothing. One cannot, however, restrict the film to this Cantonese influence. The protagonist's sometime girlfriend is a circus tightrope walker known professionally as Gelsomina, an explicit nod to Fellini's *La Strada/The Road* (1954) and a pertinent intertextual correlative to the more complicated relationship between innocence and brutality in Jang's film. The slight drawback here is that this character, along with the detectives who take up the case and begin a search for the kidnapper and his victim, remain ciphers, plot-functionaries, albeit ones deeply etched due to a roster of incredibly committed and forthright performances by a cast of veterans and relative newcomers alike. The script, though (which was apparently several years in the writing), labours over dialogue, detail and development without any sense of being self-conscious or ostentatious. The myriad genres that inform the whole never cancel each other out; indeed they conflate to create something even more than the sum of its parts.

Quite what the startling events of *Save the Green Planet* amount to is a complex question. There are broadly-allegorical overtones to a story built around the potentially-evil head of a multi-national firm but, in truth, Jang does not really develop or follow through on this potentiality. He is very interested in the mechanics of emotional as well as physical pain and, indeed, in this regard the film does at times paint a sobering picture of a damaged psyche. But even here Jan refuses to let his audience have it easy, providing a coda that seems to frustrate any clear-cut reading of the outlandish science-fiction narrative pyrotechnics as a meta-fictive manifestation of a deeply-disturbed consciousness. In the end, we are each of us on our own with this singular, shocking, hugely underrated cult classic in the making.

Adam Bingham

Save the Green Planet!, 2003, Sidus/Kobal Collection

Space Monster, Wangmagwi

Ujugoe-in wangmagwi

Studio/Distributor:
Seki Corporation

Director:
Gwon Hyeok-jin

Producer:
U Gi-dong

Screenwriter:
Byeon Ha-yeong

Cinematographer:
Ham Chang-yong

Art Director:
Song Back-su

Composer:
Jeong Jong-kun

Editor:
Hyeon Dong-chun

Duration:
85 minutes

Genre:
Science fiction

Cast:
Kim Hea-kyeong, Nam Koong-won, Jeon Sang-cheol, Kim Hee-kap, Park Am

Year:
1967

Synopsis

A race of aliens has set their sinister sights on Earth and are now preparing for an all-out invasion. In order to soften up the human race and ease their conquest of the planet, they enlarge the Gamma creature to monstrous proportions and beam the now-gigantic man-beast onto the Korean peninsula on a path of destruction that will take it into the heart of Seoul. Those that are able, flee before the creature's fearsome strength and terrible flame mists. Others are forced to take refuge in what building they can and pray that they do not fall victim to the monster's rampage. However, there are those among the population of the city to whom neither running nor hiding are options. Among them are Oh Jeong-hwan, a brave fighter pilot whose efforts to stop the monster are hindered by the creature's invulnerable nature and the heavily-populated areas it transverses. Then there is Jeong-hwan's fiancée, Ahn Hee, who is not going to let a little thing like an alien invasion interfere with her plans to get married. Finally, there is the young street urchin Squirrel who refuses to remain helpless and takes matters into his own hands to destroy the monster and save the human race.

Critique

While science fiction is an important genre is nations around the world, it is has not been traditionally so in South Korean cinema. 1967 marked the first appearance of Korean science fiction films in *Taekoesu Yonggary/Yongary, Monster from the Deep* and *Space Monster, Wangmagwi*. After these completed their run, live-action science fiction disappeared from Korean cinema for more than a decade. Only animated films aimed at children seemed interested in continuing the genre and, when science fiction finally returned in the 1980s, it was almost exclusively in comic form aimed at very young children. One might argue that the special effects needed to make these films cost too much to do effectively; however both horror and action films used special effects. Another reason could be that the genre was considered to be childish. If that is the case, I point my finger directly at *Wangmagwi*.

 Space Monster, Wangmagwi is by no stretch of imagination a great movie. It suffers on many levels, starting with the opening sequence on the alien's spacecraft. The design of the aliens plotting the destruction of the world would have done the great, B-movie director Ed Wood proud. The actors playing them were simply covered head-to-toe in a shiny metallic foil as they deliver their stilted expository dialogue. After beaming Wangmagwi to Earth, the aliens become unimportant to the story. The title monster fares no better in the costuming department. Looking vaguely humanoid with enormous ears, Wangmagwi calls to mind the TOHO Studio 1966 film *Furankenshutain no Kaiju: Sanda tai Gaira/War of the Gargantuas* (Honda Ishiro, 1966) with some major changes. The teeth of Wangmagwi are much more pronounced,

as are his claws. However, his immobile tongue is in a perpetual state of protrusion and takes away what realism the monster might have had. Furthermore, Wangmagwi is saddled with an enormous radio-control box which the aliens grafted to his back. All of these things, and the fact that part of the monster's costume seems to unravel during the course of the film, could be ignored and chalked up to the 'charm' of a low-budget films except that we see far too much of the monster. When I was young and watched 'Monster Movies' on Saturday afternoons, I used to impatiently await the appearance of the monster. *Space Monster, Wangmagwi* has the opposite problem. Most of the film is taken up with the monster slowly walking through the city, occasionally breaking a building or setting something aflame. However, the human characters are given too little to do.

Of the human characters, only Squirrel stands out and he is in fact the highlight of the film. He was provided with the most action and the best lines and he is quite different from the other child characters that are sometimes found in these films. In *Gamera* (Yuasa Noriaki, Japan: 1966) and the 1960/1970s' Godzilla films, children were often deemed to be 'friends' to the monster and in some cases it was even implied that they share a special connection and inside knowledge that adults could not hope to understand. In *Yongary, Monster from the Deep*, the child star may be the one that discovers the monster's weakness, but he also begs for the monster's life when the time comes to destroy it. In *Space Monster, Wangmagwi*, Squirrel is simply fighting for his life. He is fully aware that it is a matter of kill or be killed. But with the army helpless, and the entire population of the city hiding, fleeing or dead, what can a young boy armed with a paring knife hope to accomplish?

Websites dedicated to Kaiju or B-movies often list *Space Monster, Wangmagwi* as the 'holy grail' of giant monster movies as it has never been screened outside of Korea. It is probably better this way.

Tom Giammarco

The Host

Gwoemul

Studio/Distributor:
Chungeorahm Film, Showbox Entertainment

Director:
Bong Joon-ho

Producers:
Choe Yong-bae, Kim U-taek

Synopsis

Following the restaging of the notorious formaldehyde dumping by the US Army in Seoul, the film begins by introducing the Host, a mutated amphibian that is growing fast in the Han River. Making a living by running his father's snack car on the riverbank's popular leisure spot is good-for-nothing Gang-du, whose daughter Hyun-seo means the world to him. The drama begins one day when the man-eating Host shows up and wreaks havoc, taking Hyun-seo among its victims. Believing that Hyun-seo has been killed by the monster, the family is reunited for the first time in a long while when Gang-du's estranged brother and sister come to the funeral of their beloved niece. The family, however, learns that Hyun-seo

Screenwriters:

Bong Joon-ho, Ha Joon-won, Baek Cheol-hyeon

Cinematographer:

Kim Hyung-koo

Art Director:

Ryu Seong-hui

Editor:

Kim Sun-min

Duration:

119 minutes

Genre:

Drama/sci-fi/thriller

Cast:

Song Kang-ho, Byun Hee-bong, Park Hae-il, Bae Doo-na, Ko A-sung

Year:

2006

might be alive and embarks on a quest together, against all odds, to search for the lost daughter.

Critique

The Host, Bong Joon-ho's third feature-length film, made him a star director, replacing the domestic box-office record of *Wang-ui namja/The King and the Clown* (Lee Joon-ik, 2005) at the height of box-office hype against Hollywood imports in South Korea. Not only did it do well contra American films, the film also garnered attention as a so-called 'anti-American' film, owing to its opening scene that criticizes the formaldehyde incident of 2000. The American military presence in South Korea, however, does not appear to be the only source of the Host. Feminist critics, for instance, have noted the Host as an incarnation of the family's absent mother. The maternal allegory seems to work best when Gang-du rescues – literally pulling out – a child from the vagina-like mouth of the monster.

While these readings focus on the figure of the Host, rightly so as the film is a monster movie in the ranks of other classical beasts such as *Gojira*, Bong himself has suggested that he introduced the monster early so as to be able to focus on the family story. Indeed, compared to Peter Jackson's *King Kong* (2005), in which the *Megaprimatus kong* appears only some forty-five minutes into the movie, the Host makes its appearance uncharacteristically quickly even for a low budget Asian blockbuster with a shorter running time. The family, nonetheless, shares with the carnivorous monster's feat of eating. In the Korean language, there are two nouns that refer to family, one signifying biological kinship (*kajok*) and the other a social tie that binds people who eat together (*shikku*). Fighting against the Host, the family drama plays upon this motif of eating and being eaten.

The eating motif is as quickly established as is the well-known introductory scene of the Host. Following the title shot, we learn immediately that Gang-du is an idler when we see him catnapping, not minding the storefront. Underpinning our knowledge of Gang-du's character is the scene of him filching a leg from a squid meant for his customer, thus bringing the eating motif to the fore. In fact, Gang-du constantly handles food, beer, and instant ramen noodle cups right up to the point when he starts running away from the Host. It is fitting that Gang-du drops food with the appearance of the Host: the one who turns humans from those who eat into those being eaten. Bong once compared the Host's reckless behaviour to a highly-strung teenager; it is also as hungry as ordinary teenagers.

The mayhem wreaked by the Host, however, is a mere shadow of the monstrosity of the State. While the news of Hyun-seo's death brings the family together for the first time in the plot, it is only after the arrival of the State in the figure of a yellow sack that 'eats' Gang-du alive that those tied by biological kinship become a caring unit. In their quest to find Hyun-seo, the family finds a rundown storage room where they come together to a table, again for the first time. What follows is none other than a stationary long

The Host, 2006, Chungeorahm Film/Kobal Collection

take of their fantasy of eating with and caring for Hyun-seo. After the meal, the grandfather continues on about Gang-du's difficult childhood, 'hungry' and 'deficient in protein.' Significantly, that the siblings doze off here not only brings comic relief to the narrative but also reveals at the structural level that it is only at 'home' that one can experience relief from the absurd society that provides no protection or care. This unit of care ultimately transcends biological kinship in the film. Joined by a new son, this time eating properly with steaming white rice, the family is no longer rendered an absurd and funny spectacle by the camera flashes of journalists at the memorial scene; instead, it is now isolated but stable in a long shot, self-defending and residing in the cold reality of a winter in Seoul.

Josie Sohn

Yesterday

Yeseuteodei

Studio/Distributor:
C J Entertainment

Director:
Chong Yunsu

Producer:
An Byung-hui

Synopsis

It is the Future: Korea is a re-unified country; the chief of police has been kidnapped; and five bodies have been found in similar circumstances, within a year. Each have been found in the border region and with a matching necklace – the same necklace that was found on officer Seok's son Hanbyul, killed in a police shootout with a devious terrorist gang. That same necklace has been found at the scene of the police chief's abduction and it is up to Seok and his high-tech special investigation unit to find out why. Hui-su, the police chief's daughter and experimental criminal psychologist (focusing, in an early lecture, on the criminal's genetic propensity

Screenwriter:

Chong Yunsu

Cinematographer:

Jeong Han-chul

Art Director:

Choe Yeong-in

Composer:

Gang Ho-jeong

Editing:

Kim Sun-min

Duration:

114 minutes

Genre:

Science fiction

Cast:

Kim Seong-woo, Kim Yunjin, Choi Min-su, Kim Seon-a, Jeong So-yeong

Year:

2002

towards crime), is also on the team, drawing on her specialist knowledge and memories of her father's work to assist the case. The team investigates the victims' shadowy pasts, pursuing their targets across a variety of seedy locales and meeting a cast of suspicious characters before the final thrilling conclusion.

Critique

Yesterday is a film about politics. Everywhere the film references problems of social and sexual inequalities, crime and violence. Reunification has brought technological development but not political harmony. The border regions are still disputed, but by criminal organizations and violent gangs. The dialogue references illegal Vietnamese and Chinese immigrants and ghettoization in throwaway lines. The action passes homeless people without comment and shiny new futuristic trains pass over filthy streets, packed with cars seemingly unchanged from today. Everywhere Yesterday paints its political dystopia with science-fiction and film-noir iconography, stretching shadows and floating lights across screens of smoke and forcing the audience, with every new image (some directly related to the narrative, some not), to ponder just what kind of world this is; to consider how this future Korea relates to our contemporary situation.

As the title would imply, *Yesterday* is concerned with speaking about the past (with respect to the futuristic setting), with many of the action sequences serving as a reaction to some unnamed event occurring sometime between now and the reunified present the film depicts. This unknown event is repeatedly related to the politics of the film, as each of the set pieces – action gunfights, standoffs, riots – rather than stopping the momentum of the film, as is often the case with action spectacles, serve to propel the characters towards Korea's border regions, where the mystery event is explicitly tied to territorial disputes and Korean reunification. Each set piece requires close attention from its audience as a sophisticated iconography serves to construct (and often reconstruct) the film's politics. A gun battle occurs against a backdrop of a revolutionary demonstration, with ghetto residents accosting police in riot gear, with red flags and banners tied to sticks and wrapped around their faces; a raid on a night club features a huge Vietnamese map on one of the walls, relating the unfolding investigation with the future-Korea's foreign policies and immigration problems. Almost every scene uses such images to weave an increasingly-complex political web that will eventually lead back to some unnameable event.

When this event is finally revealed, *Yesterday*'s focus shifts from a preoccupation with the political past to its technological future, and demands a re-articulation of much of the information in many of preceding scenes. Turning its attention towards a science-fiction cloning allegory, the film invokes an imagined political past – reunification, immigration, border disputes, organized crime, inequality – and projects it into the future. In an earlier scene, Seok had learned of recent advancements in cloning technologies

and had thought about their possible uses for the recreation of his dead son. Later, we learn that such cloning technologies had already occurred, as part of the unnameable event that much of the film had been leading up to. Goliath, a young boy on whom the cloning tests had been running, had been used as the model for his clone David, and decides that his clone should suffer as he had done. He attempts to strangle his brother, but fails and then disappears, appearing throughout the film as some shadowy figure, mentioned here and there in snatches of dialogue, and intimately linked with the unnamed technological mystery at the heart of the film's narrative. This flashback sequence transforms the focus of the film, positioning it explicitly in the political reality of its audience and re-presenting this reunified future-Korea as simply a cover for the continuing conflict between north and south. Goliath feels betrayed by his brother; that the wider world had abandoned him in favour of the weaker David. And so Goliath hid. Waiting and quietly building his strength until David might stumble into his lair. The eventual conclusions of the film betray a political allegory that few of its viewers could fail to miss.

Phillip Roberts

Yongary: Monster from the Deep

Taekoesu Yonggary

Studio/Distributor:
Keuk Dong Entertainment

Director:
Kim Kee-duk

Producer:
Cha Tae-jin

Screenwriter:
Seo Yun-seong

Cinematographer:
Byeon In-jib

Art Director:
No In-taek

Composer:
Jeon Jong-kun

Editor:
Kim Kee-duk

Synopsis

Suspicions of a nuclear test in the Middle East and some subsequent earthquakes prompt Seoul to launch a reconnaissance flight to determine the level of threat these present to the Korean Peninsula. Scientists determine that the powerful earth tremors are moving right across Asia and will soon strike Korea. Military and government officials scramble, hoping to be prepared if an earthquake occurs in a populated area, but no one could be prepared for what happens next as an enormous reptile emerges through the side of a mountain and promptly begins to rampage throughout the countryside, heading directly for Seoul. The terrified populace flees before the destructive power of the formidable creature, which spews flames from its mouth, shoots a laser from its horn and seems determined to trample every living thing under its titanic bulk. The military launches an all-out assault but all weapons prove useless and the monster begins to devour the nation's fuel. Fortunately, one intrepid young boy has been following the actions of the beast closely and believes he may have found a weakness in its seemingly impenetrable defences.

Critique

During the 1950s, theatres in the US and Japan were seeing an unprecedented number of science fiction and horror movies based around titanic monsters whose size would put King Kong to shame. These humungous terrors were often either awakened or mutated by atomic testing and embodied both the fear of nuclear power and a sense of helplessness in the rapidly-changing

Duration:

80 minutes

Genre:

Science fiction

Cast:

O Yeong-il, Nam Jeong-im, Lee Soon-jae, Kim Dong-won, Gang Mun

Year:

1967

Atomic Age. It is not surprising that Japan, the only nation in the world whose population had witnessed firsthand the destructive power of nuclear warfare, produced some of the deadliest and most memorable monsters of the time. Toho Studios in particular had Godzilla, the monster that started it all, as well as some of his most famous allies and adversaries including Rodan, Ghidra and Mothra. A decade after the debut of Godzilla, Daiei Productions introduced the world to Gamera. Gamera was widely viewed as a knock-off of Godzilla, but the 1964 film featuring the giant, fire-breathing turtle strongly influenced the plot of *Yongary: Monster from the Deep*. Some of the special effects used in *Gamera*, such as running the film backwards to simulate the creature eating flame, are imitated here. However, Yongary is far more than a mere imitation of its predecessors and director Kim Kee-duk succeeded in creating something unique.

Although a suspected nuclear test is what drives Yongary from his feeding grounds, implied to be the oil fields of the Middle East, the monster itself was not created or awakened by the radiation. It does not represent either the fear of nuclear technology or the guilt of having used such weapons in wartime. Instead, Yongary can be seen to represent the fear of war itself.

It is telling that, although Yongary originates from a continent away, it burrows unseen underground, turns southward when reaching North Korea, tunnels under the North Korean Province of Hwanghae and comes to a stop, still unseen, on the border of North and South Korea and between the heavily-populated cities of Seoul and Incheon. Ever since the creation of the demilitarized zone at the 38th Parallel, residents of the Republic of Korea have had a secretive, potential threat sitting just to the north, close to two of the largest cities in the nation. When the monster suddenly emerges from the ground, the unfortunate citizens in its path flee their homes with whatever they could grab and the scenes of the frightened people evacuating southward would have been a familiar sight to movie-goers of the time, as both melodramas and war films, such as Shin Sang-ok's *To The Last Day* (1960), depicted the horror, hardship and confusion that marked the evacuations and flight before the advancing North Korean armies. Kim Kee-duk manages to take this imagery a step further than most war films by adding snippets featuring those who chose not to run. These include greedy businessmen intent on enjoying their last moments, a religious fanatic calling on the throngs running past to repent and be saved, and a group of nihilistic nightclub youth, some of who are clearly under the influence of drugs. Despite the seriousness of these images, Kim was acutely aware of his target audience. 1967 was the year that the movie industry began to consider children as a potential audience. It was the year that Korea produced its first science-fiction movie, *Ujugoe-in wangmagwi/Space Monster Wangmagwi*, as well as its first animation, *Hong Gil-Dong*. Kim knew that the Japanese counterparts of Yongary were frequently enjoyed by pre-teen boys, thus he included one in the film and added a scene where the monster appears to dance to *Arirang*

while the boy, nearby, does the Twist. Make no mistake though, Yongary is no Gamera and was not a friend of children. The boy, despite the connection he feels with the beast, does not hesitate to reveal the secret that may destroy the monster from the deep.

Tom Giammarco

The roots of contemporary South Korean Horror Cinema, colloquially called K-horror[1] by some writers and critics, can be found in the melodramas of South Korean Cinema's Golden Age, with their excessive emotions, saturated surfaces of non-requited desire and focus on female protagonists struggling for self-definition in a constrictive patriarchal culture underpinned by strict Confucian beliefs. It is no surprise, therefore, that directors associated with melodrama, such as Kim Ki-young, Shin Sang-ok and Lee Man-hee, went on to make horror films. In horror, as in melodrama, the tension between traditional Korean society and Western capitalism created heightened emotions, shifting between tears (melodrama) to fears (horror). Both melodrama and horror, are as Williams diagnoses 'body genres' connected through the ways in which 'the bodies of women … function … as the primary embodiments of pleasure, fear, and pain',[2] It is no surprise, therefore, that the main trend in horror cinema in the 1960s were films dealing with the psychological effects of the process of modernization, or the domestic gothic-horror film which laid the roots of the 'social issue' horror film of the late 1990s and centred on the horror around the unruly and transforming female body as a threat to patriarchy. In Kim Ki-young's *Hanyo/The Housemaid*, horror is a result of an external threat to the family, embodied through the destructive primal sexuality of the eponymous maid of the title, collapsing gender and class anxieties into one composite figure of desire and fear. Similarly, Lee Man-hee's *Ma-ui gyedan/The Evil Stairs* (1964) situates horror as a feminine threat of the sanctity of the familial unit, while at the same time constructing a traumatic masculinity which can only configure itself through a violent rejection of the threatening (female) intruder.

Period horror films, while fewer in number, were also concerned with seismic shifts in the socio-economic order and had much in common with Japanese gothic cinema of the time, albeit that, officially, Japanese popular culture, amongst other imports, were banned. Shin sang-ok's *Cheonnyeonho/Thousand Years Old Fox* (1969) and *Ijogoedam/ The Ghosts of Joseon Dynasty* (1970) had wronged women taking revenge through transformation into vengeful demons, taking animal form in order to take revenge against those that had wronged them. *Wolhaui Gongdongmyoji/A Public Cemetery of Wol-ha* (Gwon Cheol-hwi, 1967), has a monstrous maid wanting to usurp her employer's place within the household, aided and abetted by the step-mother, who is affronted that

Left image: *Phone*, 2002, Buena Vista International/Kobal Collection

her son has married a lowly gisaeng. In these period dramas, women scheme and plot against other women in order to gain the upper hand, which more often than not means replacing the existing wife in the husband's affections and thus sealing their economic futures in the process. Women in South Korean society, as in Japan at the same time, were forced to take a subservient role according to the rules of Confucian society. However, consumer capitalism brought with it the promise of emancipation from the patriarchal stranglehold for women after centuries of oppression, offering women a means of self-determination through modern 'soft' industries. This theme of the new woman provides a source of horror in 1960s' and 1970s' gothic cinema, as her presence threatens traditional roles and restrictions, especially at a time in which the underpinning attributes of masculinity were undermined due to the psychic castration of decades of colonization and occupation. This theme is nowhere clearer than in the films of Kim Ki-young, who repeatedly addresses the threat of the emancipated woman to traditional familial structures within an oscillating binary of fear and desire, most apparently in his housemaid trilogy: *The Housemaid*; *Hwanyeo/Woman of Fire* (1971) and *Hwanyeo '82/ Woman of Fire 1982*.

While there was a smattering of horror films made in the 1970s, including *Heugbal/ Dark hair* (Jang Il-ho, 1974) and *Manglyeong-ui gog/Song of the Dead* (Park Yun-gyo, 1980), by the 1980s the genre had largely fallen out of favour and the genre had migrated to the small screen and, in doing so, shifting away from the socio-economic critique of the domestic gothic to the less-confrontational period gothic horror with retellings of traditional ghost stories and legends in *Jeonseolui Gohyang/Hometown Legends* (aka *Korean Ghost Stories*), which first ran between 1977 and 1989. In 1995, the low-budget *301/302*, the directorial debut of Park Young-Hoon, provided a meditation on the pressures on woman in South Korea to conform to societal expectations of beauty and behaviour, and set the precedent for contemporary horror films such as *Sinderella/Cinderella* (Bong Man-dae, 2006) and *Yoga Hakwon/Yoga* (Yun Jae-Yeon, 2009).

In the late 1990s, on the back of the Hallyu wave and due in no small part to the election of a democratic government for the first time in South Korea's history and significant changes in the infrastructure of the film industry, horror cinema re-emerged with a vengeance, refreshed and revitalized with two pivotal films in 1998. The first, *Yeogo-goedam/Whispering Corridors* (Park Ki-hyung), inaugurated the School Horror Genre – one of the most popular horror genres to come out of South Korea – and marked the beginning of a popular series of films (1998-2009), all set in all-girl high schools, and each helmed by a different director, while the other was a violent and proto-feminist variation on the serial killer genre, *Telmisseomding/Tell Me Something* (Chang Yoon-hyun). A year later, South Korea produced its own version of Nakata's cult hit, *Ringu*, with Kim Dong-Bin's *Ring/Ring Virus*, a more faithful version of Suzuki's source novel on which Nakata's film was based. In 2002, Ahn Byeong-ki's *Pon/Phone* replaced the cursed videotape with a cursed phone while, the following year, the curse had migrated to mirrors in *Geoul Sokeuro/Into The Mirror* (Kim Sung-ho, 2003) and in 2004, lifesized dolls, *Inhyeongsa /The Doll Maker* (Jeong Yong-ki). 2003 also saw the release of one of the most influential of all contemporary South Korean films – certainly on a global stage – *A Tale of Two Sisters*, directed by Kim Jee-woon, whose fractured narrative and fragmenting identity positions make it required repeated viewing and which was quickly snapped up for a Hollywood remake. A trend for frightening fairytales returned the fairytale to its gothic and grotesque origins with *Cinderella*, *Bunhongsin/The Red Shoes* (Kim Yong-gyun, 2005) and *Henjelgwa Geuretel/Hansel and Gretel* (Yim Pil-sung, 2007) all providing a critique of the familial unit and the suppression of woman and children under patriarchy. While the vampire myth got new blood in Park Chan-wook's aesthetically-beautiful and poetic *Bakjwi/Thirst* (2009), zombies haunt the woods in *Juk-eum-yi Soop/Dark Forest* (Kim Jung-min, 2006) – the final film in *4 Horror Film* series – or are

found living next door in *Yieutjib Jombi/The Neighbor Zombie* (Oh Young-doo *et. al.* 2010). This appropriation of Western monsterology, through which the traditional ghost as material entity 'becomes' Othered, marks the hybridization of indigenous and foreign elements that is the distinctive feature of South Korean genre production as a whole.

Unlike ghost films – possessed objects/technological hauntings – pure psychological horror films are few and far between in South Korean cinema. One of the few is Won Shin-yeon's *Gutayubaljadeul/A Bloody Aria*, in which an operatic dance of death plays out socio-economic differences between the haves and the have-nots in contemporary South Korea. Other psychological horror films of note include *Sae-yi yaeseu/Say Yes* (Kim Sung-hong, 2001), *Deureok/The Truck* (Kwon Hyeong-jin, 2008) and *Chugyeogja/The Chaser* (Na Hong-jin, 2008), all of which concentrate on the cat-and-mouse relationship between a male protagonist and a killer with no conscience and call into question any absolute boundary between good and evil. Attempts have been made at producing a South Korean slasher or body-count movie, but with variable success. Both *Jjikhimyeon jukneunda/The Record* (Kim Ki-hun, 2000) and *Haebyeoneuro Gada/Bloody Beach* (Kim In-soo, 2000) have the requisite cast of nubile teenagers and obligatory set-pieces of bloody murder, but neither film manages to pull off this merger between West and East with much success. *Du Saram Yida/Someone Behind You* (Oh Ki-hwan, 2007) and *Hae-buhak Gyosil/The Cadaver* (Son Tae-woong, 2007) are more interesting, combining the kills of a slasher film with a Korean sensibility contained within the presence of vengeful ghosts of the past. The most successful east/west hybrid, the Sawesque thriller set in a Korean high school, *Gosa: Piui Junggangosa/Death Bell* (Kim Eun-gyeong, 2008), broke the trend, being a success in both domestic and international markets. *Death Bell* was so popular that a sequel followed soon after, *Gosa Du Beonjjae Iyagi : Gyosaeng Silseup/ Death Bell 2: Bloody Camp* (You Sun-dong, 2010), which, however, was not as inventive as the original and, indeed, towards the end slips into the vengeful-ghost genre and out of the psychological-horror genre that *Death Bell* had so expertly explored. However, all these attempts at producing teenage-orientated Korean slasher films manage to embed a critique against the competitive nature of the South Korean education system, and the unequal power relations between teachers and their students, utilizing the form of horror to provide a critique of institutional and socio-economic oppression in which success in exams determines one's future status and that of one's family, which has resulted in South Korea having the highest suicide rate amongst teenagers in the 34 countries of the OECD. These 'social issue' horror films are an area in which South Korean cinema excels, and are part of a wider movement towards human-rights cinema in South Korea. *D-day - Eoneunal Gapjigi Sebeonjjae Iyagi/Roommates* provides one of the most vivid representations of exam pressure in South Korea. The film is set in Younghwa Academy which runs an intensive one-year programme for teenage girls who have failed to get the right grades to attend University. Punishments including public humiliation are given to students for not working hard enough, and the girls are constantly belittled by the female staff who run the Academy. It is a disturbing vision of exam pressure and competition among students to be the best, and one that can only lead to tragedy in real life as in the social-issue horror film. Another film that gives an insight into teenage isolation is the low-budget film, *Oetori/The Loner* (Park Jae-sik, 2008), which has some really disturbing images and distressing scenes that perfectly convey teenage despair and disillusionment. While School Horror is mainly aimed at teenage girls, who comprise the largest demographic for the genre, female directors have also utilized horror in order to critique continuing oppression in the workplace and home. *Yoga*, which I have already mentioned, is the second film by Yun Jae-yeon, who also directed the second film in the Whispering Corridors series, and suggests that competition amongst woman for recognition in a patriarchal society is not limited to teenage girls, while *Orora gongju/Princess Aurora*, the directorial debut of Bang Eun-jin, meditates on the silencing of the female

voice, more literally and metaphorically, in South Korea, by collapsing the distinction between the mother and her daughter, who is a victim of an uncaring society and a predatory paedophile – her body dumped among rubbish functioning as a metaphor for women's position in society.

Contemporary South Korean horror cinema is marked by a continued engagement with the traumatic past, often negotiated through the use of amnesia as a metaphor for the need to forget and the impossibility of that forgetting. In *Geomi-sup/Spider Forest* (Song Il-gon, 2004), the protagonist comes across the site of a bloody murder and, in the process of unravelling it, discovers that he is in fact the culprit, while in *Gidam/Epitaph* (Jeong Sik and Jung Bum-sik, 2007) the colonial past returns with a vengeance in this sumptuous and beautifully-realized trilogy of interconnected stories ranging from 1941 to 1979 (pivotal years in South Korean history), and *Goongnyeo/Shadows in The Palace* (Kim Mi-jeong, 2007) relates the tale of palace maids, murder and intrigue during the Joseon Dynasty in order to offer a feminist critique of Confucian patriarchy, both in the past and the present. Some ghosts, however, are more contemporary, as in the case of War Horror, with the Vietnam War giving rise to ghosts of the dead in *Al-pointeu/R-Point* (2004), and the continued conflict between North and South Korea providing the traumatic origin in *GP 506/The Guard Post* (2008), both films directed by Kong Su-chang. Vietnam is also the source of trauma in *Muoi/Muoi: The Legend of a Portrait* (Kim Tae-kyung, 2007), the first horror film to be filmed on location in Vietnam, although that did not help the film being successful at the box-office.

While not a popular genre in South Korea, torture cinema has also emerged in recent years. Firstly with the bloody *Dosalja/Butcher* (Kim Jin-won, 2007), whose video-game aesthetic offers an interesting variation on a well-worn genre, and then with *Sil Jong/Missing* (Kim Sung-Hong, 2009), which is based upon at true story of a South-Korean fisherman who killed four young women in 2007. This tendency towards bloody brutality continued in 2010 when serial killers commanded the screen with the release of Kim Jee-woon's *Angmareul Boatda/I Saw The Devil* and Jang Cheol-soo's *Gimbongnam Sarinsageonui Jeonmal/Bedevilled*, both of which played to packed audiences when they screened in London that year and which were generally well received critically. In 2011, a couple of really interesting and innovative South Korean horror films were released, but unfortunately received relatively little attention. *Hwaiteu: Jeojuui Mellodi/White: Cursed Melody* (Kim Gok and Kim Sun) is set in the competitive world of K-pop and contains an implicit critique of both the K-pop industry and the fascination with westernization in contemporary South Korea, while *Goyangi: Jugeumeul Boneun Du Gaeui Nun/The Cat* (Byun Seung-wook) contains some creepy moments and disturbing images that resonate for some time afterwards – or perhaps only if you are a cat lover! With *Yeongashi/Deranged* (Park Jung-woo), *Mihwakin Donghyeongsang: Jeoldaekeul-rik Geumji/Don't Click* (Kim Tae-kyeong) , *Doo Gaeui Dal/Two Moons* (Kim Dong-bin) and *Mooseowon Iyagi/Horror Stories* (Min Kyu-dong et al) 2012 was a bumper year for South Korean Horror Cinema after a few fairly quiet years.

Colette Balmain

Notes

1 Some critics problematically collapse the distinctions between Japanese horror cinema or J-horror and South Korean Horror Cinema or K-horror, arguing that J-horror is a genre within itself and represents a particular type of vengeful ghost film whose primary demographic is teenage girls. In these terms, J-horror is a master genre and other East Asian horror cinemas, including Hong Kong horror cinema and South Korean horror cinema, are types of J-horror. This is not a view that I subscribe to, and I would argue that such views represent a continuation of

discourses of Orientalism in contemporary scholarship on East Asian cinema and culture. This approach is laid down in David Kalat's *J-Horror: The Definitive Guide to The Ring, The Grudge and Beyond* (2007), and taken up by Axelle Carolyn in *It Lives Again! Horror Movies in the New Millennium* (2008), in which she conflates K-horror with J-horror, even though both trends take off at the same time (and in fact *Whispering Corridors* comes out a year before Nakata's *Ring*).

2 Linda Williams (1991), 'Film Bodies: Gender, Genre, and Excess', *Film Quarterly*, Vol. 44, No. 4. (Summer), p. 4.

301/302 (Three-Oh-One/ Three-Oh-Two)

Samgong-il/Samgong-i

Studio/Distributor:
Park Chul-soo Films Co, Ltd.

Director:
Park Chul-soo

Producer:
Park Chul-soo

Screenwriter:
Lee Seo-gun

Cinematographer:
Lee Eun-gil

Art Director:
Chol Jeong-hwa

Composer:
Byeon Seong-ryong

Editor:
Park Gok-ji

Duration:
101 minutes

Genre:
Drama/suspense/horror

Cast:
Pang Eun-jin, Hwang Shin-hye

Year:
1995

Synopsis

A detective is investigating the disappearance of a woman from Apartment 302. This woman is a writer for woman's magazines. Apartment 301 is owned by a woman, recently divorced due to her former husband's infidelity. Having gained weight to suppress the sexual rejection from her husband while they were married, she has refashioned her life and cooking as a newly-single lady to return to her previous body size. The woman in 301 considered her neighbour in 302 mysterious when she first met her, yet she is reluctant to reveal too many details to the male detective on 302's case. What we learn through a series of flashbacks is that 301 tried to be hospitable to 302 by offering her culinary delights, but 302 refused all food. Eventually their relationship turns antagonistic as 301 tries to force-feed 302. As the film progresses, 301 and 302 learn about each other's pasts and how their status as women in modern South Korea is intertwined, while the male detective still has to put missing pieces of the larger puzzle together.

Critique

Along with being one of the first South Korean films to receive an international release outside of the festival circuit, 301/302 highlights underrepresented aspects of contemporary South Korean cinema. It is an early example of independent cinema, in this case through the efforts of director Park Chul-soo and his production company. It is also a film directly confronting issues that Korean women (and many women around the world) have had to deal with for ages, such as sexual violence, limited economic access, cultural pipelines that limit women's voices, and sexism.

Although some might disagree, *301/302* is a strongly-feminist film. Unfortunately, much of the defence of that claim requires revealing the ending, which we will not do here. But aspects that can be revealed are how the film expertly combines feminist concerns of upper- (301) and lower-class (302) Korean women. 301's and 302's slow understanding of one another represents a cross-class solidarity. The film also connects the characters across a spectrum of sexist harm, from the emotional effects of neglect and disrespect of wives along with the traumatic effects of the violence of rape. Furthermore, the detective of the film is not an all-seeing male gaze. In fact, as Joan Kee points out in her article for the journal *Positions: East Asia Cultures Critique* (Volume 9, Number 2, Fall 2001), his gaze is often deflected and 301 does not permit him the privilege of receiving the whole story. The viewer of the film is the only one permitted that privilege. The film demonstrates the silencing of women voices: 301 is a writer who is forced to speak the bland clichéd words of consumption for woman's magazines rather than reveal her truth through fiction, since those truths are rejected by publishers. As a result, the film lets what was silenced be heard.

Besides the film's politics, what also stands out in the film is the visual feast provided through the intricate Korean dishes created by 301, emphasizing the joys of Korean cooking well before *Dang Jang-geum*. Yet Park will not even let us wallow in gastronomic pornography because 301's efforts to force-feed the surreal-y anorexic 302 results in as much disgust as early visions of culinary delight. I say 'surreal-y anorexic' because the film is a variation on the horror genre and not meant to be taken as depicting real-life anorexia. 302's body is not an anorexic body, but a metaphor. (And this is where I am open to some possible flaws with this film since both Susan Sontag and Martin F Norden have argued that metaphoring illness and bodies can be a problematic trope.)

Although South Korea, like every other country, has a segment of sexist cinema, *301/302* is an example of a pocket of films of progressive female portrayals. I am not arguing that *301/302* is solely responsible for later feminist works such as *Goyangileul Butaghae/ Take Care of My Cat* (Jeong Jae-Eun, 2001) and *Keujipapor/Invisible Light* (Kim Gina, 2003) or for the prominent opportunities provided for actresses and women directors such as Pang herself, who would go on to direct *Orora gongju/Princess Aurora* later in her career. But Park's independent spirit allowed a space where alternate female visions and narratives could begin to flourish.

With the emergence of the New Korean Cinema at the end of the twentieth century, director Park Chul-soo has been mostly neglected, but *301/302* is the best example of the independent spirit and challenging work he offered prior to the world opening up to South Korean cinema.

Adam Hartzell

A Bloody Aria

Gu-ta-yu-bal-ja-deul

Studio/Distributor:
Prime Entertainment, Corea Entertainment

Director:
Won Shin-yun

Producers:
Lee Seo-yeol, Jeong Geun-hyeon

Screenwriter:
Won Shin-yun

Cinematographer:
Kim Dong-eun

Synopsis

Yeong-sun is an illustrious middle-aged opera singer, with a brand new Mercedes, who is driving back to Seoul after attending a music audition with In-jeong, his female student. When a cantankerous traffic cop orders Yeong-sun to pay a fine for running a red light, the disgruntled star shouts 'son of a bitch' and drives away. A chase ensues. The desperados flee down a country road and hide near a river. After making a fire, the teacher gets hot and heavy with the student. In-jeong smashes a mobile phone on Yeong-sun's head. Escaping into the woodlands, In-jeong spots two juvenile delinquents administering an 'ultimate ass-kicking' to a boy in a bag. She runs away. When an untamed hillbilly (with a bloodied baseball bat) investigates the fire, Yeong-sun hides in his Mercedes. Wanting to escape this madness, In-jeong hitches a ride with the gregarious gang leader Bong-yeon, who promises to take her to the bus station 'in a jiffy'. When the gang of misfits converge at the river, they invite their reluctant guests to a barbecue. Things are pleasant enough. They laugh. They smile. They eat meat. However, the festivities turn sour when the boy in the bag wakes up.

Art Director:

Jang Chun-seop

Composer:

Kim Jun-seong

Editors:

Choi Jae-geun, Eom Jin-hwa
Duration: 114 minutes

Cast:

Han Seok-kyu, Lee Mun-sik,
Oh Dal-soo, Cha Ye-ryun,
Kim See-hoo

Year:

2006

Critique

Even though Won Shin-yun's *A Bloody Aria* shares the same mis-anthropic country-bumpkin ardour of *Straw Dogs* (Sam Peckinpah, US: 1971), *Deliverance* (John Boorman, US: 1972), *The Texas Chain Saw Massacre* (Tobe Hooper, US: 1974) and *The Hills Have Eyes* (Wes Craven, US: 1977), this erratic brute of a horror film howls to its own detestable tune. It is an intense, visceral and anarchic parable of South Korean society that explores the brutality of violence, the abuse of power and the aggressive nature of bullying. In this respect, *A Bloody Aria* is similar to an ethological thesis by Desmond Morris or a moralistic stage play by William Shakespeare. As the story unfolds (in one location), we recognize that the cluster of characters are mere ciphers that represent conflicting facets of humanity. There is the arrogant, misogynistic music professor (who cares more about his brand new Mercedes than he does human life), his naive and impressionable student, a scrawny yet ferocious youngster (with a gun), a barbarous and despotic police officer and four rustic vagabonds, who live on the fringe of civilized society. As these incompatible characters converge on their desolate bucolic stage, common sense tells us something atrocious is about to happen.

The sequence that illustrates Won Shin-yun's thematic intent takes place during the barbecue. When the gregarious gang leader Bong-yeon asks In-jeong whether she would like to drive back to Seoul with him or the professor, she considers the consequences. Does she choose the psychopath or the pervert? Telling Bong-yeon she would prefer to drive back to Seoul with the professor, Bong-yeon barks 'take the fucking Mercedes then'. Elated by the result, the professor says thank you. Bong-yeon stares at the professor with choleric eyes and asks, 'what are you fucking thanking me for?' The feast becomes a madcap disco of bellicose brutality. The delirium begins with 'dodge the bomb', a sadistic game in which the boy from the bag must evade a barrage of stones by moving in forced military manures ('sit, stand, sit, stand, roll backward, roll forward'). The sequence ends with a slap in the face, some forced nudity, blood, attempted rape, taekwondo, poisoning, burials, petrol dowsing, strangling, inflamed lips, shovel-hitting, gunshots, jingoistic singing, skinny-dipping, rhythmic drums, materialistic damage, unexpected revelations and the odd verbal vulgarity.

What gives this sleazy grindhouse-style aria precedence over other South Korean torture porn is its eagerness to rise above its ostentatious generic trappings. *A Bloody Aria* does not exhibit vio-lence for violence' sake. Won Shin-yun impregnates every gaudy act with indicative social, cultural and political consequence. Even though he asphyxiates his audience with Tarantinoesque deprav-ity, he also illustrates the disastrous and destructive effects human nature has on humanity. In this respect, *A Bloody Aria* is relentless. Like *Straw Dogs* and *Deliverance*, its signs and signifiers force us to question our own cinematic comfort zone. This is why Won Shin-yun wants us to feel every punch, every kick, every harrowing moment of sadness, every moment of anger, every moment

of pain, and every moment of forgiveness because we are all victims and victimizers in one way or another.

Curtis Owen

A Tale of Two Sisters

Janghwa, Hongryeon

Studio/Distributor:
Cineclick Asia, Big Blue Film

Director:
Kim Jee-woon

Producers:
Oh Ki-min, Oh Jung-wan

Screenwriter:
Kim Jee-woon

Cinematographer:
Lee Mo-gae

Art Director:
Jo Geun-hyeon

Composer:
Lee Byung-woo

Editor:
Lee Hyeon-mi

Duration:
115 minutes

Genre:
Horror/thriller/mystery/drama

Cast:
Im Soo Jung, Moon Geun-young, Yeom Jeong-ah, Kim Kap-su

Year:
2003

Synopsis

Su-mi returns to her family home after a stay at a mental institute, following the death of her mother. Although her homecoming delights her younger sister Su-yeon, all is not well at home. The girls are both fearful of their new, cold and controlling stepmother, whilst their father is withdrawn and submissive. This soon extends from family dysfunction to the paranormal, with the appearance of apparitions and disturbingly-realistic nightmares. When an aunt and uncle visit for tea, the aunt has a fit and sees a ghostly girl under the kitchen sink, which the stepmother also encounters. The stepmother tells the father that the strange goings on started when Su-mi returned to the house; however Su-mi blames the stepmother's presence. Frightened and curious, the sisters try to investigate the stepmother's background, snooping around her room to discover that she was previously their mother's nurse. Tension mounts when the stepmother discovers stolen photos of her in the girls' room. She punishes Su-yeon by locking her in a wardrobe, only to be saved by Su-mi. The next morning, the stepmother is seen carrying a heavy sack and beating it violently. When Su-mi finds a trail of blood leading down the corridor to the sack, she fears the worst for her sister. What follows is the truth about the stepmother, and a realization for Su-mi herself.

Critique

With elements of psychological thriller, lasting horror, ghost story and family drama; *A Tale of Two Sisters* is a prime example of K-horror at its most successful and technically brilliant. This is a thriller in the true sense of the word. As we follow Sun-mi on her journey home, we are instantly placed in the situation with her, sharing her anxieties from the very outset. The family scenario allows a vehicle for horror and heightened tension, using interactions like family meals in order to build a feeling of discomfort. Within this scenario Kim sets up a backstory but does not give too much away, allowing scope for our imaginations, as well as space for the plot to progress excitingly.

The narrative is a twist on the Korean folk tale 'Janghwa Heungryeonjeon'; and the characters' names Su-mi and Su-yeon are equivalent to 'Rose' and 'Lotus' from the story. The fairytale theme dictates the striking *mise-en-scène* throughout. The stark red and white and shadow/light contrasts ensure an ominous feel to every frame. There are also generic horror film aspects throughout. The motifs of the dead mother and terrible house ring back to *Psycho* (Hitchcock: 1960), which is apt as Kim has been noted as comparing his own style to Hitchcock's. These are accompanied by

a tense claustrophobia, not only in setting but also in emotion and control. This kind of constraint is reminiscent of Park Chan-Wook's *Vengeance Trilogy*, as well as making direct reference to Hollywood blockbusters such as *Whatever Happened to Baby Jane* (Robert Aldrich, US: 1962) with images of caged birds used to physically-visualize the ambience.

As with Kim's earlier film *Choyonghan Kajok/The Quiet Family* (1998), there is a young, strong, female protagonist. Whereas *The Quiet Family* functions around a set of male characters, however, *A Tale of Two Sisters* features a matriarchy. This emphasis on the female cleverly adds another level of horror to the film. The female characters' inevitable battle for the attention and affection of the father is what propels the situation. It is as though each of them needs the male (father) to verify them. The theme of being punished for one's femininity is emphasized through the recurring theme of blood (particularly on white sheets) and menstruation, giving the film a cycle of its own. The bloody scenes, including Su-Mi's nightmare as well as a trail of blood leading down the corridor, leave lasting, memorable visual images that are hard to erase.

A different tone of horror is found in the film's few 'jumpy' moments, including an image of a girl under the kitchen sink. These are connotative of Japanese horror such as *Ju-on* (Shimizu Takashi, 2002), a genre now largely popularized in the west thanks to a number of Hollywood remakes. Sudden jerks are not the strengths of *A Tale of Two Sisters*, though. The most horrible thing here is the lingering psychology that prevails throughout. This is a terror that works on the simplest of levels: the fear of losing some-one you love, whether that be the death of a mother, the wilting loyalty of a father, or the nightmare of something terrible happen-ing to your little sister. The fear of losing the person closest to you is more terrifying than ghosts, and is inherent in every audience member's psyche.

The fact that there is a twist is intrinsically Korean and, due to the suspenseful nature of the film, its presence is not completely unexpected. Having said that, the narrative of the twist itself is unpredictable, and handled very well. Because of this, many critics pigeonhole *A Tale of Two Sisters* as a 'twist' movie; however it is so much more. Taking influence from the most diverse and influential instances of the modern horror film and applying them to the con-text of Korea, this is pure K-horror at its chilling best.

Anne Maria Cole

A Tale of Two Sisters, 2003, B.O.M. Film Productions/Kobal Collection

Hansel and Gretel

Henjelgwa Geuretel

Studio/Distributor:
CJ Entertainment/Terracotta Distribution

Director:
Yim Pil-sung

Producers:
Choi Jae-won (Executive Producer), Kang Young-mo (Line Producer), Sea Woo-sik (Executive Producer)

Screenwriters:
Yim Pil-sung, Kim Min Suk

Cinematographer:
Ji-yong Kim

Art Director:
Ryu Seong-hee

Composer:
Lee Byung-woo

Editor:
Kim Sun-min

Duration:
117 minutes

Genre:
Fantasy/horror/drama

Cast:
Cheon Jeong-myeong. Eun Won-jae, Shim Eun-kyeong, Jin Ji-hye

Year:
2007

Synopsis

When arguing with his girlfriend on the phone, Eun-soo crashes his car, and awakens to find a mysterious girl in a red cape, Young-hee, offering help. She leads him through the forest to her creepy home, 'The House of Happy Children', and introduces her elder brother Man-bok, younger sister Jeong-Sun, and nervous parents. Eun-soo tries to find his car the next day but gets lost in the forest and ends up back at the house, to find the children alone. It transpires that the 'parents' were actually other lost travellers, and the children have supernatural powers, which they use to eradicate each of the cruel adults that visit them. Later, paedophile Deacon Byeon and his selfish wife Kyeong-suk threaten the children and are brutally killed by them. Young-hee explains that 'The House of Happy Children' was once an orphanage where children were raped, beaten and killed. Man-bok, Young-hee and Jeong-soo killed the evil orphanage owner and have since occupied the house, cursed in a state of childhood, searching for kind adults to live with them. They entrap Eun-soo in the house, but he desperately wants to return to his girlfriend and sick mother in the outside world.

Critique

Hansel and Gretel is as much a fairytale for adults as it is a horror film. Yim Pil-sung's brilliant direction allows aspects of children's stories to serve as stimuli for some horror, but the film perhaps more comfortably fits into the conventions of fantasy. It epitomizes the fairytale motif that recurs throughout modern K-horror in films such as *Bunhongsin/The Red Shoes* (Kim Yong-gyun, 2005) and *Sinderella/Cinderella* (Bong Man-dae: 2006) more intricately and powerfully than any other. Images and concepts drawn from *Hansel and Gretel* (as well as *Little Red Riding Hood* and *Cinderella*), echo through narrative and *mise-en-scène*; although this is in no way a simple 'retelling' of the tale. The standard of acting is high, and one gets the sense that the interaction between adult and child actors when filming was just as important. The success of this allows multi-layered characterization and intense circumstances to be achieved throughout.

Working in connection, the two main settings in the film are as important as any of the characters. Most prominently is the 'House of Happy Children': a huge, western-style home that, although not made of gingerbread, looks good enough to eat. Ryu Seong-hee's design and Kim Ji-yong's cinematography create this bizarre world of sweets and stuffed toys so vividly that it cleverly evokes a reaction very similar to the feeling one gets after eating too much chocolate: the scenery is so sickly sweet that it is wholly uncomfortable to digest. In juxtaposition, the most shocking parts of the film occur in the dark, shadowy orphanage within the later flashback sequences (reminiscent of a comparable Spanish film *The Orphanage* (Antonio Bayona, 2007). Here unravel the terrible secrets that the house's 'happy' veneer shields, including instances of

paedophilia and child abuse. The three child-actor's abilities shine in these scenes, with recognizably human traits adding more complex dimensions to their characterizations. There is also the dark, forest setting, which symbolizes Eun-soo's entrapment as well as directly referencing the original *Hansel and Gretel*. This, later, also becomes a vehicle for fantasy; as a blue door mystically appears in the middle of the forest.

The fantasy element is what sets this apart from other K-horrors of similar subject matter, but pure horror fans should not be completely deterred. Like Brian De Palma's *Carrie* (1976), the supernatural aspect adds a new strain to the film's horror; although this is diluted somewhat in this case due to the development of the plot. Unlike in *Carrie*, though, this works best in its subtleties, with images of children with aged faces, a woman trapped inside a large china doll, and another reincarnated as a tree, eerie and memorable. Although these images disturb, the children's magical abilities also evoke our delight, and connect with the inner child in each of us. The scene where Jeong-soo's doll comes to life and begins to fly is a prime example that encapsulates the fairytale motif on a wider scale. In *Hansel and Gretel*, conventions are subverted, and it is now the children, not the fairies or witches, who have the special powers.

Ultimately, this is a moralistic film, as all horrors are; however, unlike most other K-horrors, there is an unambiguous resolution. The audience is met with a 'happy ever after' fairytale ending, and this may disappoint horror viewers who are more used to leaving the cinema chilled or even terrified. *Hansel and Gretel* is successful in its elements of fantasy, with thanks Kim Sun-min's expert CGI editing. In terms of horror, although a freaky and sometimes demented film that evokes distress and discomfort, it does not achieve fear. Overall, this is a stylish addition to K-horror that will be enjoyed by fans, if for the creative imagery, stunning cinematography and impressive acting rather than the clever interpretation of the fairytale theme.

Anne-Maria Cole

Hansel and Gretal, 2007, Cineclick Asia/Kobal Collection

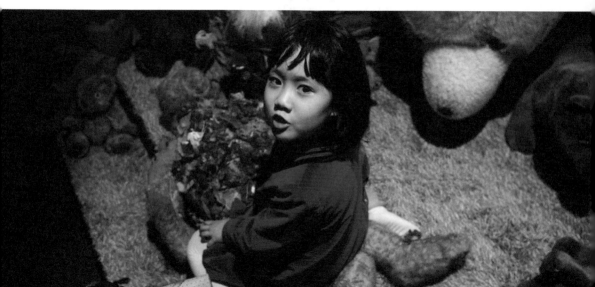

Into the Mirror

Geoul Sogeuro

Studio/Distributor:
Cinema Service

Director:
Kim Sung-ho

Producer:
Kim Eun-yeong

Screenwriter:
Kim Sung-ho

Cinematographer:
Jeong Han-chul

Art Director:
Choe Hyeon-jin

Composer:
Mun Dae-hyeon

Editor:
Kim Sun-min

Duration:
113 minutes

Genre:
Horror/thriller

Cast:
Yoo Ji-tae, Kim Myung-min,
Kim Hye-na, Key Joo-bong,
Kim Myeong-su

Year:
2003

Synopsis

After an incident at a shoot-out that kills his partner, Woo Yeong-min leaves the police to work as head of security at the Dreampia department store. The store is due to be reopened, one year after a fire, but an employee is found dead in odd circumstances, followed by another only days later, both next to mirrors and their faces full of fear. Unhappy with the explanation of suicide, Yeong-min does some investigating himself until a former friend from the police begins one himself and Yeong-min falls under suspicion. As a result, Yeong-min is forced to continue to investigate the incidences himself in order to clear his name.

Critique

The opening scenes of the film, set afterhours in a deserted department store, provide the distinctive imagery used in its promotion. The atmospheric feel, the slip into the supernatural and the resulting bloody demise might lure the viewer into thinking this was yet another of the tense ghost stories South Korean cinema produces. Like other movies in the genre, we are given the backstory at the beginning, but it is far more subtle and almost abstract in its telling. A few hints, such as a photograph, are a little too obvious and heavy-handed, especially when accompanied by heavy notes in the score. Whilst there *are* tense and gory elements in this film common to the genre, the fact that the main focus is on the police work changes it into a more cerebral thriller, with identity and self-perception as some of the more pervasive themes.

It is the multi-faceted nature of the film that gives it its unique quality – a clever combination of supernatural events, corporate corruption and murder investigation – all of which prevent it from falling into the genre of the *kwishin*-style ghost visiting revenge on a descended generation. This does cause some reviewers to find the plot a little too slow and unfocused and the characters a little too contrived, but, in truth, the roles are actually well cast and thought out. Yoo Ji-Tae, a quiet and subtle actor, is always very likeable despite the excessive angst his character Woo is burdened with, and he suits such an introspective role. Kim Myung-min as the abrasive detective Heo, who antagonizes Yeong-min, provides excellent balance for interaction and dialogue. Yeong-min's self-perception of being a failure is reinforced by the fact that his uncle got him his job, and he is not treated with respect by former colleagues. Heo plays into this perception with the natural conflict of police versus security guard, dismissive of Yeong-min's theories and contributions.

Mirrors are usually avoided where possible in film-making, simply for the technical aspect. Usually filmed at angles to omit crew and equipment, it is unsettling to see reflections almost face on as writer/director Kim Sung-ho ignores convention and makes use of some outstanding visual opportunities. The infinity mirror of the elevator and the move between reflection and reality are executed

perfectly with digital effects and well-thought-out cinematography from Jeong Han-chul. Action is often focused on the reflection rather than the reality, the camera pulling back to reveal that we were not watching what we thought. 'What you see is not always what it seems', as one of the characters says, reinforcing the idea that this is maybe not just a simple tale of terror but, perhaps, that of a more personal journey of the self.

Kay Hoddy

Possessed, aka. Living Death

Bulsinjuok

Distributor:
Showbox/Mediaplex

Director:
Lee Yong-ju

Producers:
Lee Jung-sae, Jeong Seung-hye, Cho Chul-hyun

Screenwriter:
Lee Yong-ju

Cinematographer:
Jo Sang-yuen

Composer:
Kim Hong-jib

Editors:
Kim Jae-beom, Kim Sang-bum

Duration:
112 minutes

Cast:
Nam Sang-me, Ryu Seung-ryong, Kim Bo-yeon, Sim Eun-gyeong, Moon Hee-kyung, Lee Chang-jik.

Year:
2009

Synopsis

Seoul college student Hee-jin is awoken by an emergency call from home. Her 13-year old sister, So-jin, is missing and their mother suspects the worst. Elsewhere, detective Tae-hwan visits his terminally-ill daughter in hospital. He promises that one day she will recover and they will leave together. At the family home, Hee-jin notifies the local police and deals directly with Tae-hwan, who seems reluctant to mount an investigation. Nonetheless, he begins preparatory interviews. As rumours spread of So-jin's disappearance, and that she was possessed by something nonhuman, possibly a demon, So-jin's friend Jung-mi commits suicide. Hee-jin believes that the girl was murdered and implores Tae-hwan to take her sister's disappearance more seriously. Hee-jin's mother stumbles upon their meeting and, incensed, throws the detective out. Arguing that only God's mercy can save the family now, she forbids any further cooperation with the police. When a second acquaintance of So-jin dies in hideous circumstances, Tae-hwan suspects the missing girl of murder, but the testimony of a local shaman convinces him that others may be involved. Meanwhile, the forces which are rumoured to have possessed So-jin begin to deeply affect Hee-jin.

Critique

The Christian 'success story' remains a selling point *par excellence* in Korean cinema, yet the influence of shamanic practices on Protestant Christianity, indeed the current shape of folk religions alongside new religions in modern Korean society, is less visible. In *Possessed*, a case of demonic possession becomes the flashpoint for explosive cultural tensions between semi-religious practitioners. Just as the protagonist of Lee Soo-yeon's *4 Inyong shiktak/ The Uninvited* (2003) ends up straddling an uneasy divide between modernism and the so-called dark side of superstition, so the heroine of *Possessed*, Kang Hee-jin (Nam Sang-me), navigates a course between the anti-superstitious, materialistic logic of Protestant Christianity and the apparently backward mentality of Shamanism.

Writer-director Lee Yong-ju's film is sensitive enough to bring some of these concerns to light – there is some confusion, for instance, as to whether Shamanism should be regarded today as a 'superstition' or a 'religion' – yet it features some fairly gratuitous

characterization and the only real pragmatists here turn their backs on new religion altogether. Kyeong-ja (Moon Hee-kyung), the shaman who requires no encouragement for incarnating the dead, is in the mould of the erstwhile Wicked Witch – manipulative and dangerous, her sutra-chanting exorcism of So-jin is an act of punishing intervention, if not outright cruelty. Similarly, Kim Bo-yeon's Protestant mother joins a long line of religious men and women who profess their gratitude to God but rave breathlessly about health, prosperity and salvation. Kwon (Lee Chang-jik), the resident security guard, emerges as a kind of sociopathic war veteran with Tourette's; the terminally ill Su-kyung (Jang Young-nam), terrified that So-jin's healing touch will one day fade, permitting her cancer to return, demands the girl be put through multiple exorcisms; and So-jin's friend Jung-mi (O Ji-eun), for failing to stand up for their friendship to Kyeong-ja, is quickly earmarked for her betrayal and banished from sight. It is, however, when dealing with the memory of Sim Eun-gyeong's jittery schoolgirl So-jin (a textbook *cheonyeo-gwishin*, or virgin ghost) that the film gets lost in a mishmash of perspectives and personal testimony. The convoluted backstory – filled in by an interlocking set of fairly-predictable flashbacks which reveal deceit, fear, concealment and murder – is an excuse for yet more rickety girl-ghost shenanigans, teary-eyed revelations and disturbing instances of adolescent abuse.

To this, however, the director adds some gratifying elements. In an atmosphere of mounting paranoia, the film is wonderfully acute on the hallucinations and psychic phenomena that begin to challenge our heroine's resolve. There is a single tantalizing moment when an evidently-daydreaming Hee-jin finds a bloody tooth in a playpen, only for it to be nipped cleanly from her hand by an egret. Another, in which she is pinned to the floor by a red-eyed, sickly yellow-skinned ghost, delivers a genuine hint of the macabre as the thing atop her scratches dementedly at her bare legs. Ultimately, one of the underlying assumptions of this sort of sub-genre is that the victim, or 'possessed,' is manipulated by the presence and activity of a savage spirit. To his credit, director Lee sees the dual possessions of the Kang sisters in different terms. In a scene which tips us towards fantastical prophecy, So-jin tells her friend Jung-mi that her estranged father, now on his deathbed and with whom she communicates telepathically, regrets not seeing her one last time before he dies – information which she can only have acquired through the spirit that commands her. We linger for a moment, not on Jung-mi but on So-jin's tears as she feels the man's intense sorrow then breaks down. A similar remarkable exchange, in which the possessive spirit looks divinely upon the repentant father, occurs later between Tae-hwan (Ryu Seung-ryong) and Hee-jin – again the film is most effective when conveying the characters' absolute helplessness when confronting their own mortality. The implication is that spirits empathize with strangers through their suffering, a conceit which atones for the film's apocryphal ending.

Ian London

Tell Me Something

Telmisseomding

Studio/Distributor:

Ku & See Film

Director:

Chang Yoon-hyun

Producers:

Koo Bon-han, Chang Yoon-hyun

Screenwriters:

Kong Su-chang, In Eun-ah,
Sim Hye-won, Kim Eun-jeong,
Chang Yoon-hyun

Cinematographer:

Kim Sung-bog

Art Director:

Jung Ku-ho

Composers:

Cho Young-wook,
Bang Jun-Seok

Editor:

Kim Sang-bum

Duration:

117 minutes

Cast:

Han Seok-kyu, Shim Eun-ha,
Jang Hang-sun, Yum Jung-ah

Year:

1999

Synopsis

Beware! There is a serial killer stalking the streets of Seoul. Their method of murder is a perfect six-part amputation. They drain the blood, separate the arms, legs and head from the torso and toss the body parts into black bin bags. When a homicide squad locate their first cadaver under a bridge, the autopsy report proves that the legs do not match the torso. The police find their second bin bag inside an elevator, their third and forth at a basketball court. Body parts do not correlate. A heart is missing. The victims have no fingerprints. Who is committing these horrendous crimes? The police generate a lead. They can identify the bridge corpse. He has implants in his teeth. Hospital records show Chae Su-Yeon as his next-of-kin. Detective Cho goes to the museum where she works. Brought in for questioning, Chae identifies the body as her ex-lover. Cho shows her photographs of the other victims. She knows them all. They are all her ex-lovers. Who is this woman? Why did her father disappear? Why did she try to commit suicide? Why is a serial killer murdering the men from her past? Who will be next?

Critique

By emulating a populist modus operandi, Chang Yoon-hyun's *Tell Me Something* jumped onto the freight train success of *Swiri/Shiri* (1999) and generated unprecedented box-office returns. For the first time, South Korean cinema managed to maintain its marketplace (in 1998, indigenous films only accounted for 25 per cent of the market share, this rose to an incredible 40 per cent in 1999). With big-budget blockbusters like *Tell Me Something*, South Korean films could compete with their North American counter-parts (such as *The Mummy*, *The Matrix*, *Sixth Sense* and *Star Wars: Episode One*). This extraordinary situation confirmed that domestic audiences were finally getting what they wanted: homemade blockbusters that challenged the godlike eminence of Hollywood. The vexation with any brand of blockbuster is they are typically generic and harbour a formulaic mass-produced recipe. Their aim is to make as much moola as possible, which induces film-makers (and their financiers) to cater to the lowest common denominator (so as not to alienate potential audiences). The question arose in this climate: did South Korean blockbusters compromise their artistic and thematic values in order to obtain huge box-office returns? With bland uninspired hogwash like *Tell Me Something*, the answer was a resounding yes.

What made this psychological 'hard-gore' thriller such a hit at the box office was the bankability of its stars. Han Seok-kyu (Detective Cho) and Shim Eun-ha (Chae Su-yeon) had appeared in Hur Jin-ho's *Christmas in August*, the third highest-grossing film of 1998. *Tell Me Something* also relied on a substantial marketing blitzkrieg that turned apathetic audiences into salivating zombies. This amount of hype, promotion and anticipation was unparalleled. There were evocative billboards, clever posters, titillating magazine

Tell Me Something, 1999, Koo & CE Film/Kobal Collection

articles, insightful TV interviews and a gaudy horror-inducing, two-minute trailer, which had more energy, excitement and rhythm than the 117-minute film. No wonder audiences were disappointed. It was a prime example of oversaturation; an unfulfilled promise of cinematic perfection. *Tell Me Something* is nothing more than a by-the-numbers composite of Ridley Scott's *Black Rain* (1989), Paul Verhoeven's *Basic Instinct* (1992) and David Fincher's *Se7en* (1995). In all its disastrous splendour, *Tell Me Something* ended up telling audiences nothing and financers a whole lot of noteworthy things.

Curtis Owen

The Devil's Stairway

Ma-ui gyedan

Studio/Distributor:
Seki Trading Company

Synopsis

Nurse Nam Jin-sook's blind love for young Dr Hyeon Kwang-ho is the reason she can see nothing of his all-consuming ambition and the fact that that he is merely using her affection for him. The doctor loves only the idea that he may one day own the secluded private hospital where he and Nam are employed. He can achieve this dream most quickly if he marries the daughter of the hospital's current owner and chief surgeon. However, when Nurse Nam's

Studio/Director:
Lee Man-hui

Producer:
U Gi-dong

Screenwriter:
Lee Jong-taek

Cinematographer:
Seo Jeong-min

Art Director:
Hong Seong-chil

Composer:
Han Sang-ki

Editor:
Kim Hee-su

Duration:
108 minutes

Genre:
Thriller

Cast:
Kim Jin-kyu, Moon Jung-suk,
Bang Sung-ja, Jeong Ae-ran,
Choi Nam-hyun

Year:
1964

inconvenient pregnancy threatens to destroy his dream, Dr Hyeon decides to take care of the situation by tossing her down the staircase. This results in the loss of Jin-sook's unborn child and she warns him that, as she has nothing more to lose, she is prepared to tell anyone who will listen of their affair and his heinous act. But Doctor Hyeon is not a man to be crossed and he sets out to keep Nam quiet permanently. However, it is from this point that his problems spiral out of control.

Critique

The Devil's Stairway, one of the representative films of director Lee Man-hui, utilizes all the techniques and characteristics that defined Lee's best works. Among these characteristics is verticality, to which the set of this story lends itself especially well. Shots of the characters navigating the treacherous stairs, or perhaps tumbling down them, pepper the story and make for some interesting angles for Lee to work with. Lee was also known for playing with shadows and light and Dr Hyeon's terrified search through the darkened hospital is intensified by the deep shadows and the dread they create.

The Devil's Stairway is probably the most 'Hitchcockian' Korean film produced to date. It calls to mind such films as *Vertigo* and *The Birds,* and some sequences are clearly inspired in part by *Psycho.* For example, while Dr Hyeon nervously prowls the hospital in search of whomever, or whatever, has been tormenting him with knowledge of his guilt, he enters a lab where curtains are drawn in front of a small closet. As he approaches them to throw the curtains back, the scene seems to mimic the shower scene from *Psycho* but with a reversed perspective. He pulls the curtains back and recoils in horror at what he sees, smacking into a ceiling light in the process. The light swings back and forth, alternately revealing and obscuring the horror behind the curtain, as in the shocking reveal of Hitchcock's classic. In another scene, the doctor relaxes at home surrounded by stuffed birds, just as Norman Bates did in his office at the motel. While stuffed birds appear in the background of many Korean films of the 1960s and 1970s to depict the wealth of characters, there is something menacing about the sheer number that appear in this film.

Unlike many of its contemporaries where props were re-used in different locales within the same film due to lack of funds, the set design in the *Devil's Stairway* cannot be ignored. The hospital and its grounds are characters unto themselves. The dark, murky water of the pond outside holds many secrets and gives off an aura of dread. And, more importantly, there are the staircases to consider. The inner stairs seem deceptively sturdy but we are told right at the beginning of the film that they have recently been repaired. The railing to these stairs is a menace that refuses to allow itself to stay repaired for very long. Meanwhile, the outside staircase, running from the ground to the second story, could not have been designed by a sane being. They are impossibly steep and narrow. Even a healthy person able to grasp the banister is in danger of taking a fall, let alone a patient on crutches or a nurse with an

armful of trays. It makes an interesting set, but it is a terrible design for a hospital.

Director Lee should be commended for the amount of suspense he was able to build at various points in the film. Many of these revolve around the above-mentioned stairs but there are numerous others. Doctor Hyeon's painfully-tense wait as the hospital pond is drained is one example. Hyeon fully expects the body of Nam will be discovered at that time, but there is nothing he can do except listen to the ticking of the clock while he waits. Hyeon is forced to wait again in a state of increasing terror after he receives a note he believes could only be from Nam or her vengeance-seeking spirit telling him that she is coming for him. That cryptic note propels the plot and opens up endless possibilities that increase the mystery of the story and the fear of Hyeon. The constant state of fear and guilt he is living in eventually starts to tear Hyeon apart and the result is a film that would have made Hitchcock proud.

Tom Giammarco

The Housemaid

Hanyeo

Distributor:
Kuk Dong Seki Trading Co.

Director:
Kim Ki-young

Producers:
Kim Ki-young

Screenwriter:
Kim Ki-young

Cinematographer:
Kim Deok-jin

Art Director:
Park Seok-in

Composer:
Han Sang-ki

Editor:
Oh Young-keun

Duration:
101 minutes

Genre:
Horror/melodrama

Synopsis

A middle-class household is thrown into disarray through the employment of the eponymous housemaid of the title. The father, Dong-sik is a music teacher at a factory, and gives private piano lessons to one of the female employees, Jo Gyeong-hui, at his home. Gyeong-hui introduces a young woman to him and suggests that he employs her to help out his wife, who is not well due to the hours that she is putting in doing needle work in order to improve their financial situation. Gyeong-hui becomes obsessed with Dong-sik and confesses her feelings for him, but her attentions are rebuffed and she is thrown out of the family home. However, when the young housemaid also tries to seduce him while his wife is away visiting her family, he succumbs. The housemaid becomes pregnant and a dark psychological war is waged between the housemaid and her employers, which can only lead to tragedy.

Critique

The Housemaid is one of the foundational films of modern South Korean cinema and Kim Ki-young perhaps one of the most influential South Korean Directors of all time. Despite the fact that Kim Ki-young was forced to frame the narrative as a moralistic fable proclaiming the dangers of both the working classes and middle-class pretentions, the film is thick with sexual danger and foreboding which fracture the seemingly-gentle frame through which the story is told. There is no simplistic division between good and bad here, instead all the characters are painted in an unsympathetic light – the father who gives in to his desires, the wife who plots against the housemaid and pushes her down the stairs in order to abort the child when she discovers the housemaid is pregnant, the obnoxious children, and of course the housemaid herself, who, like

Cast:
Kim Jin-kyu, Lee Eun-shim,
Ju Jeung-ryu, Um Aing-ran

Year:
1960

all monstrous maids in South Korean cinema of the time, desires
to usurp her employer's place in the household. This fracturing of
the family unit is a common feature in 1960s' horror and thriller
cinema, a response to the rapid modernization of South Korea and
the shifting social-economic structure of South Korean society. The
housemaid represents the return of the repressed – female sexual-
ity – as well as being a figuration of the oppressed working classes
at the time over whose bodies the economic miracle was being
wrought. *The Housemaid* is a powerful film, one that resists the
passage of time while being evocative of the time at which it was
made. The power of the film, and its message, is foregrounded by
the fact that Director Kim remade the film twice: once as *Woman of
Fire*, then as *Women of Fire 1982*.

There is little doubt that *The Housemaid* is one of the finest
examples of modern South Korean Cinema.

Colette Balmain

The Phone

Pon

Studio/Distributor:
Toilet Pictures

Director:
Ahn Byeong-ki

Producer:
Ahn Byeong-ki

Screenwriters:
Ahn Byeong-ki, Lee Yu-jin

Cinematographer:
Mun Yong-sik

Art Directors:
Hong Seun-jin, Lee Yo-han

Composer:
Lee Sang-ho

Editor:
Park Soon-duk

Duration:
104 minutes

Genre:
Horror/mystery/thriller

Synopsis

After exposing a child sex ring, journalist Ji-won begins to receive
ominous calls on her cell phone and is stalked by the allies of those
she exposed. This leads Ji-won to decide to lead a safer existence
by changing her phone number and moving into an unoccupied
house owned by her close friend, Ho-jeong. At an outing to an art
gallery, the mobile phone rings and displays the same number that
the previous calls and e-mails exhibited, 6644. Her friend's daugh-
ter Young-ju picks this up and starts to exhibit strange and hostile
behaviour to those around her. The strange calls persist and more
horrific images are sent to Ji-won via e-mail. Meanwhile, Young-
ju's behaviour grows more volatile and Ji-Won begins to suffer
nightmares that suggest a tragic history for the previous owners
of her mobile number. Investigating this further, she begins to find
harrowing revelations at every turn.

Critique

A loose re-interpretation of the *The Housemaid* (1960), *Phone*
updates Kim Ki-young's morality tale of class conflict and material
greed for a contemporary audience. Ahn modernizes the narrative
by incorporating recent scientific and technological changes
but retains the cynical stance on human nature. Audiences more
familiar with modern South Korean Horror will find numerous
intertextual borrowings that now frequent the innumerable popu-
list examples of the region's ever-expanding genre within Ahn's
second feature. Amongst the derivative icons that litter the film is
the inclusion of high-school girls as vessels for adolescent anxiety
and naivety alongside the incorporation of 'cheonyeo gwishin,'
the vengeful long-haired female spirit. Unfortunately, such custom-
ary iconography coupled with a filmic style that tends towards

Cast:

Ha Ji-won, Kim You-mi, Choi Woo-jai, Choi Jai-yon

Year:

2002

overblown pyrotechnics has the habit of cloaking any social commentary.

On the surface, this is an economically-driven work in which the Director has a canny eye for transnational success: a jigsaw of a film, made of commercially-proven interconnecting pieces. But Phone is not all breadth and no depth. Amongst the all-too-numerous twists and sub-plots, Ahn crafts a formally-adventurous but accomplished treatise on the nature of morality within the pressures of modern urban life.

The isolation of the modern city and accompanying social segregation are a preoccupation of Director Ahn. This is a continuing leitmotif through his work , presenting itself in career woman Se-Jin's sparsely-decorated flat in *Apateu/APT* (2006) where she admits she never has any visitors, and the dark secrets that are held by paraplegic Yu-yeon's surrogate family of neighbours. Further evidence of this concern can be seen in villager Hye-jin's ostracization from her urban classmates in *Gawi/Nightmare* (2000). The continuation of these authorial concerns are clearly present in *Phone* but more readily apparent in his other works as a director in that they are not so enamoured of elaborate narrative exposition and ostentatious theatrics, namely, the amorality of a society that places emphasis on success through hollow external material and surface harmonic aspiration at the sacrifice of rectitude and virtue.

Beyond the material ambition and external harmony of Ho-jeong within the family structure, director Ahn reveals shaky foundations and twisted ambition to her statement that 'a happy family leads to success'. While her luxurious family home is adorned by portraits of her husband and daughter, Ji-won's house decorations are dominated by reminders of the prominence of work in her life. Surrounded by material wealth and family, the juxtaposition with Ji-won's seemingly-lonesome existence as a single career woman is not subtle but is effective. First seen alone in a deserted gymnasium, Ji-Won joins the Director's rota of female leads depicted as outsiders with little possibility of romantic pairing and segregated from the seemingly-content characters that surround them. But a transparency to the outward contentment of Ho-jeong becomes apparent as the shaky foundations become ever-more fragile and reveal a malevolent existence characterized by a dependence on the outwardly superficial. Ahn is at his strongest in peeling away this artificial idealism and revealing a decayed core to his character's motives. The corruptive elements of modern urban society and the consequences that characters' actions bring are constantly questioned and ultimately moralized about in a film that deserves to be seen as more than just a facsimile of familiar horror icons.

Dave McCaig

The Doll Master

Inhyeongsa

Studio/Distributor:
Filma Pictures/Lotte cinema

Director:
Jeong Yong-ki

Producers:
Han Maan-taek,
Im Gyeong-taek

Screenwriter:
Jeong Yong-ki

Cinematographer:
Jo Cheol-ho

Art Director:
Jeon Su-a

Composer:
Kim U-cheol

Editor:
Nam Na-yeong

Duration:
90 minutes

Genre:
Horror

Cast:
Kim Yu-mi, Lim Eun-kyeong,
Shin Hyeong-tak, Ok Ji-young,
Lim Hyong-jun

Year:
2004

Synopsis

The film begins with a short fairytale prologue in which a man constructs a life-like doll to resemble his wife in order to show how much he loves her. The man does not yet know it, but this doll grows to love him too, and becomes jealous of his wife. One day he returns to find his wife murdered and hanged. The police and other villagers suspect the man; the film's audience suspects the doll. The man is taken from his home and killed in vengeance and sees the doll in the trees above him as he dies. The man is buried and the doll sits by his grave for ever more. Forward into the present day and a group of young people are visiting a suspicious-looking house in order to act as models for a master doll-maker. As befitting a master doll-maker's residence, the house is filled with a variety of sculpted dolls, some on shelving displays, some holding mirrors, some hanging from light fittings, which come to life and begin to kill the young visitors one by one.

Critique

Anyone who has seen an American teen horror or any film from any of Japan's recent horror cycles will be more than comfortable with *The Doll Master's* format. Hae-mi, the film's heroine, spends much of the early part of the film wandering about the house convincing herself that the particularly-creepy thing that she just saw did not happen; that a doll could not have just moved; that she is not being watched; that nothing suspicious is going on in the basement. Of course, having seen the opening prologue, and having any sort of knowledge of how horror films (not even specifically Korean films but, rather, *any* horror films at all) are structured, the film's audience has little to encourage it to agree with her. Of course *we* know that all of these things *are* happening, and this is perhaps the most disappointing thing about the film – that, as early as the very first scene, as the young models are invited into the house and we see the face of a doll in a Polaroid picture that is not there in real life, we know exactly where the film is going. We know that the dolls are going to start killing the visitors, we can even pretty accurately predict which of them it is going to happen to, as an early dining room scene haphazardly characterizes the visitors as either odd but likeable or mean and self-centred. The remainder of the film seems somewhat of a formality.

As much as the film borrows from the more disappointing American teen horrors with regards to its narrative structure, *The Doll Master's* horror set pieces owe more to the recent cycles of Asian horrors, both within Korea and across the region. The legacy of Japanese horror film-making seems particularly strong here and, once we meet the kidnapped man chained up in the basement and the scary little girl, the film does begin to become more interesting if not more original. But, sadly, such developments only seem to overlay one circuit of clichés with another. At best, *The Doll Master* is an interesting amalgamation of two

formal structures, utilizing one to explore, or rather expose, the other. For short sequences we can forget about the uninspiring acting, dialogue, music, sound effects or narrative and watch some quite eerie set-piece sequences. The film's lighting is occasionally wonderful, such as when a pale pink/purple light shines across the face of Yeong-ha (who the narrative supposes is mad, but who, of course, we know is seeing everything clearly), lying sideways with her own (benevolent) doll clasped tightly to her chest, watches a door swing lightly open and closed, the shadows creeping across the floorboards. The design of some of the later set pieces is also fairly exciting, particularly a sequence in which the only surviving male visitor is hanged in front of a wall of dolls and pillars and stained glass windows, and it looks, for a moment, as if Dario Argento might have taken over direction.

But such sequences are resolved too quickly and too crudely and only serve to light up what is otherwise a rather disappointing experience. There is little to surprise or inspire here and, despite the undeniable creepiness of the dolls themselves, the film sticks too closely to far too many genre conventions. *The Doll Master*, like the very dolls it focuses on, proves to be little less than a poor simulation of many more advanced models. The obvious links we may draw between the simulated nature of the porcelain dolls and the film itself may prove to be a somewhat happy coincidence, but perhaps even this is giving the film far too much credit.

Phillip Roberts

The Whispering Corridors Series (1998–2009)

Whispering Corridors

Yeogo goedam

Studio/Distributors:
Cine 2000/Cinema Service

Director:
Park Ki-hyung

Producers:
Lee Choon-young, Oh Ki-min, Lee Choon-yeon

Synopsis

In an all-girl Korean high school, an investigation into the school records leads teacher Mrs Park to make a terrifying discovery. She calls fellow teacher Hur Eun-young, herself an ex-student of the school, to share her revelation that a student Jaeng Jin-ju has returned from the dead. Mrs Park is found the following morning dead, an apparent suicide. In the aftermath of events, pupils Yoon Jae-ji and Lim Ji-oh begin a close relationship, under the scrutiny of the abusive substitute teacher Mr Oh, who actively encourages an atmosphere of unease and fierce competition amongst the girls. Miss Hur arrives at the school, to investigate the death of Mrs Park, and to uncover the strange circumstances behind the death of Jin Ju, her best school-friend. There are spooky goings-on in the

Screenwriters:

Park Ki-hyun, In Jung-ok

Cinematographer:

Seo Jeong-min

Art Director:

Gang Chang-gil

Composers:

Mun Seung-hyeon,
Yu Jae-gwang

Editor:

Ham Sung-won

Duration:

107 minutes

Genre:

School horror

Cast:

Choi Kang-hee, Kim Gyu-ri
and Kim Min-jung

Year:

1998

Memento-Mori

Yeogo goedam II

Studio/Distributors:

Cine 2000/Cinema Service

Directors:

Kim Tae-yong, Min Kyu-dong

Producer:

Lee Choon-yun

Screenwriter:

Kim Tae-yong

Cinematographer:

Kim Yun-su

Art Directors:

Oh Sang-man, Lee Dae-hoon

Composer:

Jo Seong-woo

Editor:

Kim Sang-bum

school; Mr Oh disappears, as Miss Hur and Ji-oh slowly unravel the mysteries and dark secrets the school has actively tried to bury in its shadowy past.

Synopsis

Teenage best friends Min Hyo-shin and Yoo Shi-eun have a secret that they need to keep from their schoolmates: they are lovers. They keep a record of their intense and passionate relationship in a diary which details every intimate secret of their burgeoning lesbian love affair. Their suspecting schoolmates bully and torment the girls in plain sight of the school's teachers. Hyo-shin struggles with the stigma and persecution and confides in a downtrodden male teacher, which leads to a one-night stand and subsequent pregnancy. A distraught Hyo-shin is rejected by her true love Shi-eun and so leaps from the school roof to her death. One classmate So Min-ah discovers the diary and becomes obsessed, following Shi-eun and has ghostly visions of Hyo-shin. Min-ah believes that reading the diary will bring about her own death and so attempts to return the diary to its rightful owner, the ghost of Hyo-shin.

Duration:

98 minutes

Genre:

School Horror

Cast:

Kim Gyu-ri, Park Yeh-jin,
Lee Young-jin

Year:

1999

Wishing Stairs

**Yeogo goedam 3:
Yeowoo gyedan**

Studio/Distributors:

Cine 2000/Cinema Service

Director:

Yun Jae-yeon

Producers:

Woo-suk Kang, Choon-yeon Lee

Screenwriters:

Lee So-young, Kim Su-ah,
Eun Si-yeon, Lee Yeoung-yun

Cinematographer:

Jung-min Seo

Art Director:

Ji Sang-hwa

Composers:

Park Seung-won, Jo Min-su,
Song Gyeong-geun

Editors:

Kim Sang-bum, Kim Jae-beom

Duration:

97 minutes

Genre:

School horror

Cast:

Song Ji-hyo, Park Han byul,
Jo An

Year:

2003

Synopsis

At an all-girl dance school there exists an urban myth which is
shared amongst the teenage pupils: a school stairway has twenty-
eight steps, however, for one worth enough, a twenty-ninth step
will appear and a magical fox will grant a single wish. Two ballet
students, So-hee and Jin-sung, share a lesbian love, albeit So-hee's
love seems more far more passionate and committed than that of
the distant and submissive Jin-sung. One place is available at a
prestigious Russian ballet school, so competition is fierce amongst
the girls but So-hee is the clear favourite. Consumed by jealousy
Jin-sung ascends the staircase. Her wish is granted, to defeat
her rival So-hee, with unexpected and deadly consequences
as Soo-hee is killed in a freak accident. Jin-sung gets the place.
An overweight student Hae-ju is ritually bullied by her classmates,
her only confidant and protector was Soo-hee. She is overwhelmed
with grief for her secret love, which leads her to the magical
twenty-ninth step: her wish – to bring back Soo-hee from death.
The ghost of Soo-hee returns to haunt the school and enact deadly
vengeance on the schools persecutors. But what will happen to her
lover Jin-sung?

Voice

Yeogo goedam 4: Moksori

Studio/Distributors:
Cine 2000/Cinema Service

Director:
Choe Ik-kwan

Producer:
Lee Choon-yun

Screenwriter:
Choe Ik-kwan

Cinematographer:
Kim Yong-heung

Art Director:
Kim Joon

Composers:
Lee Byung-hoon,
Jang Min-seung

Editor:
Kim Sun-min

Duration:
104 minutes

Genre:
School Horror

Cast:
Cha Ye-Ryun, Kim Ok-bin,
Kim Seo-hyung

Year:
2005

Synopsis

A committed and talented musical prodigy, Young-eon, spends countless hours after classes, training and honing her vocal skills. After one such after-hours session, she is murdered and her body vanishes. Her best friend, Sun-min, is haunted by the voice of her friend, who seems to be held captive in the confines of the school; although her presence is felt, she is invisible to all. The female music teacher appears to commit suicide by leaping down an open elevator shaft in equally-baffling circumstances. Sun-min embarks upon an investigation into the mysterious events, aided by a fellow student and the ghostly voice. She begins to uncover the dark secrets of the school, including a related student's death from the past: falling down the same open elevator doors. Young-eon slowly begins to disclose her own secrets to Sun-min, which unexpectedly ties all the events together for a shocking revelation.

A Blood Pledge

Yeogo goedam 5: Dongban Jasal

Studio/Distributors:
Cine 2000/ Lotte Entertainment

Synopsis

Four female students share a seemingly-close and sisterly group relationship, which leads to the formation of a 'suicide club' to die together by their own hands. However, the motivation for this deadly pact between the girls remains a hidden and unspoken agreement. The school's old chapel is the setting, and the girls proceed to carry out their bloody pledge. It is only one girl Eon-ju who carries out the deed, the rest of the girls backing out in the final moments, all witnessed by the horrified younger sister of

Director:

Lee Jong-yong

Producer:

Lee Se-Young

Screenwriter:

Lee Jong-yong

Cinematographer:

Kang Seung-Gi

Art Director:

Jeon In-han

Editors:

Kim Sang-bum, Kim Jae-beom

Duration:

88 minutes

Genre:

School horror

Cast:

Son Eun-seo, Jang Kyung-ah, Song Min-jung

Year:

2009

Eon-ju, Eon-jung. She begins her own investigation into her sister's involvement with the suicide group which reveals the strange and deadly relationship between the four girls. The motivations of the girls' suicide were not quite as genuine as appeared. Meanwhile, the remaining girls start dying one by one in equally bizarre and supernatural circumstances, as Eon-ju vengeful's spirit returns for deadly justice.

Critique

For the horror aficionado and passing-enthusiast alike, just the mere mention of 'Asian Horror' will immediately conjure up a series of very specific images: the long, black tendril-like hair of a lurching and contorted aberration, wearing a blood splattered white night-dress. Whilst this is a somewhat crude summary, indeed the female ghost has seen a variety of ghastly incarnations, the Asian horror genre has been subjected to repeated manifestations of this figure, which has crawled and crept across the cinema screen over the last fifteen years.

The point of origin for this powerful image can almost certainly be traced to the seminal Japanese film *Ringu*, directed by Hideo Nakata. A box-office sensation across Asia, which went on to generate international critical acclaim, *Ringu's* influence would reach far beyond Japan, the Asian region and into the horror films of Hollywood. Released in South Korea in 1998, just months after *Ringu*, *Whispering Corridors* written and directed by Park Ki-hyung, would mark the emergence of a distinct series of films which would prove to be just as influential. A relatively low-budget affair, *Whispering Corridors* superficially shares similar supernatural signi-fiers with *Ringu*, specifically that of the figure of the vengeful and deadly female ghost. However, Park Ki-hyung would subsume the stylistic and aesthetic tropes of the ghost genre under a different agenda by an explicit focus on the contemporary social concerns of a teenage Korean audience. To be more specific, a teenage *female* audience.

Whispering Corridors would lay out the narrative and thematic blueprint for the subsequent films in the series with an emphasis upon representing a series of controversial contemporary subjects. The film centres on an investigation into the shadowy circum-stances surrounding the death of reclusive pupil Jin-ju at an all-girl school. When a teacher apparently commits suicide, rumours and whispers fill the bleak and cavernous corridors of the school as the girls speculate on the possible connection of these two deaths, which are embellished with eerie tales of the supernatural. This is the realm of the urban myth, where facts and fictions overlap and entangle. Did Jin-ju's vengeful spirit take the life of the unpleas-ant and overbearing teacher? A supply teacher is appointed, Eun-young, herself an ex-pupil of the school, who takes up this paranormal enquiry against the backdrop of the clandestine and sinister activities of the school hierarchies. Ritualistic mental abuse, vicious corporeal punishment and sexual harassment of the teen-age pupils is routine; the film is unflinching in offering a harrowing

portrayal of the educational system in Korea which is more terrifying than any long-haired malevolent spirit. The school itself is a prevalent feature throughout the film, with little of the film's narrative taking place out of the confines of the institution, which only serves to offer a more suffocating and isolating experience. There is no escape for either the characters or the audience; we are forced to focus sharply on the breakdown of this female community in minute detail, isolated from any sense of an external reality. In this female-centred narrative, we are given unflinching access to the reality of a teenage-girl's existence, their tense relationships, their repressed sexual energies, their hopes and dreams, and all at the mercy of a system of control they do not fully understand. The absence of shock tactics or gruesome special effects is matched by the lack of objectification from director Park. No slow-motion shower scenes, no lingering camera fetish for the short-skirted schoolgirl in peril. Director Park replaces this with an ominous atmosphere, a carefully-paced air of mystery which builds slowly to a shocking revelation that firmly points the finger of responsibility at external institutions: the overbearing but absent parents, and the patriarchal indifference of the educational system. This vengeful female ghost embodies the 'return of the repressed', a symptom of the problematic conditions in contemporary South Korean society. Any comparison to *Ringu* misses the point, *Whispering Corridors* has more in common with the traditions of the low-budget US horror films of the 1970s as director Park occupies this genre as a means of social commentary and criticism. It is clear this approach resonated with its target audience as the film proved to be the surprise box-office hit of the year, and with such financial success comes the incumbent necessity for an inferior but equally-profitable sequel.

Following just twelve months later, *Memento Mori*, the second film in the *Whispering Corridors* series, was released. Park Ki-hyung is absent from writing and directorial duties to be replaced by newcomers Kim Tae-young and Min Kyu-dong; the sequel would not follow the events of the previous film but simply offer a similar narrative and setting. Given these factors, inferiority would seem a certainty. However, *Memento Mori* offers a bigger shock than any ghostly figure jumping out from the darkness. The conventional route for any horror sequel can be framed and outlined by the postmodern dialogue from Wes Craven's *Scream 2*; 'the body-count is always bigger, the death scenes are more elaborate'. *Memento Mori* is the antithesis of such an approach. Rather, it favours an even-more explicit focus on the emotional horrors and inherent injustices of the teenage-female experience. If lesbianism is alluded to in the first film, *Memento Mori* foregrounds this taboo subject as a central narrative theme. The diary of two teenage girls, Hyo-shin and Shi-eun, is discovered by a fellow pupil Min-ah, who becomes captivated by the trials and tribulations of their burgeoning relationship. Ostracised and humiliated by their peers at school, in fear of retributions from the judgemental school authorities, the girls' struggle for acceptance leads only to a tragic conclusion: an apparent suicide. The supernatural aspect is present

in the form of the dead girl's fleeting reappearance throughout the film, although this is blurred into the narrative amongst a series of flashbacks, never pivotal in pushing the narrative forward. The emphasis that is placed upon on the everyday social structures of the school, rather than the night-time shadowy corridors of the first film, is realized by the directors' aesthetic choices. The studio sets and steadicam of the first film are abandoned, in favour of a more hand-held, documentary feel, filmed on location at an actual school. This produces a feel and atmosphere which hardly screams 'Asian Horror', and could be an alienating experience for anyone with expectations similar to that outlined in *Scream 2*. But directors Kim and Min succeed in not only honouring the thematic agenda laid out by Park Ki-hyung but also in pushing this agenda forward in unexpected and engaging directions. *Memento Mori* offers a nuanced portrayal of the experience of female teenage sexual awakening, and the subsequent fear and terror this arouses in social institutions, from teachers and parents to the teenage girls themselves. Not as heavy-handed in its social commentary and criticism as the first film, *Memento Mori* offers a more shocking revelation; a sequel which is more intelligent, subtle and socially relevant than its predecessor.

Unlike the short space of time between first and second, the third film in the series would take some four years to reach cinema screens in South Korea. *Wishing Stairs* would interestingly mark the debut of a female director in Yoon Jae-yeon. In an attempt at originality, the film shifts the narrative to the confines of a ballet school but retains the allusions to lesbianism of the first film, as two teenage-girls' relationship is pushed to a tragic conclusion due to the inherent competition that ultimately leads to an embittered and deadly jealousy. The *Wishing Stairs* to which the title refers marks another returning theme of the series, that of the urban myth, as a whispered folk tale exchanged between the girls about a magical twenty-ninth step which appears on a school staircase to a worthy girl and will grant her a single wish. The fierce competition between the two girls So Hee and Ji Sung brings one girl to the magical step, with one wish granted that unintentionally brings about the death of So Hee, and another wish that intentionally brings about her resurrection in the form of a vengeful ghost. Despite the inclusion of themes that have been tried and tested in the previous entries, *Wishing Stairs* is a somewhat uneven film. Yoon Jae Yeon seems preoccupied with foregrounding the horror elements of the previous entries, deploying a variety of impressive visual set-pieces to ratchet up the tension and offer the occasional cheap scare. The school itself is representative of this approach: a carefully-constructed and aesthetically-effective setting, an extension of the spooky artifice of the first film, but with an amputation of the social realism of the second. The relationship between the girls often feels melodramatic in such a staged and artificial setting, and this is compounded by the inclusion of the plot device of the wishing stairs themselves. As a standalone and conventional entry into the overall South Korean horror cycle, which was gathering some significant momentum in the early noughties, *Wishing*

Stairs can certainly hold its own ground. But, given the agenda for critique and criticism laid out in the previous Whispering Corridors films, *Wishing Stairs* comes as something of a disappointment.

The series would continue in 2005 with Voice, with Choi Ik-kwan at the helm: another debutant director, although no stranger to the series, having worked alongside Park on the original *Whispering Corridors*. Choi takes the sensible decision to take the narrative back to the original, with an emphasis on the mysterious dark secrets that await discovery in the corridors of an all-girl school. Leading the investigation into the strange death of Young-eon is her best friend Su-min, who is in equal parts aided and obstructed by the ghostly voice of her deceased friend. The overriding themes associated with the franchise are all present, as the complicated nature of female relationships are foregrounded against a supernatural backdrop. The series had established a convention for the high-school ghost film: the representation of a vulnerable and misunderstood female ghost whose vengeance is justified in the context of systematic and institutionalized abuse. Choi demonstrates his genre-savvy credentials, skilfully playing with this convention, wrong-footing both Su Min and the audience in their expectations of Yeong-eon as an avenging spirit, or as an apparition with purely-evil intentions. This gives *Voice* a much-needed freshness in both direction and perspective, and a key reason for the *Whispering Corridors* series' enduring appeal.

If *Voice* took inspiration from the original *Whispering Corridors*, then in many ways the latest film in the series *A Bloody Pledge*, released in 2009, can be seen as a successor to the themes and structures of *Memento Mori*. A convoluted narrative outlining the fractured relationship of four girls who make a suicide pact, which only one will carry out, is interwoven through a series of confusing flashbacks. The breakdown of female community is central to the film's dramatic tension but, unlike *Memento Mori's* subtle and poignant approach, *A Bloody Pledge* offers an entirely more visceral experience. The vengeful-teen spirit of this film is the most blood-thirsty and terrifyingly-realized in the entire series. Whilst the film's subject matter of teen suicide ensures that the subversive and socially-conscious credentials of the series are maintained, it is inevitable that the series would eventually need to raise the stakes in terms of bloodletting and supernatural shocks to hold its ground in the Asian Horror market.

Taken as a whole, the *Whispering Corridors* series represents a distinct and culturally-specific take on the ghost film. Despite the negativity, which can be easily found in the appraisals of online reviewers from a variety of Western Horror-focused websites that question the genre credentials of the films alongside Japanese contemporaries like the *Ringu* and *Ju-on* series, these *are* horror films, make no mistake. However, the *Whispering Corridors* films are socially-aware, subtle and sophisticated horror films. The real horror lies not in the iconography of the vengeful female ghost but in the social context of gender inequalities which *produces* such dreadful apparitions.

Spencer Murphy

Thirst

Bakjwi

Studio/Distributors:
Moho Films/ CJ Entertainment,
Universal Pictures,
Focus Features

Director:
Park Chan-wook

Producers:
Park Chan-wook, An Su-hyeon

Screenwriters:
Park Chan-wook, Jeong
Seo-kyeong

Cinematographer:
Jung Jung-hoon

Art Director:
Ryu Seong-hui

Composer:
Cho Young-wook

Editors:
Kim Sang-bum, Kim Jae-beom

Duration:
133 minutes

Genre:
Horror/drama

Cast:
Song Kang-ho, Kim Ok-vin,
Shin Ha-kyun, Kim Hae-sook

Year:
2009

Synopsis

Sang-hyeon, a young catholic priest with a burning desire to 'save', volunteers to become a test subject for a highly-experimental vaccine designed to wipe out the lethal Emmanuel virus. The vaccine fails and, like all the other test subjects, he succumbs, fatally, to the virus. A blood transfusion miraculously revives him and upon his recovery he is acclaimed a saint with Christ-like healing powers. However, as it becomes evident that he has also acquired heightened sensory capabilities and a taste for blood, it seems that the blood used to save him derives from a vampire. Sang-hyeon must deal with the ethical predicaments his vampirism presents. Into this situation arrives an old friend, Kang-woo, whose mother, Mrs Ra, presses the priest to cure him of cancer. Sang-hyeon is drawn to his friend's wife, the unhappy and apparently abused Tae-ju. A torrid affair with her deepens his torment, drawing him into a plot to murder the abusive husband. Moreover, he is compelled to transform Tae-ju into a vampire, who takes to her new condition with far less equivocation. Sang-hyeon, haunted by the guilt of his compound sins, is propelled towards a final test of the moral integrity he has tried to preserve.

Critique

Cynically, one could easily consider Park Chan-wook's controversial oeuvre to have been custom-built to slot into the burgeoning discourse of 'Extreme Cinema' cultivated for western reception of DVD releases of Asian films by Tartan and others. *Thirst*, with its high concept of 'priest becomes vampire', promised a resumption of the transnational commercial success enjoyed by Park's violent crime/thriller/drama 'Vengeance' Trilogy (2002-2005) after a disappointing performance by his 2006 rom-com, *Ssaibogeujiman gwaenchanha/I'm a Cyborg, But That's OK*. The film, trading on the excitement provoked by the director's shift into the vampire horror subgenre, seems explicitly designed to play well with western audiences looking for some relief from the anodyne fare offered by *Twilight* (Catherine Hardwicke, 2008) and its ilk. With lashings of the grim fatalism paired with gallows humour that audiences have learned to expect from Park, it quickly attracted critical plaudits, winning the Prix du Jury at the 2009 Cannes festival. In its bid for cerebral kicks, the film, foregrounding Christian morality compromised by forbidden carnal desires, might superficially suggest comparison with such mature, philosophically-astute films as Abel Ferrara's Nietzschean vampire film *The Addiction* (1995) and, more contemporaneously, Tomas Alfredson's 2008, *Lat Den Ratte Komma In/Let The Right One In*.

What prevents this comparison from working fully is that *Thirst's* genre blend is not an easy one. Rabid horror buffs are likely to be disappointed. Always keen to display his fondness for western high-culture touchstones, Park's intellectual credentials rest here with his not-so-loose basis in Emile Zola's masterpiece of

nineteenth-century naturalism, *Thérèse Raquin*. The reference to the novel indicates that the film is more interested in an honest and detached exploration of illicit love and its pitfalls than in making a serious intervention into the state of horror. Indeed, the film simply never scares and for much of its length focuses centrally on painting the character of the priest (which is relatively unchanging in contrast to the shifting moods of his lover, Tae-ju). There is some gruesome bloodletting, particularly in later stages, but moments of display of vampire powers and behaviours are typically the occasion for disbelieving laughter rather than dread. In the midst of the carnage which follows Mrs Ra's disclosure of the lovers' crime during a meeting of the family's mah-jong group – she is paralysed as a result of the trauma of her son's disappearance but manages to communicate through tiny gestures, an episode directly taken from Zola, although there the occasion is a game of dominoes – Sang-hyeon advises Tae-ju on the mechanics of drawing blood from a body in which circulation has stopped, suggesting the yield be stored in Tupperware containers in the fridge. Indeed, the Korean title for the film, *Bakjwi* translating as 'The Bat', is up front in indicating the absurdist self-reflexive tone which runs through the film and undermines any real possibility of fearful affect.

Visually, *Thirst*, aside from one or two set pieces, is more restrained than some of Park's work hitherto, although there are occasional examples of expressive use of overhead shots, gliding camera and slanted angles and a colour palette emphasizing mortuary greens and blues. In fact, it is the film's sound design which is ultimately more memorable. Park's 'naturalistic' study of vampirism and seduction is discomfortingly accompanied by frequent and detailed noises of sucking, slurping, swallowing, genital friction and armpit-licking. Rather than pushing forward the animalism of the vampire as per some cinematic imaginings (think Coppola's adaptation of Stoker's *Dracula*, for example), bloodsucking and sexual exploits here foreground the abject aspects of mundane human greed. Thematically, the vampiric content appears to serve primarily in facilitating a tragicomic meditation on the curse of individual appetite, which can only be indulged at the expense of common humanity.

Dean Lockwood

Thirst, 2009, Focus Features/Kobal Collection

RECOMMEND
READING ANI

Film Guides, Cultural Theory & Industry History

Ahn, SooJeong (2011) *The Pusan International Film Festival, South Korean Cinema and Globalization* (TransAsia: Screen Cultures Series) Hong Kong: Hong Kong University Press.

Birmingham, Elizabth (2010) 'No Man Could Love Her More', in Josef Steiff & Adam Barkman (eds) *Manga and Philosophy*, Chicago: Open Court Publishing, pp.129-139.

Bowyer, Justin (ed) (2004) *The Cinema Of Japan and Korea*, London and New York: Wallflower Press.

Carolyn, Axelle (2008) *It Lives Again! Horror Movies in the New Millennium*, Moulton, Cheshire UK: Telos Publishing

Choi, Jinhee (2010) *The South Korean Film Renaissance: Local Hitmakers, Global Provocateurs*, Middleton, CT: Wesleyan University Press.

Chung, Hye Seung and David Scott Diffrient (2007) 'Forgetting to Remember, Remembering to Forget: The Politics of Memory and Modernity in the Fractured Films of Lee Chang-dong and Hong Sang-soo' in *Seoul Searching: Culture and Identity in Contemporary Korean Film*, Frances Gateward (ed) New York: State University of New York, pp. 115-139.

Cumings, Bruce (1998) *Korea's Place in the Sun: A Modern History*, New York and London: W.W. Norton & Company.

Chung S I (2006). *Korean Film Directors: Im Kwon-taek*, Korean Film Council (KOFIC). Seoul: Seoul Selection.

Bruce Cumings (1998) *Korea's Place in the Sun: A Modern History*, New York and London: W.W. Norton & Company.

Gateward, Frances (ed) (2007) Seoul Searching: Culture and Identity in Contemporary Korean Cinema, New York: State University of New York Press.

Hughes, Theodore (2012) *Literature and Film in Cold War South Korea: Freedom's Frontier*, New York: Columbia University Press.

Jeong, Kelly Y (2011) *Crisis of Gender and the Nation in Korean Literature and Cinema: Modernity Arrives Again*, Maryland; Plymouth: Lexington Books.

Kalat, David (2007) *J-Horror: The Definitive Guide to The Ring, The Grudge and Beyond*, New York:Vertical Books.

Kim, Kyung Hyun (2004) *The Remasculinization of Korean Cinema* (Asia-Pacific) Durham: Duke University Press

Kim, Kyung Hyun (2012) *Virtual Hallyu: Korean Cinema of the Global Era*, Durham: Duke University Press.

Lee, Hyangjin (2000) *Contemporary Korean Cinema: Culture, Identity and Politics*, Manchester: Manchester University Press.

Lee, Young-il & Choe, Young-chol (1988) *The History of Korean Cinema*, Seoul: Jimoondang Publishing Company.

RESOURCES

Directory of World Cinema

Leong, Anthony (2002) *Korean Cinema: The New Hong Kong*, Victoria, Canada:
Trafford Publishing.
Min, Eungjun & Joo, Jinsook & Kwak, Han Ju (2003) *Korean Film: History,
Resistance, and Democratic Imagination*, Westport, CT: Praeger Publishers.
Paquet, Darcy (2011) *New Korean Cinema: Breaking the Waves* (Short Cuts),
New York; Chichester, West Sussex: Wallflower.
Russell, James (2009) *Pop Goes Korea: Behind the Revolution in Movies, Music
and Internet Culture*, Berkeley, California: Stone Bridge Press.
Stringer, Julian and Shin, Chi-Yun (2005) *New Korean Cinema*, Edinburgh:
Edinburgh University Press.
Sun Jung (2010) *Korean Masculinities and Transcultural Consumption: Yonsama,
Rain, Oldboy, and K-Pop Idols*) Hong Kong: Hong Kong University Press
Williams, Linda (1991) 'Film Bodies: Gender, Genre, and Excess', *Film Quarterly*,
Vol. 44, No. 4.
Yecies, Brian & Shim, Ae-Gyung (2011) *Korea's Occupied Cinemas, 1893-
1948: The Untold History of the Film Industry*, New York; Abingdon, Oxon:
Routledge.
Yecies, Brian (2003) *Traces of Korean Cinema from 1945-1959*, Seoul: Korean
Film Archive.

Director Studies and Genre Studies

Balmain, Colette (forthcoming 2014) *South Korean Horror Cinema: History,
memory, identity*, Oxford: Interdisciplinary Press/Fisher Imprints.
Choi, Jinhee & Wada-Marciano, Mitsuyo (eds), *Horror to the Extreme: Changing
Boundaries in Asian Cinema*, Aberdeen, Hong Kong: Hong Kong University
Press
Chung, Hye Seung (2012) *Kim Ki-duk*, Urbana, Chicago and Springfield:
University of Illinois Press.
Kim, Kyung Hyun & James, David E (eds) (2002) *Im Kwon-Taek: The Making of a
Korean National Cinema*, Wayne State University Press.
McHugh, Kathleen & Abelmann, Nancy (eds) (2005) *South Korean Golden Age
Melodrama: Gender, Genre, and National Cinema*, Detroit, Michigan: Wayne
State University Press.
Peirse, Alison & Daniel Martin (eds) (2012) *Korean Horror Cinema*, Edinburgh:
Edinburgh University Press.
Rayns, Tony & Field, Simon (ed) (1996) *Seoul Stirring: Five Korean Directors*, BFI
Publishing: London.
Various (2007-2009) *Korean Film Directors Series*, Seoul: Seoul Selection.

SOUTH KOREA
CINEMA
ONLINE

Articles, Blogs, News and Reviews

Asia Shock
http://asiashock.blogspot.com
An online companion by Patrick Galloway to his book *Asia Shock: Horror and Dark Cinema from Japan, Korea, Hong Kong and Thailand* (2006) with regularly updated reviews of genre films from Japan and elsewhere.

Bright Lights Film Journal
http://www.brightlightsfilm.com
Bright Lights Film Journal is a hybrid of the academic and the popular, offering film analysis, commentary and history with regards to international cinema, with vantage points ranging from the aesthetic to the political.

Directory of World Cinema
http://www.worldcinemadirectory.org/
The website for the Directory of World Cinema series features film reviews and biographies for prominent directors, serving as an ideal starting point for students of World Cinema.

Intersections: Gender and Sexuality in Asia and the Pacific
http://intersections.anu.edu.au/
An online peer reviewed journal which has articles on South Korean history and culture as well as on issues of sexuality and gender in cinema.

Koreanfilm.org
http://koreanfilm.org/
This is most detailed online resource on South Korean cinema, launched by Darcy Parquet, journalist and expert on South Korean cinema, in 1999. With reviews dating back to 1945, director essays and festival overviews, this is the essential resource on South Korean cinema.

Oriental Nightmares
http://orientalnightmares.wordpress.com/
Oriental Nightmares is the blog of Colette Balmain and is dedicated to discussing East and South East Asian cinema and culture.

Senses of Cinema
http://www.sensesofcinema.com
Senses of Cinema is an online journal devoted to facilitating a serious and eclectic discussion of international cinema with a primary focus on the bodies of work of work of major film-makers.

VCinema
http://www.vcinemashow.com
VCinema started as a streaming web show in 2009 and was established as a blog in 2010, now offering regular reviews of Asian Cinema with ample South Korean-related content, alongside downloadable podcasts co-hosted by Jon Jung, Josh Samford and Rufus L de Rham.

Wild Grounds
http://wildgrounds.com
A great resource for up-to-date news on the latest Asian releases, including reviews and trailers of South Korean film.

London Korean Links
http://londonkoreanlinks.net/
London Korean Links was set up in 1996 by Philip Gowman as a forum to discuss and disseminate information and expertise about South Korean culture with particular reference to events in London including the London Korean Film Festival.

Foreigner's Guide to Film Culture in Korea
http://cinephileforeignerinkorea.blogspot.com/
Mark Raymond's blog on Korean film which looks at film culture from 'inside' Seoul.

Hangul Celluloid
http://www.hangulcelluloid.com/
Hangul Celluloid is an online film review site run by Paul Quinn. The site includes interviews and articles on South Korean cinema alongside reviews of a range of films and genres.

KoreanCinema.Org
http://www.koreancinema.org/p/home-page.html
KoreanCinema.Org is an online film review site run by Martin Cleary which covers a wide range of Korean films. There are a range of articles, discussions, reviews and interviews available.

Modern Korean Cinema
http://modernkoreancinema.blogspot.com/
Modern Korean Cinema is one of the leading Korean film resources online. With a growing team of writers it provides reviews of current and past releases, ample festival coverage, insightful interviews and a wide array of features, as well as weekly updates on Korean film news, box office and reviews.

Seen in Jeonju
http://www.koreanfilm.org/tom/
Seen In Jeonju is a blog dedicated to past, present and future Korean films and is run by Tom Giammarco. This is an essential repository for hard to access information on early South Korean cinema.

Tully's Recall
http://kierantully.blogspot.co.uk/
Tully's Recall is Kieran Tully's personal reflection on modern screen culture, with a particular focus on Asian cinema and happenings in Australia. As Kieran Tully is the Artistic Director of the Korean Film Festival in Australia, his blog is of particular interest in relation to Korean cinema and the festival scene.

Hanguk Yeonghwa
http://hangukyeonghwa.com/
Hanguk Yeonghaw is run by Simon McEnteggart and is dedicated to exploring Korean Cinema as an exciting, innovative, and challenging alternative to Hollywood.

Cultural and Industrial Organizations

The Association for Asian Studies
http://www.aasianst.org
The Association for Asian Studies is a scholarly, non-political, non-profit professional association open to anyone interested in the study of Asia. With approximately 7,000 members worldwide, the association is open to all academic disciplines.

The Korea Society
http://www.koreasociety.org/
The Korea Society is dedicated to the promotion of greater awareness and understanding between Korea and the United States. The site contains a wide range of links and discussions on South Korean cinema and culture.

The Anglo-Korean Society
http://anglokoreansociety.org.uk/
The Anglo-Korean Society is a forum for cultural and social exchanges between the UK and Korea.

The Council on East Asian Studies at Yale University
http://eastasianstudies.research.yale.edu
The Council on East Asian Studies (CEAS) at Yale University in New Haven, Connecticut was founded in 1961 and continues a long tradition of East Asian Studies at Yale. CEAS has promoted education about East Asia both in the college curricula and through lectures, workshops, conferences and cultural events.

Databases

Asian DB
http://www.asiandb.com
Database devoted to Asian media with extensive sections for film and television. Mostly reliable but not as user-friendly as asianmediawiki.com

Asian Media Wiki
http://asianmediawiki.com
Database devoted to Asian cinema, with up-to-date entries for the field of
Korean cinema. Very reliable with festival dates, trailers and stills also provided.

Han Cinema: The Korean Cinema and Drama Database
http://www.hancinema.net/
This is one of the most extensive databases on South Korean Cinema and
Culture available, including links to articles and other related materials.

Internet Movie Database
http://www.imdb.com
The biggest and most widely-used online film database with extensive informa-
tion on most titles, although care needs to be taken as there can be inaccuracies
in relation to film details.

Korean Film Archive (KOFA)
The most authoritative source on Korean cinema, with a searchable database
– Korean Movie Database (KMDB) - which allows access to some of the more
difficult to find Korean films either for a small fee or free, with informative details
about 100 Korean Films (http://www.koreafilm.org/feature/100.asp) which are
part of KOFA's ongoing preservation project. There is also a youtube channel
which gives access to 70 Korean films, available at: http://www.youtube.com/
user/KoreanFilm.

Distributors

IndieStory
http://www.indiestory.com/English/html/main-e.asp
Established in 1998, INDIESTORY INC. is one of Korea's distribution company
dedicated to all kind of independent films. Over 9 years, it has distributed over
650 titles including independent feature films, short films, short animations and
documentaries domestically and internationally. Currently, the company just
finished feature film production and is active in acquisition and distribution of
quality independent films.

Cine Asia
http://www.cine-asia.com/
Cine-Asia is the market-leading brand dedicated to the presentation of the very
best in contemporary Asian Cinema on Blu-Ray and DVD and is one of the best
sources for Korean cinema. Releases include *71 Into The Fire, Brotherhood,
Guard Post* and *Sword With No Name*.

Criterion Collection
http://www.criterion.com
Criterion specialize in releasing collector's editions of established classics and
cult favourites, often with extensive extra features

Eureka! Masters of Cinema
http://eurekavideo.co.uk/moc
As the name of the label suggests, Eureka specialises in releasing films by direc-
tors of distinction, often with detailed extra features. South Korean releases
include House and The Yellow Sea.

Palisades Tartan
http://www.palisadestartan.com
Palisades Tartan has re-launched the back catalogue of Tartan, the defunct
distributor that promoted the Asia Extreme brand throughout the 2000s. South
Korean films include The Whispering Corridor Films, The Vengeance Trilogy and
Thirst.

Third Window Films
http://thirdwindowfilms.com
Third Window Films release on interesting and provocative examples of Asian
Cinema. While they concentrate mainly on Japanese Films, their back catalogue
includes *Say Yes, Teenage Hooker Became Killing Machine, No Blood No Tears,
Dasepo Naughty Girls* and *Green Fish*.

Terracotta Distribution
http://terracottadistribution.com/
Terracotta Distribution is a UK based distribution label which specialises in Far
East Cinema which recently launched a specialist imprint label Terror-cotta,
focussing on horror, with the excellent Korean horror film, Death Bell.

Festivals

International Women's Film Festival in Seoul
http://www.wffis.or.kr/wffis2012/00eng_intro/main.htmlin
WFFIS is dedicated to the promotion of women's cinema from and across Asia
through the developing of an international network of female directors.

JeonJu International Film Festival
http://eng.jiff.or.kr/
The goal of the JIFF, established in 2000, is 'A Beautiful Change of the World
through Cinema' and the festival concentrates on digital, alternative and inde-
pendent cinema from across Asia.

Puchon International Fantastic Film Festival
http://www.pifan.com/
Established in 1997, The PiFan festival is held in July in Bucheon, South Korea.
The festival is devoted to horror, science fiction and fantasy cinema from South
Korea and other Asian countries.

Pusan International Film Festival
http://www.biff.kr/structure/eng/default.asp
The premiere film festival in Asia, the Pusan International Film Festival was first
held in 1996 and has a focus on introducing new directors and the promotion of
new films from Asia.

Seoul Human Rights Film Festival
http://seoul.humanrightsff.org/
The Seoul Human Rights Film Festival was founded by SARANGBANG (Human
Rights Group) whose remit is the promotion of human rights awareness in Korea
and across the world.

Seoul LGBT Film Festival
http://www.selff.org/
The South Korean LGBT Film Festival has been going since 2000, and is now in its 12th year. It screens both domestic and international LGBT films, alongside talks and discussions and has played a vital role in promoting LGBT rights in South Korea.

Terracotta Far East Film Festival
http://terracottafestival.com
London-based Asian film festival founded by Joey Leung of Terracotta Distribution, which shows South Korean films, along with titles from China, Hong Kong, Thailand, Taiwan and Japan.

The London Korean Film Festival
http://www.koreanfilm.co.uk/
The London Korean Film Festival premieres new films, running alongside retrospectives of key South Korean directors. The festival also features roundtable discussions about Korean cinema and Q&As with leading directors.

Udine Far East Film Festival
http://www.fareastfilm.com
Asian film festival that usually features a strong strand of Japanese titles. Special hospitality arrangements often available to academics and journalists.

TEST YOUR KNOWLEDGE

1. What is the name of the oldest surviving Korean film?
2. Which is the first South Korean film to win the Golden Lion at the Venice Film Festival and who is the director?
3. Who released their 101st film in 2011, and what is the film's title?
4. What is the South Korean name for the film *The Host*?
5. What film is based upon a Japanese manga by Fumi Yoshinaga about four men who work in a bakery?
6. Which musical film is based around the exploits of a family of *Gumiho*, who seek to become human?
7. What type of film is called *sageuk* in Korean?
8. Who directed the award-winning film *The King and the Clown*?
9. What is the difference between The Korean New Wave and New Korean Cinema?
10. What romantic comedy film is based around real life internet blogs of Kim Ho-sik?
11. Who is the director of *Green Fish* and *Peppermint Candy*?
12. What film is called South Korea's first Western?
13. Who directed *A Single Spark*, *Black Republic* and *To The Starry Island*?
14. Which series of films are set in all-girl high schools?
15. What pivotal historical event forms a pivotal element of the storyline in *A Man Who Was Superman*?
16. The success of which 1993 American film marked a change in attitudes towards film production in South Korea?
17. Which film was the first bona fide smash hit of New Korean Cinema?i
18. Who directed the 'Vengeance Trilogy'?
19. Name the film that inaugurated the Korean New Wave in 1988?
20. The Independent documentary movement was started by what film club in 1982?
21. What is the name of the famous Korean singer and K-idol who stars as Il-Sun in *I'm A Cyborg, But That's Ok*?

22. What science fiction film is loosely based upon a story by Hans Christian Anderson?
23. What alternative history does *2009 Lost Memories* imagine?
24. What is the film that was directed by Korea's first woman director, and who is the director?
25. Who is the director of the South Korean films *A Flower in Hell* and *A Thousand Year Old Fox*, who also directed the North Korean monster film, *Bulgasari*?
26. What film has been widely seen as the first Korean film to deal directly with homosexuality?
27. Who plays the mentally-disabled young man, who is responsible for the death of a young girl, in Bong Jong-ho's *Mother*?
28. What is the name of Bong Jong-ho's contribution to the 2008 omnibus film *Tokyo!*?
29. What year did the London Korean Film Festival (LKFF) in its current form begin?
30. Who is the director of *Paju* (2009)?
31. *This Charming Girl* is the directorial debut by whom?
32. Which South Korean horror film is about a remake of Nakata's 1998 Japanese horror film, *Ringu*?
33. Who directed *HaHaHa* and *Virgin Stripped Bare By Her Bachelors*?
34. Which actor had leading roles in *Green Fish*, *The Scarlet Letter*, and *Shiri*?
35. Which 1964 film is set in a hospital and is about a doctor who kills his mistress by throwing her down the stairs?
36. What is the name of the protagonist in Kimjo Kwang-soo's short film trilogy: *Boy Meets Boy, Just Friends? Love, 100 Degrees C*?
37. What does the term 'minjung' mean?
38. Why are most South Korean horror films released in the Summer?
39. In 1968, approximately 360,000 people attended screenings in Seoul of which film?
40. What was the opening film of the 2010 London Korean Film Festival?
41. Which film is about two female neighbours, one who is a chef and the other a writer who suffers from anorexia?
42. What pivotal film from 1960 by Kim Ki-young was remade in 2010 by Im Sang-Soo?
43. What is the traditional name for ghosts in Korean culture?
44. In which film is does an overweight young woman provide the vocals for Ammy, a famous singer?
45. Which South Korean horror film was recently remade as *The Uninvited*?
46. What 2003 film was based upon the French novel *Les liaisons Dangereuses*?
47. Which director directed the low-budget film *Stoker* in the US?
48. Who is the director of *Spinning a Tale of Cruelty towards Women*?
49. Which two films in 2011 were about the K-pop industry?
50. What South Korean horror film is about a pair of possessed shoes?

Answers

1. *Crossroads*
2. Pieta, directed by Kim Ki-duk
3. Im Kwon-taek/*Hanji*
4. *Gwoemul*
5. *Antique Bakery*
6. *The Fox Family*
7. Period dramas
8. Lee Joon-ik
9. The term New Korean Cinema refers to the films and film-makers that emerged from Korea in the late 1990's following the Korean New Wave which represents a new era in Korean cinema, shedding many of the restraints of its authoritarian past and creating a new creative industry and community
10. *My Sassy Girl*
11. Lee Chang-dong
12. *The Good, The Bad, The Weird*
13. Park Kwang-su
14. The Whispering Corridors series
15. The Gwang-ju uprising
16. *Jurassic Park* (Steven Spielberg, USA: 1993)
17. *Shiri*
18. Park Chan-wook
19. *Chilsu and Mansu*
20. Seoul Cine Group/Seoul Filmic Group
21. Rain
22. *Resurrection of the Little Match Girl*
23. The nation as having fallen under a fictional post-WW2 Japanese Empire
24. *Mimang-in*/Park Nam-ok
25. Shin Sang-ok
26. *No Regret.*
27. Won-bin
28. *Shaking Tokyo*
29. 2006
30. Park Chan-wok
31. Lee Joon-ki
32. *The Ring Virus*
33. Hong Sang-soo
34. Han Suk-kyu
35. *The Devil's Stairway*
36. Min-soo
37. Literally the 'oppressed'
38. Cold chills are said to help with the summer heat
39. *Love Me Once Again.*
40. *The Man From Nowhere*
41. *301/302*
42. *The Housemaid*
43. Kwishin
44. *200 Pound Beauty.*
45. *A Tale of Two Sisters*
46. *Untold Scandal*
47. Park Chan-wook
48. Lee Doo-yong
49. *Mr Idol and White: The Melody of the Curse*
50. *The Red Shoes*

NOTES ON CONTRIBUTORS

The Editor

Colette Balmain is a lecturer, film critic and writer who specializes in East Asian cinemas and cultures. She is currently working on a second edition of *Introduction to Japanese Horror Film* (2013) and a monograph on South Korean horror cinema (2013). She is also writing a third book on East Asian Gothic Cinema (2015). She has contributed to both *Directory of World Cinema: Japan 1 & 2* (2011/2012) and *Directory of World Cinema: American Independent 1 & 2* (2011/2012).

Contributors

Jason Bechervaise after completing his BA(UEL) and MA(SOAS) in film in London, Jason is now currently studying for a PhD in Korean cinema at Hanyang University, Seoul. Jason is also an active film critic in Korea where he frequently participates in broadcast and online media.

John Berra is a lecturer in Film Studies at Nanjing University. He is the author of *Declarations of Independence: American Cinema and the Partiality of Independent Production* (2008); editor of the *Directory of World Cinema: American Independent* (2010/12); editor of the *Directory of World Cinema: Japan* (2010/12); and co-editor *World Film Locations: Beijing* (2012). His essay on Kim Ki-duk's *Spring, Summer, Autumn, Winter... and Spring* was published in *The End: An Electric Sheep Anthology* (2011).

Adam Bingham has a PhD in Film Studies/Japanese cinema from the University of Sheffield, where he taught film for three years. He now teaches at Edge Hill University in Lancashire, and writes regularly for *Asian Cinemas Journal*, *CineAction*, *Cineaste*, *Electric Sheep* and *Senses of Cinema*. He is the editor of the *Directory of World Cinema: East Europe* (2011) and the *Directory of World Cinema: India* (2012).

Martin Cleary is the creator and writer of the website NewKoreanCinema.Com. He has been writing about film online for over ten years, has written for several magazines and contributed to episodes of the 'What's Korean Cinema?' series for the Podcast On Fire Network. He lives in Norwich in the UK and drinks far too much coffee.

Anne-Maria Cole after completing a Film and Theatre BA at Reading and a Theatre-Making MA, Leeds, Anne-Maria spent a year teaching English in South Korea. Here

she fell in love with Korean cinema, culture, and language, and did not look back. Now she is a regular contributor to The Korea Blog, founder of London website *Kimchi Soul*, and winner of the Korean Cultural Centre's 2010 Literature Essay Contest. Specialties include K-horror and film/theatre mixed media.

Pierce Conran, a Seoul-based writer, is the founder and editor of Modern Korean Cinema (www.modernkoreancinema.com) and the Korea correspondent for Twitchfilm. com. He has also spoken about Korean film at conferences and contributed to various publications including Korea's leading film magazine *Cine21* and the *Scope Online Journal*.

Bob Davis is Professor of Film History and Production at California State University, Fullerton. He has been a regular contributor to *American Cinematographer* magazine and has published academic essays on Asian cinema in *Film Criticism* and elsewhere.

David Scott Diffrient is Associate Professor of Film and Media Studies in the Department of Communication Studies at Colorado State University. His articles have been published in such journals as *Cinema Journal*, *Critical Studies in Television*, *Historical Journal of Film, Radio, and Television*, *Journal of Film and Video*, *Journal of Japanese and Korean Cinema*, *Journal of Popular Film and Television*, and *Post Script*, as well as in several edited collections about film and television topics. He is the author of a book on the television series *M*A*S*H* (2008) and editor of a volume on the 'screwball' TV series *Gilmore Girls* (2010).

Tom Giammarco has been living in Korea since 1995 and teaches as a professor in the Department of English at Woosuk University. At the beginning of 2012, he was appointed director of the Woosuk University Foreign Language Center. Arriving in Korea, he became interested in early Korean films and eventually earned an MA focusing on Korean Film History. Tom writes the blog *Seen in Jeonju* for Koreanfilm.org and his articles can be seen in both magazines and journals.

Adam Hartzell has been a contributing writer for the premier English-language website on South Korean cinema, Koreanfilm.org, since 2000. He has written extensively on Hong Sang-soo for festival programmes such as the San Francisco International Asian American Film Festival, the book *The Cinema of Japan and Korea* (Wallflower Press, 2004), and other websites devoted to Asian cinema such as VCinema, where he is also a contributing writer. Other film websites he has written for are sf360, GreenCine Daily, and Fandor, along with the print quarterly *Kyoto Journal*.

Kay Hoddy has been following Asian cinema and contemporary music since 2004 and works in film post production in Soho, London. Despite a DVD collection exponentially related to her income, her favourite Korean films are still *Antique* and *Memories of Murder*. Kay's blog is http://counting pulses.com, where she often rambles...

Thomas Humpal has lived and worked in South Korea for seven of the last eight years where he annually attends the Pusan International Film Festival (the largest film festival in Asia) along with many of the other regional film festivals throughout Korea, Japan, and China. He is currently an instructor of Economics and the English Language at Daegu University in South Korea.

Yun Mi Hwang is Teaching Fellow in the Department of English at the University of Ulsan, Korea, where she teaches courses in English, ESL, film, and popular culture. Her research interests include costume dramas, heritage industries, and cultural policy. She has published articles on film festivals, East Asian co-productions, and New Korean Cinema and is currently preparing a monograph titled 'Heritage on Screen: South Korean Historical Dramas'.

Nam Lee is Assistant Professor of Film Studies at Dodge College of Film and Media Arts, Chapman University in Orange, California. Before joining academia, she was a print journalist and film critic in Seoul, Korea, writing film reviews and articles for JoongAng Ilbo. She has research published in *Asian Cinema* and she is currently working on a book on Korean director Bong Joon-ho. She also organizes the annual Busan West Asian Film Festival at Chapman University, bringing prominent film-makers and films from Asia.

Dean Lockwood (PhD, York) is a Senior Lecturer in Media Theory in the School of Media, University of Lincoln, UK. His recent research has focused on the politics of affect and noise in the areas of visual, auditory and literary culture, covering, for example, post-punk/industrial music and contemporary trends in horror film, weird fiction and crime fiction. *Cloud Time*, a book written with Rob Coley, which extends these concerns to the culture of 'cloud computing', was published by Zero Books in 2012.

Ian London is a PhD at Royal Holloway University of London. His doctoral thesis on film marketing and the Hollywood blockbuster examined the development of official motion picture websites and their impact on theatrical as well as domestic film viewing.

Angus McBlane is currently completing a PhD in Critical and Cultural Theory at Cardiff University where his thesis is on Merleau-Ponty, Posthumanism and Embodiment. He has previously been published in the *Directory of World Cinema: Japan* and in Open Court's Popular Culture and Philosophy volume *Anime and Philosophy: Wide-Eyed Wonder*.

Dave McCaig is a Senior Lecturer in Media Theory at The University of Lincoln, UK. Recent publications include contributions to *World Film Locations: Beijing* (2012) and the forthcoming, *The Routledge Encyclopaedia of Films* (2013).

Matthew Melia is a Senior Lecturer in TV and Film Studies at Kingston University. He teaches on the MA module Mapping World Cinema specializing in East Asian Cinema. Matthew is also project leader for The ID-Net conference Space and Place

Spencer Murphy is a lecturer in media and communications at Coventry University. He is currently completing his PhD on the cinema of post 1997 Hong Kong for which he conducted interviews and seminars with leading figures in the Hong Kong film industry such as To Kei-Fung, Patrick Tam and Pang Ho-Cheung. He is the founder and organizer of the Coventry East Asian Film Society and the organizer of the annual East Winds Symposium.

Gary Needham teaches film and television studies at Nottingham Trent University. He is the author of *Brokeback Mountain* (2010), from the American Indies series he also co-edits, and has co-edited *Asian Cinemas: A Reader and Guide* (2006) and *Queer TV: Histories, Theories, Politics* (2009). He is currently working on two forthcoming books, *Warhol in Ten Takes* for the British Film Institute and *Film Studies: A Global Introduction*.

Curtis Owen studied film at Falmouth University and co-authored *George A Romero* for the Pocket Essentials series. He writes VHS reviews for the Video Warriors website. He is currently preparing projects on John Waters, Larry Cohen and Mary Woronov. He has also contributed to various volumes in the Directory of World Cinema series.

Sueyoung Park-Primiano is a PhD Candidate at New York University. Her dissertation concerns the dialogic relationship between South Korean cinema and Hollywood in the aftermath of the Pacific War. She is also adjunct faculty at NYU and SUNY's Fashion Institute of Technology, where she teaches courses on film and media and global communication.

Paul Quinn founded the Korean film review website www.hangulcelluloid.com in early 2008 and has been its sole writer and editor up to the present day. He is also a feature writer for magazines *Unfolded* and *Pelter* and has had several reviews featured in the Korean Cultural Centre UK's commemorative Director Retrospectives.

Rufus de Rham holds a BFA in Cinema Studies/East Asian Studies and an MFA in Moving Image Archiving and Preservation from New York University. He serves as the Operations Manager and Assistant Programmer for the New York Asian Film Festival and is heading their current project, the Asian Film Preservation Fund, which seeks to help preserve Asian genre film history. He is the editor-in-chief of cineAWESOME! a film blog covering cinema from all over the world, where he writes extensively on Korean film and British film collectives of the 1980s. Rufus is also a regular on What's Korean Cinema? a featured podcast on the Podcast on Fire network.

Jooyeon Rhee is a Luce Postdoctoral Fellow at Wittenberg University in Springfield, Ohio. She published scholarly articles on Korean literature and film, and her current research interests are Korean translations of Japanese popular fictions in the 1910s and representation of Koreans in Japan in Oshima Nagisa's films.

Phillip Roberts is a researcher in film and visual theory and twentieth-century philosophy, specializing in political film theory and the work of philosopher Gilles Deleuze. He has published work for *Deleuze Studies, Scope* and the *Directory of World Cinema: France*.

Josie Sohn is a Korea Foundation Postdoctoral Fellow at the University of California at Riverside. Her dissertation is an interdisciplinary ethnography of film culture and cinephilia in South Korea, and her interests include the transnational and techno-cultural dimensions of Korean popular culture, popular literature, and literary translation.

FILMOGRAPHY